15:00

9.6.92
H.F
£15.00

9911

B C

9911

THE NORTHERN LANDSCAPE

This exhibition was developed with the support of Mrs. Henry J. Heinz II.
This exhibition is made possible by support from The Vincent Astor
Foundation, Banca Nazionale del Lavoro, British Airways, BP North
America Inc., and Manufacturers Hanover Trust Company.
Public funds from the National Endowment for the Arts, the New York
State Council on the Arts and the Institute of Museum Services, a federal
agency that offers general operating support to the nation's museums, also
assisted in making this exhibition possible.

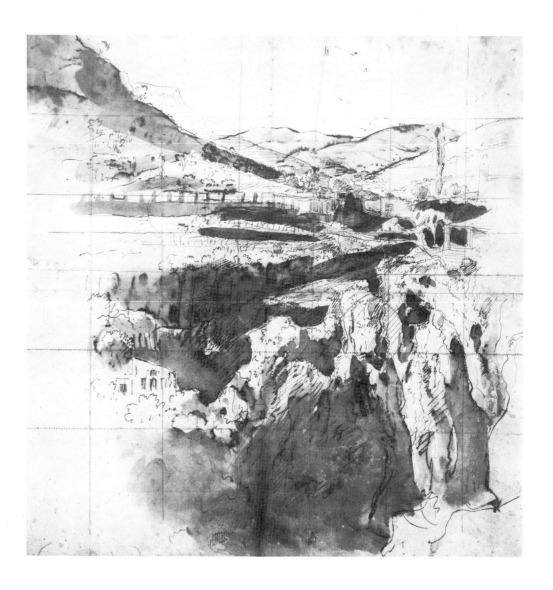

Flemish, Dutch and British Drawings from the Courtauld Collections

THE NORTHERN LANDSCAPE

DENNIS FARR AND WILLIAM BRADFORD

Trefoil Books, London

AUTHORS' ACKNOWLEDGEMENTS

This exhibition was first suggested to us by Martha Beck, Director of the Drawing Center, New York, and was enthusiastically accepted. We then decided on the theme of *The Northern Landscape*, as portrayed by Flemish, Dutch and British artists represented in the Courtauld Collections.

We greatly welcome the opportunity of showing this exhibiiton first at the Drawing Center, and afterwards, in celebration of the 150th anniversary of the foundation of the University of London, at the Courtauld Institute Galleries.

We also wish to thank Mr William Clarke, Paper Conservator at the Courtauld Institute Galleries, for, his invaluable help on technical matters, and Miss Robin Featherstone; scholars who have assisted with particular problems are thanked in the context of the appropriate catalogue entries.

We are grateful to Professor Martin Kemp for lending a vital Leonardo photograph. Our thanks also go to Conway Lloyd Morgan and his colleagues for their imaginative professional support.

D. F., W. B.

CONTENTS

Published by Trefoil Books Ltd
7 Royal Parade Dawes Rd London SW6

First published by Trefoil Books Ltd, 1986

© Dennis Farr & William Bradford, 1986

ISBN 0 86294 075 3

Designed by Elizabeth van Amerongen
Set in Sabon by Tradespools Ltd, Frome, Somerset
Colour photography by A. C. Cooper Ltd
Colour origination by Colorlito
Printed and bound by Motta, Milan

The Leonardo drawing on p. 10 is reproduced by gracious permission of Her Majesty the Queen. We are also grateful to the other museums whose works are reproduced in the introduction.

The watermarks illustrated on the endpapers refer to the following catalogue numbers (top to bottom, left to right):
14, 31, 37, 26, 55, 64, 31
43, 32, 45 & 46, 58, 62, 2
54, 15, 71, 34 (2 marks) 7, 63, 59.

Title page illustration: Van Wittel, *View of Tivoli*
Cover illustration: J. M. W. Turner, *Dawn after the Wreck*

FOREWORD

This exhibition celebrates the ninth anniversary of The Drawing Center. Since its founding in 1977, the Center, a nonprofit institution, has sought through exhibitions and educational events to express the diversity, quality and importance of drawing – the creation of unique works on paper – as a major art form. Each year the Center presents five exhibitions. Those of an historical nature complement the Center's *Selections* series – group exhibitions of drawings by promising, contemporary artists. These are chosen from the Center's ongoing Viewing Program. Through this program, over 2,000 artists a year are able to make appointments to show their drawings to a curator or leave off a portfolio for viewing by the curatorial staff. In each of the four annual exhibitions, the work of eight to fifteen artists is shown. Over the past nine years, 346 artists have been shown in thirty-two *Selections* exhibitions.

It is with special pleasure and pride that The Drawing Center presents this exhibition from the Courtauld Institute Galleries in London. The Director, Dennis Farr, has been a good friend to the Center for many years; his goodwill, cooperation and generosity have made the exhibition a particularly happy event.

The organization of this exhibition was greatly facilitated by the constant support of the directors of The Drawing Center: Werner H. Kramarsky, Chairman; Mrs. Felix G. Rohatyn, Vice Chairman; Mrs. Walter N. Thayer, Vice Chairman; James M. Clark, Jr.; George R. Collins; Mrs. Colin Draper; Colin Eisler; William S. Lieberman; John McGarrahan; Mrs. Gregor W. Medinger; Douglas Newton and Edward H. Tuck. I also appreciate the contribution of the Advisory Committee: Egbert Haverkamp Begemann; Per Bjurstrom; Dennis Farr; John Harris; C. Michael Kauffmann and Pierre Rosenberg. Special thanks go to my colleagues, Elinore Antell, Director of Development; Peter Gilmore, Exhibition Assistant and Janet Riker, Assistant Curator. All of us thank the many work/study students and interns who have made our task easier and more pleasurable.

I am particularly grateful to Michael Iovenko, our legal counsel, who from the earliest days has given gracious and kind advice. Finally, I would like to thank the following people who helped in innumerable ways: Paul Anbinder, Mrs. Vincent Astor, David Bancroft, Michael Beirut, Huntington T. Block, Carlo Cassinari, Mr and Mrs Michael Coles, Keith Davis, R. C. H. Genochio, Linda Gillies, Mrs. Marco Grassi, Laura Hillyer, Paul Hopper, Marie T. Keller, John Lampl, Irene Mann, Alastair Manson, Colin Marshall, Barbara Merna, Ward Mintz, Mary Moro, Andrew Oliver, John R. Price, Jr., Gilbert Robinson, Felix G. Rohatyn, Sarah Rubenstein, Rosemary Serra, John Smith, David Snelling, Leslie Spector, Edward A. Sultan, Walter N. Thayer, William H. Told, Jr., Brenda Trimarco, Joline Tyhach, and Lella and Massimo Vignelli.

Martha Beck
Director,
The Drawing Center

THE COURTAULD INSTITUTE OF ART
AND ITS COLLECTIONS

The exhibition, *The Northern Landscape*, brings to New York 120 masterpieces from the drawings collections belonging to the Courtauld Institute of Art, University of London. They are a distinguished but highly selective introduction to the art treasures owned by the Courtauld. The drawings come principally from the bequest of Sir Robert Witt in 1952, the bequest and gift of Mr and Mrs William Wycliffe Spooner 1967; the drawing by Pieter Breugel the Elder is from Viscount Lee of Fareham's collection. To these are added a selection of five Turner watercolours from 13 thirteen choice examples which once belonged to Sir Stephen Courtauld (brother of our founder, Samuel Courtauld), and which were presented to us in his memory by the family in 1974.

When Count Antoine Seilern bequeathed to us his collection of old master paintings and drawings in 1978, known as The Princes Gate Collection, he stipulated in his Will that no drawing from the bequest may be lent to locations outside London. We refer, in the Introduction, to some important northern drawings from this Collection that are relevant to our present theme.

The Courtauld is chiefly renowned for its superb collection of Impressionist and Post-Impressionist paintings and drawings, given and bequeathed to us by Samuel Courtauld, who, encouraged by Lord Lee and Sir Robert Witt, offered to endow from his personal fortune an institute for the study of the history of art in the University of London. Negotiations were begun in 1928 and by 1931, the Institute was in being but still without proper accommodation. After the sudden death of Courtauld's wife, Elizabeth, in 1931, he decided to offer the University the remaining 50-year lease on his beautiful house at 20 Portman Square. This was Home House, built by Robert Adam for the Dowager Countess of Home in 1773–75. Courtauld had become Chairman of the family silk and rayon manufactory in 1921, by which time it was already rapidly expanding. It was then that he and his wife began to collect Impressionist paintings, and he continued to do so until 1936. Not only did he build up his private collection, in 1923 he gave £50,000 to the Tate Gallery to enable it to buy Impressionist and Post-Impressionist works for the national collection of modern art. Masterpieces such as Seurat's grand *Bathers* (now National Gallery, London), and Manet's *A Bar at the Folies-Bergère* (Courtauld Institute Galleries) thus became accessible to a wider public, as he had wished.

Courtauld's munificent example prompted other benefactions: from Sir Martin (later Lord) Conway and Sir Joseph Duveen; from Lord Lee (in 1947) the bequest of his early Italian, German, Netherlandish, and eighteenth-century British paintings, and Italian *cassone*; from Sir Robert Witt, some 4000 old master drawings, and his photographic art-reference library; and by bequest in 1964 from Mark Gambier-Parry, the collection of his grandfather, Thomas Gambier-Parry, consisting mainly of Trecento and Quattrocento paintings, sculpture and *objets d'art* (including some Islamic art). The Gambier-Parry collection is of importance not only for its aesthetic qualities, but as a memorial to a pioneer nineteenth-century collector of gold-back pictures by the so-called Italian primitives. In 1934, following the death of Roger Fry and in accordance with his wishes, his family presented his collection of twentieth-century paintings, including work by the artists of the Bloomsbury Group and designs and furniture produced by Fry's Omega Workshops (1913–19).

The Princes Gate Collection, already mentioned, was bequeathed to us in 1978, and is arguably the finest benefaction since Samuel Courtauld's foundation gift and endowment. It complements the Lee and Gambier-Parry collections, for it is strong in Netherlandish art of the fifteenth century, as well as containing a superb Bernardo Daddi triptych of 1338. The bias of Seilern's taste reflects his formative years in Vienna and familiarity with the collections of the Kunsthistorisches Museum. He made a special study of the work of Rubens (there are 32 of his finished oils and sketches in the collection), but his sympathies extended to Venetian sixteenth-century painting and the art of G. B. Tiepolo, as well as Degas, Renoir, Pissarro, and late Cézanne. His choice collection of nearly 300 drawings also ranges widely, from Mantegna and Hugo van der Goes to Delacroix and Picasso, with particular emphasis on Bruegel, Rembrandt, Rubens, and the Tiepolos.

Gifts and bequests continue to come to the Courtauld. Recently, Lillian Browse, the former London art dealer, gave a group of works and signified her intention to bequeath the greater part of the remainder of her collection of late nineteenth- and early twentieth-century French and British paintings and sculpture, including fine examples of Degas, Sir William Nicholson, and Sickert, as well as contemporary artists. The late Alastair Hunter, a former Dean of St. George's Hospital Medical School, London University, bequeathed in 1983 a small but carefully chosen group of modern British paintings, including an early abstract *Painting*, 1937, by Ben Nicholson, and works by Sutherland, Hitchens, Keith Vaughan, John Hoyland, and a Picasso etching from the Minotaur suite. In the same year, Anthony Blunt, a former Director of the Courtauld, bequeathed his collection of architectural drawings, mainly French and Italian of the seventeenth century, a field in which he had himself made many distinguished scholarly contributions.

All these collections were formed by men and women of great discernment and knowledge; each of them bears the personal imprint of their collector. Seilern, in particular, combined connoisseurship with scholarship, backed by financial resources which, though considerable, were by no means unlimited. The collections thus form a unique and precious adjunct to the teaching activities of the Courtauld, as well as providing enjoyment to the general public. It had always been the intention of our founder and his friends that the Courtauld Institute and its collections should be housed under one roof. Lord Lee, who had served as a diplomat in the United States and whose wife was American, was familiar with the Fogg Art Museum at Harvard, and he persuaded Courtauld that a similar institution should be established in London. Part of Courtauld's collection hung in the principal rooms at Portman Square until 1958, when the new Courtauld Institute Galleries were opened at their present site in Woburn Square, within the main Bloomsbury campus of the University and above the Warburg Institute. Plans to build a new Courtauld Institute on a site adjoining the Galleries came to nothing, partly because of financial difficulties. The accommodation for the Institute is now quite inadequate to house the four specialist libraries and academic staff and students. The space at the Galleries allows us to exhibit barely 40 percent of our collections, and study facilities are most inadequate. However, a solution to the problems was at hand.

By 1978 the Fine Rooms at Somerset House, which form part of the North Block and overlook The Strand, had become available. The Fine Rooms, built by Sir William Chambers between 1776 and 1780, as part of a grand government office development on the site of an old royal palace, housed the Royal Society, the Society of Antiquaries, and the Royal Academy of Arts who also, from 1780 until they moved to Burlington House, Piccadilly, in the mid-nineteenth century, held their annual summer exhibitions in the Great Room at Somerset House. We plan to move both the Courtauld Institute and the Galleries to the North Block of Somerset House by 1988 or early 1989.

We hope the exhibition will bring enjoyment to our American visitors and help to make known to a wider public in the United States the work of the Courtauld Institute, as we stand on the threshold of an exciting new development which will secure our future well into the next century.

Dennis Farr
Director
Courtauld Institute Galleries

INTRODUCTION: THE NORTHERN LANDSCAPE

Dennis Farr

THE THEME

The cultural and political links between Britain and the Netherlands have been close ever since the seventeenth century, and even when the two countries were intermittently at war with each other, these ties were never completely severed. The very word 'landscape' came into the English language from the Dutch. This exhibition charts one part of the history of landscape painting and drawing, through the resources of the Courtauld collections. Our theme is the evolution of landscape in Flanders, Holland, and later, in Britain: central to this development, in all its many aspects, is the gradual acceptance by artists and their patrons of landscape as a self-sufficient subject from the mid-sixteenth century onwards in the work of eminent northern masters. We explore a secondary but by no means unimportant theme of the interaction between northern art and Italy, especially Italy seen both as the cradle and the repository of an ancient civilisation. This idealised vision of a lost golden age found its expression first in the landscapes of Dutch and Flemish artists of the sixteenth and seventeenth centuries, and then of British artists working in and around Rome in the 1750s.

Side by side with this idealising mode of expression runs a new realism, a sharper observation of natural phenomena, of climate and the morphology of the landscape depicted. A recurrent motif is the artist's reaction to Alpine scenery, and the changing attitudes which underpin such different representations of the Alps as those by Pieter Bruegel the Elder in the sixteenth century, and the quest for the Sublime in the work of an eighteenth-century watercolourist such as John Robert Cozens. The five watercolours by J. M. W. Turner range from the charming, picturesque tradition of the 1790s, to the full-blooded romanticism of works inspired by his first visit to the Alps in 1802. Here, the savage forces of nature may be contrasted with the calm, Arcadian vision of an earlier age.

THE COLLECTORS

The collections of the Courtauld Institute of Art in London represent the achievements of a number of distinguished collectors and benefactors (see p. 6), which make it an ideal source for such a selection. In this exhibition we have drawn principally on the collections of Sir Robert Witt, Mr and Mrs William Spooner, and Sir Stephen Courtauld. The largest collection was formed by Sir Robert Witt (1872–1952), a lawyer by profession, whose deep interest in the fine arts found expression in several ways; he was a founder-Secretary (and later Chairman) of the National Art-Collections Fund, a body formed in 1903 to provide money for museum purchases at a time when the export of major works of art from British private collections had reached alarming proportions. His photographic art-reference library, which he began in the early 1900s, was one of the first of its kind (the Frick Art Reference Library, New York, was based on his prototype), and he started to collect old master drawings in about 1910. He chose his drawings not solely on the principle of quality or through a wish to specialise in a particular school. Given his relatively modest means, he decided to concentrate on obtaining representative work by artists, who, while interesting or charming, were slightly below the highest rank, or who were temporarily out of fashion. There are certainly works of great intrinsic beauty in the collection, as may be seen from this exhibition, but Sir Robert conceived his collection as supplementing his library of photographs and reproductions. These drawings are, in a sense, a corpus of documents of use to the art historian,

and as such, could help the student to identify the characteristics of a large range of artists. The acquisition of work signed by a rare artist always gave him particular pleasure. One feels he would have thoroughly approved of the aims of The Drawing Center, devoted as it is 'for the study and exhibition of drawings'.

William Wycliffe Spooner (1882–1967) and his wife, Mercy, were interested in the classic English watercolourists. Before her marriage to William Spooner in 1938, Mercy had been the wife of H. B. Milling, a specialist in the subject and she, too, had also dealt in watercolours. Spooner had formed part of his collection before his marriage to her, but the greater part of their collection was formed between 1938 and 1967. On Spooner's death, much of the collection was bequeathed to the Courtauld; further works, in which Mrs Spooner had a life interest, were subsequently given by her to us, some she still retains. The Spooner bequest and gift contains splendid watercolours by such leading artists as Cotman, Alexander and J. R. Cozens, Girtin, Sandby, and Francis Towne. They complement the British works in the Witt Collection in a particularly felicitous way.

The third collector, the industrialist Sir Stephen Courtauld (1883–1967), was a younger brother of our founder Samuel Courtauld, and he collected the 13 Turner watercolours, which form the most significant part of his collection, between 1916 and about 1937. They all came through the London art market, seven from Agnew's (and almost all the others had at some time passed through Agnew's hands), the remainder from other dealers, notably the Cotswold Gallery, which flourished at 59 Frith Street from 1921 to 1935, and specialised in Turner's watercolours. Sir Stephen also owned the Turner oil painting, *Bonneville* (BJ.50), which is based on the watercolour in his collection. The oil was sold at Sotheby's in June 1973 and acquired by Mr Paul Mellon for the Yale Center for British Art. Before World War II, Sir Stephen went to live in Rhodesia, and as a result, his Turner watercolours, which had hitherto been famous, well documented, and often exhibited, became almost forgotten. Only six of them were shown at the Turner Centenary exhibition at Agnew's in 1951, including *The Upper Falls of the Reichenbach* (cat. no. 111), *Colchester* (cat. no. 113), and *Dawn after the Wreck* (cat. no. 114) in the present exhibition. As might be expected of a collector of Sir Stephen's generation, almost all of his Turner watercolours are finished or relatively finished works, and the emphasis is on topographical subjects, including six Alpine views. Nevertheless, as a group, these 13 watercolours cover a wide range of mood and stylistic development. They were first shown together as a group at the Courtauld Institute Galleries in 1974, after Sir Stephen's family had presented them to us in his memory.

THE MEDIEVAL AND RENAISSANCE ARTISTS

Landscape has been an integral part of Western European painting since at least the fourteenth century. It appears in medieval illuminated manuscripts, of which the Limburg Brothers' *Très Riches Heures* for Jean, Duc de Berry, is one of the most renowned early fifteenth-century examples. Kenneth Clark, in his *Landscape into Art*, described such work as the 'Landscape of Symbols'.[1] He contrasted it with the post-medieval landscape, which can be seen, in his words as 'part of a cycle in which the human spirit attempted once more to create a harmony with its environment'.[2] The few landscapes which appear as settings for the life of the Virgin and the drama of Christ's Passion in Giotto's frescoes

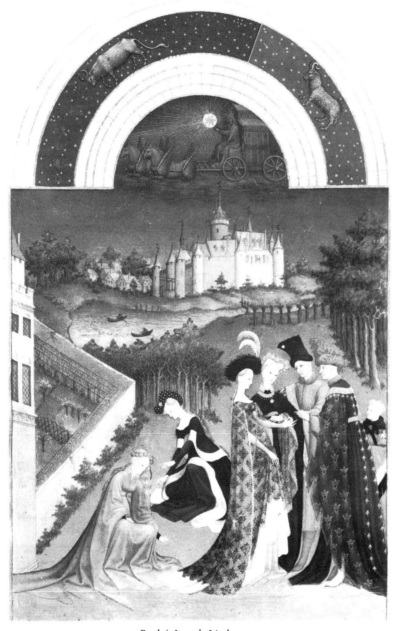

Paul & Jean de Limbourg,
April (Musée Condé, Chantilly)

Typical of the Renaissance artist in his response to landscape is Leonardo da Vinci, for just as the opposing forces of fact and fantasy pull at every artist in varying degrees, nowhere does this creative tension find more brilliant, and poignant, expression than in his work. Leonardo, who sought by careful observation of its phenomena, to discover an underlying unity in the natural world which surrounded him, was aware that imaginative leaps into uncharted areas of natural philosophy, of speculation, were no less necessary if theoretical principles were to be tested against practical experience. An early response to the beauties of his native Tuscany is preserved in an inscribed and dated pen and ink panoramic drawing *Study of a Tuscan Landscape* of 5 August 1473 (Florence, Uffizi), seen from a high viewpoint. The drawing is in the manner of the Pollaiuoli, who were themselves adapting a Netherlandish prototype, but there is nothing derivative in the vivacity of Leonardo's drawing, where the flickering penstrokes convey a sense of the foliage of the trees trembling in the warm summer breeze.[4] On the other hand, the fantastic landscapes which Leonardo introduced into such works as *Portrait of a Lady on a Balcony* (the so-called 'Mona Lisa') of *c*.1505–14 (Paris, Louvre), are not intended merely as a decorative backdrop, but embody a philosophical principle, as Leonardo perceived it, between the mechanisms of man and the earth, the microcosm participating in the grandeurs of the macrocosm.[5] In this painting and the Louvre's *Madonna, Child, St. Anne and a Lamb* (*c*.1508 onwards), Leonardo's acute observations derived from his study of optics, hydrography, and the geology of the Arno valley are applied to convey a sense of bilateral recession in his treatment of the distant mountains, and even to suggest the curvature of the earth's surface.

Although Leonardo was not alone in his study of nature – for example, an album of some 40 delicate pencil drawings of trees and landscape (a few of which are in the Princes Gate Collection) by his fellow Florentine, Fra Bartolommeo, have survived – his was by far the most rigorously analytical intellect to be brought to bear on the subject. His *Studies of Hydrodynamic Turbulence* (Windsor, Royal Library), *c*.1508–09, are but one instance of his probing mind seeking to record exactly the effects of a jet of water striking a pool of calm water, or of the turbulence created by the insertion of an obstacle into a stream of flowing water. What some artists may have instinctively realised or observed in nature, Leonardo sought also to explain and synthesise. His comments on the difference between the 'apparent' colour and form of, say, trees, in relation to their 'actual' properties; that is, the difference between what is actually seen in particular circumstances from what is independently known, is of relevance here.[6] He distinguished between the local colour of a leaf, and the effect on it of reflected light; he drew attention to the effect of distance, of atmospheric 'blueness', on a leaf, and noted many other modifying elements, in great subtlety of detail. The distinctive shape of a tree will modify particularities: 'Remember, O painter, that the varieties of light and shade in the same species of tree will be relative to the rarity and density of the branching.'[7] It is within such a tradition of scientific enquiry and artistic observation that one must see John Constable's cloud studies of over 300 years later.

Leonardo's importance as a writer about art as well as a practitioner can be illustrated by the much-quoted passage from his *Treatise on Painting*, where he does not hesitate to put forward as a source of artistic invention the apparently 'trivial and almost laughable' idea 'that you should look at certain walls stained with damp or at stones of uneven colour. If you have to invent some setting you

for the Arena Chapel at Padua (1305–08) are for the most part symbols of a hostile world, but the bleak, angular rocks of the scene of lamentation over Christ's body are subordinated to the artist's primary concern, the depiction of human gesture and expression.

A century after Giotto, the great Netherlandish artists, Hubert and Jan van Eyck, painted a large, panoramic and quite exotic landscape, *The Adoration of the Lamb*, as the central panel of the Ghent Altarpiece. It is here that we begin to see northern artists observing and recording the minutiae of plant forms in a major work. There is already a grasp of atmospheric perspective, and we observe the distant mountains in this landscape dissolve into light; this feeling for atmosphere, for what J. M. W. Turner in speaking of Rubens, called the 'swampy vernality of the Low Countries', was to find its most glorious expression in the art of Holland and Flanders during the seventeenth century.[3]

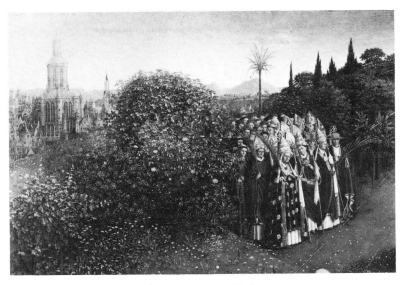

Hubert & Jan van Eyck,
The Adoration of the Holy Lamb (detail) (St Bavon, Ghent)

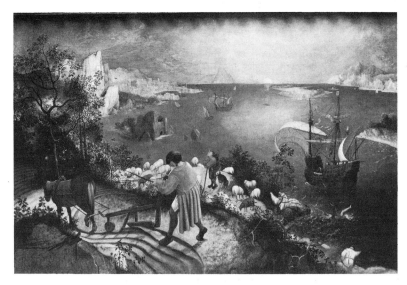

Pieter Bruegel the Elder
The Fall of Icarus (Musée des Beaux Arts, Brussels)

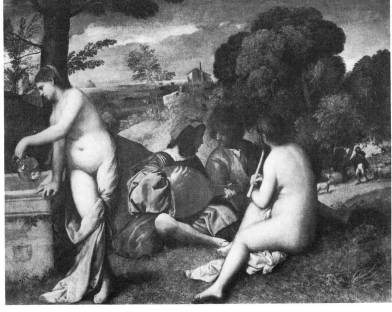

Giorgione
La Fête champêtre (Musée du Louvre, Paris)

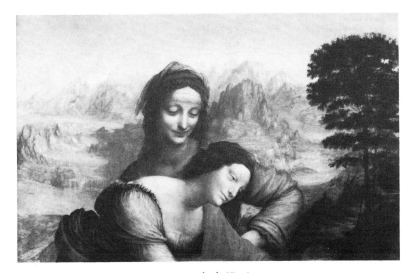

Leonardo da Vinci
Madonna, Child, Saint Anne (detail) (Musée du Louvre, Paris)

Leonardo da Vinci
Study of a Tuscan landscape
(Uffizi, Florence)

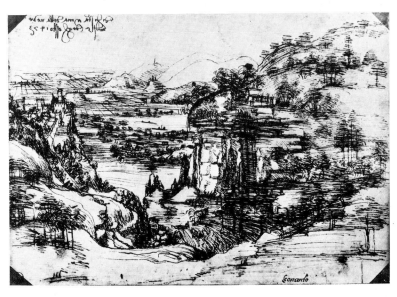

9

will be able to see in these the likeness of divine landscapes, adorned with mountains, ruins, rocks, woods, great plains, hills and valleys in great variety; and then again you will see there battles and strange figures in violent action, expressions of faces and clothes and an infinity of things which you will be able to reduce to their complete and proper forms.'[8] It was this hint to artists that, as we shall see, spurred Alexander Cozens to investigate the possibilities of transforming 'blot' images into landscapes. This was probably as early as the 1750s, according to a recently rediscovered publication, *An Essay to Facilitate the Inventing of Landskips* (1759), and which he codified as *A New Method of Assisting the Invention in Drawing Original Compositions of Landscape*, published in 1785 (see cat. nos. 75, 82 and 83).[9] The relationship between the

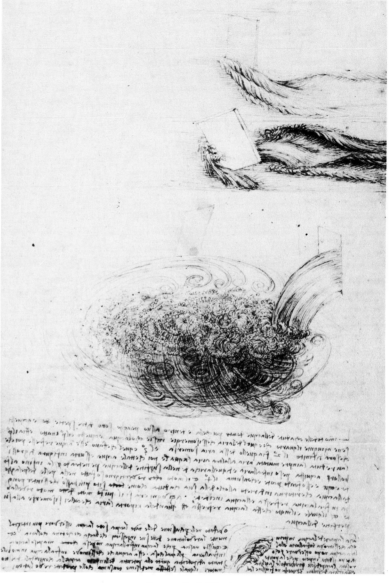

Leonardo da Vinci,
Studies of hydrodynamic turbulence (Royal Library, Windsor)

observable world and the artist's imaginative inventions (Leonardo's 'fantasia') is neatly captured in Cozens' engraved sequence of 20 cloud formations, which were also published in *A New Method*. Here we are presented with what appears to be a continuous chain of events, the build-up of cumulus clouds in the early morning through to their dissipation in the evening. Yet the schematic presentation and the variations in shading (both in Cozens' original studies and Constable's copies after them), suggest that artistic considerations have outweighed factual observation.

THE SIXTEENTH CENTURY

The first 'pure' landscapes, that is, those landscapes painted for their own sake as an independent, self-sufficient subject, are generally credited to Albrecht Altdorfer (died 1538), who painted during the last years of his life miniature-like works on vellum depicting scenes of the Danube valley in and around Regensburg, where he had settled in 1505. Yet Dürer, on his Venetian journey of 1505–06, had executed landscapes in watercolour for his own pleasure; nor should the influence of Venetian art on the development of landscape painting

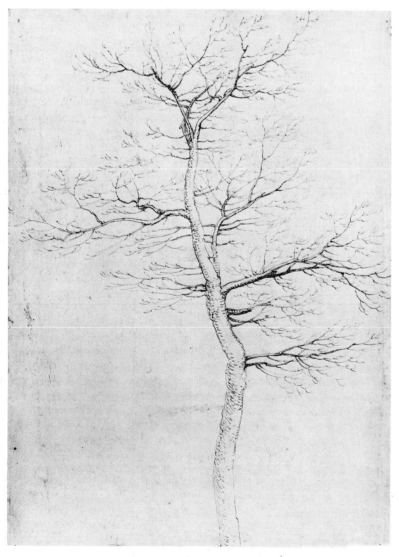

Fra Bartolommeo,
A Tree in Winter (Princes Gate Collection)

be underestimated. It is in the late works of Giovanni Bellini, whom Dürer had acclaimed, that we see a new brilliance of colour and heightened sensitivity to the subtleties wrought by changes in sunlight and time of day on the landscape of the Veneto. Again, for Bellini this empathy with landscape probably had its artistic roots in Netherlandish painting, perhaps distilled through the art of Antonello da Messina and Piero della Francesca. Giorgione, a pupil of Bellini, brought to landscape an element of mystery and enchantment. The poetic and often ambiguous themes of his paintings, of which the *Fête Champêtre* (Louvre) is perhaps the most accessible and *The Tempestà* (Venice, Accademia) the most arcane, are set in landscapes of arcadian remoteness. They point the way to the ideal landscapes of Claude Lorrain and Nicolas Poussin of the next century, and of these, Claude was to become a talisman for English landscape artists of the eighteenth century.

It is a relatively short step from those fantastic 'world landscapes' (or panoramas) of the Fleming, Joachim Patenier, where the mountains tower over the tiny figures below, to the alpine scenes of his great compatriot, Pieter Bruegel the Elder. Bruegel traversed the Alps on his journeys to and from Italy *c.*1551–54, and his alpine drawings seem to have been drawn mainly in the studio in the mid-1550s, with the aid of chalk drawings made during the actual journey. A pen and ink *Landscape with an Artist Sketching* (London, Princes

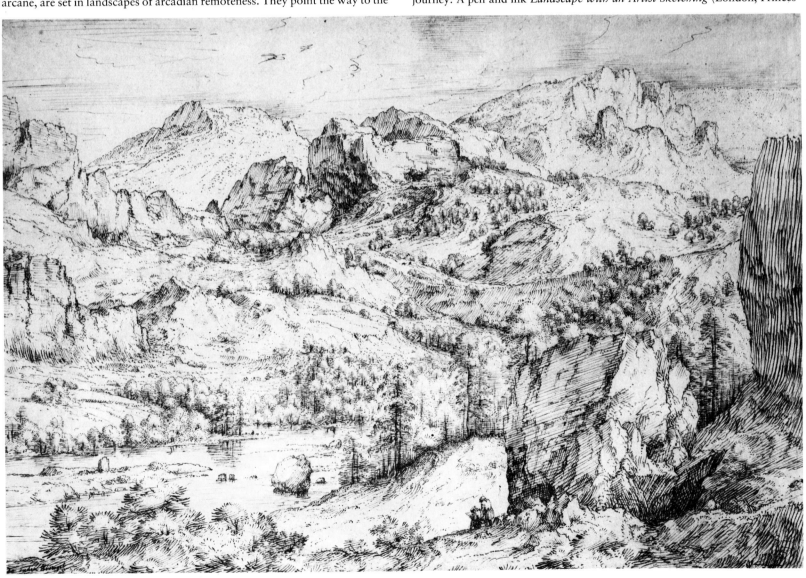

Pieter Bruegel the Elder,
Landscape with an Artist Sketching (Princes Gate Collection)

Gate Collection) may even have been worked up thus during his stay in Italy.[10] The inclusion of a tiny figure of the artist sketching is a rare and significant feature for the period, and overtly symbolises both the artist as a creator in his own right and as interpreter of the awesome works of nature. But if this *Landscape* is based on factual observation, another pen drawing, *View of Antwerp from the Sea* (Princes Gate Collection) of *c*.1559, combines an exaggerated Mannerist rendering of the choppy seas off Antwerp harbour with old-fashioned allegory. The ships are sailing from the sunshine of a safe haven to the uncertainties of the storms which blow in from the right of the composition, and as if to underline the ill-omens, the tiny island in the foreground is only occupied by an empty gallows.[11] A third pen and ink

drawing, *Kermesse at Hoboken* (cat. no. 7), signed and dated 1559, and more a townscape than pure landscape, is perhaps the first of Bruegel's drawings to treat the subject of peasant revelry at festivals, without, in this instance, any explicit allegory. The influence of Hieronymous Bosch may also be detected here, and the drawing became popular enough to be engraved several times, with reworkings.

Although landscape had begun to emerge as an autonomous subject in Flemish art by the mid-1550s, it continued to support narrative content in the work of Hans Bol, an artist much influenced by Pieter Bruegel. Bol's *Fall of Phaëthon*, 1560 (cat. no. 1), is a curious mixture of classical motifs (as befits the subject) clad in Flemish Mannerist style, set in a familiar, panoramic

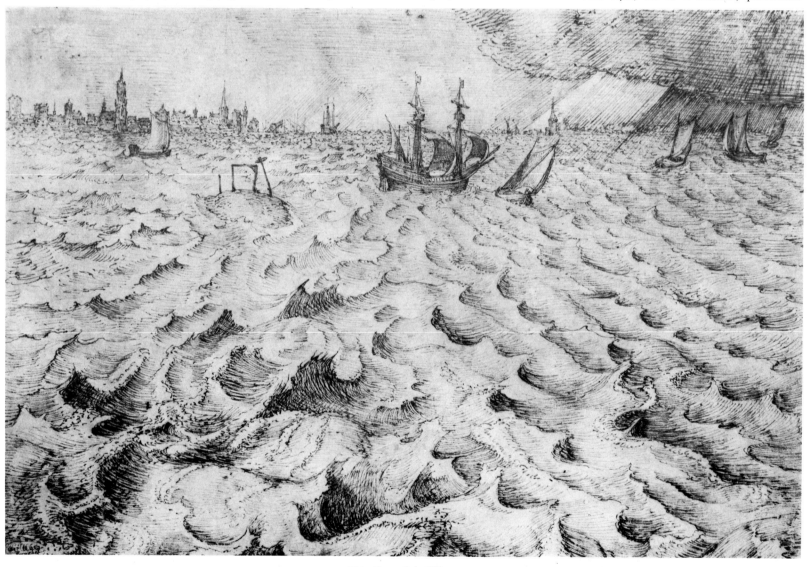

Pieter Bruegel the Elder,
View of Antwerp from the Sea (Princes Gate Collection)

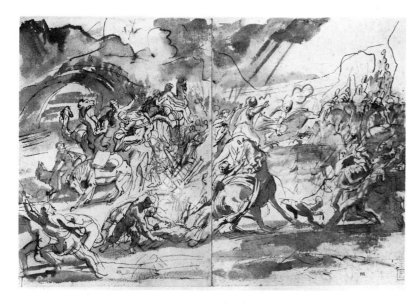

Sir Peter Paul Rubens,
The Conversion of St Paul (Princes Gate Collection)

Weltlandschaft. His treatment of this subject appears even more old-fashioned than Bruegel's archaising *Fall of Icarus* (Brussels, Musées Royaux), *c.*1555–58, where the figure of the doomed Icarus has been hidden away in the landscape. Nor can it be surprising that Bol's two loosely related drawings of *The City of Jerusalem, with Christ as the Good Shepherd*, 1575, and *The False Shepherds*, 1576 (cat nos. 2 and 3) should bring to mind the complex allegorical fantasies of William Blake, created over two centuries later. Jan Wiericx also adopts the Bruegelesque landscape to serve as the setting for religious subjects, one of which, *Landscape with the Conversion of Saul* (cat. no. 28), makes a fascinating contrast with a pen and wash drawing by Rubens of the same subject, now in the Princes Gate Collection. This drawing, incidentally, had once belonged to Sir Joshua Reynolds.[12]

THE SEVENTEENTH CENTURY

The pervasive influence of Pieter Bruegel and of his son, Jan Breughel (1568–1625); not to be confused with Jan Breughel II, whose panoramic landscape is in the exhibition, cat. no. 6), was continued by Joos de Momper in Antwerp. He acts as the link between the landscape artists of Flanders and Holland at the beginning of the seventeenth century, and in the three drawings by him in this exhibition, we can observe him moving from the somewhat artificially constructed landscapes of his earlier period, to a more naturalistic style. Like the Breughels, the Coninxloo family produced several generations of painters, and it may be remarked in passing that the old system of apprenticeship and social expectation tended to nurture continuity of professional calling, paradoxically, because of the artist's enhanced status in society. No longer was he regarded as a mere tradesman but was respected for his learning and culture. Gillis Coninxloo, the third of that name, represented here by a *Wood Landscape* (cat. no. 8), settled first in Frankenthal, then Amsterdam in 1595. Here he was joined by other Flemish artists, including Roelant Savery (cat. no. 18). The mysterious atmosphere of the forests which so attracted Coninxloo, appealed also to Paul Bril, whose *Rocky Landscape* (cat. no. 4) shows the artist not only clearly distinguishing the different species of trees and plants, but delighting in the strange, misshapen forms of decaying tree-boles and exposed roots. His pupils, Hercules Seghers and Esaias van der Velde, were important Haarlem painters; van der Velde's most notable pupil was Jan van Goyen, and Seghers much influenced the landscapes of Rembrandt, who owned eight of his paintings. Paul Bril, and his older brother Mattheus II, both went to Italy (they

died in Rome), thus becoming part of the vanguard of the 'Italianising' Netherlandish artists whose idealised landscapes mark the next stage in the development of that art. Though Paul Bril's work lacks the poetic simplicity of Elsheimer's jewel-like scenes from the Bible or Ovid, he is an important formative influence on Agostino Tassi, the master of Claude.

THE DUTCH GOLDEN AGE

It is at this point that we may link the Dutch and Flemish masters represented in this exhibition, pausing only to note the two drawings by Martijn van Heemskerk, both of 1570, *The Colossus at Rhodes* and *The Temple of Diana at Ephesus* (cat. nos. 43 and 44). These are Mannerist landscapes of fantasy, overlaid, one might almost say overwhelmed, by the classical impedimenta picked up by the artist on his Roman visit (1532–36), and henceforth to be pressed into service at every opportunity. But with the landscapes of Jan Asselyn and the later work of Abraham Bloemaert, we begin a new phase of greater realism. Though Asselyn's *Landscape with a Ruined Bridge* (cat. no. 29) is clearly set in the Roman Campagna, the horizon has been lowered so that the drawing becomes a sober topographical record, just as Bloemaert's *Landscape with Cottage* (cat. no. 32) is a lively but factual rendering of a scene near his native Utrecht. Isack van Ostade, younger brother and talented pupil of Adriaen and, like him, active in Haarlem, continues this tradition in his *Rear View of a Cottage*, 1646–49 (cat. no. 54). Cornelis and Herman Saftleven were also brothers, Herman winning renown as a topographer, although in his drawing of *A Derelict Cottage* (cat. no. 61) he transforms decay into the picturesque, and reminds us of the many debts owed to Dutch art by such different English artists of the mid- to later eighteenth century as Thomas Gainsborough and George Morland. Even the word 'landskip' was imported into the English language as a phonetic rendering of the Middle Dutch word *Lantscap*.[13]

The great masters of the Dutch seventeenth-century realist landscape were Jan van Goyen, Pieter de Molyn, Philips de Koninck, and Salomon van Ruysdael, the first three of whom are represented in this exhibition. The two dune and river scenes by van Goyen (cat. nos. 39 and 41) are typical of the many drawings he made as he travelled round the countryside and which he used and re-used again and again for his delicate, almost monochrome oil paintings. His observation of the vast expanses of sea, dune, and clouds is quickened by an intense emotional rapport that was to win Constable's admiration. Van Goyen's sea and harbour scenes may be contrasted with the more dramatic treatment of these themes by the Flemish artist Kerstiaen de Keuninck, especially the storm-tossed *Rocky Coastline with Shipping in a Storm* (cat. no. 11), where the fury of the elements has aroused the artist to a form of expressionism that looks back to Bruegel's *View of Antwerp*, and forward to the cataclysmic scenes of Turner. The drawing, *A Farmyard by a Canal*, by Philips de Koninck (cat. no. 49) brings us into the orbit of Rembrandt, whose landscapes of the 1640s are a starting point for Koninck. Rembrandt's pen and wash drawing *View of Diemen*, *c.* 1650 (Princes Gate Collection), shows how subtly he is able to suggest the depth of foreground by alternating bands of shadow and light, whilst conveying the expanse of countryside stretching beyond Diemen on the left of the composition. Koninck makes more limited use of this last device in his own, more rugged drawing, where the farmhouse and its outbuildings loom larger and the line of the canal is used to lead the eye into the landscape on the left. Koninck was also the owner of barges which plied

13

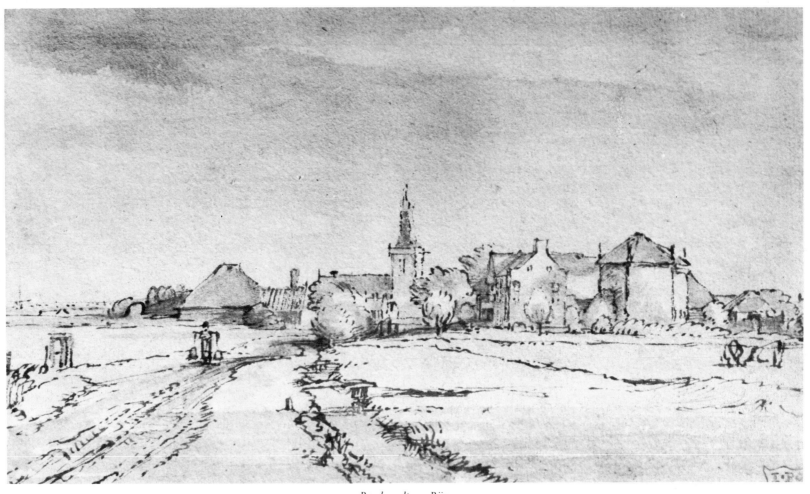

Rembrandt van Rijn,
View of Diemen (Princes Gate Collection)

between Leiden and Rotterdam; he was prosperous enough to collect, and owned the *Calvary* drawing by Mantegna which is now in the British Museum.

We have already mentioned the 'Italianising' Netherlandish artists Paul and Mattheus Bril, who were, in fact, Flemish, and had painted frescoes in the Vatican. Paul Bril's Roman views in oils were popular tourist items. The Dutchman, Cornelis van Poelenburgh spent some five years in Rome (c.1617–22), after studying with Bloemaert in Utrecht, and his *Landscape with Ruin and Figures* (cat. no. 56) is in subject typical also of his oil paintings; Arcadian landscapes which are clearly Italianate in character, although idealised and touched with that element of the mysterious that was so liked by Elsheimer, an artist whom Poelenburgh much admired. Poelenburgh was invited to England in 1637 by Charles I, who owned landscapes by him, by Bril, Coninxloo, Momper, and Savery; but the prevailing style of linear topographical drawing in England practised by Dutch immigrant artists such as Claude de Jongh or the Czech-born Wenceslaus Hollar, was to be superseded by Italian-inspired landscapists in the eighteenth century.[14] The Flemish artist, Adam Frans van der Meulen's *View of Courtrai* of 1667 (cat. no. 12), with its restricted use of wash, is a fine extension of this tradition, although here the artist was designing for the Gobelins tapestry factory, as Louis XIV's court painter. Adam Pynacker's graceful, feathery trees are also a legacy of a prolonged Italian visit, and have an almost rococo elegance *avant la lettre* (cat. nos. 57 and 58), whilst Herman van Swanevelt's *Landscape with the Flight into Egypt* (cat. no. 63) is Claudian in conception, with the obligatory *repoussoir* elements of trees and hills on the left and right of the composition, leading the spectator's eye into a central vista of idealised Campagna-like terrain.[15] Swanevelt, known as 'Herman d'Italie', is said to have lived in the same house as Claude c.1627–28, and then worked in Paris, where he died. Gaspar van Wittel, whose name became Italianised into Vanvitelli, died in Italy and his son Luigi Vanvitelli achieved fame as the architect of the Palace at Caserta. Van Wittel's dramatic *View of Tivoli* (cat. no. 71), with its high horizon and unusual viewpoint makes a convenient link with the eighteenth century and, in particular, with the new generations of British artists who worked in Italy from the 1750s onwards, foremost among whom was Richard Wilson, who is said to have exclaimed 'Well done water, by God!' on his first sight of Tivoli.[16]

The links between Dutch and British art which had become quite strong in the early seventeenth century, under the patronage of the Stuart kings, particularly in portraiture, received new impetus after the Restoration in 1660 with the employment by Charles II of the artists Willem van de Velde, father and son, by 1674. Willem van de Velde II was incomparably the more gifted of the two, and his marine pieces set a standard of quality which was to influence this genre in both Holland and Britain well into the eighteenth century. He combined accuracy of detail with fine painterly qualities of light and atmosphere in his oils. In drawings such as *Estuary Scene: pinks, barges, frigate*, c.1675 and *Estuary Scene: galliots, barge, frigate* (cat. nos. 64 and 65) these virtues appear in a vivacity of pencil stroke which is subtly varied so as to suggest recession and shimmering water. His peculiar manner of delineating rigging, little curlicues for the blocks, is repeated by Richard Wilson in the treatment of the boat in the foreground of *The Thames looking towards Syon House* (cat. no. 118). But the

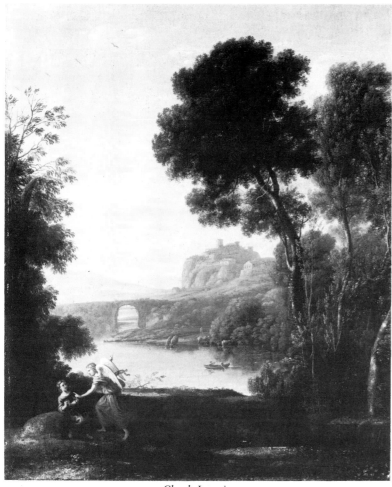

Claude Lorrain,
Landscape: Hagar and the Angel (National Gallery, London)

twin strands of topographical and antiquarian draughtsmanship already alluded to, is represented in this exhibition by Jan Siberechts' *Landscape in Derbyshire* (cat. no. 19). This is, however, much livelier and more freely drawn than his oil 'portraits' of country houses and their surrounding estates such as *Wollaton Hall and Park* of 1697 (New Haven, Paul Mellon Collection), which he produced for English patrons from about 1672–74 to his death in 1703. It may well have been done for his own pleasure, and he is known to have painted English landscapes for Sir Thomas Willoughby (the owner of Wollaton Hall), which are composed in the style of Gaspard Poussin.[17]

THE EIGHTEENTH CENTURY: THE GRAND TOUR

Some of the early landscapes of Richard Wilson too, like those of Thomas Gainsborough's, are cast in the mould of Dutch masters, particularly of Jacob van Ruisdael and Isack van Ostade; but he was equally familiar with the conventions of Claude and Gaspard, as well as with those of the French rococo, exemplified by Hubert Gravelot, which were fashionable in London in the 1740s. Continental travel was once again easier after hostilities between England and France were halted, for a time at least, by the Treaty of Aix-la-Chapelle in 1748; in the autumn of 1750 Wilson set off for Venice and in 1752 reached Rome, where he was to stay for almost five years. The experience changed his whole outlook on painting and almost literally coloured his view of landscape thereafter.[18] Wilson was well connected and extremely well grounded in the classical authors; he, like several of his artist contemporaries, was better educated than the general run of earlier generations of British

journeymen painters. For him, as for many of his well-born compatriots who went on the Grand Tour, Rome and the surrounding Campagna was the shrine of an ancient civilisation, of a Virgilian golden age now gone forever, no doubt, but the ruins of which could still deeply move those who beheld them. In 1765 James Barry wrote of Wilson that 'his style of design is generally more grand, more consistent, and more poetical than any other person's among us'.[19] By that time Wilson had established himself as a landscape painter in the Grand Manner, and had raised the art of landscape to a new intellectual level in his own country. He did for landscape what Reynolds had achieved for portraiture. Landscape, according to the old academic hierarchy of values, was rated a very lowly branch of art, unless it could convey some high moral principle and/or incorporate an appropriate classical allusion – as Wilson did in the *Destruction of the Children of Niobe* of 1759–60. In his paintings he also suffused the golden light of Italy over English and his native Welsh scenery, bringing to it the canons of formal harmony and idealised beauty that he had learned from Claude and Gaspard. He preferred to draw in chalk, and exploited the soft lines of this medium to suggest the solidity of forms and atmospheric perspective, as in the *View in Rome, with the Basilica of Constantine* (cat. no. 117).

Italy had been a magnet for English aristocratic travellers, as well as for artists, architects, and scholars, since the early seventeenth century, and from the mid-1660s it had become an obligatory part of a gentleman's education to make the European Grand Tour. The Italian decorative artists, Verrio, Amigoni, Pellegrini, Sebastiano and Marco Ricci, had already worked extensively in England since the 1670s, and established the Italianate Grand Manner of history and mythological painting in their ambitious schemes at the great houses such as Chatsworth and Castle Howard, or Hampton Court. A flourishing tourist trade developed to supply a demand for views of Italy, especially of Rome and Venice, and when wars interrupted the flow of wealthy tourists in the 1750s, the Italian artists Canaletto and Zuccarelli came to England to work for their aristocratic patrons. Zuccarelli's rather superficial, picturesque landscapes (his 'light, airy manner'[20]) appealed to George III, thus almost certainly depriving Wilson of the royal patronage he so much sought after, and contributing in part to his eventual failure. Although there had been nearly a century-old tradition of foreign travel for the upper classes, the number of English artists in Rome in the 1750s was quite remarkable. The following artists, whose work is represented in this exhibition, were in Italy at some time over the next 30 years, and a few, like Skelton, Pars, and Jones died in Italy: Alexander Cozens (1746), Jonathan Skelton (1757–59), Thomas Jones (1776–83), William Pars (1770–72 and 1775–82), Francis Towne (1780–81), and John Robert Cozens (1776–79 and 1782–83). Even William Taverner, who did not travel abroad, so far as we know, imparts a sun-baked Mediterranean light to his English scenes, such as *Hampstead Heath* (cat. no. 106).[21] We are now on the threshold of that specifically English phenomenon, the development of the watercolour as an art form in its own right. As Kenneth Clark said of J. R. Cozens: 'He painted only in the native medium of water-colour, and his work belongs to that kind of painted poetry which the French find so peculiarly irritating.[22]

We can trace the emergence of the English watercolour from the strictly limited range of colour washes used by Alexander Cozens and Skelton, through the elegant precision of Towne, to the splendours of the tonal architecture developed by Girtin and Cotman, to its culmination in the dazzling technical

15

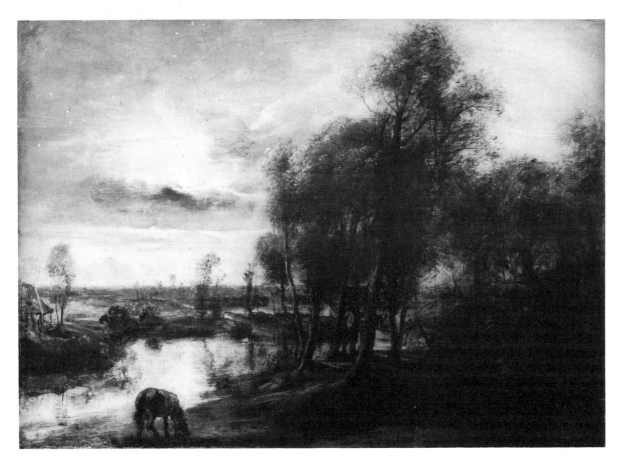

virtuosity and profoundly moving work of Turner. The five watercolours by Turner span the whole gamut of his achievement, from the early Picturesque, topographical *Chepstow Castle* (cat. no. 110), to the hauntingly melancholic, yet brilliantly coloured, *Dawn after the Wreck* (cat. no. 114). It must also be remembered that watercolourists were regarded as inferior practitioners by the Royal Academy, so much so that in 1805 they formed their own exhibiting society, The Old Water-Colour Society (now the Royal Society of Painters in Water Colours), which was challenged in 1832 by the New Society of Painters in Watercolours (now the Royal Institute of Painters in Watercolours).[23] As time went on, some Victorian watercolourists extended their range of colour, technique and scale, so as to compete with the solidity and brilliance of oil painting, even mounting their work in gold mats and frames to match. The essential delicacy and translucent qualities of the medium were thus negated. This process can be observed even in the work of an eighteenth-century artist, Paul Sandby, whose topographical watercolours such as *Old Windsor Green* of 1762 and *The Henry VIII Gateway, Windsor*, 1767 (cat. nos. 103 and 104), demonstrate his methods of working. The first is almost entirely executed in watercolour; the second has considerable areas of bodycolour or gouache, which gives a freshness of colour and opacity to the work, especially in the architectural setting, that creates the impression of greater weight and solidity. The artist clearly intended this to be an exhibition piece, for it is highly finished and carefully signed and dated in gold paint.

THE EIGHTEENTH CENTURY: THE ALPS AND THE PICTURESQUE
We should now consider why English artists in the 1770s and 1780s began to extend their subject matter to include the Swiss Alps in addition to the more traditional views of Rome, Tivoli, and the Campagna. What was the change in attitude that made alpine scenery an acceptable subject to the connoisseurs of the later eighteenth century? We have discussed Leonardo's interest in natural phenomena of all kinds as a revelation of divine purpose, and noted the way some Flemish artists emphasised the fantastic aspects of mountain landscapes, exaggerating their natural shapes. The young Horace Walpole described his crossing of the Alps as 'Precipices, mountains, torrents, wolves, rumblings, Salvator Rosa – the pomp of our park and the meekness of our palace! Here we are, the lonely lords of glorious desolate prospects.'[24] Salvator Rosa's wild mountainous landscapes, sometimes populated with banditti, were indeed a touchstone for the proponents of the Picturesque, of which the Reverend William Gilpin was the chief theorist from 1748 onwards. In essence, Gilpin defined 'picturesque' as 'a term expressive of that peculiar kind of beauty, which is agreeable in a picture',[25] and developed this into a comfortable aesthetic of art improving upon nature, whose more savage aspects (roughnesses) could be skilfully manipulated and edited to produce a pleasing artefact. Landscape architects were also to put Picturesque theories into practice.

Gainsborough's *Wooded Landscape* of the mid-1750s (cat. no. 89) belongs to his Suffolk period, when he was still much influenced by Dutch seventeenth-century art, and sketched directly from nature, a practice that he later almost entirely abandoned. During the next decade he came to admire Rubens' grand panoramic landscapes, a taste he shared with Reynolds, who was to become the owner of Rubens' late *Landscape by Moonlight* (Princes Gate Collection) by 1778 and refer to it in his Eighth Discourse, given that same year, as an example of how to treat a night scene.[26] But by the 1780s Gainsborough was composing his 'fancy' pictures entirely from studio properties, as described perceptively, by Reynolds in his Fourteenth Discourse soon after Gainsborough's death: 'from the fields he brought into his painting-room; stumps of trees, weeds, and animals of various kinds; and designed them, not from memory, but immediately from the objects. He even framed a kind of model of landskips,

dried herbs, and pieces of looking glass, which he magnified and improved into rocks, trees, and water.'[27] Gainsborough had visited the Lake District in the summer of 1783, with the intention of painting picturesque landscapes which, he declared, would outshine the theorists such as the Reverend Thomas Gray (now best known for his poetry). Yet if Gainsborough's idealised vision of rural England springs from English sources (he never travelled abroad), it is shaped by his knowledge of Gaspard, and of Dutch and Flemish art.

The blot landscapes of Alexander Cozens fall into a special category, for their starting points are not specific locations but rather a generalised abstraction of a type of landscape, which he nevertheless makes credible to us by conveying a precise sense of atmosphere or feeling. He has been seen as a forerunner of the Surrealists' dream landscapes, and his *Mountain Lake or River among Rocks* (cat. no. 82) has an eerie stillness about it that one associates with the petrified landscapes of Max Ernst. We may gain an aesthetic experience from the feelings of awe or dread aroused in us by the magnificent drama of the Alps. Edmund Burke elevated this into a general philosophical principle by categorising the elements of the Sublime as Terror, Obscurity, Power, Privation (Vacuity, Darkness, Solitude, Silence), Vastness, Infinity, and so forth.[28] Thus armed with an intellectually respectable rationale, the Picturesque could be extended to admit the Sublime. John Robert Cozens' *In the Canton of Unterwalden* (cat. no. 85) was such a response to the challenge presented by the grandeurs of alpine scenery. Broad, simply massed areas of colour convey the massiveness of the mountains, an effect heightened by the thin wisp of insubstantial smoke that drifts up from the valley below. Francis Towne's *In the Valley of the Grisons* (cat. no. 107) evokes similar feelings about the menacing harshness of the mountains. The way had been prepared for Turner to follow.

THE EARLY NINETEENTH CENTURY: TURNER AND CONSTABLE

'If Tom Girtin had lived I should have starved.'[29] Thus Turner about an artist who was his exact contemporary and whom he greatly admired. His meaning is a little ambiguous, for although Girtin quickly made a name for himself among certain collectors who bought his work for quite high prices, he did not enjoy the meteoric rise in the ranks of the Royal Academy that distinguished Turner's career: an A.R.A. by 1799 at the age of 24, and full Academician in 1802, followed by the appointment as Professor of Perspective 1806–38. Girtin had been apprenticed to Dayes, an irascible, jealous man whose style nevertheless helped to form that of both Girtin and Turner, who had worked together colouring prints for J. R. Smith. By 1795, both men were employed by Dr Thomas Monro to copy drawings by J. R. Cozens. Girtin's work for the antiquarian, James Moore, is represented here by one of several versions he made of the West Front of Peterborough Cathedral (cat. no. 93). It shows astonishing technical mastery and brilliant compositional skill for a 19-year-old artist, who was to die of tuberculosis at the early age of 27. Turner was perhaps right to be apprehensive about so talented a rival, yet he was to become the great virtuoso of the century, for his range was enormous. He worked for antiquarians, the picturesque/topographical market, as an architectural draughtsman, but only briefly, and moved on to grand history pieces. His considerable fortune was made principally from prints after his work. Of keen intelligence, Turner's comments in his 1811 Lecture to R.A. students about the work of Poussin and Rubens are shrewdly perceptive. Ruskin endorses this aspect of his character in his description of his first meeting with Turner:

'Introduced to-day [22 June 1840] to the man who beyond all doubt is the greatest of the age; greatest in every faculty of the imagination, in every branch of scenic knowledge; at once *the* painter and poet of the day, J. M. W. Turner. Everybody had described him to me as coarse, boorish, unintellectual, vulgar. This I knew to be impossible. I found him somewhat eccentric, keen-mannered, matter-of-fact, English-minded-gentleman; good-natured evidently, bad-tempered evidently, hating humbug of all sorts, shrewd, ..., highly intellectual, the powers of the mind not brought out with any delight in their manifestation, ..., but flashing out occasionally in a word or a look.'[30] Ruskin's admiration for, and advocacy of Turner's work was unstinted during the artist's lifetime, although some change in his feelings is discernible in the fifth volume of *Modern Painters*, which was written in 1858–59, immediately after his work on the Turner Bequest.[31]

East Anglia has nurtured some of England's most illustrious landscape painters. Gainsborough was a Suffolk man, so, too, John Constable; John Sell Cotman was born in Norwich. After coming to London in 1798, where he first coloured aquatints for Ackermann, Cotman was then employed by Dr Monro in making watercolours for drawing-copies. He returned to Norwich in 1806, and worked for the antiquarian Dawson Turner, at whose behest he visited Normandy three times (in 1817, 1818 and 1820) to gather material for the *Architectural Antiquities of Normandy*, published by Dawson Turner in 1822. His subtle range of colour and tone, particularly in his architectural work, capture the solidity of the forms with breathtaking beauty (cat. nos. 77 and 78). He was a prominent member of the Norwich Society of Artists and became Drawing Master to King's College, London, in 1834.

In comparison with Turner, Constable's career was almost one of failure. He grudgingly won admission to full membership of the Royal Academy in 1829, at the age of 53 and a year after his wife's death, and at no time enjoyed patronage outside a small circle of family friends and supporters. Yet today he is regarded as quintessentially the master interpreter of English (that is to say almost exclusively southern and eastern English) landscape. His famous statement of artistic belief, written in a letter from London of May 1802 to his first tutor, the amateur artist, John Dunthorne, gives the flavour of the man and his art: 'For these two years past I have been running after pictures and seeking the truth at second hand. ... I shall return to Bergholt where I shall make some laborious studies from nature – and I shall endeavour to get a pure and unaffected representation of the scenes that may employ me. ... there is room enough for a natural painter.'[32] But one must also put this *credo* into context, for in the same letter he remarks he has been studying the Old Masters in Sir George Beaumont's collection, and in particular, Claude's *Hagar and the Angel*. To study nature at first hand did not mean jettisoning the guidance of past example. In one area, however, Constable pursued his study of nature beyond immediate needs, and embarked on an intensive course of cloud studies at Hampstead Heath in 1821–22 as much for their own sake.[33] 'I have done a good deal of skying – I am determined to conquer all difficulties and that most arduous one among the rest. ... The sky is the *source of light* in nature – and governs everything.'[34] Constable, in the same letter, speaks of the sky in a picture as 'the chief "*Organ of Sentiment*".' His cloud studies in oils seem to have become for him autonomous works of art, executed for his own pleasure, since by the 1820s, he had achieved mastery of the skies in his major works. Unlike Turner, who concentrated more on the colour of clouds, Constable was

intrigued by their changing shapes and formations, which he had first learnt to observe as a young windmiller in his father's employ.

David Cox was also a master of skyscapes, as we see from his two beach scenes where the skies form a major part of the compositions (cat. nos. 80 and 81). Cox had been a scene painter in Birmingham and London (1800–08), before taking private pupils and earning a modest living as a drawing master. He produced at least three manuals of instruction aimed at taking beginners by progressive steps through the rudiments of painting to more advanced work, with particular reference to landscape.[35] John Varley, from whom Cox took lessons, was a very successful teacher and the author of two treatises on *The Principles of Landscape Design* (in eight parts 1816–21) and the *Art of Drawing in Perspective* (1815–20), which like those by Cox, reached a wide audience of amateur painters. Varley's work undergoes quite a dramatic change from the Cotman-like view of the Royal Naval College at Greenwich (cat. no. 115), to the elegaic pastoral mood of his late *Landscape Idyll – Sunset* (cat. no. 116). This last is much closer in spirit to the art of William Blake and his circle, among whom were two of his pupils, John Linnell and Samuel Palmer. It was probably under Palmer's inspiration that Varley moved from his earlier Picturesque and Augustan Pastoral modes of painting, to a more intensely personal expression.[36] Although Palmer's *Trefriew Mill* (cat. no. 98) falls just outside the Shoreham period of his career (sometimes known as the 'visionary years' because of the idyllic, intense emotional vibrancy of the work then produced) his careful observation of the minutiae of natural forms in this watercolour is perhaps a harbinger of that quest for an earlier, purer naturalism begun by the earnest young members of the Pre-Raphaelite Brotherhood in 1848.

Dennis Farr

December 1985

1 Kenneth Clark, *Landscape into Art* (1949), p. 2. Clark's Slade Lectures at the University of Oxford, of which this book was a product; it is still one of the most illuminating introductions to the subject.

2 ibid., p. 1.

3 'Backgrounds' lecture, Royal Academy 1811: Jerrold Ziff, ' "Backgrounds, Introduction of Architecture and Landscape": A Lecture by J. M. W. Turner', *Journal of the Warburg and Courtauld Institutes*, XXVI (1963), p. 146.

4 Martin Kemp, *Leonardo da Vinci: The Marvellous Works of Nature and Man* (1981), p. 52, repr. p. 51, pl. 11.

5 Kemp, ibid., p. 261, discusses at length the implications of this philosophical tenet. He also observes that Leonardo's 'increasing awareness of some superficial discrepancies in the mechanisms of man and the earth had as yet done nothing to unsettle his sense of their underlying affinity'.

6 Kemp, ibid., pp. 333–34, for a detailed analysis of Leonardo's observations.

7 Quoted by Kemp, ibid., p. 334 (MS. E.18v., Institut de France: 1513–14).

8 *Codex Urbinas Latinas 1270* (Rome, Vatican), quoted by K. Clark, op. cit., pp. 45–46; Clark appears to have made his own translation of the text as published by J. P. Richter, *The Literary Works of Leonardo da Vinci* (1939), I, pp. 311–12.

9 He acknowledges his debt to Leonardo in the preface to the 1759 *Essay*, by quoting from the 1721 English edition of Leonardo's *Treatise*, and saying: 'The Author of this Essay has endeavour'd to improve upon the above hint by making these imperfect Forms on Purpose, and with some degree of Design, which otherwise must be catch'd from Accidents.' For a discussion of this and related matters, see: Kim Sloan, 'A new chronology for Alexander Cozens, Part I; 1717–59; Part II: 1759–86', *Burlington Magazine*, CXXVII (February and June 1985), pp. 70–75, 355–63. The text of the 1759 publication is reproduced at Appendix A, p. 360. Cozens refers again to Leonardo's advice in his 1785 *A New Method*, pp. 5–6.

10 Helen Braham, *The Princes Gate Collection* (1981), No. 126.

11 ibid., No. 127.

12 ibid., No. 180: *The Conversion of S. Paul*.

13 According to the *Shorter Oxford English Dictionary*, its first recorded use in English was as early as 1598.

14 Andrew Wilton, Preface to the exhibition catalogue (by Christopher White), *English Landscape 1630–1850: Drawings, Prints & Books from the Paul Mellon Collection*, Yale Center for British Art, New Haven (1977), is a useful introduction to the historical and theoretical developments of the theme of the exhibition; see also Conal Shields and Leslie Parris, *Landscape in Britain: 1750–1850*, Tate Gallery (1973), pp. 9ff.

15 Jakob Rosenberg, Seymour Slive, E. H. Ter Kuile, *Dutch Art and Architecture 1600 to 1800*, Harmondsworth (1966), p. 170, suggest that in certain respects, especially in the use of a centralised composition and golden evening light, van Swanevelt anticipated the high Claudian style during the early 1630s. Swanevelt's etchings, of which he made over 100, were much prized long after his death, and Thomas Girtin made copies of them.

16 Thomas Wright, *The Life of Richard Wilson, Esq., R.A.* (1824), p. 19; the remark was overheard by Reynolds, and the anecdote passed on to Wright.

17 Two such views have survived, both of Henley-on-Thames, 1692; one in the collection of Lord Middleton, the other in the Tate Gallery.

18 David H. Solkin, *Richard Wilson. The Landscape of Reaction*, Tate Gallery (1982), pp. 11–134, analyses in great depth the socio-cultural context of Wilson's art and the effect on it, in Solkin's view, of Wilson's own patrician aspirations and the type of patronage he enjoyed.

19 Quoted by Solkin, ibid., p. 51. (From J. Barry's letter of 1765 to Dr Sleigh, in *The Works of James Barry* (1809), I, p. 20.) Edward Dayes thought Wilson's 'forms are grand, majestic, and well selected; and his compositions are not encumbered with a multitude of parts, a fault frequently observed in Claude . . .' (*The Works of the Late Edward Dayes* (1805), pp. 357–58).

20 The words are those of Wilson's apprentice, William Hodges, published in the *European Magazine and London Review*, 1790, and quoted by W. G. Constable, *Richard Wilson* (1953), p. 48. Hodges also describes how Wilson attempted to change his own style to accommodate the new taste for Zuccarelli's work, but 'disgusted with what he considered as frivolity, he soon returned to his old pursuit formed in the School of Rome'. As Parris (loc. cit., p. 35) has pointed out, Hodges erroneously suggests this happened in the early 1760s, whereas Zuccarelli had been in England since 1751.

21 A. Wilton, op. cit., p. xiii, sees in Taverner's work the influence of Marco Ricci's gouache landscapes.

22 K. Clark, op. cit., p. 71.

23 Iolo A. Williams, *Early English Watercolours, and some cognate drawings by artists born not later than 1785* (1952; reprinted Bath, 1970), pp. 211–29, for an account of some of the principal members of the Old Water-Colour Society.

24 Letter to Richard West 'from a hamlet among the mountains of Savoy', 28 September 1739: W. S. Lewis, *The Yale Edition of Horace Walpole's Correspondence*, 13, p. 181.

25 W. Gilpin, *An Essay Upon Prints* (1768), p. 2: quoted by A. Wilton, op. cit., p. xiv, who discusses Gilpin's theories in some detail.

26 Sir Joshua Reynolds, ed. R. Wark, *Discourses on Art* (1959), p. 161.

27 ibid., p. 250.

28 Edmund Burke, *A Philosophical Inquiry into the Origin of our Ideas of the Sublime and Beautiful* (1757), as summarised by A. Wilton, op. cit., p. xvii. As Wilton observes, many earlier writers had recorded their awe before the grandeurs of nature, but Burke provided an intellectually satisfying framework or codification for human experience.

29 Walter Thornbury, *The Life of J. M. W. Turner, R.A.* (1862), I, p. 117.

30 J. Ruskin, extract from his Journal, published in *Praeterita*, II, para. 66 (Cook & Wedderburn (eds.), *Works*, XXXV, p. 305).

31 K. Clark, *Ruskin Today* (1964), pp. 7 and 221–22.

32 R. B. Beckett (ed.), *John Constable's Correspondence*, II (1964), p. 32.

33 Louis Hawes, 'Constable's Sky Sketches', *Journal of the Warburg and Courtauld Institutes*, XXXII (1969), pp. 344–65, for an extensive discussion of their significance, and an effective refutation of Kurt Badt's hypothesis of a causal link with the meteorological researches of Luke Howard.

34 Letter to John Fisher, 23 October 1821 (Beckett (ed.), *Correspondence*, VI (1968), pp. 76–78), quoted by Hawes, ibid., p. 344. 'Skying' was a term used by Willem van de Velde II, an artist whom Constable greatly admired.

35 D. Cox, *A Treatise on Landscape Painting and Effect in Water Colours . . .* (1814); *A Series of Progressive Lessons in Landscape for Young Beginners* (1816); and *The Young Artist's Companion; or, Drawing Book of Studies and Landscape Embellishments: . . . arranged as progressive lessons* (1825). Cox did not begin to paint in oils until the early 1840s.

36 C. M. Kauffmann, *John Varley 1778–1842* (1984), pp. 59–60, for a discussion of Varley's late style and techniques.

CATALOGUE

The catalogue has been divided into three sections: Flemish, Dutch, and British drawings. Within each section the drawings are listed by artist in alphabetical order.

The entries for the Flemish and Dutch drawings have been compiled by Mr. William Bradford, those for the British school by Dr. Dennis Farr.

In addition to the artist's name, birth and death dates where known, and title of work (with date(s) where known), each entry contains a physical description of the work. This is followed by sections dealing with the history and documentation for each work.

Under PROVENANCE, the historical sequence of ownership is given so far as is known; the form '; . . . ;' is used where a break in ownership is known or presumed to have occurred and for which we have no precise details. Neither Sir Robert Witt, nor Mr. and Mrs. W. W. Spooner, kept detailed records of where they acquired drawings. There has not been an opportunity to follow up some of the dealers' stock numbers which are recorded in certain entries; where the firms' records are still extant, it may be possible to fill out details at some future date.

The EXHIBITIONS recorded for each work do not include a few held at the Courtauld Institute Galleries which were essentially anthologies of works previously exhibited and which, therefore, do not add to our knowledge of the history of the individual works concerned. An abbreviated form has been used for exhibitions referred to several times in the text.

The LITERATURE, especially in the Flemish and Dutch sections, covers a wide field and, to avoid unnecessary repetition, an abbreviated form has been used for authors frequently quoted. A list of abbreviations used for both EXHIBITIONS and LITERATURE appears below, as does a Glossary of Technical Terms Used.

ABBREVIATIONS USED IN TEXT

Exhibitions

N.B. Where no catalogue number is given for a particular exhibit under 'EXHIBITIONS:', it may be assumed either that it was an unnumbered handlist, or that no catalogue was published.

Agnew, 1931	*Annual Exhibition of Selected Water Colour Drawings. In aid of the Artists' General Benevolent Institution,* Thos. Agnew & Sons, March 1931.
Agnew, 1953	*Loan Exhibition of Water-Colour Drawings by Thomas Girtin. In aid of the National Art-Collections Fund,* Agnew, February–March 1953.
Agnew, 1961	*The Italian Scene Drawings by Vauvitelli,* Thos. Agnew & Sons, April–May 1961.
Aldeburgh, 1949	*The Drawings of Thomas Gainsborough,* Aldeburgh Festival, Aldeburgh, Suffolk, 1949.
Amsterdam, 1936	*Twee Eeuwen Engelsche Kunst,* Stedelijk Museum, Amsterdam, July–October 1936.
Amsterdam/Ghent, 1982–3	*Met Huygens op reis,* Rijksmuseum, Amsterdam; Museum voor Schone Kunsten, Ghent, 1982–3.
Ann Arbor, 1964	*Italy through Dutch Eyes: Dutch Seventeenth Century Landscape Artists in Italy,* University of Michigan, Ann Arbor, Michigan, 1964.
Antwerp, 1930	*Trésor de l'art flamand du moyen âge au XVIIIme Siècle* Antwerp 1930. *Mémorial de l'exposition d'art flamand ancien à Anvers,* 1932.
Arts Council, 1948	*Some British Drawings from the Collection of Sir Robert Witt,* Arts Council of Great Britain, London, 1948.
Arts Council, 1951	*Three Centuries of British Watercolours and Drawings,* Arts Council, London, 1951.
Arts Council, 1953	*Drawings from the Witt Collection at the Courtauld Institute of Art,* Arts Council, London; City Art Gallery, York; The Art Gallery, Peterborough, 1953.
Arts Council, 1960	*Gainsborough Drawings,* Arts Council tour to York, Bristol, Liverpool, National Gallery of Scotland, National Museum of Wales, 1960.
Australia, 1968	*Master Drawings of the Seventeenth Century from the Witt Collection,* Adelaide; Perth; Brisbane; Sydney; Newcastle; Hobart; and Melbourne, 1968.
Bath, 1950	*Paintings and Drawings by Gainsborough,* Holburne of Menstrie Museum, Bath, 1950.
Bath, 1969	*Masters of the Watercolour: Watercolours from the Spooner Collection,* Holburne of Menstrie Museum, Bath, May–July 1969.
Berlin, 1963	*Englische Aquarelmalerei vom 18. bis 20. Jahrhundert,* Staatliche Museen zu Berlin, Nationalgalerie, 1963.
Berlin, 1974	*Die Holländische Landschaftszeichnung 1600–1740,* Staatliche Museen Preussischer Kulturbesitz, Berlin, 1974.
Berlin, 1975	*Pieter Bruegel d. Ä als Zeichner Herkunft und Nachfolge,* Staatliche Museen Preussischer Kulturbesitz, Berlin, 1975.
Berlin/Bochun 1927–8	catalogue not traced.
Bonn, 1968	*Niederländische Zeichnungen des 17. bis 19. Jahrhunderts aus der Sammlung Hans von Leeuwen, Utrecht,* Rheinisches Landesmuseum, Bonn, 1968.
Bristol, 1956	*French XVIIth Century Drawings,* City Art Gallery, February–March 1956.
Bristol, 1973	*English Watercolours, The Spooner Collection and Bequest,* City Art Gallery, Bristol, May–June 1973.
British Museum, 1983	*Mantegna to Cézanne: Master Drawings from the Courtauld. A Fiftieth Anniversary Exhibition,* British Museum, February–June 1983.
Brunswick, 1979	*Jan Lievens ein Maler im Schatten Rembrandts,* Herzog Anton Ulrich-Museum, Brunswick, 1979.
Brussels, 1935	*Exposition Universelle et Internationale, Cinq siècles d'art (Dessins et Tapisseries,* exh. cat. vol. III), Brussels, 1935.
Brussels, 1937	*Dessins hollandais de Jérome Bosch à Rembrandt,* Palais des Beaux-Arts, Brussels, 1937.
Brussels, 1961	*Dessins hollandais du Siècle d'Or,* Bibliothèque Royale Albert 1er, Brussels, 1961.
Brussels, 1965	*Rubens et son Temps,* Musées Royaux des Beaux-Arts, Brussels, 1965.
Brussels, 1978	*Dessins des Maîtres Anciens des Musées Royaux des Beaux-Arts de Belgique,* Musées royaux des Beaux-Arts, Brussels, 1978.
Brussels, 1980	*Bruegel: Une Dynastie de peintres,* Palais des Beaux-Arts, Brussels, 1980.
Brussels/Rotterdam/Paris 1972–3	*Dessins flamands et hollandais du XVII Siècle du Musée de l'Ermitage, Léningrad et du Musée Pouchkine, Moscou,* Bibliothèque Royale Albert 1er, Brussels; Boymans-van Beuningen Museum, Rotterdam; Institut Néerlandais, Paris, 1972–3.
Brussels/Rotterdam/Paris/Berne, 1968–9	*Dessins de Paysagistes hollandais du XVIIe Siècle,* Bibliothèque Royale Albert 1er, Brussels; Boymans-van Beuningen Museum, Rotterdam; Institut Néerlandais, Paris; Musée des Beaux-Arts, Berne, 1968–69.
Calais, 1961	*L'Aquarelle romantique en France et en Angleterre,* Musée des Beaux-Arts, Calais, 1961.
Cambridge, 1961	*One Hundred of the Finest Drawings from Polish Collections,* Fitzwilliam Museum, Cambridge, 1961.
Canada/USA, 1948–51	catalogue not traced.
Colnaghi, 1948	*Exhibition of Old Master Drawings,* P. & D. Colnaghi & Co., Ltd., London, 1948.
Colnaghi, 1952	*A Loan Exhibition of Old Master Drawings,* P. & D. Colnaghi & Co., Ltd., London, 1952.
Colnaghi, 1968	*Old Master Drawings,* Colnaghi, London, 1968.
Colnaghi, 1970	*A Loan Exhibition of Drawings and Watercolours by East Anglian Artists of the 18th and 19th Centuries,* Colnaghi, London, September–October 1970.
Constable Bicentenary, 1976	*Constable: Paintings, Watercolours & Drawings,* The Tate Gallery, London, February–April 1976.
Cotman Bicentenary, 1982–3	*John Sell Cotman 1782–1842,* Victoria & Albert Museum, London, August–October 1982; Whitworth Art Gallery, Manchester, November–December 1982; Bristol Museum & Art Gallery, December 1982–January 1983.
Courtauld (20 Portman Sq.), 1956	no catalogue published.
Courtauld, 1958	*Drawings from the Witt Collection,* Courtauld Institute Galleries, London, 1958.
Courtauld, 1965	*English Landscape Drawings from the Witt Collection,* Courtauld Institute Galleries, January–May 1965.
Courtauld, 1965–6	*Newly Acquired Drawings for the Witt Collection,* Courtauld Institute Galleries, London, October 1965–March 1966.
Courtauld, 1968	*The William Spooner Collection and Bequest,* Courtauld Institute Galleries, April–July 1968.
Courtauld, 1972	*Dutch Drawings from the Witt Collection, Part I, Landscape,* Courtauld Institute Galleries, January–March 1972.
Courtauld, 1974	*Watercolours by J. M. W. Turner from the Collection of Sir Stephen Courtauld,* Courtald Insitute Galleries, London, May 1974.
Courtauld, 1977–8	*Flemish Drawings from the Witt Collection,* Courtauld Institute Galleries, October 1977–January 1978.
Courtauld, 1980	*Turner, Prout, Steer. Three Bequests to the Courtauld Institute of Art,* Courtauld Institute Galleries, June–December 1980.
Cox Bicentenary, 1983–4	*David Cox 1783–1859,* Birmingham Museums and Art Gallery, July–October 1983; Victoria & Albert Museum, November 1983–January 1984.
Dordrecht, 1968	*Nederlandse tekeningen,* Dordrecht Museum, Dordrecht, 1968.
Düsseldorf, 1968	*Niederländische Handzeichnungen 1500–1800, aus dem Kunstmuseum, Düsseldorf,* Düsseldorf, 1968.
Empire Art Loans Collection Society, South Africa, 1937–38	catalogue not traced.
Ghent, 1954	*Roelandt Savery,* Musée des Beaux-Arts, Ghent, 1954.
Ghent, 1961	*Le Paysage aux Pays-Bas de Bruegel à Rubens,* Musée des Beaux-Arts, Ghent, 1961.

Girtin Bicentenary, 1975 — *Watercolours by Thomas Girtin*, Whitworth Art Gallery, Manchester, January–February; Victoria & Albert Museum, March–April 1975.

Grenoble, 1977 — *Dessins hollandais du Musée de Grenoble*, Musée de Peinture et de Sculpture, Grenoble, 1977.

Grosvenor Square, London, 1937 — *British Country Life through the Centuries*, 39 Grosvenor Square, London, June 1937.

Hamburg/Oslo/Stockholm/Copenhagen, 1949–50 — *English Art from Hogarth to Turner*, British Council touring exhibition to Hamburg, Oslo, Stockholm and Copenhagen, 1949–50.

Hamburg, 1965 — *Zeichnung alter Meister aus deutschen Privatbesitz*, Kunsthalle, Hamburg, 1965.

Hamburg, 1967 — *Hundert Meisterzeichnungen aus der Hamburger Kunsthalle*, Kunsthalle, Hamburg, 1967.

Hannover, 1963 — *Handzeichnung Niederländer*, Kestner Museum, Hannover, 1963.

Harrogate, 1968 — *English Watercolours: Memorial Exhibition to William Wycliffe Spooner*, Corporation Art Gallery, Harrogate, August 1968.

Huddersfield, 1946 — *Two Hundred Years of British Painting*, Public Library & Art Gallery, Huddersfield, May–July 1946.

International Exhibitions Foundation, 1976–7 — *European Drawings from the Fitzwilliam*, International Exhibitions Foundation (Washington D.C.), travelling exhibition U.S.A. 1976–7.

International Exhibitions Foundation, 1977 — *Seventeenth Century Dutch Drawings from American Collections*, International Exhibitions Foundation (Washington D.C.), travelling exhibition U.S.A., 1977.

Ipswich, 1927 — *Gainsborough Bicentenary Exhibition*, Christchurch Museum, Ipswich, 1927.

Jeudwine and ffrench, 1961 — *Four Centuries of Italian Landscape*, Jeudwine and ffrench (Alpine Club Gallery), London, 1961.

Koetser, 1962 — *Flemish, Dutch, and Italian Old Masters*, Leonard Koetser, London, 1962.

Laren, 1966 — *Oude Tekeningen*, Singer Museum, Laren, 1966.

Leeds, 1958 — *Early English Water Colours*, City Art Gallery, Leeds, October–November 1958.

Leiden/Arnhem, 1960 — *Jan van Goyen*, Stedelijk Museum, Leiden; Gemeentemuseum, Arnhem, 1960.

London/Paris/Berne/Brussels, 1972 — *Flemish Drawings from the Seventeenth Century*, Victoria & Albert Museum; Institut Néerlandais, Paris; Kunstmuseum, Berne; Bibliothèque Royale Albert 1er, Brussels, 1972.

Manchester, 1962 — *Master Drawings from the Witt and Courtauld Collections*, Whitworth Art Gallery, Manchester, November–December 1962.

Manchester, 1965 — *Between Renaissance and Baroque*, City Art Gallery, Manchester, 1965.

Milwaukee, 1964 — *Great Art from Private Colleges and Universities*, Marquette University, Milwaukee, February 1964.

Munich, 1973 — *Das Aquarell 1400–1600*, Haus der Kunst, Munich, 1973.

New York, 1972 — *Seventeenth Century Dutch and Flemish Drawings from the Robert Lehman Collection*, Metropolitan Museum of Art, New York, 1972.

New York/Paris, 1977–8 — *Rembrandt and his Century. Dutch Drawings of the Seventeenth Century*, Pierpont Morgan Library, New York, 1977–8; Institut Néerlandais, Paris, 1978.

New Zealand, 1960 — *Old Master Drawings from the Witt Collection*, City Art Gallery, Auckland, New Zealand, 1960.

New Zealand and Australia, 1976–8 — *Exhibition of Drawings and Watercolours from the Spooner and Witt Collections*, National Art Gallery of New Zealand, Wellington, and other locations in New Zealand; Art Gallery of New South Wales, Sydney, Australia, and other locations in Australia, 1976–8.

N.M.M., London, 1982 — *The Art of the Van de Veldes*, National Maritime Museum, London, 1982.

Nottingham, 1962 — *Landscapes by Thomas Gainsborough*, The University Art Gallery, Nottingham, 1962.

Nottingham, 1966 — *Drawings from the Courtauld Collections*, The University Art Gallery, Nottingham, 1966 (unnumbered typescript).

Ottawa, 1977 — *Drawings by Gaspar van Wittel from Neapolitan Collections*, The National Gallery of Canada, Ottawa, 1977.

Oxford, 1929 — *Dutch Drawings XVI to XVII Century lent by Sir Robert and Lady Witt, Campbell Dodgrou, Esq., Julian G. Lousada Esq., and J. C. Witt, Esq.* Oxford Arts Club, 1929.

Paris, 1938 — *La Peinture anglaise du XVIIIe et XIXe siècles*, Louvre, Paris, 1938.

Paris, 1953 — *La Paysage anglais de Gainsborough à Turner*, British Council, Orangerie, Paris, 1953.

Paris/Antwerp/London/New York, 1979–80 — *Rubens Rembrandt in their Century: Flemish Dutch Drawings of the 17th Century from The Pierpont Morgan Library*, Institut Néerlandais, Paris; Koninklijk Museum voor Schone Kunsten, Antwerp; The British Museum, London; The Pierpont Morgan Library, New York, 1979–80.

Petit Palais, Paris, 1972 — *La Peinture romantique anglaise et les préraphaélites*, Petit Palais, Paris, January–April 1972.

R.A., 1927 — *Exhibition of Belgian and Flemish Art 1300–1900*, Royal Academy of Arts, London, 1927.

R.A., 1934 — *British Art c.1000–1860*, Royal Academy of Arts, London, 1934.

R.A., 1953 — *Drawings by Old Masters* Royal Academy of Arts, London, 1953.

Royal Academy Bicentenary, 1968–9 — *Royal Academy of Arts Bicentenary Exhibition*, Royal Academy of Arts, London, December 1968–March 1969.

Rotterdam/Amsterdam, 1961 — *150 Tekeningen uit vier eeuwen uit de verzamelingen van Sir Bruce Ingram*, Boymans-van Beuningen Museum, Rotterdam; Rijksmuseum, Amsterdam, 1961.

Rotterdam/Brussels/Paris, 1948–9 — *Tekeningen van Van Eyck tot Rubens (De Van Eyck à Rubens)*, Boymans-van Beuningen Museum, Rotterdam; Palais des Beaux-Arts, Brussels; Bibliothèque Nationale, Paris, 1948–9.

Rotterdam/Paris, 1974–5 — *Willem Buytewech*, Boymans-van Beuningen Museum, Rotterdam; Institut Néerlandais, Paris, 1974–5.

Rotterdam/Paris/Brussels, 1977 — *Le Cabinet d'un Amateur; dessins flamands et hollandais des XVIe et XVIIe Siècles d'une collection privée d'Amsterdam*, Boymans-van Beuningen Museum, Rotterdam; Institut Néerlandais, Paris; Bibliothèque Royale Albert 1er, Brussels, 1977.

Rye, 1971 — *English Landscape Drawings*, The Art Gallery, Rye, October–November 1971 (no catalogue).

Rye, 1972 — *David Teniers the Younger*, The Art Gallery, Rye, 1972.

Sacramento, 1940 — *Three Centuries of Landscape Drawings*, E. B. Crocker Art Gallery, Sacramento, California, 1940.

Sacramento, 1971 — *Master Drawings from Sacramento*, E. B. Crocker Art Gallery, Sacramento, California, 1971.

San Francisco, 1933 — *Loan Exhibition of English Painting of the Late Eighteenth and Early Nineteenth Centuries*, The California Palace of the Legion of Honor, San Francisco, June–July 1933.

Sassoon, London, 1936 — *Gainsborough Exhibition*, Sir Philip Sassoon, 45 Park Lane, London, 1936.

Sheffield, 1961 — *Samuel Palmer (1805–1881)*, Graves Art Gallery, Sheffield, October–November 1961.

Sheffield and Tate Gallery, 1946 — *Drawings and Paintings by Alexander Cozens*, Graves Art Gallery, Sheffield, and Tate Gallery, London, 1946.

Slatter Gallery, 1943–4 — *Pieter Bruegel and His Circle*, Slatter Gallery, London, 1943–4.

South Kensington, 1880–83 — *The Collection of Mrs (Anna) Charles Golding Constable*, South Kensington Museum (later V. & A.), April 1880–May 1883.

Stockholm, 1953 — *Dutch and Flemish Drawings in the Nationalmuseum and other Swedish Collections*, Nationalmuseum, Stockholm, 1953.

Sudbury, 1977 — *The Painter's Eye*, Gainsborough's House, Sudbury, Suffolk, June 1977.

Swansea, 1962 — *French Master Drawings*, Swansea Festival of Music and the Arts, Glynn Vivian Art Gallery, Swansea, 1962.

Tate Gallery, 1973 — *Landscape in Britain 1750–1850*, Tate Gallery, London, 1973.

Tokyo, 1929 — An exhibition at the Institute of Art Research, Tokyo (catalogue not traced).

Tokyo, 1978 — *European Landscape Painting*, National Museum of Western Art, Tokyo, September–October 1978.

Tokyo and Kyoto, 1970–71 — *English Landscape Painting of the 18th and 19th Centuries*, Tokyo and Kyoto, 1970–71.

Turner Centenary, Agnew, 1951 — *Centenary loan exhibition of water-colour drawings by J. M. W. Turner, R.A., in aid of the Artists' General Benevolent Institution*, Agnew, February–March 1951.

Turner Courtauld, 1974 — *Turner Watercolours from the Collection of Stephen Courtauld*, Courtauld Institute Galleries, May 1974.

Utrecht, 1965 — *Nederlandse 17e eeuwse italianiserende landschapschilders*, Centraal Museum, Utrecht, 1965.

V. & A., London — Victoria & Albert Museum, London.

V. & A., 1943 — *Drawings of the Old Masters from the Witt Collection*, Victoria & Albert Museum, London, 1943 (unnumbered typescript).

V. & A., 1970 — *Drawings from the Teylers Museum, Haarlem*, Victoria & Albert Museum, London, 1970.

Vienna, 1925 — catalogue not traced

Whitworth Art Gallery and V. & A., 1971 — *Watercolours by J. R. Cozens*, Whitworth Art Gallery, Manchester, March–April and Victoria & Albert Museum, London, April–May 1971.

Wildenstein/London, 1955 — *Artists in Seventeenth-Century Rome*, Wildenstein, London, 1955.

Literature

Amsterdam — P. J. J. van Thiel et al., *All the Paintings of the Rijksmuseum in Amsterdam* (Amsterdam 1976).

Andrews — K. Andrews, *Adam Elsheimer Paintings – Drawings – Prints* (London, 1977).

Arndt — K. Arndt, 'Pieter Bruegel d. Ä und die Geschichte der Waldlandschaft', *Jahrbuch der Berliner Museen* no. 14, 1972, pp. 71ff.

Baer — R. Baer, *Studien zur Entwicklungsgeschichte der Landschaftsmalerei um 1600* (Munich, 1930).

Bartsch — A. Bartsch, *Le Peintre Graveur*, 22 vols. (Leipzig, 1854).

Bartsch, Illustrated — *The Illustrated Bartsch*, 25 vols, eds. M. Carter Leach and P. Morse (New York, 1978).

Beck, I. — H-U. Beck, *Jan van Goyen 1596–1656; ein Oeuvreverzeichnis,* vol. I (Amsterdam, 1972).

Beck, II — H-U. Beck, *Jan van Goyen 1596–1656; ein Oeuvreverzeichnis*, vol. II (Amsterdam, 1973).

Benesch, 1928 — O. Benesch, *Die Zeichnungen der Niederländischen Schulen des XV und XVI Jahrhunderts in der Graphischen Sammlung, Albertina* (Vienna, 1928).

Benesch, 1957 — O. Benesch, *The Drawings of Rembrandt*, 6 vols. (London, 1954–1957).

Benesch, 1964 — O. Benesch, *Meisterzeichnungen der Albertina* (Salzburg, 1964).

Bernhard — M. Bernhard, *Rubens Handzeichnungen* (Munich, 1977).

Bernt, I. — W. Bernt, *Die Niederländischen Zeichner des 17 Jahrhunderts*, vol. I (Munich, 1957).

Bernt, II — W. Bernt, *Die Niederländischen Ziechner des 17 Jahrhunderts*, vol. II (Munich, 1958).

Bierens de Haan — J. C. J. Bierens de Haan, *L'œuvre gravé de Cornelis Cort graveur hollandais 1533–1578* (The Hague, 1948).

Blunt — A. Blunt, *The Paintings of Nicolas Poussin*, vol. I (London, 1966).

Bock/Rosenberg — E. Bock, J. Rosenberg, *Die Niederländischen Meister, Staatliche Museen zu Berlin*, 2 vols. (Berlin, 1930).

Boëthius/Ward-Perkins — A. Boëthius, J. B. Ward-Perkins, *Etruscan and Roman Architecture* (London, 1970).

Bodart — D. Bodart, *Les Peintres des Pays-Bas Méridionaux et de la Principauté de Liège à Rome au XVII siècle*, 2 vols. (Rome and Brussels, 1970).

Bol/Keyes/Butôt — L. J. Bol, G. S. Keyes, F. C. Butôt, *Netherlandish Paintings and Drawings from the Collection of F. C. Butôt* (London, 1981)

Bolten, 1965 — J. Bolten, *Nederlandse en Vlaamse tekeningen uit de zeventiende en achttiende eeuw ... van het Groninger Museum voor Stad en Lande* (Groningen, 1965).

Bolten, 1967 — J. Bolten, *Dutch Drawings from the Collection of Dr. C. Hofstede de Groot, Groninger Museum voor Stad en Lande* (Utrecht, 1967).

Brett — G. Brett, 'The Seven Wonders of the World in the Renaissance', *Art Quarterly*, XII, 1949, pp. 346ff.

Briels — J. Briels, *Vlaamse schilders in het Noorden in het begin van de Gouden Eeuw* (Brussels, 1978).

Brière, 1930 — G. Brière 'Van der Meulen, Collaborateur de Le Brun' *Société de l'histoire de l'art français*, 1930, pp. 150ff.

Brière, 1931 — G. Brière 'Les dessins de l'atelier de van der Meulen aux Gobelins', *Société de l'histoire de l'art français*, 1931, pp. 6ff.

Briganti — G. Briganti, *Gaspar van Wittel e l'origine della veduta settecentesca* (Rome, 1966).

Briquet — C. M. Briquet, *Les Filigranes*, 4 vols (2nd ed., New York, 1966).

Brown — C. Malcolm Brown, 'Martin van Heemskerk the Villa Madama Jupiter and the Gonzaga Correspondence Files', *Gazette des Beaux-Arts*, VIth series, vol. 94, 1979, pp. 49ff.

Budde — I. Budde, *Beschriebender katalog der Handzeichnungen in der Staatlichen Kunstakademie Düsseldorf* (Düsseldorf, 1930).

Burke — J. D. Burke, *Jan Both Paintings Drawings and Prints* (Ph.D. thesis, Harvard University, 1972; published New York and London, 1976).

Byam Shaw, 1928 — J. Byam Shaw 'Valentine Klotz', *Old Master Drawings*, vol. III, no. II, 1928, pp. 53ff.

Byam Shaw, 1929 — J. Byam Shaw 'Drawings by Minor Dutch Masters in the Collection of Sir Robert and Lady Witt', *The Studio*, July–December 1929, vol. 98, pp. 541 ff.

Churchill — W. A. Churchill, *Watermarks in Paper in Holland, France, England Etc. in the XVII and XVIII Centuries and their Interconnection* (Amsterdam, 1937, 3rd imp., 1967).

Copenhagen — *Royal Museum of Fine Arts Catalogue of Old Foreign Paintings* (Copenhagen, 1951).

Croft-Murray/Hulton — E. Croft-Murray, P. Hulton, *Catalogue of British Drawings. British Museum, vol. I: XVI & XVII Centuries. Supplemented by a list of foreign artists' drawings connected with Great Britain* by C. White (London, 1960).

Davis — M. Davis, 'Francisque Millet', *Bulletin de la Société Poussin*, 2e Cahier, 1948, pp. 13ff.

Delen, 1938 — A. J. J. Delen, *Cabinet des Estampes de la Ville d'Anvers, Musée Plantin-Moretus Catalogue des Dessins Anciens (Ecole Flamande et Hollandaise)* 2 vols. (Brussels, 1938).

Delen, 1948 — A. J. J. Delen, *Musée Royal des Beaux-Arts Anvers, Catalogue descriptif, Maîtres anciens* (Antwerp, 1948).

Denucé — J. Denucé, *Brieven en documenten betreffend Jan Brueghel, I en II* (Antwerp, The Hague, 1934).

De Tolnay, 1935 — C. de Tolnay, *Pierre Bruegel l'Ancien* (Brussels, 1935).

De Tolnay, 1952 — C. de Tolnay, *The Drawings of Pieter Bruegel the Elder* (London, 1952),

Detroit — *Paintings in the Detroit Institute of Arts: a checklist of the paintings acquired before 1965* (Detroit, 1965).

Dresden — *Katalog der Königlichen Gemäldegalerie zu Dresden* (Berlin and Dresden, 1912).

Duclaux — L. Duclaux, 'Dessins de Martin van Heemskerck', *La Revue du Louvre ...*, No. 5/6, December 1981, pp. 375ff.

Egger, I — H. Egger, *Römische Veduten*, vol. I (Vienna and Leipzig, 1911).

Egger, II — H. Egger, *Römische Veduten*, vol. II, (Vienna, 1931).

Faggin — G. T. Faggin, 'Per Paolo Bril', *Paragone*, no. 185/5, July 1965, pp. 21ff.

Fairfax-Murray C. Fairfax-Murray, *The J. Pierpont Morgan Collection of Drawings by the Old Masters Formed by C. Fairfax-Murray*, 4 vols. (London, 1905–1912).

Fokker J. H. Fokker, *Jan Siberechts, Peintre de la Paysanne Flamande* (Brussels, 1931).

Franken/Kellen D. Franken, J. P. van der Kellen, *L'Oeuvre de Jan van der Velde* (Amsterdam and Paris, 1883).

Franz, 1963 F. G. Franz, 'De boslandschappen van Gillis Coninxloo en hun voorbeelde', *Bulletin Museum Boymans-van Beuningen*, Deel XIV, no. 3, 1963, pp. 66ff.

Franz, 1965 H. G. Franz, 'Hans Bol als Landschaftszeichner' *Jahrbuch des Kunsthistorischen Instituts der Universität Graz*, I, 1965, pp. 21ff.

Gerson H. Gerson, *Philips Koninck* (Berlin, 1936).

Gerson, 1976 H. Gerson, 'Gezicht op Naarden door Constantijn Huygens, de Zoon' *Festoen (Essays presented to A. N. Zadoks – Josephus Jitta on His Seventieth Birthday)* (*Scripta archeologic Groningana*, 6: Groningen/Bussum, 1976)

Gerspach Gerspach, 'Les Dessins de van der Meulen aux Gobelins', *Gazette des Beaux-Arts*, 3ᵉ période, vol. VIII, 1892, pp. 138ff.

Gerzi T. Gerzi, 'Landschaftszeichnungen aus der Nachfolge Pieter Bruegels; *Jahrbuch der Berliner Museen*, vol. VII, 1965, pp. 92ff.

Gibson W. Gibson, *Bruegel* (London, 1977).

Glück G. Glück, *Das Grosse Bruegel-Werk* (Vienna, Munich, 1951).

Graves R. Graves, *The Greek Myths*, 2 vols (Middlesex, 1955).

Grossmann, 1954 F. Grossmann, 'The Drawings of Pieter Bruegel the Elder in the Museum Boymans and some Problems of Attribution', *Bulletin Boymans-van Beuningen*, no. 5, 1954, pp. 41ff.

Grossmann, 1955 F. Grossmann, *Pieter Bruegel The Paintings* (London, 1955).

Guiffrey, 1897 J. Guiffrey, 'Van der Meulen', *Nouvelles Archives de l'art français*, IIᵉ série, tome I, 1897, pp. 119ff.

Guiffrey, 1902 J. Guiffrey, Inventaire Général des Richesses d'Art de la France, Paris, Monuments civils, tome III (Paris, 1902)

Guiffrey/Marcel J. Guiffrey, P. Marcel, *Musée du Louvre Inventaire général des dessins de l'école française*, tome VIII (Paris, 1913).

Hand-list *Hand-list of the Drawings in the Witt Collection* (London University, 1956).

Haverkamp Begemann, 1959 E. Haverkamp Begemann, *Willem Buytewech* (Amsterdam, 1959).

Haverkamp Begemann, 1963 E. Haverkamp Begemann, 'The Etchings of Willem Buytewech', *Prints (Thirteen Illustrated Essays on the Art of the Print Selected by Carl Zigrosser)* (London, 1963).

Heawood E. Heawood, *Watermarks mainly of the 17th and 18th centuries* (Hilversum, 1950; revised ed., 1973).

Held, 1937 J. S. Held, 'Ett bidrag till kännendomen om Everdingens skandinaviska resa', *Konsthistorisk Tidskrift*, VI, 1937, pp. 41ff.

Henkel M. D. Henkel, *Catalogus van der Nederlandsche Teekeningen in het Rijksmuseum te Amsterdam, Deel I, Teekeningen van Rembrandt en zijn School* (The Hague, 1942).

Hermitage *The State Hermitage West-European Painting Album of Reproductions*, 2 vols. (Russian text, Moscow, 1957, 1958).

Heydenreich/Lotz L. Heydenreich, W. Lotz, *Architecture in Italy 1400–1600* (London, 1974).

Hind, III A. M. Hind, *Catalogue of Drawings by Dutch and Flemish Artists … in the British Museum*, vol. III (London, 1926).

Hind, IV A. M. Hind, *Catalogue of Drawings by Dutch and Flemish Artists … in the British Museum*, vol. IV (London, 1931).

Hind, 1967 A. M. Hind, *A Catalogue of Rembrandt's Etchings* (New York, 1967; reprint of 1923 ed.).

Hofstede de Groot C. Hofstede de Groot, *Beschriebendes und Kritisches Verzeichnis der Werke der Hervorangenden Hol-ländischer Maler des XVIII Jahrhunderts* (Esslingen, 1926).

Hollstein F. W. H. Hollstein, *Dutch and Flemish Etchings Engravings and Woodcuts c.1450–1700*, 25 vols. (Amsterdam, 1949 – incomplete).

Hollstein/German F. W. H. Hollstein, *German Engravings Etchings and Woodcuts ca.1400–1700*, 13 vols. (Amsterdam, 1954 – incomplete).

Houbraken A. Houbraken, *De Groote Schouburgh der Nederlantsche Konstschilders en Schilderessen* 3 vols. (The Hague, 1753).

Hülsen/Egger C. Hülsen, H. Egger, *Die römischen Skizzenbücher von Marten van Heemskerck im Königlichen Kupferstichkabinett zu Berlin*, 2 vols. (Berlin, 1916).

JCC VI R. B. Beckett (ed.), *John Constable's Correspondence*, VI, 'The Fishers' (Suffolk Records Office XII, 1968).

Keyes G. S. Keyes, *Esaias van den Velde* (Doornspijk, 1984).

Khanenko *Collection Khanenko, Tableaux des écoles néerlandaises*, 5 vols. (Kiev, 1911–1912).

Knapp/Borel C. Knapp, M. Borel, *Dictionnaire Géographique de la Suisse* (ed. V. Attinger) 3 vols. (Neuchâtel, 1905).

Knuttel G. Knuttel, *Adriaen Brouwer The Master and His Works* (The Hague, 1962).

Koester O. Koester, 'Joos de Momper the Younger Prolegomena to the Study of his Paintings', *Artes*, II, 1966, pp. 5ff.

Kusnetsov Y. Kusnetsov, *Western European Drawings in the Hermitage* (Leningrad, 1981).

Laes, 1931 A. Laes, 'Un paysagiste flamand de la fin du XVIᵉ siècle: Kerstiaen de Keuninck', *Mélanges Hulin de Loo* (Brussels and Paris, 1931), pp. 225ff.

Laes, 1939 A. Laes, 'Gillis van Coninxloo, rénovateur du paysage flamand au XVIᵉ siècle', *Annuaire des Musées Royaux des Beaux-Arts*, Brussels, I 1939, pp. 109ff.

Lavalleye J. Lavalleye, 'Le Château de Courtrai', *Société d'Archéologie de la Belgique Annales Mémoirs*, 1930, p. 157ff.

Lebeer, 1949 L. Lebeer 'La Kermesse d'Hoboken' *Miscellanea Leo van Puyvelde* (Brussels, 1949), pp. 99ff.

Lebeer, 1969 L. Lebeer, *Catalogue raisonné des Estampes de Pierre Bruegel l'ancien* (Brussels, 1969).

Lugt/J. P. K. F. Lugt, 'Beiträge zu dem Katalog der Niederländischen Handzeichnungen in Berlin', *Jahrbuch der Preuszischen Kunstsammlungen*, no. 52, 1931.

Lugt, 1920 F. Lugt, *Mit Rembrandt in Amsterdam* (Berlin, 1920).

Lugt, 1927 F. Lugt, *Les Dessins des écoles du Nord de la Collection Duthuit* (Paris, 1927).

Lugt, 1929–33 F. Lugt, *Musée du Louvre. Inventaire général des dessins des écoles du nord. Ecole hollandaise*, 3 vols. (Paris, 1929–1933).

Lugt, 1949 F. Lugt, *Musée du Louvre. Inventaire général des dessins des écoles du nord. Ecole flamande*, 2 vols. (Paris, 1949).

Lugt, 1950 F. Lugt, *Inventaire général des dessins des écoles du nord, Ecole Nationale Supérieure des Beaux-Arts, Paris, Tome I, école hollandaise* (Paris, 1950).

Lugt (**)** F. Lugt, *Les Marques de Collections de dessins & d'estampes* (Amsterdam, 1921).

Lugt supp. (**)** F. Lugt, *Les Marques de Collections de dessins & d'estampes Supplément* (The Hague, 1956).

MacLaren N. MacLaren, *The Dutch School, National Gallery Catalogues* (London, 1960).

Maeterlinck L. Maeterlinck, *Chronique des Arts et de la Curiosité* (Paris, 1903).

Malta *Elenco dei disegni del Museo della Cattedrale di Malta* (Malta, 1980).

Marlier G. Marlier, *Pierre Brueghel le Jeune* (Brussels, 1969).

Mauquoy-Hendrickx M. Mauquoy-Hendrickx, *Les Estampes des Wiericx*, 3 vols. (Brussels, 1978).

Mayer A. Mayer, *Das Leben und die Werke der Bruder Matthäus und Paul Brill* (Leipzig, 1910).

Monballieu A. Monballieu, 'De "Kermis van Hoboken" bij P. Bruegel, J. Grimmer en G. Mostaert', *Jaarboek van het Koninklijk Museum voor Schone Kunsten*, Antwerp, 1974, pp. 139ff.

Mongan/Sachs — A. Mongan, P. Sachs, *Drawings in the Fogg Art Museum* (Harvard, 1940).

Montpellier — *Catalogue des Peintures & Sculptures exposés dans les Galleries du Musée Fabre* (Montpellier, 1914).

Mosti — R. Mosti, *Storia e monumenti di Tivoli* (Tivoli, 1961).

Müller — C. Müller, 'Abraham Bloemaert als Landschaftsmaler *Oud-Holland*, XLIV, 1927, pp. 193ff.

Münz — L. Münz, *Bruegel Drawings* (London, 1961).

Murray — P. Murray, *The Dulwich Picture Gallery: A Catalogue* (London, 1980).

Nash — E. Nash, *Pictorial Dictionary of Ancient Rome*, 2 vols. (Deutsches Archaeologisches Institut, London, 1962).

Nationalmuseum/Stockholm — *Äldre Utländska Målningar och Skulpturer* (Nationalmuseum, Stockholm, 1958).

Oxford Classical Dictionary — *The Oxford Classical Dictionary* (eds. M. Cary, J.D. Denniston, J. Wright Duff, A.D. Nock, W.D. Ross, H.H. Scullard, Oxford, 1949).

Pauli — G. Pauli, *Zeichnungen alter Meister in der Kunsthalle zu Bremen*, 3 vols. (Frankfurt, 1914–1916).

Pératé/Brière — A. Pératé, G. Brière, *Musée Nationale de Versailles Compositions Historiques*, I (Paris, 1931).

Pierron — S. Pierron, *Histoire de la forêt de Soigne* (Brussels, 1905).

Popham V — A. E. Popham, *Catalogue of Drawings by Dutch and Flemish Artists … in the British Museum*, vol. V (London, 1932).

Popham, 1935 — A.E. Popham, *Catalogue of drawings in the collection formed by Sir Thomas Phillipps, Bart., F.R.S., now in the possession of his grandson T. Fitzroy Phillipps Fenwick of Thirlestaine House, Cheltenham* (London, 1935).

Popham/Fenwick — A. E. Popham, K. M. Fenwick, *European Drawings in the Collection of the National Gallery of Canada* (Ottawa, 1965).

Prado — *Museo del Prado, Madrid. Catálogo de los Cuadros* (Madrid, 1952).

Preibisz — L. Preibisz, *Martin van Heemskerck* (Leipzig, 1911).

Raczyński — Graf J.A. Raczyński, *Die flämische Landschaft vor Rubens* (Frankfurt, 1934).

Robinson, I — M. S. Robinson, *Van de Velde Drawings: a catalogue of drawings in the National Maritime Museum made by the Elder and the Younger van de Velde*, vol. I (Cambridge, 1958).

Robinson, II — M. S. Robinson, *Van de Velde Drawings: a catalogue of drawings in the National Maritime Museum made by the Elder and the Younger van de Velde*, vol. II (Cambridge, 1973).

Rosenberg — J. Rosenberg, *Jacob van Ruisdael* (Berlin, 1928).

Rosenberg/Rubens — *P.P. Rubens* (Klassiker der Kunst in Gesamtausgaben), vol. 5 (Berlin and Leipzig, 1921, reprinted with A. Rosenberg's biography from the 1905 ed.).

Röthlisberger, 1961 — M. Röthlisberger, *Claude Lorrain The Paintings*, 2 vols. (New Haven, 1961).

Röthlisberger, 1963 — M. Röthlisberger, 'Adriaen Honing alias Lossenbruy', *Münchner Jahrbuch des bildenden Kunst*, vol. XIV, 1963, pp. 121ff.

Röthlisberger, 1964 — M. Röthlisberger, 'A la recherche d'Adriaen Honing' *National Gallery of Canada Bulletin*, no. 4, 1964, pp. 14ff.

Röthlisberger, 1968 — M. Röthlisberger, *Claude Lorrain The Drawings* (Berkeley, Los Angeles, 1968).

Röthlisberger, 1969 — M. Röthlisberger, *Bartholomäus Breenbergh Handzeichnungen* (Berlin, 1969).

Schaar — E. Schaar, 'Poelenburgh und Breenbergh in Italien und ein Bild Elsheimers', *Mitteilungen des Kunsthistorischen Instituts in Florenz*, no. IX, 1959, pp. 27ff.

Schnackenburg — B. Schnackenburg, *Adriaen van Ostade Isack van Ostade Zeichnungen und Aquarelle* (Hamburg, 1981).

Schneider — H. Schneider, *Jan Lievens, sein Leben und seine Werk* (Haarlem, 1932).

Schneider/Ekkart — H. Schneider and R. E. O. Ekkart, *Jan Lievens, sein Leben und seine Werke* (Amsterdam and Israel, 1973).

Scholten — H. J. Scholten, *Catalogue raisonné des dessins des écoles française et hollandaise au Musée Teyler à Haarlem* (Haarlem, 1904).

Schönbrunner/Meder — J. Schönbrunner, J. Meder, *Handzeichnungen älter meister aus der Albertina und anderen Sammlungen*, 12 vols. (Vienna 1896–1908).

Schotel — G.D.J. Schotel, *De Abdy van Rijnsberg* (The Hague, 1851).

Schulz — W. Schulz, *Herman Saftleven* (Berlin and New York, 1982).

Seilern — A. Seilern, *Flemish Paintings & Drawings at 56 Princes Gate* (London, 1955).

Slive/Hoetinck — S. Slive, H. R. Hoetinck, *Jacob van Ruisdael* (New York, 1981).

Sluijter-Seijffert — N. C. Sluijter-Seijffert, *Cornelis van Poelenburch (c.1593–1667)* (Enschede, 1984).

Smolskaya — N. Smolskaya, *Teniers in the Hermitage* (Leningrad, 1962).

Soulié — E. Soulié, *Notice du Musée Impérial de Versailles*, 2 vols. (Paris, 1881).

Spicer Durham — J. A. Spicer Durham, *The Drawings of Roelandt Savery*, 2 vols (PhD. thesis, Yale University, published Ann Arbor, Michigan, 1983).

Stechow — W. Stechow, *Dutch Landscape Painting of the Seventeenth Century* (3rd ed., Oxford, 1981).

Stechow, 1960 — W. Stechow, 'Significant Dates of Some Seventeenth Century Dutch Landscape Paintings', *Oud-Holland*, LXXVI, 1960, pp. 74ff.

Steland-Stief, 1971 — A. C. Steland-Stief, *Jan Asselijn* (Amsterdam, 1971).

Steland-Stief, 1980 — A. C. Steland-Stief, 'Zum zeichnerischen Werk des Jan Asselyn. Neue Funde und Forschungsperspektiven', Oud-Holland, no. 94, 1980, pp. 213ff.

Stelling-Michaud, 1936 — S. Stelling-Michaud, 'Die Via Mala im Jahre 1655 wie sie Jan Hachaert sah und zeichnete', *Anzeiger für Schweizerische Altertumskunde*, vol. XXXVIII, 1936, pp. 261ff.

Stelling-Michaud, 1937 — S. Stelling-Michaud, *Unbekannte Schweizer Landschaften aus dem XVII Jahrhundert, Zeichnungen und Schilderungen von Jan Hackaert und anderen holländischen Malern* (Zürich and Leipzig, 1937).

Steneberg — K. E. Steneberg, *Kristinatidens Måleri* (Malmö, 1955).

Thieme/Becker — U. Thieme, F. Becker, *Allgemeines Lexikon der bildenden Künstler*, 38 vols. (Leipzig, 1907–1950).

Thiéry — Y. Thiéry, *Le Paysage Flamand au XVII siècle* (Paris and Brussels, 1953).

Timm — W. Timm, 'Der gestrandete Wal, eine motivkundliche Stie' *Forschungen und Berichte der Stadlichen Museen zu Berlin*, vol. 3/4, 1961, pp. 76ff.

Tolnai — K. Tolnai, *Die Zeichnungen Pieter Bruegels* (Munich, 1925).

Van Gelder — J. G. van Gelder, *Jan van de Velde 1593–1641 Teekenaar-schilder* (The Hague, 1933).

Van Hasselt — R. J. van Hasselt, 'Drie tekenaars van topografische prenten in Brabant en elders: Valentijn Klotz, Josua de Grave en Constantijn Huygens Jr.', *Jaarboek Oudheidkundige Kring de Ghulden Roos*, vol. 25, 1965, pp. 145ff.

Van Leeuwen — S. van Leeuwen, *Batavia Illustrata* (Amsterdam, 1685).

Van Mander — K. van Mander, *Het Leven der Doorluchtige Schilders Nederlantsche en Hoogsduytsche*, trans. A. Floerke (reprinted from 1617 ed., Munich and Leipzig, 1906).

Van Puyvelde — L. van Puyvelde, *The Dutch Drawings at Windsor Castle* (London, 1944).

Van Regteren Altena — J. Q. van Regteren Altena, *Holländische Meisterzeichnungen des siebzehnten Jahrhunderts* (Basel, 1948).

Varshavskaya — M. Varshavskaya, *Rubens' Paintings in the Hermitage Museum, Leningrad* (Leningrad, 1975).

Vermeulen — E. A. J. Vermeulen, *Handboek tot de Geschiedenis der Nederlandsche Bouwkunst*, 3 vols. (The Hague, 1928).

Vey/Kesting — H. Vey, A. Kesting, *Katalog der Niederländischen Gemälde von 1550 bis 1800 im Wallraf-Richartz-Museum und Öffentlichen Besitz der Stadt Köln* (Cologne, 1967).

Virch — C. Virch, *Master Drawings in the Collection of Walter C. Baker* (New York, 1962).

Von Sick — I. von Sick, *Nicolas Berchem ein Vorläufer des Rokoko* (Berlin, 1930).

Von Wurzbach	A. von Wurzbach, *Niederländischen Künstler-Lexikon*, 3 vols. (Leipzig, 1906–1911).
Waddingham	M. Waddingham, 'Herman van Swanevelt in Rome', *Paragone* XI, no. 126, 1960, pp. 37ff.
Wallace Coll.	*The Wallace Collection Illustrated Catalogue of Pictures and Drawings* (London, 1920).
Washington	*Master Drawings from the Collection of the National Gallery of Art and Promised Gifts* (introduction by J. Carter Brown) (Washington D.C., 1978).
Watrous	J. Watrous, *The craft of Old-Master drawings* (Wisconsin, 1957).
Wauters	A. Wauters, *Histoire des Environs de Bruxelles* (Brussels, 1973) vol. IXB.
Wegner/München	W. Wegner, *Katalog der Staatlichen Graphischen Sammlung München Die Niederländischen Handzeichnungen des 15–18 Jahrhunderts*, 2 vols. (Berlin, 1973).
Wegner, 1967	W. Wegner 'Zeichnungen von Gillis van Coninxloo und seiner Nachfolge', *Oud-Holland*, vol. LXXXII, 1967, pp. 203ff.
Wegner, 1973	W. Wegner, 'Nachlese zu Zeichnungen des Coninxloo-Umkreises' *Album Amicorum J. G. van Gelder* (eds. J. Bruy, J.A. Emmens, E. de Jongh, D.P. Snoep; The Hague, 1973), pp. 353ff.
Wethey	H.E. Wethey, *The Paintings of Titian, vol. III The Mythological and Historical Paintings* (London, 1975).
Wilenski	R.H. Wilenski, *Flemish Painters 1430–1830*, 2 vols. (London, 1960).
Winner	M. Winner, 'Zeichnungen des Älteren Jan Breughel' *Jahrbuch der Berliner Museen*, vol. III, no. 2, 1961, pp. 190ff.

GLOSSARY OF TECHNICAL TERMS USED

What follows is not an alphabetical list of terms used, but a brief summary of the principal materials employed by draughtsmen in Western Europe set out in a historical sequence. The surfaces (or "supports") come first, i.e. vellum, parchment etc.; followed by the drawing and painting materials (the "media"), i.e. chalk, pencil, and watercolour, etc.

VELLUM
Before the introduction of paper, parchment and vellum were the principal surfaces on which artists drew. Parchment and vellum are made from the treated skins of calves, goats or sheep and are prepared for drawing by polishing with pumice, sandarach, ground bone or chalk to produce a smooth, hard surface.

PAPER
Papermaking, in existence in China by 200 AD, was introduced into Spain by the Moors in about 1150. Initially made in Europe from the macerated fibres of linen, and after 1793 (with the invention of the cotton gin) from cotton; since the 19th century it has also been manufactured from other materials, especially wood-pulp.
Handmade paper is formed by immersing a wire mesh screen or mould into a watery suspension of macerated fibres, draining the water off, and pressing the mould against a piece of felt to which the sheet of paper adheres. After pressing, the individual sheets of paper can be peeled from the felt, and after further pressing and sizing with gelatin can be hung up to dry completely.

BLUE PAPER
Integrally coloured blue paper was first manufactured in Southern Europe during the final quarter of the 15th century. Originating in Venice, it emulated Arabian papers dyed with cobalt or indigo, and was known as 'Turkish' paper. Although made in Germany in the 1530s, it only became popular in Holland during the latter half of the 17th century.

LAID PAPER
Until *c.*1750, the base or cover of all occidental paper moulds was a screen constructed from thin wire (first iron, then brass), and these parallel wires (the 'laid lines' from which paper made on this type of mould derives its name) were stretched across the frame at close, regular intervals. Wires which interlaced these at right angles and set further apart aare known as 'chain lines'.

WOVE PAPER
The mould on which this type of paper is formed has an upper surface constructed from a fine woven brass screen. It leaves in paper an indistinct impression, resembling the texture of fabric. Almost certainly invented by James Whatman Senior (1702–1759), the surface of wove paper is smoother than that of laid, enabling the artist to apply a more even wash.

WATERMARKS
Watermarks are designs of twisted wire stitched with thread-like wire on to the top surface of the laid and chain lines of the paper mould. The first watermark appears on an Italian-made paper of *c.*1282. Watermarks reproduced in this catalogue do not appear in Briquet, Churchill, or Heawood.

NATURAL CHALKS: BLACK
A species of carbonaceous shale, black chalk is an amorphous composition whose principal ingredients are carbon and clay. As in its red counterpart, the amount of clay in the composition determines its softness and fine texture. It is relatively permanent, but may be erased with difficulty. Black chalk became popular during the latter part of the 15th century and the early years of the 16th, and was extensively used until the 19th, when it was superseded by fabricated chalks or crayons, and pencils.

RED CHALK
The chromatic strength of red chalk is derived from iron oxide. In the form of hematite, iron oxide is diffused with clay, and is sufficiently soft for the purposes of drawing. Its colour may vary from a warm, blood-red to a cool hue comparable to Indian Red pigment. Natural red chalk became less used at the end of the 18th century, probably because the quality obtainable had deteriorated: inferior natural red chalk tends to be gritty.

WHITE CHALK
Natural white chalk is of two varieties: the first is carbonate of calcium, the second, soapstone or steatite. Carbonate of calcium was a source of whiting for painters' gesso: it varies in physical properties, but produces a soft and brilliant white stroke. Soapstone, also known as 'tailors' chalk', produces by comparison a bluish-white stroke, and was used principally in small scale drawings of the Renaissance as a heightening medium.

FABRICATED CHALK
Most of the dry pigments used by the artist may be employed to prepare fabricated chalks, whose range of colours is thus greater than natural chalks. All fabricated chalk must have a binding medium, of which the commonest are glue, gum arabic and plaster of Paris; after the pigment and medium has been mixed, the resulting chalk is formed into finger-length sticks and allowed to dry slowly and naturally. The use of fabricated chalk has been noted as early as the first half of the 16th century.

GRAPHITE
The natural form of pure, semi-crystalline carbon, graphite possesses a great range of light–dark tone value, and when applied heavily, a slightly metallic lustre. Mentioned as early as 1573, the lode which supplied Europe with graphite was discovered perhaps in the previous decade in Borrowdale, Cumbria. Inferior graphite was also mined from lodes in Germany, Holland and Spain.
Natural graphite was used either in a lump or stick, sharpened at the end and set into a *porte-crayon*. It was not widely employed by artists until the 17th century; in the 19th, the lode at Borrowdale was mined out, and natural graphite was supplanted by the pencil.

PENCIL
In the 18th century, an embargo was placed on the export of graphite from Borrowdale to Europe. Attempts to utilize inferior European graphite lead to the invention of the pencil. The graphite was crushed and purified, and the powder was either compressed, or mixed with binding medium and inserted into hollow wooden rods, normally of cedar. By 1800, the pencil was the standard instrument for drawing outside the studio.

BROWN INK
In this catalogue, BROWN INK signifies IRON-GALL INK. Its principal ingredients are galls – a growth of oak trees resulting from the sting of the gall-wasp – and ferrous sulphate. Initially a weak violet-grey colour, it forms a black precipitate soon after application, but turns brown in the course of time. An excess of the tanning agent produces excessive acidity and destroys the paper support.

CARBON BLACK INK
Carbon black ('Chinese' or so-called 'Indian') ink is prepared from carbon particles obtained from the soot deposited by burning oils, resins, and charcoal of wood, bones, etc., mixed with a binding medium and water. Its origins in China are obscure. Recipes for preparing this type of ink first appear in Europe in the 16th century, although carbon inks of Chinese manufacture were still regarded as being of the highest quality. These inks are produced in the form of compressed sticks which can be mixed with water on a slab at will. Waterproof carbon drawing inks contain shellac.

BISTRE
Bistre is made by extracting soluble tars from wood soot. Its colour may range from golden- to grey-brown, depending on the wood burned. Often difficult to distinguish from other brown inks, it frequently has a granular aspect to its surface. The colour of bistre may be altered by mixing with iron-gall ink or red chalks. Unlike iron-gall, bistre was not used as a writing ink.

WATERCOLOUR
In this catalogue, 'watercolour' is used to describe transparent washes. Watercolour may be made from any pigment ground in water and gum-arabic. In addition watercolours may also contain a plasticiser such as sugarwater or glycerin to keep the paint moist, and a preservative such as phenol.

BODYCOLOUR
Watercolour mixed with white pigment to make it opaque.

WHITE LEAD
A basic lead carbonate, white lead carries the risk of turning black with time. It was nevertheless favoured by artists for its fine texture, excellent covering power, and the ability to be extensively diluted while retaining an evenly dispersed tint.

HANS BOL
(1534–1593)

1 Landscape with the Fall of Phaëthon 1569

Pen and brown ink; brown ink and purple watercolour washes, with some drawing with the point of the brush; on cream-buff (stained) laid paper. The sheet unevenly trimmed at all sides, and enclosed by a later hand within a ruled framing line in pen and brown ink. A tear repaired, lower left side.

18.6 × 27.1 cm.

Signed in pen and brown ink, top left of centre: 'H Bol/1569' (the initials interlaced).

PROVENANCE: Sir Robert Witt (purchased from Parsons, no date); Witt Bequest 1952 (22)

EXHIBITIONS: R.A., 1927 (534); Berlin/Bochum, 1927–8; Antwerp, 1930 (362); Arts Council, 1953 (81); New Zealand, 1960 (53); Courtauld, 1977–8 (16).

LITERATURE: Franz, 1965, p. 37, fig. 52, signature No. 3.

The story of the Fall of Phaëthon is recounted by Ovid in *The Metamorphoses*, II, verses 49–380. The sun god, Phoebus, permitted his son Phaëthon to steer the solar chariot across the heavens for one day. Unable to control the horses, Phaëthon at first drove so high that the world shivered, and later so low that earth and cities were scorched and seas dried up. Angered by the resulting chaos, Jove shot Phaëthon from the sky with a thunderbolt: the body landed in the Eridanus, a river identified by many with the Po.[1]

Episodes of Ovid's narrative treating events both before and after Phaëthon's Fall are represented by Bol in the composition exhibited here. Landed fish and grounded boats signify the moment of the waters' evaporation. In the foreground, four[2] male nudes, identifiable as river deities, expire from the heat, while at the left, the goddess symbolising the earth, Tellus (whose attribute of a wheatsheaf, symbol of fecundity, is located behind her chariot) laments her suffering caused by Phaëthon's recklessness. Tellus is attached by a cord to a whale, an allusion perhaps to the indestructible bond between earth and water: from the final quarter of the sixteenth century the motif of the beached whale was also understood as a portent of ill fortune.[3] Phaëthon himself appears twice: in the background, careering low over the earth in the chariot, and in the middleground, falling from the skies. Jove is included at the upper centre of the sheet.

In the middle distance, right, are located two[4] of Phaëthon's sisters, the Heliades, whose grief at the news of their brother's death was so great that they became transformed into poplars or alders weeping tears of amber into the Eridanus: Bol represents them here at the moment of metamorphosis. To the left of the Heliades reclines a female figure identifiable as the sorrowing Clymene, Phaëthon's mother[5], while in front of her glides Cycnus, Phaëthon's cousin who was transformed into a swan after witnessing the metamorphosis of the Heliades.

One of ten extant compositions treating mythological subjects in Bol's drawn *œuvre*[6], the present sheet appears to have been conceived as a work of art in its own right. A suite of 30 engravings after the artist's designs for subjects from Ovid and the New Testament were, however, published by Philip Galle in either 1573 or later.[7]

The composition of the landscape visible here is a variant of that invented by Bol in 1567, displayed in its most extreme form in a drawing of *Cephalus and*

Procris dated in that year.[8] As in that drawing, the present landscape is divided into three planes governed by disparate perspective systems: the first comprises the foreground tract of raised earth on which sea gods, Tellus, and the whale are located; the second is formed by the *coulisse* of high rocks which closes the composition at the left. Juxtaposed with these and observed from an elevated vantage point is the third zone, a distant valley, whose form and structure first appear in an engraving by Bol published by Hieronymous Cock in 1562.[9] The transition between planes here, unlike that in *Cephalus and Procris*, is softened by the overlapping of motifs (e.g. the wheatsheaf and whale's tail linking foreground with middleground *coulisse*); by the alignment of contours of one plane with those of the plane adjacent (e.g. the rising mountain path, left, continuing the contours of the lower rock formation of the *coulisse*); and by the application in all areas of the composition of gradated washes and open, curling pen strokes of similar scale. Such pen work, originating in the agitated draughtsmanship of compositions of 1567,[10] also appears in the second sheet in Bol's work dated 1569 depicting Christ on the way to Emmaus,[11] in a variant of that subject of 1573,[12] and finally in a drawing dated 1579.[13]

Perhaps the dominant unifying factor in the Courtauld composition is the 'V'-shaped cloud formations, which echo the form of the valley landscape. Appearing first in a sheet of 1568,[14] this configuration of clouds suggests recession into deep space while providing a framing device within which persons or dramas of religious or mythological significance may be contained: in the present drawing, Phaëthon literally falls out of the enclosing clouds, while horses and overturned chariot remain rhythmically unified with them. Similar configurations of cloud appear in compositions treating the Sacrifice of Isaac of 1570[15] and 1573,[16] while in 1574 they are used in a second version of *The Fall of Phaëthon*[17], a variant of the composition in the upper area of the Courtauld sheet. The last drawing in Bol's work in which such cloud formations appear is *The City of Jerusalem with Christ as the Good Shepherd* of 1575 (see No. 2).

1 Cf entry in *Oxford Classical Dictionary*.
2 The fourth male nude is partly trimmed away at the extreme right of the sheet.
3 For a discussion of the symbolism of the stranded whale, see Timm.
4 Ovid mentions three Heliades: the third was probably trimmed from the extreme right of Bol's composition.
5 According to Graves, Vol. I, p. 156 (42.d) Clymene was Phaëthon's sister, and his mother was Rhode.
6 Franz, 1965, Nos. 37, 52, 59, 81, 86, 87, 95a, 111, 112, 144.
7 Hollstein, Vol. III, p. 52, Nos. 164–193.
8 Bibliothèque Royale Albert 1er, Brussels; Franz, 1965, No. 37.
9 Hollstein, Vol III, p. 50, No. 9.
10 e.g., Franz, 1965, Nos. 37, 38, 40.
11 Formerly Staatliche Museen, Berlin; Franz, 1965, No. 52a.
12 Hermitage, Leningrad; Franz, 1965, No. 68g.
13 Formerly Staatliche Museen, Berlin; Franz, 1965, No. 96.
14 Öffentliche Kunstsammlung, Basel; Franz, 1965, No. 44.
15 Formerly Staatliche Museen, Berlin; Franz, 1965, No. 53.
16 Uffizi, Florence; Franz, 1965, No. 83.
17 Hermitage, Leningrad; Franz, 1965, No. 95a.

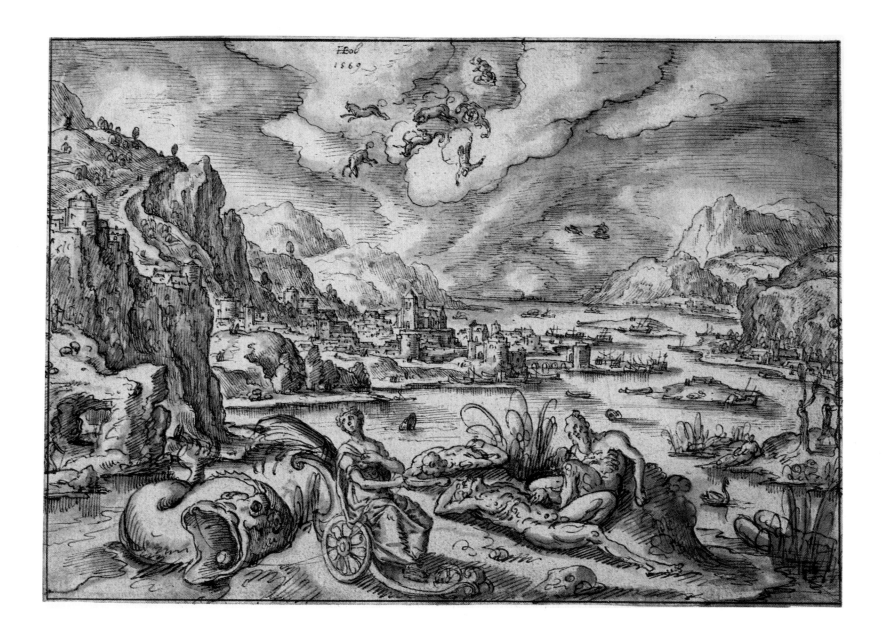

HANS BOL
(1534–1593)

2 The City of Jerusalem with Christ as the Good Shepherd 1575

Traces of preliminary drawing in black chalk, both freehand and ruled; brown ink and blue watercolour washes, with drawing with pen and the point of the brush; on off-white (discoloured) laid paper. The pictorial area enclosed within the artist's ruled lines in pen and light brown ink. The sheet unevenly trimmed at all sides, pressed through for engraving, *recto* and prepared with red chalk, *verso*.

Watermark: scrollwork, with letters 'B' and 'B' (?) below.

20.3 × 30.4 cm.

Signed in pen and brown ink, lower left: 'HANS BOL/1575'.

PROVENANCE: W. A. Baillie-Grohman, sold Sotherby, 14 May 1923 (lot 154, with Witt Nos. 1629, 1630) bt. Sir Robert Witt; Witt Bequest 1952 (1628).

EXHIBITIONS: Antwerp, 1930 (362); Manchester 1962 (36); Courtauld, 1977–8 (17); British Museum, 1983 (15).

LITERATURE: Franz, 1965, No. 97, pl. LXXXIII.

This drawing, signed and dated 1575, was engraved by Pieter van der Heyden (*c*.1530–after 1572) and published as an independent print in an undated edition.[1] A variant after it, including in the right background a writing apostle guided by an angel, was drawn by Maerten de Vos (1532–1603); engraved by Julius Goltzius (*c*.1550–1595), that design was subsequently published in Amsterdam by Claes Jansz. Visscher (1586–1652) in the *Theatrum biblicum Tabulis aenis expressum* of 1614,[2] with the addition of the Latin text of St Matthew, chapter 26, verses 32–34 (erroneously credited in the engraving to chapter 25, verse 33). That quotation has only superficial relevance to the print, and would not have inspired the drawing exhibited here.

For details of the appearance of the exterior of the City of Jerusalem (which lies four-square, enclosed by walls, each of which are pierced by three gateways of pearl) Bol faithfully adheres to the account given by the Book of Revelations, chapters 21 and 22.[3] The internal plan of the city, however, in which straight avenues intersect at right angles, with at the centre (which is also the centre of the composition), a circular mound, is reminiscent of the plan of the garden in the Elder Pieter Bruegel's drawing of *Spring* of 1565, now in Vienna.[4] Bol would have been familiar with that work, since in 1570 it was engraved by van der Heyden[5] as one of a suite for *Four Seasons* to which Bol himself had contributed designs for *Autumn* and *Winter*[6] in a style compatible with that of the older master. The Bruegel-inspired garden plan first appears in a drawing by Bol of 1573, and was to be employed in a design from a suite illustrating the Four Seasons drawn in or before 1580.

The perspective of the City of Jerusalem suggests, at first sight, a dependence upon a single vanishing point located at the upper centre of the sheet, although closer inspection confirms that the orthogonals emanate from a series of points grouped, appropriately, around the Head of God. The perspectives of the cityscape do not govern the surrounding landscape, yet a degree of unity between architecture and countryside is established by the straight course of the River of Life, which bisects both laterally.

The background motifs of winding river and *coulisses* of flat-topped hill or rock formations are comparable to those which appear in Bol's drawing of an extensive valley landscape, also dated 1575, in Brussels.[9]

The subject of the new Jerusalem is combined in this composition with the theme of Christ as the Good Shepherd, taken from the Gospel of St John, Chapter 10, verse 11. In pose and treatment, the Christ figure betrays Bol's debt to the Italianate Mannerist draughtsmanship of Maerten de Vos.[10]

1 Hollstein, vol. III, p. 52, No. 203.
2 Not catalogued in Hollstein. A copy of the print from the 1674 edition is in the Witt print coll.
3 Chapter 21, verses 12, 13, 16, 231, and chapter 22, verses 1, 2.
4 Münz, No. 151. The design for *Summer* is in the Kunsthalle, Hamburg (Münz, No. 152).
5 Lebeer, 1969, No. 77.
6 Hollstein, vol. III, p. 52, Nos. 201, 202.
7 Formerly Staatliche Museen, Berlin; Franz, 1965, No. 73.
8 Hermitage, Leningrad: Franz, 1965, No. 101a.
9 Bibliothèque Royale Albert 1er, Brussels; Franz, 1965, No. 95.
10 Compare for example the figure draughtsmanship in de Vos' drawings in the Courtauld Institute Galleries, Witt Nos. 98, 570, 2257.

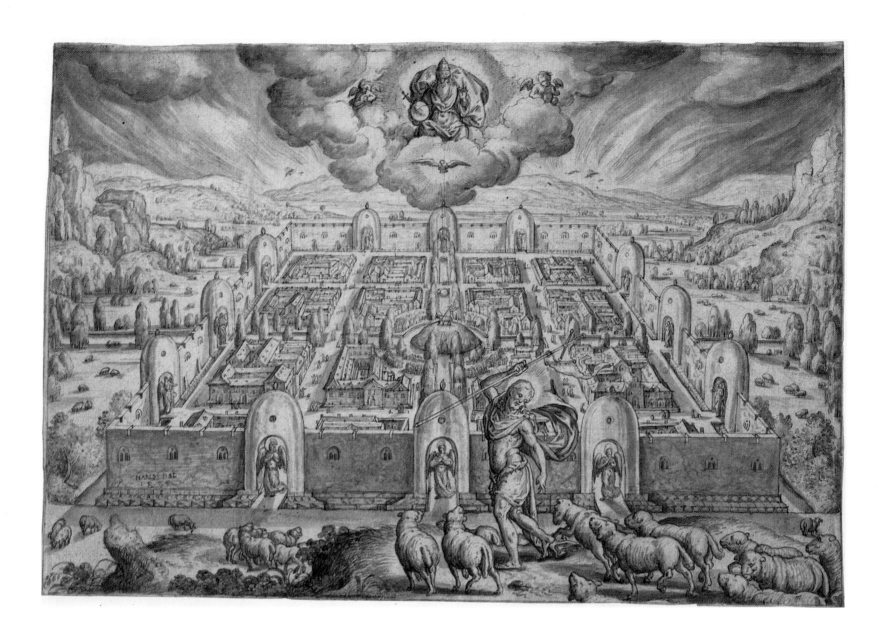

HANS BOL
(1534–1593)

3 The False Shepherds 1576

Traces of slight preliminary drawing in black chalk, restricted to the sheepfold and foreground figures; pen and pale brown ink; brown ink and blue watercolour washes, with drawing with the pen and the point of the brush; on off-white (stained) laid paper. The pictorial area enclosed within the artist's ruled line in pen and pale brown ink, the sheet unevenly trimmed at all sides. Pressed through for engraving, and prepared with red chalk to the height of the sheepfold roof, *verso*.

20.5 × 30.5 cm.

Inscribed in graphite, bottom right: 'H.BOL'.
Inscribed by the artist in pen and brown ink, *verso* (now partly effaced and illegible), and dated: '…anno 1576', and numbered: '12'.

PROVENANCE: W. A. Baillie-Grohman, sold Sotherby, 14 May 1923 (lot 154, with Witt Nos. 1628, 1629) bt. Sir Robert Witt; Witt Bequest 1952 (1630).

EXHIBITIONS: R.A., 1927 (538); Berlin/Bochum, 1927–28; Manchester, 1965 (270); British Museum, 1983 (14).

LITERATURE: Franz, 1965, pp. 45, 62, fig. 98.

The drawing relates to Philip Galle's engraving, dated 1565, after a lost design by Pieter Bruegel the Elder for the *Parable of the Good Shepherd*.[1] In that work, Christ, impassive amid the violence of the false shepherds' raid, stands at the doorway to the sheepfold. The fold ocupies almost the entire pictorial area, with the exception of the upper corners, into which are introduced contrasting scenes, located within shallow pictorial space, of the secular shepherd who defends his sheep against the wolf, and he who abandons them. The archaic image of Christ is juxtaposed with representations of contemporary false shepherds, while Bruegel adheres to medieval convention in the simultaneous depiction of disparate narrative episodes.[2]

Bol's composition relocates the sheepfold – a smaller structure than that in Bruegel's work, and represented in reverse – on the raised foreground of a panoramic landscape. Constructed around the zig-zag course of a river, the background vista is closed off at either side by flat-topped hills, comparable to those which in the far distance create a level horizon line which is punctuated only by the vertical accents of trees and sheepfold's gable. Landscapes structured in this manner first apear in Bol's drawings of 1575,[3] and are employed in the background of sheets datable to *c*.1580, illustrating the Four Seasons, now in Leningrad.[4]

Figure motifs in this composition are closely dependent upon those invented by Bruegel. The plump, hooded shepherds derive from a figure at the left of the older master's design, who similarly steals a sheep from the fold through a hole in the side wall; the raider on the roof here is posed in reverse to his counterpart at the right of the print; while the figure with claw-hammer who climbs the ladder presents a synthesis of shepherds on both the left and right of Bruegel's composition.

By eliminating the more grotesque shepherd types, the contrasting figure of Christ, and the quotation from the 10th chapter of St John[5] prominently inscribed on the print after Bruegel, Bol diffuses the grim didacticism of that work, creating from its narrative a contemporary genre scene set naturalistically within a panoramic landscape. The dependence on Bruegel's motifs of figures and sheepfold, even more evident when the design is reversed through translation into the medium of engraving, may have been deliberately exploited by Bol in order to display, by contrast, his own invention of a modern landscape which challenges the vestigial country scenes included in the senior artist's design. Motifs incorporated in the present background nevertheless refer to those found in another landscape by Bruegel: for that master's design of 1565 for *Spring*, with which Bol was familiar,[6] includes a sheep-shearing scene to which that on the left of this drawing is indebted.

Franz[7] erroneously regards the drawing exhibited here as the pendant to No. 2, and has therefore assigned to it the date on that sheet, i.e. 1575: the date on the *verso* of this drawing, however, indicates that it was created in the following year. The true pendant of *The False Shepherds*, a drawing in which the good shepherds repair the damaged fold, was also formerly in the collections of Baillie-Grohman and Sir Robert Witt, and was exhibited with the present work in London in 1927.[8] Both served as designs for engravings by Jan Sadeler (1550–1600), published in an undated edition.[9] Variants drawn after the prints by Maerten de Vos and engraved by Julius Goltzius were published in 1614 in Visscher's *Theatrum biblicum*.[10]

1 Lebeer, 1969, No. 59.
2 Lebeer, *ibid*.
3 Bibliothèque Royale Albert 1^{er}, Brussels: Franz, 1965, No. 95. See also cat. No. 2.
4 Hermitage: Franz, 1965, Nos. 101 a–d.
5 'EGO SVUM OSTIUM OVIUM'.
6 Münz, No. 151. See also cat. No. 2.
7 *ibid*.
8 R.A., 1927 (535).
9 Hollstein, vol. II, p. 54, Nos. 227, 228.
10 Not catalogued in Hollstein. A copy of the print from the 1674 edition is in the Witt print coll.

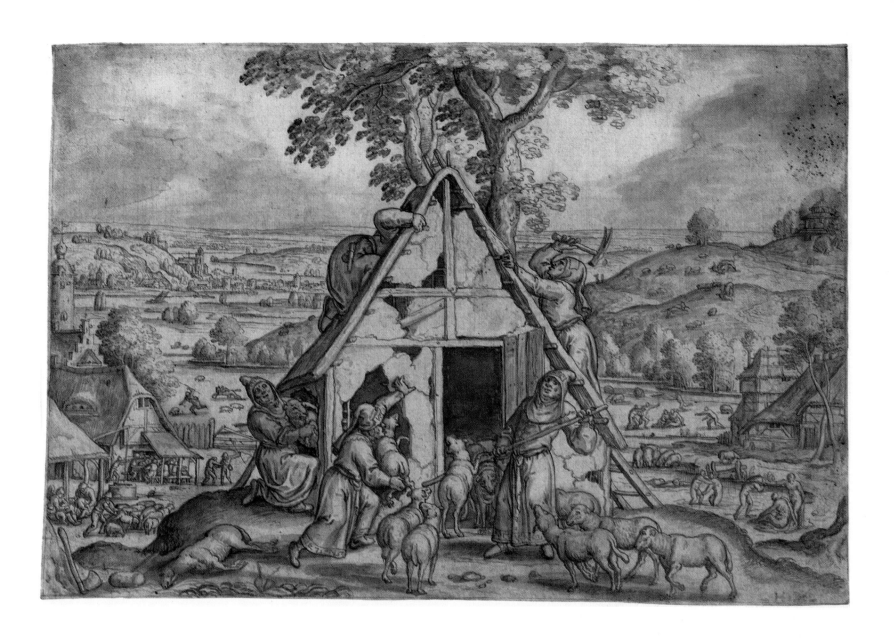

PAUL BRIL
(1554–1626)

4 Rocky Landscape with Waterfall and Castle
1607

Traces of preliminary drawing in graphite (underlying principally the left and right foreground); pen and brown ink, apparently mixed with some ochre bodycolour in the tree, foreground; on pale cream (now stained and discoloured) laid paper. The sheet repaired left, and upper and lower right, and unevenly trimmed at all sides. Laid down on Japanese tissue.

20.3 × 27.4 cm.

Signed and dated in pen and brown ink, bottom centre: 'Pauuelse bril 1607', and inscribed by the artist, right: 'Roma' (now partly trimmed away).

Stamped with collector's mark Lugt 474,[1] and that of Sir Thomas Lawrence (Lugt 2445), recto.

PROVENANCE: Collection unknown (Lugt 474); Sir Thomas Lawrence; Sir Robert Witt (purchased from Williams & Sutch, no date); Witt Bequest 1952 (1030).

EXHIBITIONS: R.A., 1927 (541); Berlin/Bochum, 1927–28; Arts Council, 1953 (82); New Zealand, 1960 (54); Manchester, 1962 (37); Australia, 1968 (48); Courtauld, 1977–78 (22); British Museum, 1983 (16).

LITERATURE: Baer, pp. 49, 97; Faggin, p. 23, pl. 126.

The drawing exhibited here, like other landscapes by Paul Bril, is a work primarily from the imagination rather than after nature.[2] Its date of 1607 helps document Bril's change in style, brought about principally by the impact of Annibale Carracci's (1560–1609) work, away from late-Mannerist compositions to those of a more rigorously constructed, 'classical' type. A typically Mannerist composition by Bril, and perhaps the last of its kind to be executed by the artist, is the painting of the Campo Vaccino, dated 1600:[3] here the scene is observed from an elevated vantage point, and discrete landscape elements are arranged in a series of interlocking diagonals, illuminated by random, flickering patches of multi-directional light. In the works of 1602–09[4] Bril adopted a progressively lower viewpoint and larger, more clearly defined and more evenly balanced compositional elements. The work of Domenico Campagnola (1528–92) and particularly that of Girolamo Muziano (1528–92) were an important influence at this stage in the artist's career. Bril probably met Muziano while working with his brother Matthijs (1550–84) at the Vatican, shortly after his arrival in Rome,[5] and may have known the Italian artist's numerous drawings: he would certainly have been familiar with Cornelis Cort's masterly and much-prized suite of engravings after Muziano's designs of Saints in landscape settings (see cat. no. 36).[6] The detailed and complex forms of towering rocks and exposed tree roots, lucidly rendered by meticulous hatching, which characterise Muziano's drawings and Cort's engravings after them are also adopted by Bril in the present design. Unlike Muziano, however, Bril displays a concern to render the effects of clear southern light by emphasising the contrast of areas of hatching in dark ink with blank white paper. Faggin[7] suggests that the style of the present drawing is also indebted to the work of Adam Elsheimer (1578–1610), with whom Bril was by this time closely associated.[8] While it is probable that Bril, the older artist, both exerted an influence upon, and was influenced by, this German artist, the lack of dated works in Elsheimer's œuvre renders it impossible, as Blankert[9] observes, to determine which of the two artists was first to employ a particular compositional device or motif at any one time.

1 Thought by Lugt to be Crozat's mark, but perhaps that of an earlier collector (cf. exh. cat. Manchester, 1962).
2 That this work is a studio invention appears to be signified by the inscription 'Roma'.
3 Private coll., Rome; Bodart, pp. 227–28, fig. 108.
4 A drawing in the Uffizi, Florence, dated 1602 (exh. cat. Utrecht, 1965, fig. 177) employs the new, dramatically lower viewpoint.
5 Bodart, p. 236.
6 Bierens de Haan, Nos. 80, 83, 113–19, 135.
7 ibid.
8 Andrews, p. 22, notes that in 1606 Bril was a witness at Elsheimer's wedding.
9 In exh. cat. Utrecht, 1965, p. 15. Bril owned Elsheimer's paintings The Three Marys at the Cross (c.1603) and The Stoning of St Stephen (Andrews, Nos. 13, 15, respectively). The only dated works by Elsheimer are the drawings A Painter presented to Mercury (Brunswick), and Neptune and Triton (Dresden) (Andrews, nos. 30, 32, respectively).

PAUL BRIL
(1554–1626)

5 Landscape with a Tree c.1613–14

Extensive preliminary drawing in graphite; pen and brown inks (a grey-brown underlying areas of the tree and figures, right; a red-brown for the rest of the drawing); on pale buff laid paper. A freehand vertical in graphite, right, apparently indicates the extent of the initial pictorial area. The sheet edged with ruled lines in black ink washes by a later hand, and unevenly trimmed at all sides.

18.6 × 16.6 cm.

Signed in pen and brown ink, bottom centre: 'P.Bril'.

Inscribed in pencil, *verso*: 'F S' (?) and in a modern hand: 'BRIL'. Numbered in red chalk: '10', and by Sir Robert Witt in pencil: '676'.

PROVENANCE: Sir Robert Witt (purchased from Parsons, no date); Witt Bequest 1952 (676).

EXHIBITIONS: Berlin/Bochum, 1927–28; Courtauld, 1972 (1); Courtauld, 1977–78 (21).

LITERATURE: Baer, p. 56 and note 82.

This signed[1] drawing, dated by Baer to the middle of the second decade of the seventeenth century, displays certain affinities of style with such drawings of 1615 as the *Landscape with Christ at Supper with the Pilgrims to Emmaus* in the Louvre.[2] Both designs include tree forms whose compact, rounded foliage clusters are indebted to the work of Adam Elsheimer (1578–1610), while in each sheet the artist bands together large areas of shadow by means of horizontal striations, thereby enhancing the stateliness and stability of the compositions. Striations in the present drawing, unlike those in the Louvre's work, are not reinforced by broad glides of carbon ink wash, a technique learned from the work of Jacques Callot (1592–1635) which begins to appear in Bril's drawings of 1615. The Courtauld drawing may therefore be assigned the slightly earlier date of c.1613–14. When the drawing of 1615 is compared to a sheet dated in the following year, also in the Louvre,[3] the rapidity with which Bril adopted and modified Callot's manner may be appreciated.

A similar composition of an oak located at the centre foreground of a vertical sheet, comparable in handling to the drawing exhibited here, is in Munich,[4] while a related work was sold at Sotheby in 1965.[5]

A replica of the Courtauld composition is in Mdina, Malta:[6] unsigned and in poor condition,[7] it is now difficult to ascribe to Bril with any certainty, although the artist is known to have made copies of both his paintings and drawings.[8] Baer sees in this sheet a greater schematisation of forms than in the Courtauld composition, but his suggestion[9] that it is a copy by Pieter Stevens (1567–after 1624) cannot be supported. Stevens may have been in Rome during 1591–92, but as early as 1594 was probably in Prague, where he remained until 1624. It is unlikely, therefore, that he would have been familiar with the present example of Bril's mature manner of draughtsmanship.

locating the work is gratefully acknowledged.

8 As early as 1600 Bril was making replicas of his paintings (cf. Bodart, p. 639), while a replica of a drawing in the Louvre (Lugt, 1949, No. 406) is in the Plantin-Moretus Museum, Antwerp (Delen, 1938, No. 124).

9 *ibid.*

1 Baer, *ibid.*, regards the signature as authentic.
2 Lugt, 1949, No. 418.
3 Lugt, 1949, No. 420.
4 Staatliche Graphische Sammlung; Wegner/München, No. 14.
5 27 May 1965 (lot 30), as from an English private collection.
6 Baer, p. 56, fn. 82; Malta, No. 314.
7 The sheet is at present undergoing restoration in London: Canon John Azzopardi's help in

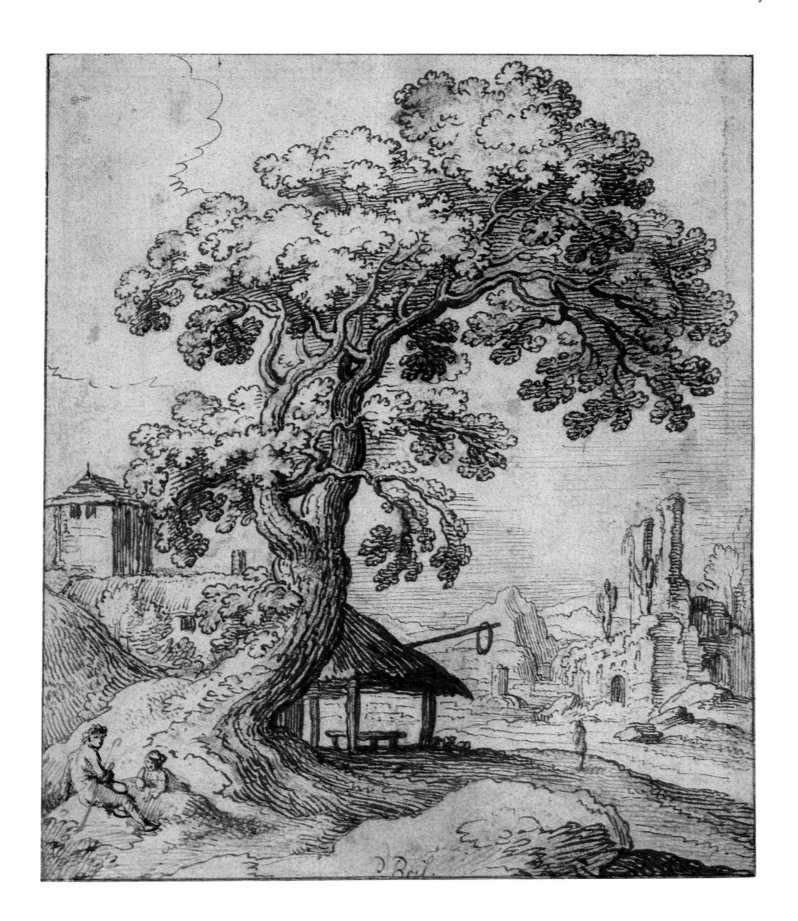

JAN BRUEGHEL THE YOUNGER
(1601–1678)

6 Panoramic Landscape 1619

Slight preliminary drawing in graphite (largely underlying the right of the sheet); pen and brown ink washes; on buff (stained) laid paper. The pictorial area enclosed within the artist's ruled line in pen and brown ink. The sheet folded vertically four times, and unevenly trimmed at all sides. Tears repaired, top right of centre and left.

Sheet: 14 × 18.1 cm.

Pictorial area: 12.0 × 17.7 cm.

Signed in pen and brown ink, below the pictorial area, centre: 'Johan·breŭ-gel·1619·'.

Inscribed in pencil, *verso:* 'P T N'.

Stamped with the collector's mark of Prince W. Argoutinsky-Dolgoroukoff (Lugt supp. 2602d), *recto.*

PROVENANCE: W. Argoutinsky-Dolgoroukoff, sold Sotheby, 4 July 1923 (lot 57), bt. Sir Robert Witt; Witt Bequest 1952 (1647).

EXHIBITIONS: Berlin/Bochum, 1927–28; Arts Council, 1953 (83); New Zealand, 1960 (55); Australia 1968 (50); Courtauld, 1977–78 (31).

LITERATURE: Winner, p. 225, pl. 35; Gerzi, p. 119.

Drawings by Jan Brueghel I (1568–1625), those by his son, Jan II, and by other followers have in the past been confused, although during the last 20 years work has been undertaken to differentiate between the various artists' hands.[1] The sheet exhibited here was purchased by Sir Robert Witt as an example of the late manner of Jan Brueghel I, to whom, as Winner[2] has convincingly demonstrated, it is no longer attributable.

Below the small pictorial area, here enclosed by ruled lines, a signature and date is inscribed. Sheets in Berlin,[3] Paris[4] and Stuttgart[5] display similar framed compositional areas, also signed and dated below by the neat and regular hand which appears on the Courtauld work. Since the Berlin and Paris drawings, views of landscape in the outskirts of Milan,[6] bear the date 1626 (i.e. one year after the death of Jan Brueghel I) they must be by the hand of the son. Jan II, however, had returned to Antwerp from Italy on 12 August 1625,[7] and the date on the north Italian landscapes thus signifies that they were in some manner completed (or perhaps merely inscribed) in Flanders. The possibility that these drawings are indeed from the hand of the Elder Jan Brueghel, annotated by Jan II on taking over his father's studio, may be discounted when their style is compared to that displayed in drawings securely attributed to the elder artist.[8]

The Courtauld composition, created when Jan II was eighteen, employs a distinctive tree type (visible at the left and right of the path) which recurs in the Italian landscapes: a curving trunk of uniform slenderness supports a tall crown of foliage of either fan or bud shape, constructed from leaf masses disposed equally at either side of the principal branches. Contours of foliage are rendered by loops or tight curling strokes of similar small scale, while dots or flecks suggest the perspective and grouping of leaves within the clusters. Modelling is indicated by short and regular hooks, or, to suggest larger planes of foliage masses, by broad areas of wash which are frequently brushed over the boundaries of forms. Often a single tone of wash is applied over a crown (e.g. that at the right of this drawing) reducing the tree to a silhouette. This flattening of forms becomes more pronounced in the landscapes of 1626, where the two-dimensionality of trees is now stressed by eliminating the dotted internal modelling in favour of parallel hatching sustained over the entire foliage.

In those works, a regularised, linear and somewhat arid draughtsmanship influenced by Remigio Cantagallina (*c.*1582–1635) is evolved, and the artist draws on sheets of a larger scale than that exhibited here.[9] The Courtauld sheet is related by format to the topographical studies drawn by the Younger Jan Brueghel in Nuremberg in 1616,[10] while the style employed in those works can be seen to have matured here. The fresh, open and lively penwork which explores a range of dots, curves and hatchings (indebted ultimately to the manner of Pieter Bruegel the Elder) is strongly reminiscent of that employed in detailed drawings created by the Elder Jan Brueghel in the 1590s; yet the handling displayed here lacks that artist's power or certainty of touch. The present composition may also have been inspired by those of the father's Alpine landscapes, and is closely comparable to a drawing dated 1596 in Rotterdam.[11]

A drawing in Vienna,[12] convincingly reattributed by Gerzi[13] to the Younger Jan Brueghel, reverses the pictorial structure of the Courtauld drawing, and may have been conceived as a pendant to it. A copy after the work exhibited here, incorporating into the foreground additional staffage and spruce trees, is in the British Museum:[14] it is probably a forgery, since it bears a 'signature' in a hand other than that of the artist, and an inscription suggesting that it was created in Nuremberg in either 1616 or 1617.

1 e.g. H. G. Franz, *Niederländische Landschaftsmalerei im Zeitalter des Manierismus* (Graz, 1963); Gerzi, *op. cit.*; Winner, *op. cit.*

2 *ibid.* Biographical details of the Elder and Younger Jan Brueghel are included in Winner.

3 Staatliche Museen; Bock/Rosenberg, p. 100, No. 761.

4 Institut Néerlandais, Fondation Custodia (Lugt coll.); exh. London/Paris/Berne/Brussels, 1972 (18). In exh. cat. Brussels, 1980 (177, 178), the drawing in Paris is reproduced with the entry for the work in Berlin, and vice versa.

5 Staatsgalerie, Inv. No. C.1964–1346.

6 The drawing in Berlin depicts the village of Pernate, that in Paris probably Cittero, while the Stuttgart sheet, also an Italian view, is inscribed: 'palasso del principe dolando a zurbick'.

7 Denucé, pp. 139–40, quotes from the Younger Jan Brueghel's diaries.

8 e.g. Institut Néerlandais, Fondation Custodia (Lugt coll.), Paris, Inv. No. 6618, signed and dated 1595. Albertina, Vienna; exh. Brussels, 1980 (165). Yale University, New Haven; exh. Brussels, 1980 (162).

9 e.g. the Berlin sheet measures 21.5 × 31.6 cm., that in Paris, 20.6 × 30.6 cm., and that in Stuttgart, 20.2 × 29.8 cm.

10 A drawing in the Rijksmuseum, Amsterdam, inv. A 1908 (with trimmed margins), measures 11.5 × 18.1 cm. (compare the pictorial area of the Courtauld sheet). A sheet in the Öffentliche Kunstsammlungen, Basle, inv. no. U.16–65, measures 12 × 18 cm. (cf. exh. cat. London/Paris/Berne/Brussels, 1972 (17, fn. 6). A sheet in the Institut Néerlandais, Fondation Custodia (Lugt coll.), Paris, Inv. No. 8598 measures 14.1 × 17.8 cm.

11 Boymans–van Beuningen Museum; exh. Berlin, 1975 (114).

12 Albertina; Benesch, No. 277, attributed to J. Savery.

13 *ibid.*

14 Formerly in the Fenwick coll. and attributed to Jan Brueghel I; Popham, 1935, p. 178, No. 1.

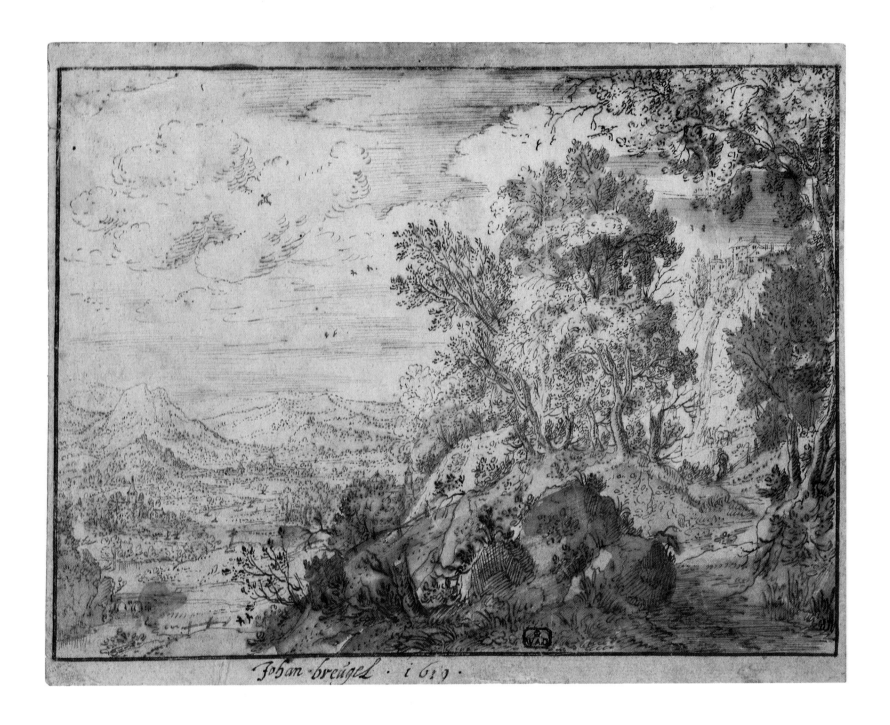

Johan breugel · 1619 ·

PIETER BRUEGEL the ELDER
(1525?–1569)

7 Kermesse at Hoboken

Traces of preliminary drawing in black chalk pen and brown ink; on pale buff laid paper. The sheet adbraded in the area of the ring of dancers, the most distant figures of which retouched in black chalk. Unevenly trimmed at all sides, apparently to a ruled line in graphite (partly visible top and bottom). Vertical and horizontal folds, centre. Pressed through for engraving, with vestiges of preparation with black chalk, *verso*.

Watermark: crossed arrows.

26.5 × 39.4 cm.

Signed and dated in pen and brown ink, lower left: '1559/BRVEGEL', and inscribed by the artist on the banner, left: 'Gilde /.../ hoboken /.../.../...'

PROVENANCE: Sir Kenneth Mackenzie, Bt. of Gairloch, sold Sotheby, 15–16 February 1921, (lot 216); Henry Oppenheimer, sold Christie, 10–14 July 1936 (lot 223) with Matthiesent; with the Slatter Gallery from whom purchased by Lord Lee of Fareham[1], 1944, Lee Bequest, 1957.

LITERATURE: Vasari Society, 2nd Series, Part II, 1921, No. 12; Tolnai, p. 73; de Tolnay, 1935, p. 91; Lebeer, 1949, p. 99ff.; Glück, p. 109ff.; de Tolnay, 1952, p. 91, No. A20; Münz, p. 228, No. 141; Lebeer, 1969, p. 90, No. 30; Marlier, pp. 213–217; Monballieu, p. 153; Gibson, p. 159; Briels, p. 40.

EXHIBITIONS: British Empire Exhibition, 1925; Slatter Gallery, 1943–4 (45); Manchester, 1965 (280); Nottingham, 1966; Berlin, 1975 (68); Brussels, 1980 (36).

The attribution of this drawing to Bruegel has been doubted by certain authors without convincing arguments: Tolnai[2] rejected it from the master's *œuvre*, while Lebeer[3] suggested that it is a copy by the engraver Frans Hogenburg (before 1540–1590) after a lost design by Bruegel. Lebeer's theory is unacceptable when the handling of the compositional elements in the drawing is compared to that of Hogenburg's signed print, which follows this design with certain alterations.[4] If Hogenburg himself had been the author of the present work, it is unlikely that he would have deviated from its design when executing the print. The spectator visible in the drawing at the right of the church door, for example, and the praying figure to the left of the banner-carriers at the end of the procession[5], also the pigs and poultry at the upper left, are not included in the engraving. Instead, a cross has been added at the head of the procession, while those figures filing through the church door or seated at the windows of the tavern, left, have been simplified and crudely redrawn. A possible clue to such deviations from the original composition is provided by the character of the indentations with the stylus which follow the drawing's contours, and whose function is to transfer the design on to the etching plate. On this sheet, the indentations are almost imperceptible, which may suggest that many details of the composition were inadequately registered on the copper. The publisher de Momper's standards were obviously less rigorous than those of Hieronymous Cock, under whose supervision the majority of Bruegel's designs were engraved without error.

It has been stated above that this drawing has been trimmed: when compared to Hogenburg's engraving, it can be seen to have been cut slightly at the right and left, and by a significant amount at the top.

Hoboken, a village to the east of Antwerp, was visited principally by those city-dwellers eager to avail themselves of the cheap beer sold there. The village held three annual feast-days, and that represented here may be the Kermesse of Whit Monday, at which archers, a group of whom are prominently located at the left of this composition, celebrated the festival of their Guild[6]. In 1559, the date inscribed on this drawing, Hoboken was purchased from Willem of Orange by Melchior Schetz: Monballieu[7], therefore, regards the composition as Bruegel's plea to the new landlord of the village for tolerance towards those whose celebrations during Kermesses led to excess. A broader interpretation, however, is suggested by the rhyming couplets added below the engraving, which may be loosely translated as: 'The peasants rejoice at such festivals. They must hold Kermesse even if they make themselves poor to do so, and then die from over-indulgence'.[8]

Renger[9] has noted similarities between the drinker here seated on the carthorse – who energetically drains the pitcher of ale in order to begin the fresh one offered to him – with Gula, the personification of Gluttony, who appears in an engraving of that subject after an earlier design by Bruegel[10]. In that work, Gula's attribute is the pig: he is seated on one and served by one. The pigs located in the foreground of the present composition may also have a similar symbolic significance. Allied with the vice of Gluttony were the sins of Stupefaction and Stultification, both of which were represented during the sixteenth century by infantile games, or more obliquely, by the toys employed in them[11]. Such sins may be represented by the marble-playing boys and the professional fool, figures linked here with the image of Gluttony not only symbolically, but also formally through the positioning of the foreground pig. However, moral judgments are not made explicit in the drawing, the imagery of which appears intentionally ambiguous, and the composition may be enjoyed simply as a village landscape peopled by peasant revellers.

This drawing, the first representation of the Kermesse subject in Bruegel's *œuvre*[12], shares many formal characteristics with an engraving of the *Kermesse of St George*, dated by Lebeer to 1561[13]. In both works, motifs are distributed over the sheet apparently at random, although closer examination reveals that they are grouped in patterns of intersecting diagonals and contrasting circles which are repeated in all areas of the composition. The angle formed by the shafts of foreground carts, for example, is taken up in the gables of the buildings, and restated in the contrasting lines of the church procession and the spectators and amorous couples to its right: variants of the circle of the cart wheels appear in the waggons' canopies, the ring of dancer, and in the wall surrounding the church. There appears to be no Flemish precursor for Bruegel's depiction of the Kermesse scene, although the subject, conceived in a different manner, was engraved by Pieter van den Borcht IV (1545–1572) and published by Bartolomeus de Momper also in 1559[14]. An engraving of a Kermesse of 1539 by the German, Hans Sebald Beham (1500–1550)[15] does, however, share compositional similarities with the present design and may have served as its inspiration.

1 The purchase from Slatter's is confirmed by a letter from E. Slatter to Lord Lee of 22 April 1944 (Lee file, Courtauld Institute Galleries).
2 ibid.
3 Lebeer, 1949 and 1969, *loc. cit.*
4 Lebeer, 1969, No. 30.
5 Monballieu, p. 145, was the first to list these alterations.
6 Monballieu, pp. 142–144.
7 ibid.
8 'Die boeren verblijen hun in sulken feesten Te dansen springhen en droncken-drinken als beesten./Sij moeten die kermissen onderhouwen Als souwen sij vasten en sterven van kauwen.'
9 exh. cat. Berlin, 1975 (68).
10 Engraved by P. van der Heyden, published by H. Cock, 1558; Lebeer, 1969, No. 22.
11 Renger, in exh. cat. Berlin, 1975 (68).
12 Gibson, *loc. cit.*
13 Lebeer, 1969, No. 52.
14 Hollstein, Vol. III, p. 104, No. 467.
15 Hollstein/German, p. 255.

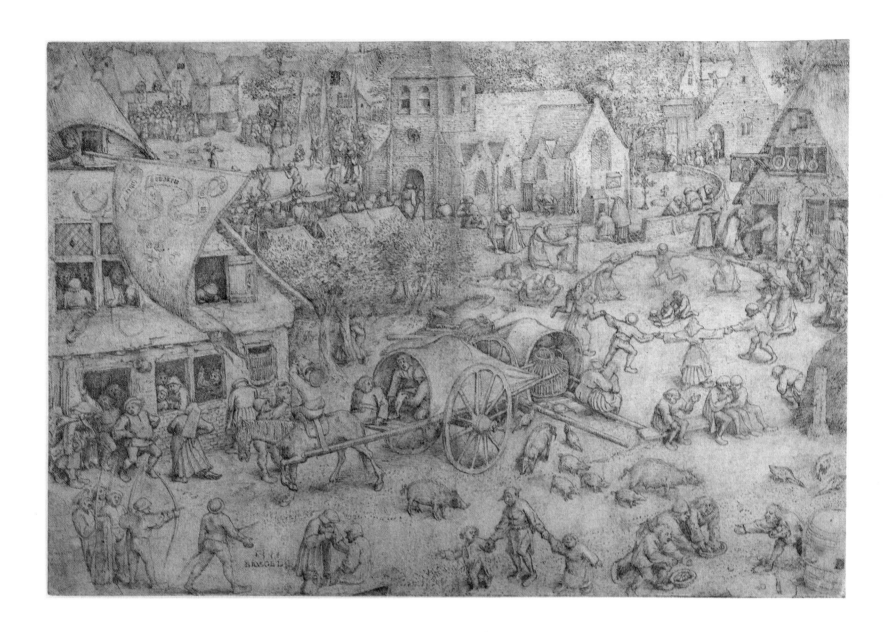

GILLIS VAN CONINXLOO III
(1544–1607)

8 Wood Landscape c.1598–1600

Pen and brown ink; brown ink wash, and grey, blue, green and purple watercolour wash, with extensive drawing with the point of the brush and some drawing with the pen; on pale buff laid paper. The sheet edged by ruled lines in grey (carbon) ink or watercolour wash and dark brown ink, and unevenly trimmed at all sides. Two vertical folds, left of centre.

25.9 × 25.7 cm.

Inscribed in pen and grey (carbon) ink or watercolour wash, bottom right: 'C.', and in pen and brown ink, verso: 'D'.

Inscribed with the collector's mark of William Esdaile (Lugt 2617), recto.

PROVENANCE: W. Esdaile; Sir Robert Witt (purchased from Sotheby, no date); Witt Bequest 1952 (2740).

EXHIBITION: Courtauld, 1977–78 (25).

Born in Antwerp, Coninxloo studied under Lenaert Kroes[1] and Gillis Mostaert (?–1598) prior to travelling to France. By 1570, he had returned to Antwerp, where he was enrolled in the Guild of St. Luke. In 1585 the artist left his native city to escape religious persecution, travelling first to Zeeland and later to Frankenthal (near Mannheim in the Palatinate) where he remained from 1587 to 1595. In 1596 he arrived in Amsterdam, where he spent the rest of his life.

Coninxloo's œuvre may be divided into three periods coinciding with his movements in Europe.[2] During the first, up to 1585, his landscapes were largely imaginary, but towards the end of his exile in Frankenthal he became absorbed by a closer study of nature, and particularly of trees. Stechow has suggested[3] that Cort's engravings after Muziano and Titian may have aided the artist at this time, while Frans has noted[4] the significance for Coninxloo of the later landscapes of Hans Bol. New elements which Coninxloo introduced into his compositions of c.1590 reflect those in the slightly earlier work of that artist. Trees which were formerly placed at the edges of the composition are now moved to the centre and closer to the spectator, so that crowns of foliage are cropped by the edges of the picture: the earth's undulations become more pronounced, the horizon-line is lowered and the narrative importance of staffage diminished. It is the work from this and the later Amsterdam period which, as Stechow observed,[5] was to have such a great impact on the development of seventeenth-century Dutch forest painting.

Although a number of reliably signed and dated paintings are extant from Coninxloo's Amsterdam years, there appear to be no signed drawings from any period of his career: the problem of attributing drawings to the artist is complicated by the number of copies or imitations by pupils and followers.[6] The drawing exhibited here, however, may with a degree of confidence be assigned to Coninxloo.[7] While more highly worked and arguably later than drawings in Munich catalogued by Wegner as from the master's hand,[8] the present sheet shares with those works a characteristically nervous handling, in which vertical hatching with a fine, almost scratchy pen is employed to describe shadows and model the irregularities of the earth's structure. A vigorous combination of multi-directional banding and hooked strokes indicates volume, texture and direction of growth of trunks and principal limbs of trees, while ragged, looped and scalloped contours delineate leaf clusters.

In this drawing, a dominant group of trees located off-centre is flanked by two recesses: that at the left is closed off by a foreground framing tree, counterbalancing the open view at the right. In the general disposition of tree groups and contrast between deep and shallow recesses the Courtauld composition is reminiscent of that of a signed painting dated 1598 in Vaduz.[9] In that work, however, each clearing is framed at the lateral edge of the composition by trees. The present drawing is also closely related through format, pictorial structure and motifs to a painting dated 1600 in Graz,[10] the composition of which is a reversed variant of that stated here. That painting, for example, includes at the left an open view of architecture equivalent to that which appears here at the right, and which is similarly located at the highest point of the landscape. While the view of architecture is more prominent in the Graz work than in this drawing, it is nevertheless similarly subordinate to the recess created by the perspective of the pathway, the vanishing point of which, in both works, is masked. Unlike the drawing, however, the painting in Graz establishes a greater spatial coherence between main and subsidiary clearings by reducing the dominance of the dividing tree cluster, creating smoother transitions between ground levels, and by introducing motifs of huntsmen and dogs in a cross formation over fore- and middleground. Since the Courtauld drawing states compositional properties of the Vaduz painting of 1598, yet includes others for which more elegant solutions are found in the Graz picture of 1600, it may be assigned a probable date within the final years of the sixteenth century.

1 Dates unknown.
2 Laes, 1939, p. 112. Biographical details are indebted to Laes.
3 p. 65.
4 Discussed at length in the article of 1963.
5 ibid.
6 cf. Wegner, 1967 and 1973, where problems of attribution are discussed.
7 Confirmed by Wolfgang Wegner, letter, 17 December 1977.
8 e.g. Wegner, 1973, Nos. 37–40.
9 Liechtensteinische Galerie, Inv. No. 361; Franz, 1963, pl. 11.
10 Alte Galerie; Franz, 1963, pl. 14.

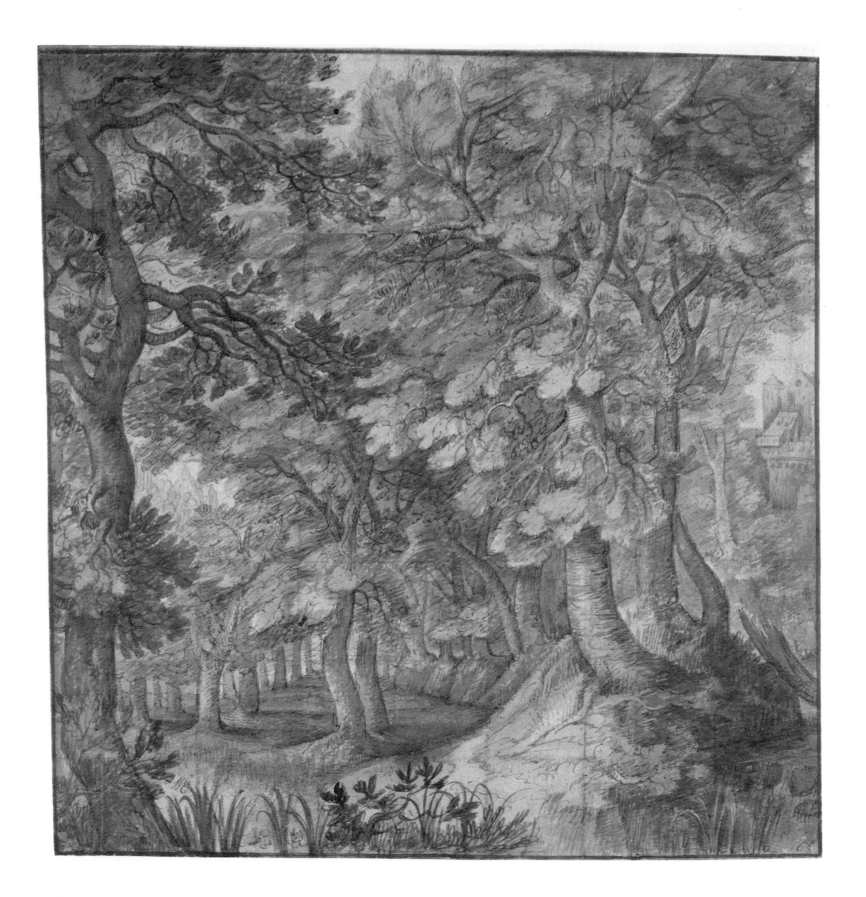

FOLLOWER OF CONINXLOO
(17th century?)

9 Interior of a Wood (?)*c*.1600

Pen and light brown ink; grey (carbon) ink and blue watercolour washes, with extensive drawing with the point of the brush; on off-white laid paper. The sheet folded vertically at the centre, and unevenly trimmed at all sides, apparently to a ruled line in graphite (visible top).

34.1 × 46.8 cm.

Inscribed in pen and brown ink, *verso*: 'paul Brill', and by the same hand in graphite: 'paul *Bril*', and numbered in pen and brown ink: 'page 57'. Inscribed in different hands in pencil, *verso*: 'Aus einer Versteigerung d'Alliance d'art/ Vielleicht aus der/Sammlung Delbecq – Ghent', and: 'Gillis van Coninxloo/ 1544–1607/Antwerpen – Amsterdam', and: 'Wasserzeichen', and numbered: '511'; '#8'; 'Jh 21'; '2'. Numbered in pen and brown ink, *verso*: 'S/13c.', and: '13c'.

Stamped with the mark of the Alliance des Arts (Lugt 61), *recto*.

PROVENANCE: M. C. T. Villeneuve, sold Paris 1842 (as Hobbema, *Coin de Forêt*); ? Delbecq, Ghent; with the Alliance des Arts, Brussels; sold Hollstein & Puppel, Berlin, 4–6 May 1931 (lot 939); W. H. Jervis Legg; Sir Robert Witt (gift from Drey, Christmas, 1941); Witt Bequest 1952 (3123).

EXHIBITIONS: V. & A., 1943; Courtauld, 1977–78 (24).

LITERATURE: Wegner, 1973, Appendix.

In all phases of his career, Coninxloo attracted pupils and followers, of whom some, as Wegner observed, made direct copies of his drawings, while others seem to have made original works in his manner.[1] General similarities of style between the drawing exhibited here and Coninxloo's painting of 1598[2] in Vaduz indicate that it is dependent for inspiration on works created by the Flemish master around the turn of the century. It may thus have been executed by an artist working in Amsterdam, where Coninxloo lived from 1596, although we have no means of knowing whether or not it was created during that artist's lifetime.

The drawing is a decorative work: tree trunks, root formations and the irregularities of the earth's structure are described in all areas of the composition by similar restrained, precise contours and smooth and shallow modelling. Leaf clusters are conceived as repetitious, slightly concave, ragged configurations. In contrast to Coninxloo's drawings, there is no differentiation in this work between weights and textures of natural forms, all of which appear to have been created from a similar dough-like substance. Light is not employed here to unify elements within the landscape, but rather to isolate whole or parts of forms in order to create a pattern of alternating pale and dark silhouettes over the sheet.

A drawing by the same hand, but more highly finished with fine and controlled penwork, is in Brunswick.[3] Of comparable size to the Courtauld sheet,[4] it has a similar vertical crease at its centre, suggesting that it was once part of the same album or portfolio. A similarly highly worked drawing, also probably by the same artist, is in Paris.[5]

The Brunswick sheet is an elaborate copy, with variations, of a composition by Coninxloo in Dresden.[6] Since no Coninxloo drawing related to the Courtauld sheet has yet been located, it is impossible to establish whether this work, too, is a copy, or an independent composition in the Flemish master's style.

1 Discussed by Wegner, 1967 and 1973.
2 Liechtensteinische Galerie, Inv. No. 361; Franz, 1963, pl. 11.
3 Herzog Anton Ulrich-Museum, Inv. No. KK 294: Wegner, 1973, loc. cit., notes that the present drawing is by the 'Brunswick copyist', but does not relate it to any one of three sheets, all by different hands, in Brunswick (repr. Wegner, 1967, Nos. 24, 26, 31).
4 31.9 × 46.0 cm.
5 Coll. B. Pardo, Galerie Pardo, Paris; photo Witt.
6 Kupferstichkabinett, Dresden; Franz, 1963, pl. 3.

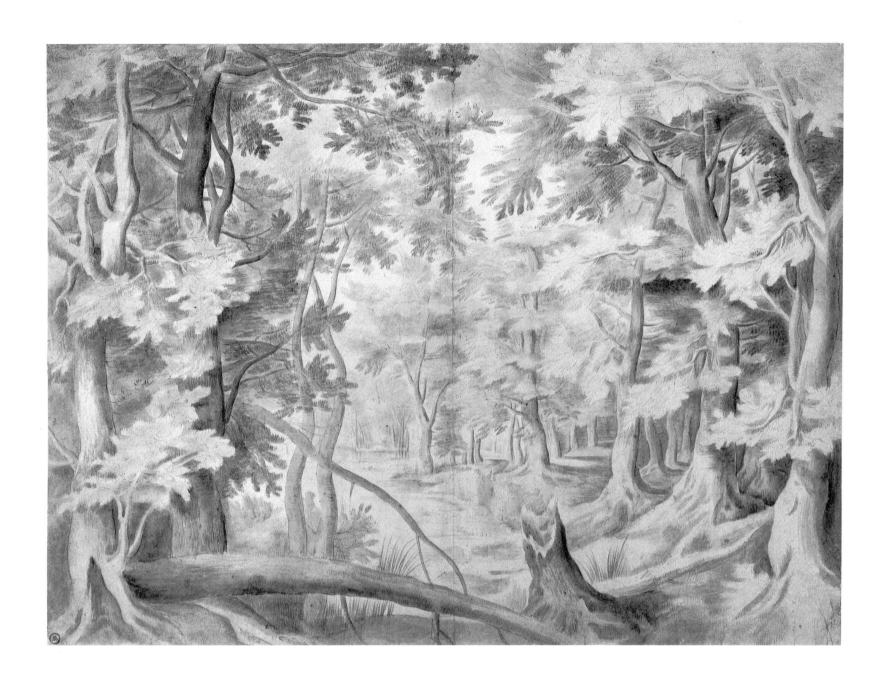

KERSTIAEN DE KEUNINCK
(*c*.1560–1635)

10 Imaginary Coastal Scene with Fishing Vessels

Traces of slight preliminary drawing in black chalk; pen and brown ink; brown ink wash and yellow watercolour wash; blue bodycolour of varying dilutions (also mixing with the yellow watercolour to form pale green, left, and with brown to form grey in the sky, right) and touches of dilute red bodycolour; on pale buff laid paper. The pictorial area enclosed within the artist's ruled line in pen and dark brown ink, and unevenly trimmed at all sides. A vertical fold, right of centre, and the sheet now laid down on Japanese tissue.

20.1 × 28.7 cm.

PROVENANCE: Arnal; Sir Robert Witt (purchased from Sotheby, no date); Witt Bequest 1952 (1995).

EXHIBITIONS: Berlin/Bochum, 1927–28; Courtauld, 1977–78 (35).

Facts about this obscure artist, rediscovered only in 1903,[1] are few and uncertain. Believed to have been born in Cambrai, he apparently moved in 1577 to Antwerp, where he may have been a pupil of Hans Bol. In 1580 he was received into the Guild of St. Luke in Antwerp, and apparently died in that city.[2] The extent of de Keuninck's *œuvre* is unclear, although the paintings which can confidently be attributed[3] to him reveal him to have been an eclectic artist working in styles influenced by, among others, Joos de Momper and Gillis van Coninxloo. The drawing exhibited here, however, is inspired by the Italianate coastal scenes of Paul Bril.

A drawing by Bril in Paris[4] states in reverse the composition of a painting in oil on copper in Detroit,[5] which has also been attributed to Bril on the basis of its monogrammed initials. When compared to similar painted coastal landscapes and harbour scenes by Bril in Brussels,[6] Cologne,[7] Milan[8] and Rome,[9] however, the handling of the Detroit panel appears broad and coarse. Motifs extracted from the Paris drawing are in that work loosely juxtaposed in unstable spatial relationships, while the original placid imagery is magnified and violently interpreted. Similar characteristics of turbulent form allied to coarse handling are visible in a painting in Ghent[10] signed by de Keuninck, and the Detroit work should now be reattributed to that artist.

That de Keuninck painted the Detroit composition in reverse from Bril's original design suggests that he knew of the latter only through the medium of engraving: the drawing in Paris was indeed the subject of an undated print by Raphael Sadeler I (1560–1628/32).[11]

The composition of the drawing exhibited here has not been traced to one particular source in Bril's *œuvre*, but presents an amalgam of motifs employed by the latter in the drawings and paintings of coastal scenes, many of which were interpreted as engravings.[12] Although the forms in the present work are exaggerated, the scene represented is one of comparative calm. Motifs adopted from Bril include the fantastic outcrop of rock, generally oblong in form, rising vertically from the sea; the misty profile of a distant tongue of land at the end of which is a prominent vertical accent of a tower or lighthouse; the repetition of sailing craft characterised by a high prow and rounded hull and propelled by a single triangular sail rigged to a mast set at an oblique angle to the hull; and a prominent and often low sun from which emanate geometrical rays.

1 First mention by a modern historian of de Keuninck occurs in Maeterlinck, pp. 60, 69, 96, 106.
2 Laes, 1931, p. 227.
3 Laes, 1931, lists 13 paintings, of which 7 are signed.

4 Louvre, Lugt, 1949, No. 392.
5 A. Haberkorn Bequest, Detroit Institute of Art; Detroit, p. 18, Inv. No. 30.389.
6 Musée des Beaux-Arts; Röthlisberger, 1961, fig. 429.
7 Wallraf-Richartz-Museum; Vey/Kesting, p. 24, Inv. No. 3179 and pl. 24.
8 Ambrosiana; Röthlisberger, 1961, fig. 432.
9 Palazzo Borghese; Röthlisberger, 1961, fig. 430.
10 *Human Calamities*, Musée des Beaux-Arts; exh. Ghent, 1961 (40).
11 Hollstein, Vol. XXI, p. 257, No. 217.
12 Willem van Nieulandt II (1584–1636), for example, made 36 etchings after Bril's coastal landscape designs (Hollstein, Vol. XIV, p. 166, Nos. 76–111).

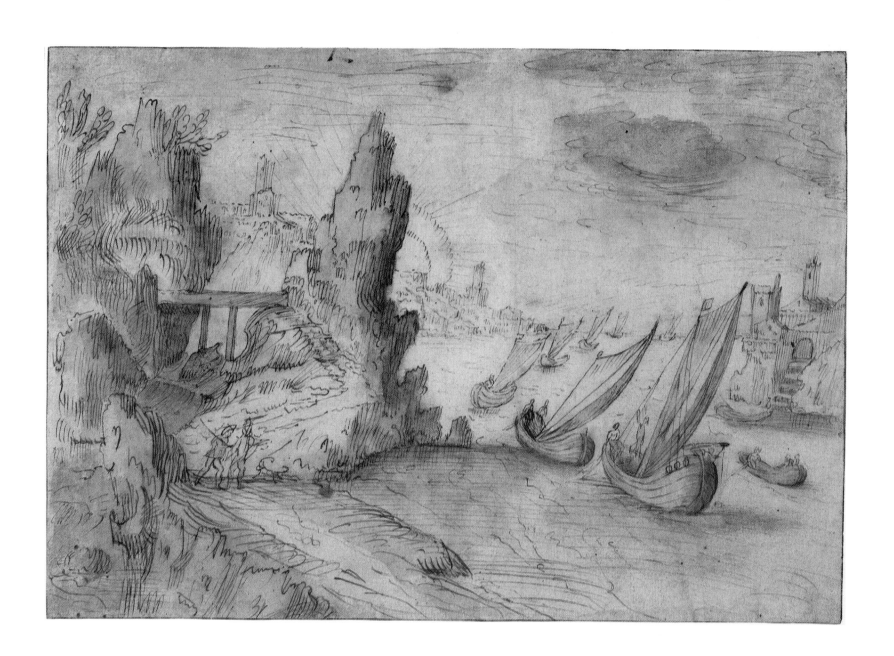

KERSTIAEN DE KEUNINCK
(*c*.1560–1635)

11 Rocky Coastline with Shipping in a Storm
before 1628

Some preliminary drawing with black chalk (chiefly underlying the rocks, left, and boats, lower right); pen and brown ink washes; brown ink and blue watercolour washes (applied separately and also mixed to form cool greys) with drawing with the brush and some use of the dry brush; on pale buff (stained) laid paper. The sheet folded vertically twice at the centre, and unevenly trimmed at all sides.

21.2 × 33.8 cm.

Inscribed in a modern hand in pencil, *verso*: 'P.Brill' and numbered: 'A5620'.

PROVENANCE: Sir Robert Witt (purchased from Colnaghi in part exchange, 1935); Witt Bequest 1952 (2261).

EXHIBITION: V. & A., 1943.

This drawing, like the preceding sheet, is inspired by the work of Paul Bril, e.g. those depictions of storms at sea in the frescoes of Sta Maria Maggiore[1] or the violent scenes of the Jonah and the Whale pendants in the Scala Santa, Rome.[2] It is unknown whether de Keuninck saw these works at first hand, but he probably knew of Bril's small-scale paintings on copper of similar subjects.[3] The treatment of the architecture in the drawing exhibited here also betrays the influence of drawings and prints by Willem van Nieulandt (1584–1626)[4] after works by the Bril brothers.[5]

The abruptly cropped motifs of stormcloud and ship in this work indicate that the sheet has been trimmed at the right and bottom: there is also evidence of trimming at the top and left. While it is not possible to gauge exactly how far the sheet extended in any one direction, it is nevertheless certain that the initial composition would have included the hull of the vessel whose sails alone are visible at the bottom of the present design. The vertical dimensions of the sheet would thus have been at least 3 cm. greater than its present measurement.

Deductions concerning the possible format, type of composition, and even subject matter of the larger design from which this is a fragment may be made by reference to other works by de Keuninck which include comparable storm scenes. This is not to suggest that the proposed larger drawing need have complied with any of the compositional types cited below, although it is known that the artist did make variations of his own compositions.[6]

Motifs of ships in peril appear in works in which de Keuninck does not treat marine subjects exclusively.[7] The prominence accorded in this sheet to images of ruined and abandoned buildings (from one of which smoke curls) suggests that the original subject dealt with disaster more widespread than merely at sea. If this is the case, two compositional types in de Keuninck's painted *œuvre* treating related themes may be cited as models for the hypothetical larger drawn composition. The first is found in the painting *Fortuna* in Leningrad.[8] Here, scenes of natural and man-made disaster (including shipwreck) on one side of the composition are contrasted with images of nature's calm benevolence and man's goodness on the other. Similar scenes of calm and optimism may have been trimmed from one of the lateral sides (perhaps the right) of this drawing, which would indicate an original frieze-like format.

Of a more apocalyptic theme is the signed panel depicting *Human Calamities* in Ghent,[9] and its smaller, more spectacular variant in the Khanenko collection, Kiev, in 1912.[10] The centre of both compositions is dominated by proud vessels driven by lowering cloud towards grim coastlines, while located at the bottom and sides are despairing saints, repentant sinners, and buildings erupting into flames or smouldering. The imagery of the present sheet is sufficiently similar to that at the centre of these paintings for it to be argued that the drawing is a fragment from a comparable *Human Calamities* subject. It is doubtful, however, whether such a drawn composition would have been either as complex as the painted versions or would have retained the relative proportions of motifs stated in those pictures, since this would presuppose a work on paper of perhaps three times the dimensions of the sheet exhibited here.

The final alternative for a subject and compositional type for the Courtauld drawing is offered by two of the four engravings depicting *The Ages of the World*, executed by Hans Collaert (1566–1628) after designs by Tobias Verhaecht.[11] At the centre of plates illustrating *Aetas Aenea* and *Aetas Ferrea* are motifs comparable to those visible here, while each incorporates within a roughly square format landscape elements at the sides and bottom. Verhaecht, an almost exact contemporary of de Keuninck, was also a native of Antwerp, in which city the latter apparently spent his working life: each would therefore have known the other's work. Since the *Ages of the World* compositions are inconsistent with those normally employed by Verhaecht (see Nos. 25, 26), it may be argued that he was working in the manner of de Keuninck. The engravings are undated, but must have been completed before 1628, the date of Collaert's death. If Verhaecht was indeed imitating de Keuninck's compositions and style in these designs, it suggests that this type of violent subject matter was an established and perhaps celebrated feature of the latter's *œuvre* before 1628.

1 Mayer, p. 73 and pl. XVIa.
2 Mayer, p. 73 and pl. XVIb.
3 e.g. that sold Sotheby, 15 December 1976 (lot 127); rep. *Apollo*, CII, October 1975, p. 164).
4 cf. Hollstein, vol. XIV, pp. 166ff.
5 Matthijs Bril (1550–84) was Paul's elder brother and teacher.
6 Laes, 1931, p. 228, lists three versions of *The Fire of Troy* in Coutrai, Musée Forché, Orléans, and in coll. J. van Merlen.
7 Laes, ibid., lists no paintings dealing specifically with marine subjects, although the painting in the Detroit Institute of Art, Inv. No. 30.389 (see under No. 10), the preceding drawing and a sheet formerly ascribed to Bril but certainly by de Keuninck, ex coll. A. G. B. Russell and W. H. J. Wegg and F. Drey of London in 1941 (photo Witt) demonstrate that the artist did execute marine subjects.
8 Hermitage; Hermitage, Vol. I, p. 129, No. 275.
9 Musée des Beaux-Arts; exh. Ghent, 1961 (40).
10 Khanenko, Vol. 1, No. 7.
11 Hollstein, Vol. IV, p. 213, Nos. 121–24.

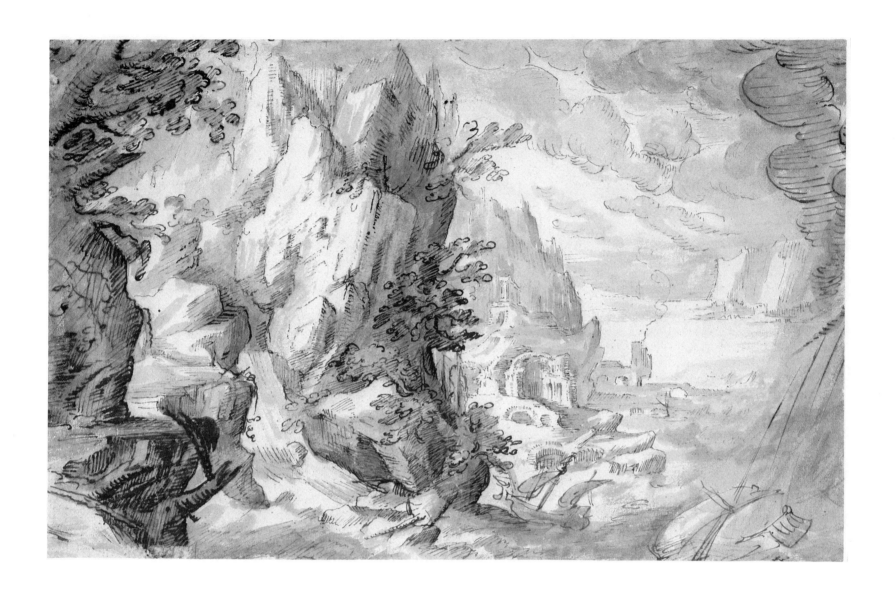

ADAM FRANS VAN DER MEULEN
(1632–1690)

12 View of Courtrai 1667

Extensive preliminary drawing in graphite; black (carbon) ink washes, with some drawing with the point of the brush, particularly in the fore- and middleground, and restricted watercolour washes; on off-white laid paper. The drawing made up of three sheets, that at the centre having been folded vertically. Pinholes at irregular intervals at all edges of the drawing. Unevenly trimmed at all sides, and faded, particularly in the sky.

Watermark: on central sheet, a Maltese cross encircled with a string of pearls (variant of Lugt, 1949, watermark No. 15), and to its left, a spade with letters 'B' and 'G' (Lugt, 1949, watermark No. 38).

Overall: 38.3 × 128.0 cm. (Left sheet: 38.3 × 24.3 cm. Centre sheet: 38.3 × 79.3 cm. Right sheet: 38.3 × 25.2 cm.)

Inscribed in pen and brown ink vertically along the right edge of the right sheet, *verso:* 'Courtray N° 17 (the number deleted) N° 53', and by the same hand in graphite on each side of the fold of the central sheet, *verso:* 'courtray'. (The hand identifiable as 'Hand A' in Lugt, 1949.)

PROVENANCE: acquired through the Witt Fund from Colnaghi, March 1958 (4661).

EXHIBITIONS: Courtauld, 1958 (56); Courtauld, 1965–66 (37); Courtauld, 1977–78 (76); British Museum, 1983 (49).

Van der Meulen's precocious talent[1] – in which was combined the science of a civil engineer and geographer with the eye of a landscapist of rare sensibility – was quickly recognised by the 'Premier Peintre' to Louis XIV, Charles Le Brun (1619–90), who advised Colbert to invite the Flemish artist to Paris to work for the King. Arriving from Brussels on 1 April 1664,[2] van der Meulen was housed at the Gobelins tapestry factory, and began an amicable collaboration with Le Brun which continued until the death of both men in 1690.[3]

Van der Meulen was employed to accompany the armies of Louis XIV on campaigns at home and abroad in order to record the appearance of conquered towns or depict glorious episodes of battle. The resulting drawings were submitted to Le Brun or Colbert (and perhaps to the King himself) who selected from them those designs to be made up into tapestries. The topographical studies executed in front of the motif appear to be largely the work of van der Meulen, with the occasional help of assistants,[4] but in the mechanical process of squaring up the designs and painting cartoons the artist worked as part of a larger body of studio craftsmen.[5]

Of nine campaigns[6] on which van der Meulen accompanied the French forces, the drawing exhibited here is from the second (known as the War of Devolution), of 1667. The town of Courtrai (Kortrijk), situated some 25 miles north-east of Brussels, capitulated to French troops under Marshall Daumont on 18 July 1667.[7] This drawing records the appearance of the town just prior to that date, since its bridge and ramparts, destroyed by the invaders, are here shown intact.[8] Viewed from a westerly observation point, Courtrai's principal buildings are faithfully represented. At the centre of the composition lies the castle, with, to the left (i.e. north) the short towers of the Broel bridge (which spans the River Lys, visible in the foreground), while to the right are depicted the double-spired thirteenth-century church of Notre Dame and the fifteenth-century church of St. Martin, the subject of a small watercolour by van der Meulen sold in Paris in 1972.[9]

The present drawing may be identified with that described by van der Meulen in an undated memoir, listing works executed by him for the King, as '…la ville de Courtrait [*sic*] colourée …'.[10] Since there is no record of the work's early provenance we may only speculate as to how a design destined for the royal collection entered private hands. It is known, however, that at the artist's death a rough inventory of the studio's contents was drawn up in which remaining pictures were allocated to the King and the artist's widow:[11] designs destined for the latter nevertheless entered the royal collection,[12] and it may be assumed that the reverse also occurred. That the present drawing was among the 215 works on paper in the studio in 1690[13] is very probable, since as late as 1685 it had served as the design for an engraving executed by van der Meulen's assistants A. F. Baudouins (1644–1711) and G. Scotin (1643–1715).[14]

The Courtauld work is related to a larger squared-up drawing in ink by van der Meulen (?)[15] in the collection of the Gobelins tapestry factory. The artist also lists two paintings of the Courtrai subject; the first, of the town, with in the foreground the besieging army, is identifiable as that now in Versailles.[16] For the second, van der Meulen gives no dimensions, but records that it was used as the design for part of a border of a tapestry, implying that it was of a low, wide format, similar perhaps to that of the present drawing; and indeed, a painting of such a format was recorded by Soulié at Versailles in 1881.[17] The tapestry to which van der Meulen refers treats the subject of the *Taking of Douai*, one of a series of 14 comprising the *Histoire du Roi*, to which the artist contributed 6 complete designs and two studies of details.[18]

The two large oil representations of Courtrai mentioned by van der Meulen have been accounted for above. A painting of the Courtrai subject with Arthur Tooth of London in 1958 may probably be identified with the picture listed in the 1691 inventory as a copy after van der Meulen by Saveur LeComte (1659/60–94) and other studio assistants, reworked in part by the master.[19]

1 The artist entered the Brussels Guild in 1648.
2 Memoir, in Guiffrey, 1897, pp. 127ff.
3 cf. Brière, 1930, pp. 150–55. Drawings by van der Meulen and Le Brun are in the Louvre (cf. Guiffrey/Marcel, Vol. VIII).
4 Views of Ghent and Mont-Cassel (Louvre; Lugt, 1949, Nos. 815, 816, 830) are inscribed by van der Meulen, *verso:* 'par mon homme'. Assistants in the field may have been Martin Le Jeune and LeComte (Gerspach, p. 140).
5 Brière, 1931, p. 8. Gerspach, p. 140 and Lugt, 1949, list studio assistants.
6 Listed in the Memoir; Guiffrey, 1897, pp. 127–28.
7 Lavalleye, p. 167.
8 Louis XIV often had models or plans made of towns he was about to transform or destroy (now in the Musée des Invalides, Paris). No model of Courtrai was executed, but this drawing may have served in its stead.
9 Hotel Drouot, 23 February 1972 (lot 36).
10 Memoir, in Guiffrey, 1897, pp. 127–28.
11 The Inventory of 6 March 1691 is published in full in Guiffrey, 1897, pp. 140ff.
12 Gerspach, p. 140.
13 86 drawings in 3 rolls, and 129 (including coloured views of towns) in a chest; Guiffrey, 1897, p. 141.
14 Hollstein, Vol. XIV, p. 20, No. 117, erroneously attributed to the son, J. B. Scotin (1671–1716).
15 Guiffrey, 1902, p. 119, unnumbered (42.0 × 318.0 cm.). The squaring-up may indicate that it is the work of a studio assistant.
16 Pératé/Brière, No. 263.
17 Soulié, No. 2219, gives the dimensions (42.0 × 133.0 cm.) width before height.
18 Guiffrey, 1897, p. 120. The central panel of the *Taking of Douai* designed by van der Meulen. Cf. Gerspach, 'Analyses de Tapisseries' *Gazette des Beaux-Arts*, 3ᵉ periode, No. 1, 1889, pp. 159ff.
19 Inventory, Guiffrey, 1897, p. 141, measuring 3.3 × 4.3 *pieds* (approx. 105.0 × 148.0 cm.). The Tooth painting measures 95.3 × 137.3 cm.

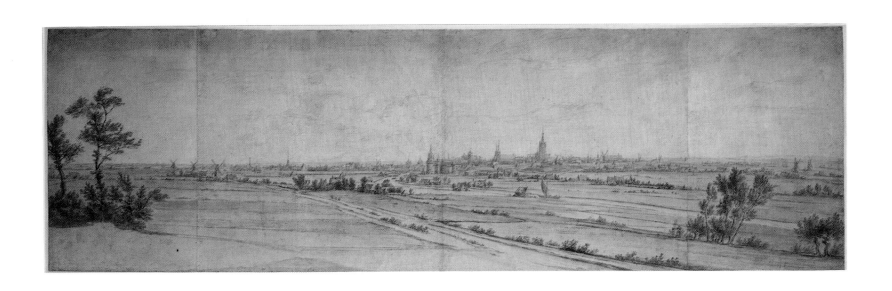

FRANCISQUE MILLET
(1642–1679)

13 Classical Landscape

Traces of preliminary drawing with graphite; pen and brown ink; brown ink and grey (carbon) ink washes, with some drawing with the pen and point of the brush, and slight use of the dry brush; extensive redrawing with graphite, both ruled and freehand; on buff (stained) laid paper. The sheet unevenly trimmed at all sides and laid down (?)by the artist.

35.2 × 24.0 cm.

Backing: study of leg bones, in black chalk.

Inscribed (?) in pen and brown ink on the backing: 'Francisco mille Fecit', and numbered in a modern hand in pencil: 'A.14871'.

PROVENANCE: Sir Robert Witt (purchased from Sotheby, 15 December 1948 (lot 56); Witt Bequest 1952 (4052).

EXHIBITIONS: Bristol, 1956 (52); Swansea, 1962 (23); Courtauld, 1962 (21).

Born in Antwerp, apparently the son of an ivory-worker from Dijon, Millet was in Paris by 1659, studying under Laureys Frank (active 1622/23-62) and Abraham Genoels (1640–1723).[1] He is said to have travelled widely in Holland and Flanders, and may have visited England, but not Italy.[2] Millet's reputation is as a painter of Italianate landscapes, although as Bodart[3] notes, he, in common with many later seventeenth-century Netherlandish artists, preferred to work in France and gain the classicising motifs for his paintings at second-hand from the work of earlier masters. In c.1662[4] Millet had painted for the Parisian collector Jabach eleven copies after landscapes by Poussin,[5] although he also made copies after genre and other compositions by Italian masters.[6]

It is doubtful whether any signed paintings by Millet are extant, and no work attributed to him is certified by documentary evidence. There is also confusion, as Davis noted,[7] between the work of the Elder Millet, that of his son, Jean (c.1666–1723), and that of the grandson, Joseph (1697/98–1777): as an added complication, son and grandson were also known as Francisque. Twenty-eight of Francisque I's compositions, however, were reproduced as engravings by one Théodore, who may have been Millet's pupil.[8] While Théodore's prints are not a comprehensive record of the master's styles, they nevertheless document motifs and pictorial structures employed by him in certain paintings.

The structure of the landscape in the Courtauld drawing, ultimately dependent on the type invented by Poussin in such paintings as the *Landscape with St Matthew*,[9] reappears in two engravings by Théodore; *Man with a Large Coat in the Middle of the Road*,[10] and in reverse, in *Man with a large Stick*.[11] Both employ the motif stated in the present drawing of curving bank of river or pool framed at either side by fore- and middleground trees. Paintings attributed to the Flemish artist which display compositions related to that shown here, but with the omission of architectural details, are at Audley End[12] and Kassel.[13]

The backing of this drawing is inscribed with the artist's name by a hand closely comparable to that which inscribed the name, spelt differently, on a sheet in Bremen.[14] Both inscriptions appear to be contemporary with the drawings, but it is a moot point whether they are to be considered as signatures.[15] The Courtauld and Bremen sheets also display common traits of handling and technique which are indebted to the open, linear style of Claude Lorrain's draughtsmanship, visible in sheets of the *Liber Veritatis*.[16] In each work, tree trunks are modelled with a combination of loose hatching and zigzag, while knots in the bark are indicated by rapidly drawn circles. Foliage

clusters, viewed either frontally or in profile, are represented by similar, regularly scalloped forms whose solidity is accentuated by strong but inconsistent illumination. Located in the foreground of both sheets are plants whose large leaf type is reminiscent of the dock.

Unlike the Bremen design, which appears to be a completed work of art in its own right, the present sheet is an exploratory drawing, as the frequent *pentimenti* denote. Initial ideas for a group of trees and tall vegetation are stated on the left and foreground river banks, respectively. At an intermediate stage in the working process, the upper half of the figures of mother and baby were delineated in graphite on the right: they were apparently destined to occupy a position on the left bank, but the idea was abandoned, leaving the relationship of figures to landscape unresolved. Drawing with graphite which overlays work with pen and wash in the background indicates steeper inclines of the mountain, and revisions to the pitch and perspective of the buildings' walls and roofs. Overdrawn in the left foreground is a second female figure, the upper half of which has been transformed into a fisherman with rod and line. The ruled lines which isolate the centre-left of the composition appear to have been the final addition to the sheet, and probably indicate a revised pictorial area.

1 Wilenski, p. 605.
2 Davis, p. 13.
3 Vol. I, pp. 205, 210.
4 Wilenski, *ibid.*
5 Cited by Davis, p. 15, from Vicomte de Grouchy, *Mémoires de la Société de l'Histoire de Paris et de l'Ile de France* (1894), pp. 249ff. in which the inventory of the Jabach collection made on 17 July 1696 is reproduced.
6 The Jabach collection comprised 57 paintings by Millet, among which were copies after Annibale Carracci, Domenichino, Giulio Romano, Guido Reni, Titian, 'Carracci' and 'Vandereck'.
7 p. 15, fn. 13.
8 Nothing is known of Théodore, although it has been suggested that he may be identified with Gerard Hoet (1648–1733); cf. Davis, p. 28.
9 Staatliche Museen, Museum Dahlem, Berlin, of c.1644–45; Blunt, no. 87.
10 Davis, pl. XXV.
11 Davis, pl. XXVI. A variant of this composition was also engraved by Jacobus Coelemans (1654–after 1735) as in the Boyer d'Aguilles collection, Aix, cf. *Recueil des plus beaux tableaux du Cabinet de Messire Jean-Baptiste Boyer, seigneur d'Aguilles* (Aix, 1709), no. 89; an impression from the second edition of 1744 is in the Witt Print coll. It is unknown if that print reproduced the composition interpreted by Théodore, or a variant of it also painted by Millet.
12 *Landscape with a Man in Red*; photo Witt.
13 Marburg Museum, inv. no. 473; photo Witt.
14 Kunsthalle; Pauli, vol. III, no. 7.
15 Pauli, *ibid.*, considers the inscription, which reads: 'Francisque Millet', to be a signature.
16 e.g. pp. 36, 39, 40, 41, 47, 50, 52, 55; Röthlisberger, 1968, nos. 328, 342, 344, 345, 363, 367, 379, 460, respectively.

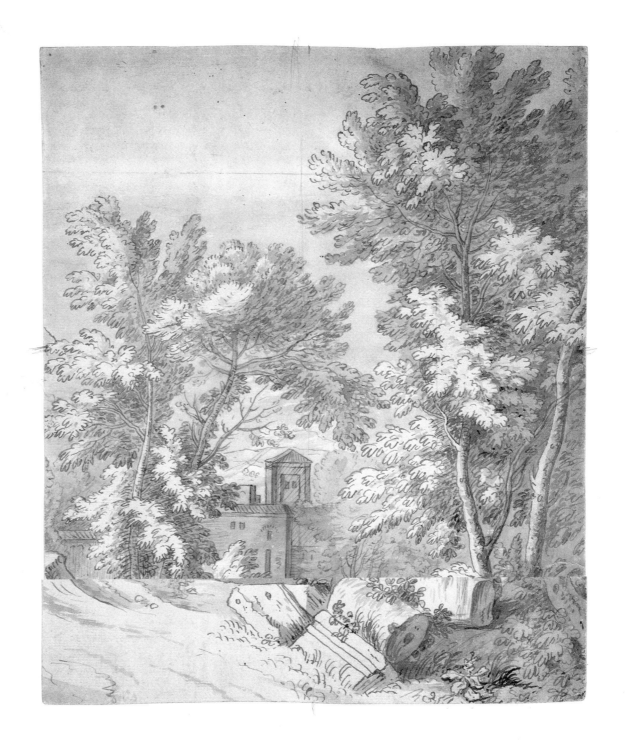

JOOS DE MOMPER
(1564–1635)

14 Landscape with Horse and Rider and Standard-Bearer 1598

Traces of preliminary drawing in black chalk; pen and brown ink; brown ink washes, with drawing with the point and flat of the brush; on off-white (stained) laid paper. The limits of the pictorial area indicated by freehand lines in pen and brown ink, and brush and wash. The sheet unevenly trimmed at all sides.

Watermark: illegible motif, encircled.

Sheet: 22.7 × 18.1 cm.

Pictorial area: 21.3 × 16.7 cm.

Signed and dated in pen and brown ink, lower right of centre: 'Jooes de momper,/1598', and numbered in a different hand in pen and brown ink, below the pictorial area, right: '616lt'.

Verso:

FRANCISCUS BAEDENS
(1571–1618)

Mercury and Venus, with Cupid 1596

Black and red chalk (the latter used mainly for flesh tones); dark brown ink wash, and yellow-brown ink or watercolour washes, with drawing with the point and flat of the brush; white, off-white and pink oil paint (the white mixing with the ink and watercolour washes to form pale buff: the oil paint restricted to Mercury's forearm and the drapery in Venus' lap).

Signed and dated in pen and brown ink, bottom left: 'franciscũ. baedens/a roma 1596..', and in a paler brown ink, bottom right (now partly effaced): 'francius'.

PROVENANCE: Lord St. Helens (cf. inscription on old mount); ...; Sir Robert Witt (purchased from Drey, London, 1941); Witt Bequest 1952 (3110).

EXHIBITIONS: V. & A., 1943; Rotterdam/Brussels/Paris, 1948–49 (46); Manchester, 1962 (43); Berlin, 1975 (202); Courtauld, 1977–78 (26); British Museum, 1983 (31).

Drawings by Joos de Momper which are either signed or dated are rare. A drawing in Paris of *The Fall of Icarus*[1] is inscribed 1618, while a sheet in Brussels is dated 1622[2]. A drawing destroyed during the last war, but formerly in Dresden, was dated either 1620 or 1629[3].

 The sheet exhibited here, which is prominently signed and dated 1598, is therefore an important document for the understanding of de Momper's early drawing style. As Mielke has observed,[4] it clearly reflects the artist's interest in the draughtsmanship of Lodewyk Toeput (*c.*1550–1604), displayed in the forms and handling of serpentine tree trunks crowned with heavy clusters of large, oval leaves, and in the motif of horse and rider. Variants of this stocky animal with powerfully arched neck, mounted by a bulky figure whose hat and cape are described by contrasting angular contours, appear in many of de Momper's later landscape drawings, and enlivened the lost Dresden composition. In few drawings is this motif accorded the prominence or decorative treatment it receives in the present composition: closely comparable in

handling, however, is the horse and rider on the left of two conjoined sheets depicting an extensive landscape in a private collection in Augsburg. That drawing is also signed and dated, and although only the last number of the date – a figure 8 – is clearly legible, the work was almost certainly created in the same year as the Courtauld drawing. A less decorative treatment of an equally prominent horse and rider motif is displayed in a signed drawing in Edinburgh,[5] which is probably a later work.

 The debt to Toeput's style betrayed by this and other drawings by de Momper datable to the last decade of the sixteenth century supports Raczyński's hypothesis[6] that after admission into the Guild at Antwerp, and sometime during the period 1581–91, the artist journeyed to Italy. Toeput was already in the north of that country by 1575, and by the beginning of the following decade had settled in Treviso.

 The signed composition in the Venetian manner by Franciscus Baedens on the *verso* of the sheet exhibited here is inscribed and dated 'a roma 1596'. Since we know nothing of the work's early provenance, we may only surmise the circumstances under which de Momper's composition came to be executed on the back of it. It is probable, however, that on returning from Italy to Amsterdam in 1597, Baedens brought the drawing with him.[7] It must have rapidly entered a Netherlandish collection, perhaps as a leaf in an 'Album Amicorum', where its blank side was subsequently drawn on by de Momper.

1 Louvre; Lugt, 1949, No. 936.
2 De Grez coll., Inv. No. 2605.
3 Kupferstichkabinett, No. 1882; Thiéry, pl. 35, and p. 53 reads the date as 1629, van Hasselt (London/Paris/Berne/Brussels, 1972, under No. 56) interprets it as 1620.
4 Berlin, 1975, loc. cit.
5 National Galleries of Scotland (F. W. Watson Bequest), Inv. No. 2855.
6 Raczyński, pp. 66–67.
7 Baedens purchased a house in Kalverstraat in 1598; Thieme-Becker, vol. II.

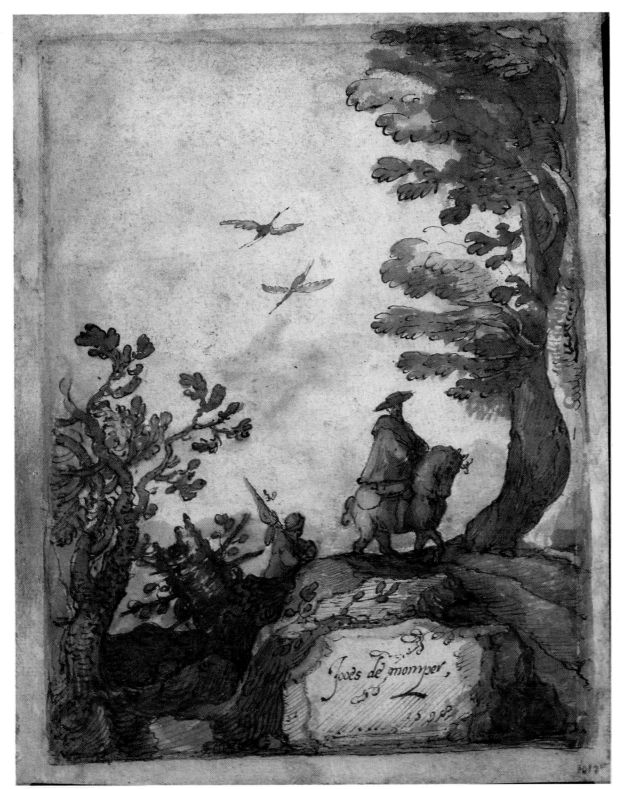

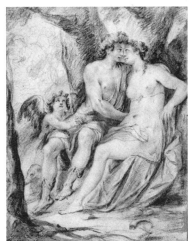

JOOS DE MOMPER
(1564–1635)

15 Winter Landscape

Preliminary drawing with black chalk; pen and brown and golden-brown ink; golden brown ink and blue watercolour washes, with drawing with the point of the brush and use of the dry brush; white chalk, applied with the brush as bodycolour, and used as a corrective, upper right of centre; on off-white (now stained) laid paper. The sheet folded vertically, centre, and diagonally, upper right, and unevenly trimmed at all sides, apparently to a ruled line in graphite.

Watermark: eagle, with letters below.

24.3 × 37.9 cm.

PROVENANCE: Sir Robert Witt (purchased from Colnaghi, no date); Witt Bequest 1952 (4177).

EXHIBITIONS: Courtauld, 1977–78 (28).

LITERATURE: Bernt, II, No. 417.

The drawing may be considered as a preliminary study for two paintings on panel which incorporate numerous small figures engaged in pursuits symbolic of the season of winter. One painting was with Clifford Duits in London in 1949,[1] while a smaller replica from a private collection in Ireland was sold in London in 1971.[2]

Both in pictorial structure and specific detail (e.g. the rectangular ponds and complex of bridge and mill buildings, right) this drawing and its cognate paintings are dependent upon Pieter Bruegel the Elder's composition *Hunters in the Snow* of 1565.[3] In 1566, that work entered the collection of Nicolaes Jonghelinck of Antwerp, where it remained until it was given in 1594 to Archduke Ernst of Austria, Governor of the Netherlands; whether de Momper was familiar with it at first hand, or knew of the composition only through the copy by Jacob Savery (*c*.1545–1602)[4] is uncertain. De Momper's interest in Bruegel's compositions, which Koester suggests[5] is reflected in paintings dating from early in the artist's career, is signalled by a copy in Stockholm after *The Conversion of St Paul*,[6] by a mountainous landscape in Vienna thought to record a lost composition by the older master,[7] and by two mountain scenes in Dresden which are strongly reminiscent of Bruegel's late landscape inventions.[8]

This drawing is closer than either of its related oils to *The Hunters in the Snow*. As in that composition, a similar screen of trees is here aligned with the ponds' banks, forming a space-creating diagonal which relates background to foreground, uniting earth levels of dramatically varied heights. In de Momper's panels the line of trees is abbreviated, resulting in dislocation between areas of higher and lower ground, which is intensified by the arbitrary distribution of light and shadow.

The separation of fore-, middle- and background planes into bands of brown, green, and blue, to indicate atmospheric recession characterises de Momper's paintings, and is also evident in this drawing. Superimposed over the three colour zones here is the drawing of contours with the pen, which is in itself a creator of coherent and unifying aerial perspective; continuous outlines detailing foreground motifs become increasingly broken when describing those of the middleground, and dissolve into a sequence of isolated hooks, dashes and dots to indicate the imagery of the background. In the background, more distant motifs such as the area of mountain where blue wash alone is first employed, the application of ink becomes more restricted, and finally gives way to the delicate underdrawing in black chalk which describes the summits. For the farthest band of misty distance, de Momper abandons all drawing, adding with the brush the palest glide of a refined grey-green wash.

1 Cf. undated note in Sir Robert Witt's file from Duits; photo Witt.
2 Christie, 14 May 1971 (lot 131); photo Witt.
3 Kunsthistorisches Museum, Vienna; Grossmann, 1955, No. 79.
4 Private coll., Brussels; Marlier, pl. 301.
5 p. 9.
6 Private coll.; Gluck, No. 47. The Bruegel (Grossmann, 1955, No. 125) is in the Kunsthistorisches Museum, Vienna. Its early history is unknown, but it was purchased by Archduke Ernst of Austria in 1594. A copy after it was made by Pieter Brueghel the Younger (1564/5–1637/8), now in a private coll., Brussels (Marlier, pp. 99–101, pls. 40, 41).
7 Kunsthistorisches Museum, inv. No. 986; Grossmann, 1954, p. 81.
8 Gemäldegalerie; *Mountain Landscape with Watermill* (Koestler, p. 9), and *Landscape with broken Spruce* (Koester, p. 10).

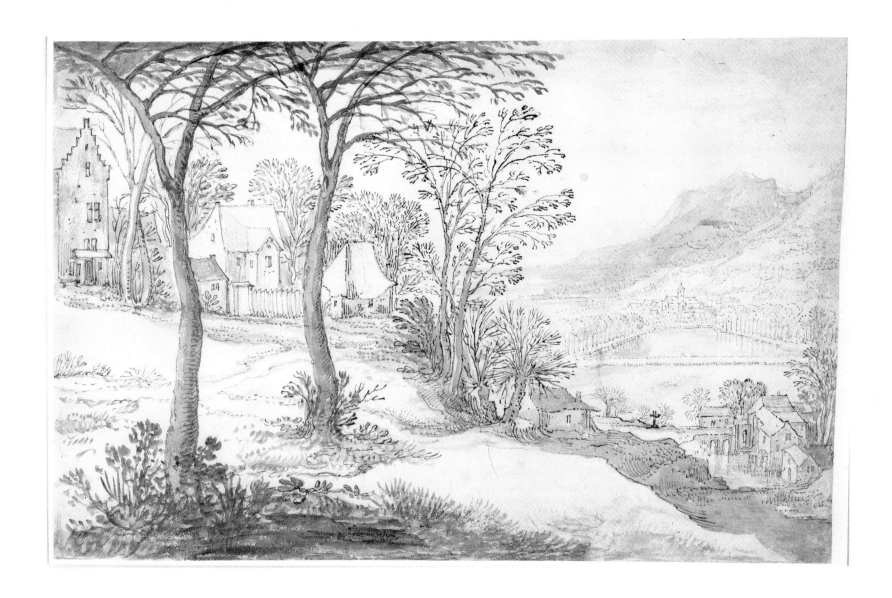

JOOS DE MOMPER
(1564–1635)

16 Landscape with Figures, Cattle and Waggons

Red chalk, with some rubbing in the middle- and background, and some moistening for the foreground accents, with heightening in white chalk, applied with the brush as very dilute bodycolour; on thick grey (discoloured) laid paper. A vertical fold, centre, and a horizontal fold approximately 4 cm. from the bottom.

36.9 × 55.5 cm.

Numbered and inscribed in a modern hand in pencil, *verso*: 'Nr. 1', and: 'J. de Momper'.

PROVENANCE: Sold de Vries, Amsterdam, 24–25 January 1922 (lot 384); with Ziegert, Frankfurt, from whom purchased by Sir Robert Witt, 1926; Witt Bequest 1952 (2202).

EXHIBITIONS: R.A., 1927 (629); Berlin/Bochum, 1927; Antwerp, 1930 (425); Manchester, 1962 (42); Courtauld, 1977–78 (27).

The drawing depicts an extensive valley landscape, in which the plasticity of the terrain is defined by interlocking wedges of alternating light and shadow, and through which riders, horses and waggons travel towards a richly undulating foreground. It is related in composition and treatment to a group of paintings in Copenhagen, Hamburg, Moscow, Munich, Nantes, Pommersfelden, Vienna and Warsaw, in which Koester[1] has observed a reliance on pictorial structures invented by Jan Brueghel the Elder (1568–1625). Since these paintings are undated, they may be located only approximately within de Momper's *œuvre*. Compositions of this type could have been created by the present artist only after the return of Jan Brueghel the Elder from Italy to Flanders, that is, in 1596 at the earliest; yet such a date apears improbably early when the style of the present design is compared with the Toeput-inspired composition of 1598 (see cat. no. 14), and Koester's suggestion[2] that the extensive landscape subjects be assigned to a period in the seventeenth century is here supported.

Directly related to the Courtauld drawing is a small painting on panel, sold in London in 1976,[3] which includes the composition and motifs visible at the lower right of the sheet. The panel extends laterally to incorporate at the extreme left the drawn motif of the foreground covered waggon, and vertically, to include much of the foliage of the smallest tree. In its depiction of a narrow but deep tract of terrain dominated by large-scale staffage, the painting is untypical of de Momper's pictorial structures; and cropping of the motif of horse and rider at the extreme left confirms that it has indeed been cut from a more extensive panel, the entire composition of which may have been that of the work exhibited here.

It may be argued that the large scale and advanced degree of realisation of this drawing would indicate that it is a record of a completed composition. If this were so, the lower right of the sheet would probably repeat with reasonable accuracy both the motifs in the panel and their respective positions within pictorial space. Instead, the background pedestrians and horsemen in the drawing differ substantially in both pose and location within the landscape from those in the panel. The horizon in the drawing is also placed higher within the pictorial area; while space in the foreground plane tends to be more compressed, and figures and animals in this area are grouped more closely, both laterally and in depth (note the uncomfortable positioning of horse, dogs and cattle at the extreme right: the cows in the panel, by contrast, are particularly lucidly arranged). Further uncertainties in both the location and drawing of form are manifest in the waggons' wheels, in which frequent *pentimenti* are evident.

This drawing, then, confronts problems of arrangement of figure and other motifs over a landscape which are resolved in the painting, thus confirming that of the two works, it is the earlier, and probably the exploratory working study for the lost composition of which the London panel is a fragment.

1 Koester records all inventory numbers and bibliographical references of the paintings, which are in the following museums: Royal Museum of Fine Arts; Kunsthalle; Pushkin Museum; Alte Pinakothek; Musée des Beaux-Arts; Schönborn Gemäldegalerie; Gemäldegalerie der Akademie der bildenden Künste; Museum Narodne.
2 p. 38.
3 Christie, 21 May 1976 (lot 319); photo Witt.

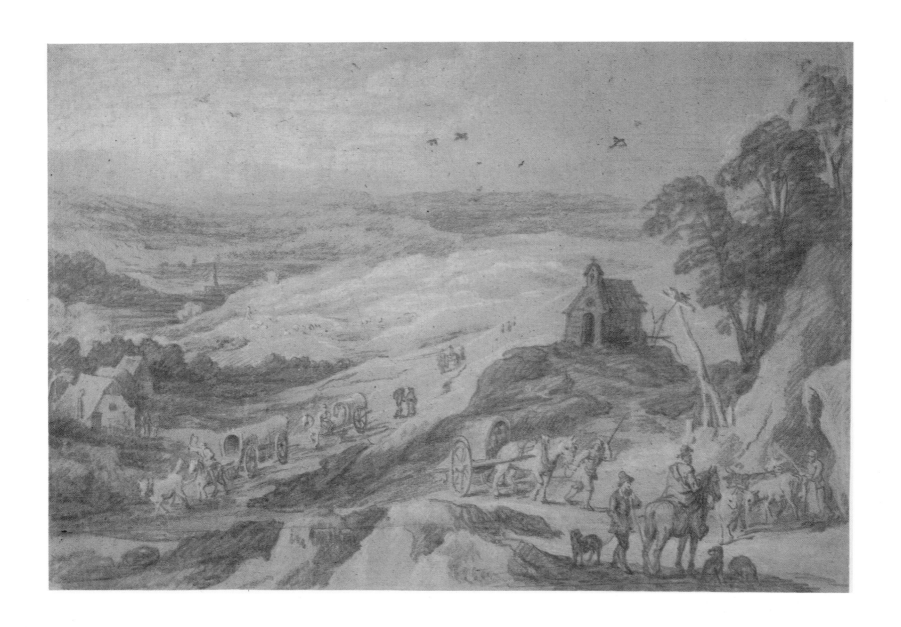

BONAVENTURA PEETERS
(1614–1652)

17 A Northern Port in Winter c.1641

Preliminary drawing in graphite; pen and brown ink; brown ink washes with some drawing with the point of the brush; on pale buff (stained) laid paper (? a sheet from a sketchbook). The sheet edged with a ruled line in pen and dark brown ink. The top right corner torn away and made up.

15.0 × 18.9 cm.

VERSO: a view of the same port, in pen and brown ink and brown wash.

Numbered by a later hand in graphite, *verso*: '483'.

PROVENANCE: Sir Robert Witt (purchased from 'Neb' – no clear record of acquisition); Witt Bequest 1952 (2436).

EXHIBITIONS: Courtauld, 1977–78 (71).

Bonaventura Peeters, a painter, engraver, and poet, was one of a family of artists which included the brothers Gillis (1612–1653) and Jan (1624–1680), and sister Catherina (1615–after 1670). Bonaventura was inscribed in the Guild at Antwerp in 1634, but in *c*.1648 was forced to leave that city to escape the enmity of the Jesuits whom his verses had satirised. Although principally a marine artist, he was also the author of a number of landscapes[1] and Biblical scenes[2]: a more prolific painter than draughtsman, his compositions were prized by the Antwerp bourgeoisie, and were also exported to Seville and Vienna.[3]

The extent of Peeters' travels is unknown, and it has been questioned[4] whether he visited any of the foreign sites he depicted. A contemporary inscription dated 24 February 1652 on a drawing of the port of San Sebastian (northern Spain)[5] indicates that the artist did, however, die at sea.

The site represented on the sheet exhibited here was formerly identified[6] as the Muscovite port of Archangel, situated some 130 miles south of the Arctic circle, on the right bank of the Dvina river and 15 miles from the White Sea coast. Since these drawings clearly include views of the open sea, they cannot depict that port: this is confirmed by comparison with an engraving of Archangel by Romeyn de Hoogh (1645–1708), published in 1667,[7] which shows a bustling and extensive harbour built on an area of flat terrain. That these compositions nevertheless represent a location close to the Arctic circle is shown by the motifs of frozen sea and reindeer: and the view may indeed be taken in the Dvina delta, in which there are numerous small, inhabited islands, although a precise identification of the site has thus far proved impossible.[8]

The same tract of land is depicted on both sides of the Courtauld sheet: when recording the scene on the *verso*, the artist's vantage point would have been from the side of the fortified island at the extreme right middleground of the landscape on the *recto*. Details of the castle (oblong entrance, circular tower located at one side of the principal structure) noted on the *recto* are reproduced on the *verso* from an angle consistent with the rotated viewpoint. The relative positions of vessels embayed in the ice, and hence immobile, which are drawn on one side of the sheet are similarly accurately rendered on the other, indicating that not only were the drawings executed from nature, but also that they record the scene with a degree of fidelity and precision.

Peeters nevertheless presents his observations from the motif according to accepted conventions of picture construction, and includes at one side of the sheet the device of framing tree, and at the bottom, a *repoussoir* of rising ground. The pictorial structure of the *recto* is restated in the opposite sense on the *verso*, while the handling of forms on this side of the sheet is more cursory, suggesting that it is the later of the two drawings. That this composition is also inverted indicates Peeters' probable use of a sketchbook whose spine was at the top of the present *recto*.

The general viewpoint adopted for the composition on the *recto* is repeated in a painting on panel formerly in Sir Robert Witt's collection and now in the National Maritime Museum, Greenwich.[9] Details in that work are substantially altered from those in the drawing: the foreground tree, for example, is eliminated; the island is situated closer to the picture surface, while the position of its church and castle is reversed; and booths and sledges whose random location over the ice is recorded in this sheet are in the panel regrouped to establish space-creating curves which unite back- and foreground. A Norwegian merchantman is in the centre of the painting. A similar vessel, but observed from a different angle, occupies a comparably prominent position in a drawing in Rotterdam,[10] the background of which includes the motif of the fortified island included in the Courtauld sheet. That motif is depicted from the viewpoint adopted in the present *verso*, yet its fortress is represented from an angle akin to that on the *recto*. Such a synthesis of viewpoints suggests that the Rotterdam drawing was composed in the studio; and the poses and contrived grouping of foreground staffage, the arrangement of iced-in vessels (whose positions do not concur with those in the present sheet), and the work's large scale and elaborate execution corroborate this.

The date on Peeters' panel in Greenwich has been published as 1644,[11] although a reading of 1641 is also valid: a comparable date may be assigned to the Rotterdam drawing, while the sheet exhibited here, which generated motifs employed in both studio compositions, must be the earliest of the three works.

1 A view of Montaigne, near Diest, Brabant, is in the Courtauld Institute Galleries (Witt coll. No. 479); a view of Louvain, Lugt coll. Inv. No. 1799, was removed during the war; a view of Dyce near Cologne was at Aschaffenburg in 1932 (cf. *Münchner Jahrbuch*, IX, No. 2, 1932, p. 81).
2 A painting of *The Flight into Egypt* is in Würzburg University, Inv. No. 359; photo Witt.
3 Biographical details from Wilenski, pp. 305, 311, 316, 620.
4 Wilenski, p. 316.
5 Coll. Miss Armide Oppé. Inscribed: 'Dit is de Leste Teekeninge die Bonaventura Peeters gheteekendt heeft en is gestorven op. Zee', (i.e. 'This is the last drawing which Bonaventura Peeters made and he died at sea'); photo Witt.
6 Identified as Archangel when purchased by Sir Robert Witt, and accepted as such in the Hand-list, and in exh. cat. Courtauld 1977–8 (71).
7 Published in Balthazar Coyet's *Historisch verhael ... van de voyagie ... van de Heere Koenraad van Klenk extraord. ambassadeur ... aan Zijne Zaarsche Mayesteyt van Moscovien etc.* (Amsterdam, 1667). De Hoogh's engraving not catalogued in Hollstein, but reproduced in R. Wittram, *Russia and Europe* (London, 1973) p. 39, pl. 22. Grateful acknowledgement to Mr. Maarten Reuchlin, Royal Netherlands Embassy, London, for assistance in locating a copy of Coyet.
8 Grateful acknowledgement to Dr. George Lewinson, London, for assistance with the identification of the site.
9 Inv. No. 1945/43/7, and also entitled *Shipping off Archangel*.
10 Boymans-van Beuningen Museum, Inv. No. B.P.I. (cf. P. Cannon-Brookes, 'The Peeters of Antwerp', *The Antique Collector*, September 1974, p. 68).
11 in exh. cat. R.A., 1927 (307).

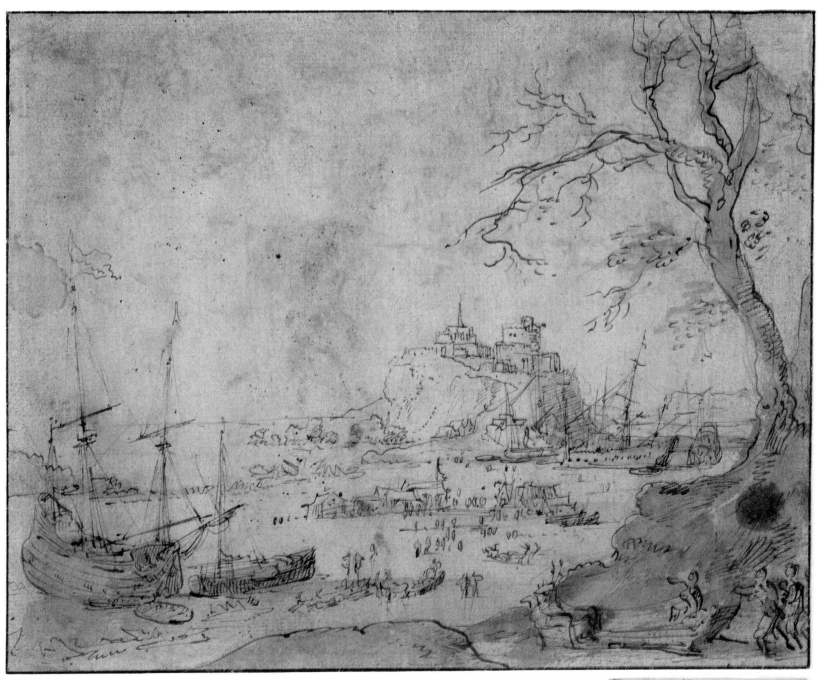

ROELANT SAVERY
(1576–1639)

18 Mountain landscape 1607

Black chalk, black chalk bound with oil, and red chalk, with some rubbing, and in restricted areas, slight moistening; on off white (now stained with oil paint) laid paper. The pictorial area indicated by the artist's ruled line in black chalk, and vestiges of a ruled line in pen and brown ink, by a later hand. The sheet unevenly trimmed at all sides.

20.2 × 28.9 cm.

Inscribed by the artist in pen and brown ink, *verso*: 'van swat naer roetholt tessyen in tyrol' (i.e. 'from Schwaz to Rotholz Tessin in Tirol').

Inscribed by a later hand in graphite, lower right, *recto*: 'Everding'.

PROVENANCE: Sir Robert Witt (purchased from Parsons, no date); Witt Bequest 1952 (955).

EXHIBITIONS: Berlin/Bochum, 1927–28; V. & A., 1943; Ghent, 1954 (144); Manchester, 1965 (377); Courtauld, 1977–78 (36).

LITERATURE: Spicer Durham, pp. 54, 58, and C.35.

The Saverys left Courtrai, Roelant's birthplace, in the early 1580s, in order to avoid the effects of Philip II's tightening of Spanish control over the southern Netherlands, and perhaps also to escape religious persecution. By 1585, the family was in Haarlem, after residing briefly in Antwerp and possibly Dordrecht, but by 1591 it had apparently settled in Amsterdam.

In 1604, Roelant was in Prague: neither the date nor the circumstances under which he went to that city are documented, although it is known that there he entered the service of the Emperor Rudolf II (who had reigned from 1575), and after that ruler's deposition and death in 1612 remained until 1618 to serve Emperor Matthias. In 1619, the artist returned to Holland, settling in Utrecht.[1]

In the service of Rudolf, Savery travelled throughout Bohemia, and beyond, drawing landscapes from nature.[2] Rudolf was the first great patron of art to interest himself on a grand scale in landscape, and Spicer Durham[3] interprets Savery's views of the awesome mountains and valleys of Bohemia as an evocation of the variety and magnificence of the Emperor's domain. She also suggests[4] that at Rudolf's behest, the artist may have made three voyages, the first of which, in 1605, was possibly to the Erzgebirge (Ore Mountains) on Bohemia's north-western border. During the following summer he probably travelled to the Böhmerwald, in the south-west, from where he may have either returned to Prague, or continued to the Alps, returning to the capital for the winter; the first dated rocky landscape in Savery's *œuvre* was created during this journey.[5] In 1607, the artist went to the Tirol, and on to the Swiss Alps.[6]

The handling of Savery's topographical drawings of the period 1604–1608, inspired by that adopted by Pieter Bruegel the Elder in the early 1560s for views of rocky wildernesses, was transmitted to the artist through the teaching of his brother, Jacob Savery (c.1545–1603), a complete master of Bruegel's manner. Roelant's mountain landscapes of 1604–1606, in common with those by Bruegel, are in pen and brown ink: in views resulting from the 1607 journey, by contrast, all principal drawing is in chalk. By substituting that medium for pen and ink Savery was able to work rapidly, thus heightening the immediacy and actuality of the scene:[7] chalk may also have been favoured because of its ready friability, which the artist exploited in compositions' backgrounds to suggest atmospheric recession and to create an illusion of infinite space. In addition to natural(?) black chalk, Savery frequently used black chalk impregnated with an oily binding, red chalk, and in two elaborate sheets in Vienna,[8] fabricated chalks of green-blue and ochre. Chalks of different hue, however, do not indicate local colour. In the sheet exhibited here, for example, red alternates with lean and rich blacks in the drawing of contours, but is also rubbed or smudged at random, to create below and above the darker colours luminous orange-toned patches, which communicate to the viewer a sense of intense visual excitement. The chalk drawing, particularly in the larger sheets which were assembled as the Atlas Blaeu-van der Hem, is often enhanced by watercolour washes, which may be restricted to a single hue (either blue or brown)[9] or may comprise in addition pinks, greens, yellows and greys.[10]

In both range of media and treatment of background mountains and trees, the Courtauld drawing is closely comparable with a sheet in a private collection in Amsterdam.[11] Unlike that work, however, this view is not incorporated into one of the larger compositions in the Atlas van der Hem, yet Savery may have regarded it, and indeed all works on paper created during his travels, as a source of motifs and pictorial structures to be used in later paintings.

The view shown in this drawing was erroneously identified by Spicer Durham as of Sion(?) (Sitten) and the Rhone valley, as a result of having read the inscription on the *verso* from a reversed photograph taken with light transmitted through the drawing's old backing sheet. Removal of the backing in 1985 allowed a clear reading,[12] confirming that the view is of the Inn valley in the Tirol. From the town of Schwaz (from *c*.1500 a commercial and artistic centre situated some 15 miles east-north-east of Innsbruck) the artist looked eastwards along the southern side of a five mile tract of the Inn valley towards the village of Rotholz. The drawing was thus probably executed within days of two chalk studies in Berlin, one of which includes the motif of the tower of Hall,[13] which lies approximately one mile north-east of Innsbruck, while the other depicts Innsbruck itself.[14] That town and its environs may have been of particular interest to both Savery and his patron, since in 1605 Rudolf II had considered retiring there to Schloss Ambass, where his *kunstkammer* could be united with a collection formed by his uncle, Ferdinand I.[15]

1 Biographical details are taken from Spicer Durham, pp. 11–19.
2 That the drawings are taken from nature is confirmed by the inscription on the *verso* of a sheet in the Nationalbibliothek, Vienna, Atlas van der Hem, XLVI, folio 13 (Spicer Durham, C.16) which reads: 'Roelandt Savery gedaen/. . . et leuen . . . 1606'. An inscription below an engraving after Savery's design by Jacob Matham (Hollstein, vol. XI, p. 235, No. 360) which reads 'R. SAVERI effigiavit ad vivum in Bohemia' also indicates that the drawings were made from life.
3 pp. 23–24.
4 pp. 54–57.
5 Nationalbibliothek, Vienna, Atlas van der Hem, XLVI, folio 13; Spicer Durham, C.16. See above.
6 A drawing in the Nationalbibliothek, Vienna, Atlas van der Hem XLVI, folio 11 (Spicer Durham, C.30) is identified as a view of the Falls of the Rhine at Schaffhausen. The present drawing was also cited as evidence of the journey to Switzerland (see below).
7 Keys, p. 64, makes a similar observation.
8 Nationalbibliothek, Atlas van der Hem XLVI, folio 14, and XIII, folio 66; Spicer Durham, C.32, C.33, respectively.
9 Atlas van der Hem, XLVI, folio 9 (Spicer Durham, C.28) is washed in blue. Atlas van der hem, XLVI, folio 7 (Spicer Durham, C.26) is washed in brown. Atlas van der Hem XLVI, folios 3 and 4 (Spicer Durham, C.24, C.25, respectively) are washed in blue and brown.
10 e.g. Atlas van der Hem, XLVI, folio 12; Spicer Durham, C.31.
11 Spicer Durham, *ibid*. The drawing is Spicer Durham, C.36; exh. Rotterdam/Paris/Brussels, 1977 (17). Its composition is repeated in Atlas van der Hem XLVI, folio 7; Spicer Durham, C.26. Other drawings with the combination of black chalk, black chalk bound with oil and red chalk are in Amsterdam, Berlin, Darmstadt, Göttingen, London and Paris; Spicer Durham C.40, C.88, C.51, C.85, C.103, C.39, respectively.
12 Grateful acknowledgement to Sebastian Dudok van Heel of the Gemeente-Archief, who read the inscription, and to Christopher Brown of the National Gallery, London.
13 Staatliche Museen; Bock/Rosenberg, p. 270, No. 3227; Spicer Durham, C.48
14 Staatliche Museen; Bock/Rosenberg, p. 270, No 3230; Spicer Durham, C.96.
15 Cf. R. J. W. Evans, *Rudolf II and his world. A study in intellectual history* (Oxford, 1973) pp. 178–9, for a discussion of the collections of Ferdinand and Rudolf, and the latter's intention to unite them.

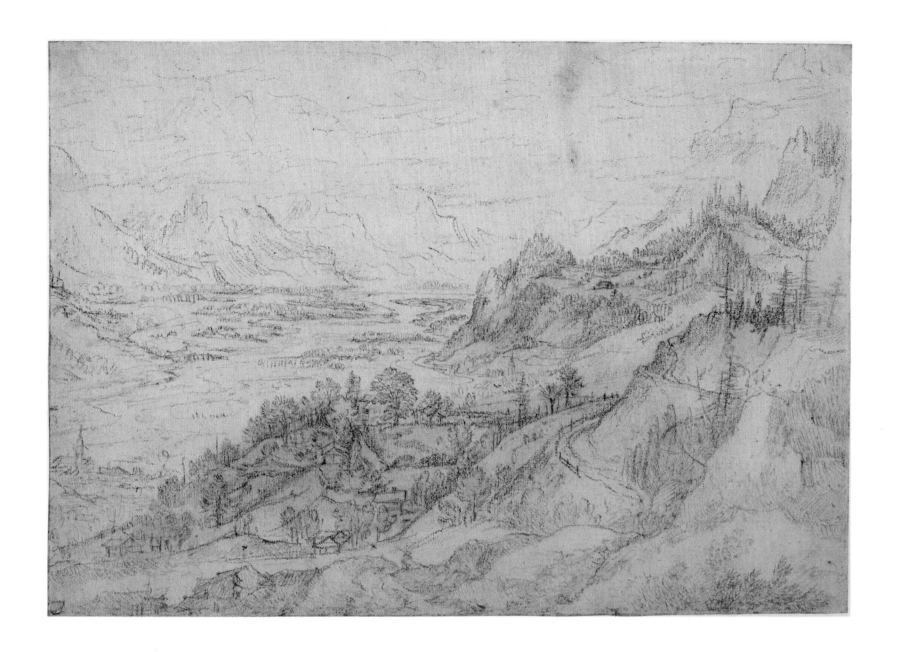

JAN SIBERECHTS
(1627–c.1703)

19 Landscape in Derbyshire c.1693–99

Extensive preliminary drawing in graphite; restricted watercolour washes, with some drawing with the point of the brush; on pale buff laid paper. The pictorial area enclosed within the artist's ruled line in graphite (visible bottom). The sheet unevenly trimmed at all sides.

12.7 × 17.6 cm.

PROVENANCE: C. R. Rudolf; Sir Robert Witt (in part exchange, no date); Witt Bequest 1952 (3083).

EXHIBITION: Courtauld, 1977–78 (74).

Details of Siberechts' early artistic training are unknown, although he painted for the Amsterdam art market pastoral and genre scenes inspired by Berchem and Waterloo. Said to have been introduced to England by George Villers, Duke of Buckingham (1628–87), who had been impressed by landscapes he saw in Antwerp in 1670, Siberechts was nevertheless still in that city in 1672, although by 1674 he had arrived in this country. He apparently remained for the rest of his life in England, where he was patronised by the nobility to produce decorative landscapes and overdoors to adorn their drawing-rooms, as well as bird's-eye prospects of their country houses.[1] Fokker lists only 30 paintings from the English period, and knew of only one drawing, the signed sheet in the British Museum.[2] Comparable signed or otherwise inscribed and dated sheets have been discovered in Amsterdam[3] and Manchester,[4] yet the topography of the British Museum's landscape provides the closest parallel with that depicted in the work exhibited here, which was purchased by Sir Robert Witt as by Abraham Rademaker (1675–1735).[5]

The pictorial structure of the present sheet, closely comparable to that of the British Museum's drawing, nevertheless shares general characteristics with the compositions in Amsterdam, and also with that of an unsigned study in Paris.[6] All main drawing in the British Museum sheet, a much larger work than this drawing, is with the brush and wash. Contours created with the pliant tip of the brush tend to be less crisply curving or flexible and are neither as mobile nor as sustained as those obtained from the resistant graphite point. After taking into account the characteristics and limitations imposed on the contours by particular drawing materials, it becomes evident that the hand which is at work on the present sheet is that which executed the British Museum's landscape.

Silhouettes of hills and boundaries of fields in both sheets are plotted by a wiry, almost unsteady contour. Here, as in the brush drawing, trunks of young trees are connected at their base to an accented horizontal line (which may be interpreted as a shadow) while the lively multi-directional zigzags defining the foliage clusters of the larger trees and the barbed hatching of their interior modelling find their equivalents in the heavier, dislocated strokes describing middleground trees in the latter work. In both drawings lines of irregular semi-circles denote distant crowns of closely planted trees, although those which are visible here are more varied and cursive than those rendered with the brush. The notation of such trees bordering the fields in the British Museum landscape introduces a decorative element which is continued by the application of wedge-like stippling and banding over the fields themselves. Such a vocabulary of strokes, which records the lines of haystacks and uncut corn, is visible in the fields at the right of the Courtauld drawing, where it is similarly rendered with the point of the brush. Characteristics of handling comparable to those mentioned above are also visible in a study of a flat landscape formerly in the collection of Sir John and Lady Witt;[7] and that work, too, should be included in Siberechts' œuvre.

Unlike the inscribed compositions, the present sheet displays an informal study of landscape: the small scale, swift and perhaps unfinished execution and lack of annotations suggest the drawing's private nature. It may well have been made as a personal record by Siberechts, who of all the seventeenth-century Netherlandish artists to visit England was perhaps the most responsive to her countryside.

The view drawn here is identifiable as of northern Derbyshire, an area which Siberechts probably visited in 1683,[8] and to which he may have made any number of journeys during the period 1693–96 while employed at Wollaston Hall, some twenty miles south-east of the district: one such journey, to the environs of Chatsworth, is documented by inscriptions on two drawings dated 1694.[9] The last recorded visit to this area was in 1699.[10] Since the fresh, intimate and detailed drawing of landscape in the Courtauld sheet occurs only in works after c.1690, it may therefore be assigned to the period of the later visits, i.e. 1693–99[11].

1 Chronology dependent on that given by Fokker. The exact date of Siberechts' death and his place of burial are unknown.
2 Fokker, pp. 47, 57; C. White in Croft-Murray/Hulton, p. 477, No. 2. The figures in this drawing are probably by John Wooton (1682?–1765).
3 Rijksmuseum, Inv. Nos. 13–58 (Bernt, II, No. 543) and 52–10.
4 Whitworth Art Gallery, Inv. No. 1993, signed jointly by Siberechts and Wooton.
5 Gillis Neyts (1623–87) has also been suggested as the author of this drawing, although it is catalogued under Flemish School in the Hand-list.
6 Institut Néerlandais, Fondation Custodia (Lugt coll.), Inv. No. 9335; exh. London/Paris/Berne/Brussels, 1972 (92).
7 Inv. No. 1400; photo Witt.
8 The church of Edensor appears in the background of a painting of this date in the Larsen coll., London; Fokker, p. 52.
9 In the British Museum, and Rijksmuseum, Amsterdam, Inv. No. 13–58.
10 Rijksmuseum, Amsterdam, Inv. No. 52–10 depicts The Peak.
11 Fokker, p. 54. The type of landscape Siberechts drew before 1690 may be seen in sheets in the Szépmuvészeti Museum, Budapest (Inv. No. 1911–466) dated 1665; Rijksmuseum, Amsterdam (Inv. No. 64–35); Museum voor Stad en Lande, Groningen (Bolten, 1965, No. 148); ex. coll. Besoltzheimer, Munich, sold Sotheby, 21 March 1973 (lot 72).

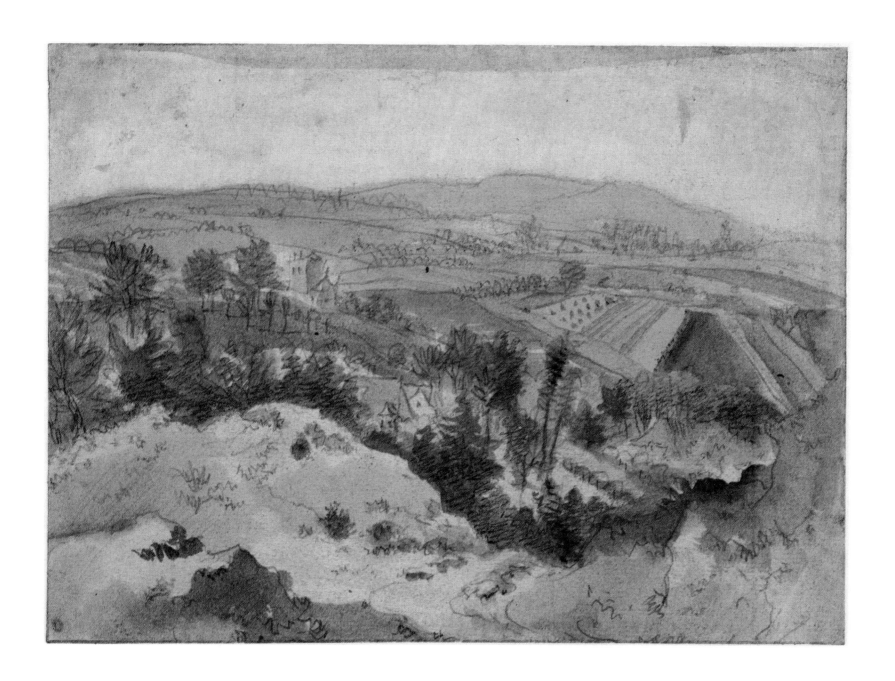

DAVID TENIERS THE YOUNGER
(1610–1690)

20 Rocky Landscape (?)1634

Graphite, with some rubbing; on white (now stained) laid paper. The sheet unevenly trimmed at all sides.

18.0 × 29.4 cm.

Verso: a house with a rainbow, in graphite.

Stamped with the collector's marks of Jonathan Richardson the Elder (Lugt 2184) and Thomas Hudson (Lugt 2432), *verso*.

PROVENANCE: Jonathan Richardson the Elder; Thomas Hudson; Arthur Pond (cf. Witt file); ...; sale, Christie, 18 December 1942 (lot 30), bt. Beer; Sir Robert Witt; Witt Bequest 1952 (3211).

EXHIBITIONS: Rye, 1972 (4); Courtauld, 1977–78 (65); Brussels, 1980 (229).

The imaginary landscape on the *recto* is a preliminary study for the signed painting in Dulwich, *St Peter in Penitence*,[1] in which the scene stated here remains unaltered except for the introduction in the left foreground of the kneeling saint. A pendant to this panel, depicting Mary Magdalene and also in Dulwich,[2] is inscribed 1634, a date which may equally be assigned to the *St Peter* and the present sheet. The three works would thus have been created approximately one year after Teniers' admission into the Guild of St. Luke in Antwerp, and this drawing manifests the artist's precocious and complete formation of a style of draughtsmanship which was to vary little during his career. His preferred medium was graphite, and the few sheets in this artist's extensive body of work executed in charcoal or ink are late experiments.[3]

Although Teniers was taught by his father and as early as 1626 had collaborated with him on commissions, this work betrays no influence of the senior artist. Instead, the building up of the composition by ragged patches of hatching contained by roughly drawn contours (a crudeness of handling exactly appropriate to the ruggedness of the landscape represented) indicates that Teniers was quick to adapt and systematise the free and vigorous draughtsmanship of Adriaen Brouwer (1602–38), who had moved to Antwerp and joined the Guild only in 1631/32.[4] The composition and subject matter of this drawing, however, are derived from the work of Joos de Momper, one of whose cave or grotto landscapes Teniers had copied in the 1630s,[5] and perhaps prior to executing the present drawing.

Teniers' reliance on certain compositional formulae to treat particular subjects is noted by Klinge:[6] the compositional model used here is applied equally to paintings whose theme is the hermit in his cave denying the world of the senses, or the cave as home to picturesque gipsies, fortune-tellers, etc. Such subjects recur in Teniers' painted work of the 1630s, and reappear 40 years later: examples are to be seen in, among other places, Leningrad,[7] London[8] and Madrid.[9]

The motif of the peasant's cottage on the *verso* of this sheet may also have been intended for inclusion in a painting, although no related work has yet been identified. Examples of similar subjects, executed with varying degrees of detail and rapidity, date from all periods of Teniers' career, and are to be found in printrooms in Amsterdam,[10] Paris[11] and London.[12]

Institute Galleries (Witt Nos. 2089, 2287) and wash drawings are in the same collection (Witt No. 2724) and in the Louvre (Lugt, 1949, No. 132).

4 Knuttel, p. 14.
5 A landscape in the Kunsthistorisches Museum, Vienna (Thiéry, pl. 30), was copied by Teniers (ex coll. Capt. E. G. Spencer Churchill, Northwick Park, sold Christie, October 1962 (lot 77) as by de Momper and Teniers); cf. Koester, p. 50, fn. 24.
6 Exh. cat. Brussels, 1980, loc. cit.
7 Smolskaya, Nos. 34, 37.
8 With Patterson & Shipman, London, in 1964, and sold Sotheby, 16 April 1980 (lot 87); photo Witt.
9 Prado: Prado, p. 639, No. 1817; p. 640, No. 1819; p. 641, No. 1832.
10 Rijksmuseum, Inv. No. 1898 A 3668, *verso*.
11 Institut Néerlandais, Fondation Custodia (Lugt coll.), Inv. No. 2205; Louvre (Lugt, 1949, No. 1326).
12 Courtauld Institute Galleries, Witt Nos. 2035, 2089, 2091.

1 Murray, p. 214, No. 314.
2 Murray, p. 214, No. 313.
3 cf. Klinge, in exh. cat. Brussels, 1980, p. 292: charcoal drawings are in the Courtauld

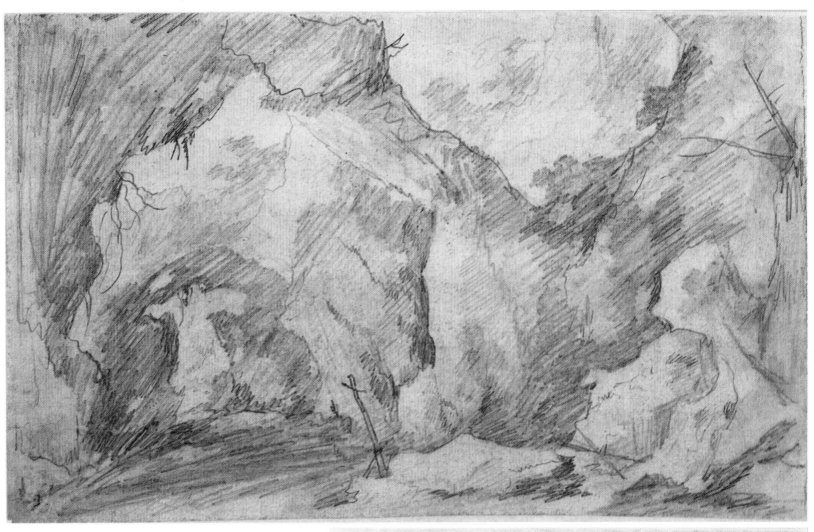

DAVID TENIERS THE YOUNGER
(1610–1690)

21 Landscape with Château *c.1645*

Graphite, with some rubbing; on off-white (stained) laid paper. The pictorial area enclosed within the artist's ruled lines in graphite (visible top and bottom), the sheet unevenly trimmed at all sides. A tear repaired, bottom left of centre.

17.3 × 26.8 cm.

Verso: slight sketch of a ruin on a hill, in graphite.

Signed in graphite, bottom right of centre: 'DT·F' (the initials in monogram), and numbered by the artist (?) in graphite, top right: '48'.

Inscribed in a modern hand in pencil, *verso:* 'plain'.

PROVENANCE: Sir Robert Witt (purchased from Parsons, no date); Witt Bequest 1952 (2035).

EXHIBITIONS: R.A., 1927 (640); Antwerp, 1930 (452); Rye, 1972 (5); Courtauld, 1977–78 (67); Brussels, 1980 (253).

The motif of the unidentified château on the *recto* of the sheet exhibited here is included in paintings by Teniers in Antwerp,[1] Dresden[2] and Montpellier:[3] in these works, it is observed under light conditions and from a viewpoint identical to those in the present drawing, and its immediate wooded surroundings are also similar. The compositions in Antwerp and Montpellier are most closely dependent on that stated here, since in each, the château is prominently located in the middleground and is the principal focus of attention. In the Dresden painting, by contrast, the château is introduced into the right background of a larger scene dominated by a village inn with groups of peasant drinkers and revellers. Variants of this composition attributed to Teniers were sold in Paris in 1884[4] and in Stockholm in 1920.[5] Related to these is a signed panel sold in New York in 1962,[6] in which the present château appears in reverse at the left.

Of the paintings cited above, only that in Antwerp bears a date, which is 1670. The Dresden panel, however, has been assigned by Klinge[7] to a date within the period of Teniers' creative maturity, during which his interpretation of Flemish landscape became influenced by the bucolic poetry of Horace and Virgil; that is, to *c.*1646. The Courtauld drawing is probably of the same or slightly earlier date, while variants of the Dresden composition may possibly be assigned to the later 1640s or to the early years of the following decade. If the date on the Antwerp panel is authentic, it affords an insight into Teniers' working methods, indicating the artist's willingness to re-employ motifs created some 24 years previously.

This drawing, however, does not appear to have been created specifically as a preliminary design for paintings; the prominent signature, careful handling with precise and tight hatching, and close attention to detail suggest that Teniers accorded it the status of an autonomous work of art. A comparable treatment and high degree of realisation is manifest in a signed and dated study of two peasants in a collection in Paris.[8]

The type of laterally banded construction of the present landscape, in which the lower storeys of architecture in the middleground are masked by a screen of trees aligned with the picture plane is restated in a less highly worked drawing of the Castellum of Westmalle, which is also signed.[9] Examples of similar layered compositions appear in paintings formerly in London[10] and in Lucerne.[11]

On the *verso* of this sheet is a slight, fluid sketch of a building (perhaps a ruined castle) on the summit of a hill. This drawing may have been jotted from nature, but nevertheless follows the landscape traditions established by Paul Bril and Joos de Momper. Related motifs of hilltop architecture appear in paintings by Teniers in a private collection in Denmark,[12] and in Leningrad.[13]

1 Musée Royal des Beaux-Arts; Delen, 1948, p. 250, No. 727.
2 Gemäldegalerie; Dresden, p. 110, No. 1068.
3 Musée Fabre; Montpellier, p. 259, No. 928.
4 Detsy sale, Hôtel Drouot, 28 March 1884 (lot 44); photo Witt.
5 Hakansson sale, Bukowski, 3–4 March 1920 (lot 49); photo Witt.
6 Parke-Bernet, 28 November 1962 (lot 19); photo Witt.
7 Exh. cat. Brussels, 1980, p. 255.
8 Institut Néerlandais, Fondation Custodia (Lugt coll.); exh. London/Paris/Berne/Brussels, 1972 (105).
9 Boymans–van Beuningen Museum, Rotterdam; exh. Brussels, 1980 (254).
10 *Château de Drie Torens*, exh. L. Koetser, 1962 (78).
11 Sold Galerie Fischer, 17–18 June 1977 (lot 380); photo Witt.
12 Exh. Brussels, 1980 (226).
13 Hermitage; Smolskaya, No. 36.

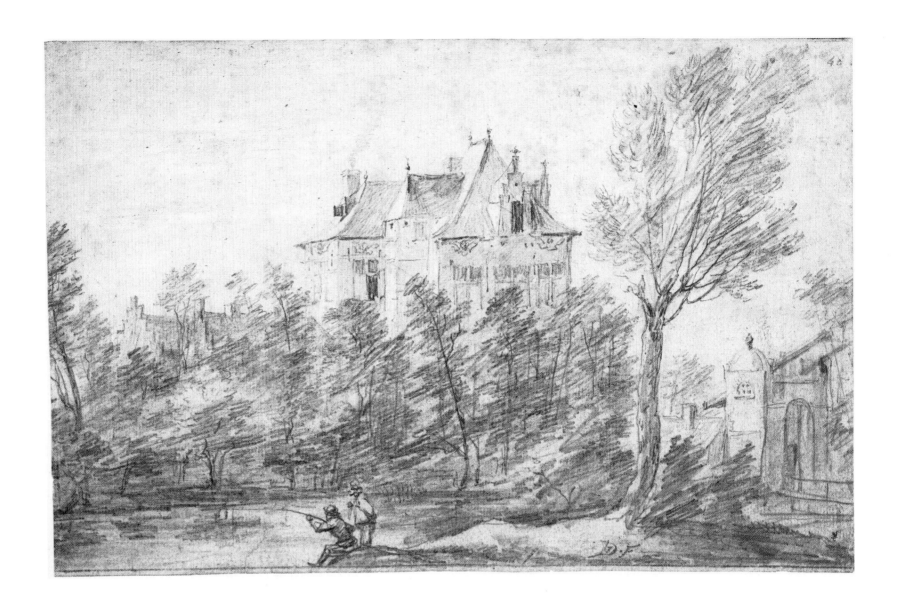

LUCAS VAN UDEN
(1595–1672/73)

22 A Tree

Black chalk, moistened for the darker accents, and soft graphite; brush and white bodycolour; on off-white laid paper, prepared with a ground of grey-blue bodycolour (now abraded, and apparently discoloured to green at the left). A tear repaired, top right of centre, the sheet unevenly trimmed at all sides and laid down. Double ruled lines in pen and dark brown ink on the protruding backing sheet.

28.4 × 19.9 cm.

Inscribed in pen and brown ink, above an inscription (?) in black chalk: 'W.uden'. Numbered in different hands in pencil, on the backing: '120', and: '40', and by Sir Robert Witt: '950/Uden'.

Stamped with the mark of an unknown French collector (Lugt 3000), backing, and inscribed with effaced and illegible attribution (?).

PROVENANCE: Unknown French collection; Benno Geiger; Sir Robert Witt (purchased from Parsons, no date); Witt Bequest 1951 (950).

EXHIBITIONS: R.A., 1927 (635); Manchester, 1962 (7); Courtauld, 1977–78 (51).

Lucas van Uden, probably a pupil of his father, Artus (1544–after 1627/28), became a master in the Guild at Antwerp in 1627/28. Apart from a tour of the Rhine during the period 1644–46, the artist appears to have spent most of his life in Flanders. From 1615 to 1630 he worked in Rubens' studio, making engravings after that master's designs.[1]

Van Uden's large oil paintings of woodland scenes are often hesitant, and even occasionally stilted or clumsy in execution, and it is in the paintings of a less ambitious scale and in drawings and watercolours that his talents are fully displayed. In the sheet exhibited here, for example, the freshness and tenderness of observation is matched by a delicate certainty of touch.

In the oils, van Uden commonly represents two distinct tree types, both of which derive from prototypes in the work of Rubens.[2] The motif of a sturdy, gnarled oak with exposed roots is employed principally as a framing device at the edge of compositions, while situated in the middleground are slender ash or birch trees. It is these latter varieties which are commonly the subject of the drawings. Usually of vertical format, these works depict trees either singly or in small groups, sometimes against the background of a rolling landscape or sunset. They are drawn on off-white paper in chalk or pen, sometimes enhanced with touches of watercolour (e.g. sheets in Berlin[3] and Paris[4]), or in chalk heightened with white on a prepared ground of either pink, or as in the present example, blue bodycolour. Drawings comparable in technique and degree of realisation to the Courtauld sheet are found in the Spellman collection, London,[5] the Baker collection, New York,[6] formerly in the collection of Sir Bruce Ingram,[7] and in Stockholm.[8] Such drawings, as van Hasselt observed,[9] were probably executed from nature as reference material for the more elaborate watercolours, oils and etchings, although no drawing known to us may be classed strictly as a preliminary study for a more complete work.

3 Staatliche Museen; Bock/Rosenberg, p. 287, no. 3132.
4 Institut Néerlandais, Fondation Custodia (Lugt coll.), exh. London/Paris/Berne/Brussels, 1972 (111). Louvre; Lugt, 1949, no. 1357.
5 Exh. R.A., 1927 (259).
6 Virch, no. 46.
7 Exh. Colnaghi, 1952 (57).
8 Nationalmuseum; Schönbrunner/Meder, vol. IX, no. 1024.
9 In exh. cat. London/Paris/Berne/Brussels, 1972, under 111.

1 Bartsch, vol. V, nos. 56–59.
2 e.g. in paintings in Leningrad (Rosenberg/Rubens, nos. 185, 356), London (Rosenberg/Rubens, nos. 186, 397, 402), Munich (Rosenberg/Rubens, nos. 187, 396) and Vienna (Rosenberg/Rubens, no. 189), and in drawings in Cambridge, Leningrad, London, Oxford, Posnàn (Bernhard, pp. 344, 427, 428, 426, 401, respectively).

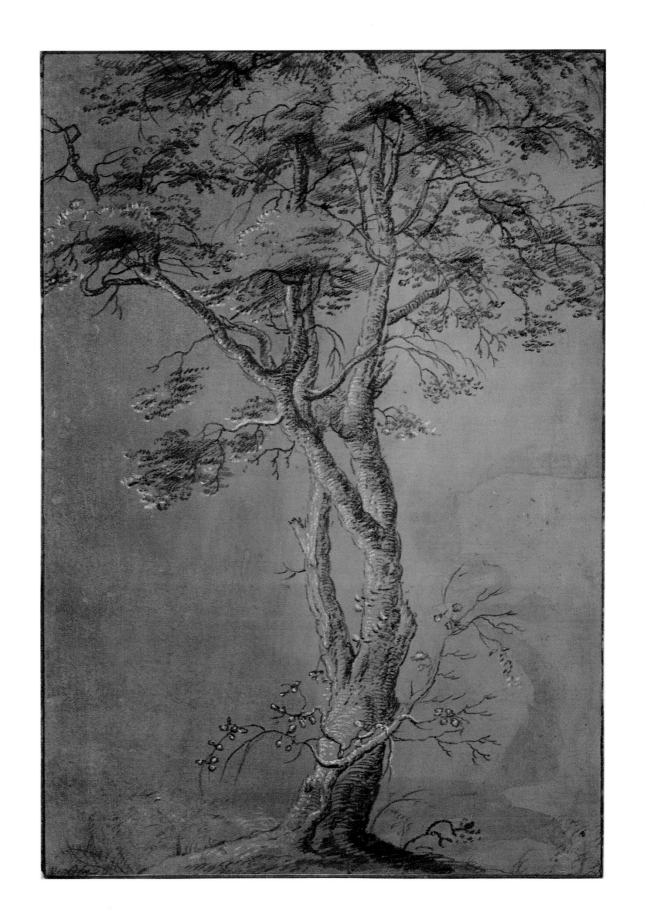

LUCAS VAN UDEN
(1595–1672/73)

23 Wooded Landscape with Monastery 1640

Preliminary drawing with graphite, both freehand, and for the initial pictorial area, ruled; pen and brown ink washes; grey (carbon) ink washes, with drawing with the pen and point of the brush, and restricted watercolour wash with drawing with the brush alone; white and blue bodycolour (restricted to the sky); slight overdrawing in graphite on the cabins, left of centre; on pale buff (now stained) laid paper. The sheet unevenly trimmed at all sides.

Watermark: fleur-de-lis in a shield, surmounted by a crown, with letters or numbers below.

19.4 × 34.9 cm.

Signed in brush and grey ink wash, with strengthening with the pen and brown ink, lower right: 'L.V.V.', and dated in pen and brown ink: '1640'.

Inscribed in pen and brown ink, *verso*: 'utdens'.

PROVENANCE: Sir Robert Witt (purchased from the Garrett sale, Puttick and Simpson, 2 June 1926, lot 1); Witt Bequest 1952 (2175).

EXHIBITIONS: R.A., 1927 (644); Stoke, 1928; York, 1928; V. & A., 1943; Courtauld, 1977–78 (50).

The type of extensive, wooded landscape with prominent stretches of water represented in the drawing exhibited here is frequently encountered in van Uden's larger watercolour compositions, e.g. those in Antwerp,[1] Berlin,[2] Hamburg,[3] Paris[4] and Stockholm.[5]

The site depicted in the present work is the Capuchin convent near Tervueren, at the northern edge of the Forêt de Soigne, which lies just to the south-east of Brussels. The last of many religious establishments to be set up in the forest, this convent was also the most short-lived. Its land, known as Eschendel (valley of ash trees) was donated by the pious Archduchess Isabella (1566–1633) who in 1626 also laid the cornerstone of the principal cloister. By 1627 construction work on the convent, designed by Father Charles d'Arenburg, was complete. Many wealthy and fashionable adherents were attracted to the cloister, among whom was the Infanta herself, who frequently held retreats in a specially constructed cell on the periphery of the grounds. From the mid-eighteenth century, the convent went into decline: its land and trees were sold off piecemeal until 1796, when it was suppressed by the French Republic.[6]

The group of five small buildings represented in the middleground of the Courtauld composition are identifiable as the convent's hospital; the taller building, whose roof is crowned by a lantern, was the hospital chapel. Part of the side wall surrounding the cloister is visible here at the extreme right.[7]

A watercolour by van Uden of the hospital buildings viewed beyond the dijk surrounding Eschendel and including in the foreground the reclining figure of an angler is in a private collection in Berlin.[8] The vantage point from which the artist observed this scene would have been located at what is the extreme right middleground of the present composition.

A second watercolour, incorporating at the right a rear view of the hospital complex and looking towards the main cloister in the middle distance is in New York.[9] This composition is closely related to a small painting on panel by van Uden, to the foreground of which peasants and a Capuchin monk were added by David Teniers II. This work, which is now in Basle,[10] was sold from the Watremez collection in Brussels in 1922 as one of a pair.[11] Its pendant represents the main convent building observed from the opposite direction,

while in the foreground are the figures of a country girl, a herdsman, and cattle and sheep, also added by David Teniers. This panel was last recorded in 1935 in the Rotthier collection, Brussels.[12] Van Uden translated that composition, in reverse and without staffage, into an etching published in an undated edition by Franciscus van den Wyngaerde (1614–79),[13] an impression of which, heightened with watercolour by the artist, was recently acquired for the Rijksmuseum, Amsterdam.[14]

Of the cloister subjects mentioned above, only that exhibited here bears a date, which is 1640. A similar date may be assigned to the drawings in Berlin and New York, although the paintings and etchings were probably later creations.

1 Plantin–Moretus Museum; Delen, 1938, Nos. 334, 335.
2 Bock/Rosenberg, p. 287, Nos. 3755, 12052.
3 Kunsthalle, Inv. No. 22594; exh. Hamburg, 1967 (66).
4 Louvre; Lugt, 1949, Nos. 1355, 1357.
5 Nationalmuseum; Schönbrunner/Meder, Vol. IX, No. 1060.
6 The site was first identified by S. Pierron, *Savoir et Beauté*, October 1924, pp. 307–08, from van Uden's etching, mentioned below. The history of the Tervueren cloister is recounted in full in Pierron, pp. 424ff.
7 An etched bird's-eye view of the convent, reproduced from A. Sanderus' *Flandria Illustrata...* (Cologne, 1641–44) is in Wauters, p. 292, No. 521.
8 ex coll. Huldchinaky, sold Graupe, Berlin, 3 November 1931 (lot 88); exh. Hamburg, 1965 (125).
9 Pierpont Morgan Library; exh. Paris/Antwerp/London/New York, 1979–80 (27).
10 Öffentliche Kunstsammlung, Inv. No. 1145.
11 Le Roy, Brussels, 6–7 March 1922 (lot 196); its pendant was lot 195.
12 cf. L. Lebeer, in *Le Brabant et l'Art de la Gravure*, p. 236, in *Mémorial* of exh. cat. Brussels, 1935.
13 Bartsch, vol. V, p. 50, No. 56, as after Rubens.
14 Inv. No. 69:130.

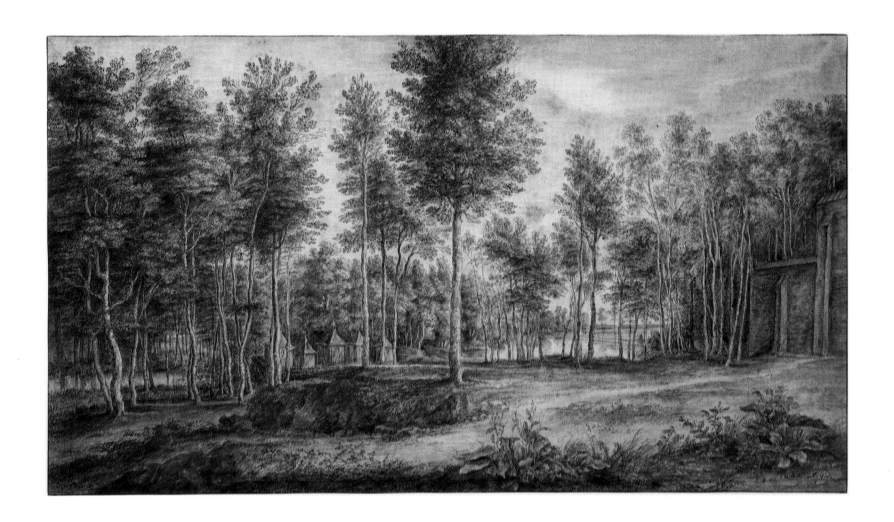

LODEWYK DE VADDER
(1605–1655)

24 Landscape with Shepherd and Flock

Pen and brown ink; restricted watercolour washes, with some drawing with the point and flat of the brush; on pale buff (stained) laid paper. The drawing edged with a ruled line in pen and black ink, and unevenly trimmed at all sides.

13.7 × 21.1 cm.

Verso: studies of foliage and trees in graphite and pen and brown ink, and a study of a man's head in pen and brown ink. Flourishes in graphite, terminating in illegible script.

PROVENANCE: Sir Robert Witt (purchased from Parsons, no date); Witt Bequest 1952 (1003)

EXHIBITIONS: Brussels, 1935 (512).

Inscribed as a master in the Guild in Brussels in 1628 and one of the leading landscape painters of his day,[1] de Vadder was equally renowned for his late tapestry cartoons of *The Story of Diana and Pan*;[2] he also executed eleven small landscape etchings.[3] His works generally depict the undulating, lightly wooded scenery associated with the forest of Soigne in the environs of Brussels.[4] After his death, much of his work was forgotten, and today examples of his draughtsmanship are scarce. Signed sheets indicate,[5] however, that de Vadder was able to draw in a range of styles, and it is possible that works by him are filed either with those of his pupils Ignatius van der Stock (master of the Brussels Guild in 1660) and Lucas Achtschellinck (1628–1699),[6] or ascribed to his follower Jacques d'Artois (1623–1686), or even confused with drawings by Lucas van Uden (see Nos. 22 and 23).[7]

The drawing exhibited here is comparable to signed sheets in Munich[8] and Paris:[9] it shares with these a characteristic tree form, with leaves growing low on a slender and often sinuous trunk, and a narrow crown of foliage built up from circular leaf clusters described by continuous and unevenly looped contours. Areas of shadow defining masses of foliage are created by the repetition of hooked strokes of generally diagonal direction, while those indicating the relief of the earth display a greater variety of length, direction, thickness and openness. The hatching across foliage, even in the background, tends to be the densest in the sheet. All lines are nervously rendered with a fine-nibbed pen, and the overall handling of the drawing suggests rapidity of execution.

Unlike the sheets in Munich and Paris, this drawing is delicately tinted with watercolour: an unsigned sheet in Brussels,[10] more heavily worked than that exhibited here, but nonetheless convincingly attributed to de Vadder, is washed with a comparable range of pale yellows, browns, greens and blues.

The Munich and Paris drawings give the impression of having been recorded from nature. More decorative than these, the Courtauld work, which includes the figures of shepherds and a small flock to enhance its idyllic character, was probably created in the studio. The path between sandy banks partly covered with vegetation visible here in the background is a motif which van Hasselt notes[11] is frequently encountered in the work of de Vadder and his followers. Signed paintings whose compositions relate to that exhibited here are in Barnard Castle,[12] and were sold in Stockholm in 1960.[13]

1 Houbraken, vol. I, p. 216, and Bartsch, vol. V, p. 57 ff. were of this opinion.
2 De Vadder was paid 1000 Guilders for the cartoons in 1646: the tapestries were woven by Baudouin van Beveren (?–1651)
3 Bartsch, *loc. cit.*

4 Wilenski, p. 301.
5 Compare drawings in the Kunsthalle, Hamburg, inv. No. 22605 (Bernt, II, No. 581), in Munich (Wegner/München, No. 972) and in the Courtauld Institute Galleries (Witt No. 2305).
6 Houbraken, *loc. cit.*, reports that Achtschellinck was de Vadder's pupil.
7 Bartsch, *loc. cit.*, notes that de Vadder's etchings were previously uncatalogued due to confusion with van Uden's work: Witt drawing No. 1002 entered the Courtauld Institute Galleries as by the hand of van Uden, but is now reattributed to de Vadder.
8 Staatliche Graphische Sammlung; Wegner/München, No. 974.
9 Louvre; Lugt, 1949, No. 1358.
10 de Grez coll.; exh. Brussels, 1978 (25).
11 Van Hasselt, in exh. cat. London/Paris/Berne/Brussels, 1972 under No. 113.
12 exh. Brussels, 1965 (289).
13 Bukowski, 9–12 November 1966 (lot 190, 191 (pendants)); photos Witt.

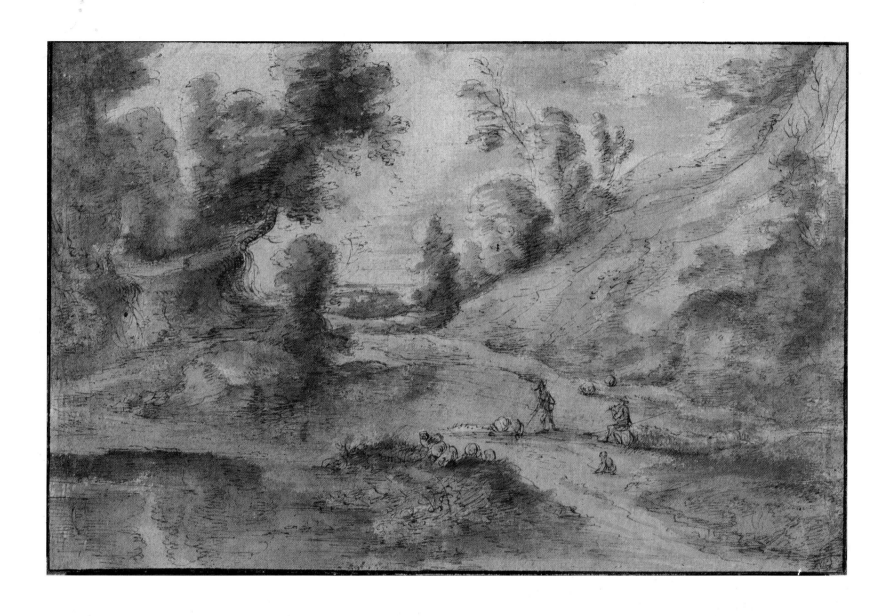

TOBIAS VERHAECHT
(1561–1631)

25 Mountainous Landscape with a Cross

Slight preliminary drawing in graphite; pen and brown ink; brush and brown ink washes; on pale buff (stained) laid paper. The sheet edged by the artist's ruled line in pen and brown ink, and unevenly trimmed at all sides. Laid down.

20.5 × 32.3 cm.

Numbered in blue crayon on the backing: '538' (encircled).

PROVENANCE: Sir Robert Witt (purchased from Colnaghi, no date); Witt Bequest 1952 (3365).

EXHIBITION: Courtauld, 1977–78 (42).

Verhaecht, a conservative artist[1] working within the older Flemish landscape tradition, is perhaps best known today as the early teacher of Peter Paul Rubens (1577–1640). He entered the Guild of St. Luke in Antwerp in 1590/91 after having journeyed to Italy. During his travels, he passed through the Valley of the Inn,[2] the topography of which provided inspiration for many subsequent paintings and drawings. The majority of the artist's works on paper (in the past confused with those by Joos de Momper[3]) are unsigned and undated; and since his bold and personal handling varied little throughout his career, there is no secure basis upon which the drawings may be chronologically arranged.

The drawing exhibited here is a typical example of Verhaecht's Alpine landscape compositions: the open and somewhat coarse penwork, the dislocation of scale between strokes describing motifs in the fore- and background, and the summary application of monochrome wash suggests that it is an informal and rapid work. Like most drawings in this artist's *œuvre*, it is not a preliminary sketch for a painting, and must therefore be considered as an autonomous work of art.

The general disposition of the landscape here recalls not only that of the painting dated 1612 in Munich,[4] but also that included in several drawings, fine examples of which are in Berlin[5] and Leningrad.[6] The right half of the composition, comprising a rocky hillside in which is planted a cross and at whose summit is a small wood, is an elaboration of a motif stated in a drawing in the collection of Victor Goldschmit of Heidelberg, in 1927.[7] In that sheet, the cross marks the cave of a hermit, who is seated at its entrance: in the present composition, all staffage is eliminated. The motif of a framing tree with a view beyond to a small wood traversed by diverging paths, upper right, betrays a debt to woodland scenes of the Bol–Coninxloo tradition, and is also visible in drawings by Verhaecht in, among other places, Brunswick,[8] Dordrecht[9] and London,[10] and in plates 1 and 3 of Hans Collaert's undated engravings after the latter's designs for *The Ages of the World*.[11] Such variations of motifs, and even restatement of entire compositions, are frequently encountered in Verhaecht's work, as is revealed by comparison between sheets in Stockholm[12] and Antwerp;[13] a work formerly in the collection of Sir John Witt, London[14] and that sold at Sotheby in 1974;[15] and the drawings in Berlin and Leningrad cited above.

1 Raczyński, p. 65.
2 A drawing of the Inn Valley with the Martinswand, apparently after nature, is reproduced by A. P. Oppé, *Old Master Drawings*, September–March, 1939–40, pl. 49.
3 See inscription on No. 26, *verso*. Lugt, 1949, observed that Verhaecht drawings in the Louvre had been confused with those by de Momper.
4 Ältere Pinakothek; Raczyński, pl. 35.
5 Staatliche Museen; Bock/Rosenberg, p. 56, No. 5851, and a sheet in the Beck coll.; Bernt, II, No. 623.

6 Hermitage; Kusnetsov, No. 122.
7 Repr. *Stift und Feder*, 1927, p. 66.
8 Landesmuseum; photo Witt.
9 exh. Dordrecht, 1968 (119).
10 ex coll. Dr Victor Bloch, sold Sotheby, 13 December 1973 (lot 106); photo Witt.
11 Hollstein, Vol. IV, p. 213, Nos. 121–24.
12 ex Perman coll.; Bernt, II, No. 622.
13 Plantin–Moretus Museum; Delen, 1938, p. 24, No. 138.
14 *A Mountain Landscape*; photo Witt.
15 *A Mountain River Landscape*, sold Sotheby, 27 June 1974 (lot 11); photo Witt.

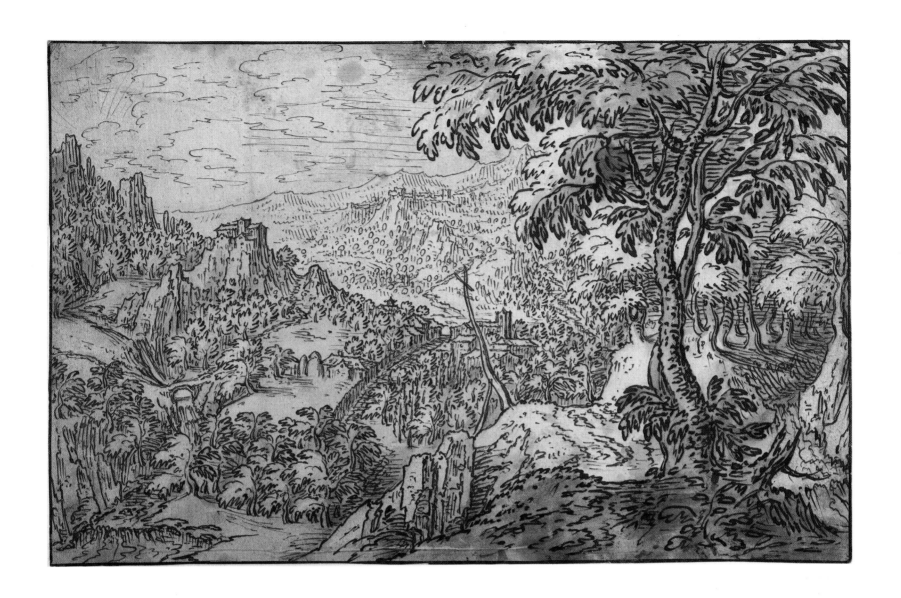

TOBIAS VERHAECHT
(1561–1631)

26 Mountainous Landscape with River and Waterfall

Traces of preliminary drawing in graphite; pen and dark brown ink washes; grey (carbon) and brown ink and blue watercolour washes, with slight drawing with the point of the brush; on off-white laid paper. The pictorial area enclosed within the artist's ruled line in pen and dark brown ink. The sheet folded diagonally, twice, upper right, and unevenly trimmed at all sides. A tear repaired, upper right.

Watermark: 'J Kool' (?)

22.4 × 38.6 cm.

Inscribed in different hands in graphite, *verso*: 'Momper/112', and three times: 'Momper', and: 'Aw.-'. An erased inscription in graphite, *verso*, may read: 'J.E.:. 101 1726'.

PROVENANCE: Lannoy, sold de Vries, Amsterdam, 19–28 May 1925 (lot 769); Sir Robert Witt (purchased from Holgen, no date); Witt Bequest 1952 (2128).

EXHIBITIONS: R.A., 1927 (557); Berlin/Bochum, 1927–28; V. & A., 1943; Rotterdam/Brussels/Paris, 1948–49 (69); Courtauld, 1977–78 (40).

The present sheet offers an example of Verhaecht's more finished manner of drawing. Similar highly worked compositions, also tinted with blue and grey washes, are to be found in most major printrooms.[1]

The type of landscape depicted in this work – a tract of elevated ground at the right occupying approximately two-thirds of the pictorial area, the remainder comprising a panoramic view over a valley – is similar to that included in the paintings *The Temptation*, with the Matthiesen Gallery, London, in 1950,[2] and *A Mountain Landscape with the Flight into Egypt* with the Gottschewski–Schäffer Gallery in Berlin in 1927.[3] Comparable drawn compositions are in Paris[4] and Vienna.[5]

The motif included here in the middleground of a centrally located tree, the angle of whose trunk is contrasted with opposing diagonals of background rock strata and forms of lesser tree trunks, occurs rarely in Verhaecht's work, but is a variant of that shown in a drawing in Dresden.[6] In that composition, the background mountains and valley are almost completely subordinate to the large crossing rhythms of centrally positioned pines.

1 e.g. in Berlin (Bock/Rosenberg, p. 56, No. 5851), in the British Museum (Popham V, p. 137, nos. 1, 2), in the Louvre (Lugt, 1949, Nos. 1371, 1372, 1374) and in the Albertina, Vienna (Benesch, 1928, Nos. 267, 268).
2 Photo Witt.
3 Cf. *Cicerone*, no. XIX, 22 November 1927, p. 690.
4 Louvre; Lugt, 1949, No. 1371.
5 Albertina; Benesch, 1928, No. 267.
6 ex coll. C. Otto, sold Boerner, Leipzig, 7 November 1929 (lot 248); acquired by the Kupferstichkabinett, Dresden; photo Witt.

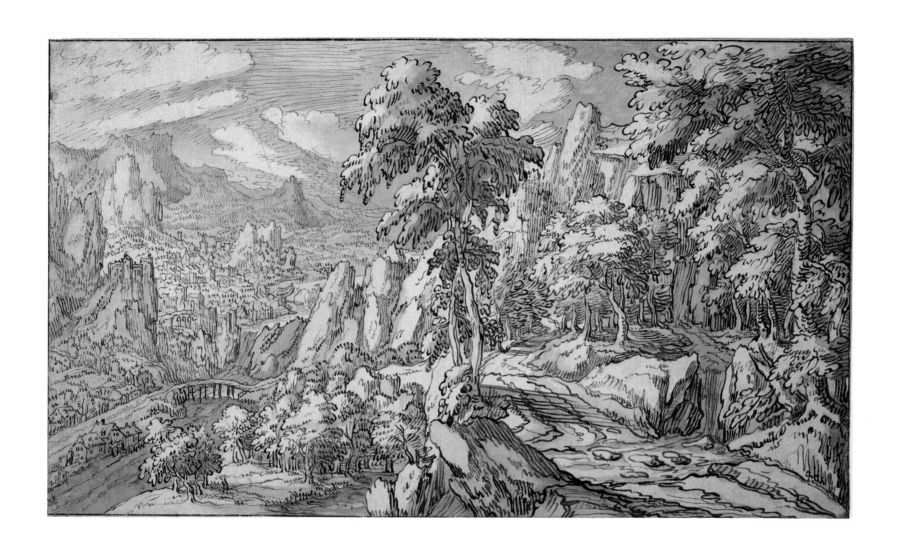

JAN WIERICX
(*c*.1549–after 1615)

27 The Pool of Bethesda (?) 1590

Pen and brown ink; slight heightening with lead white (apparently restricted to the figures of man and woman, right of centre, and the cloak of Christ); on vellum (now stained and abraded). The sheet unevenly trimmed at all sides and laid down.

19.8 × 27.5 cm.

Signed in pen and brown ink, lower left: 'Johannes Nieriecs/Inventa Et Fecit/1590 . . . [?]'

A long initialled inscription in French erased from the backing. Inscribed in a modern hand in pencil, on the backing: 'Jan Wierix b 1548 or 9 d after 1615/ The Pool of Bethesda perhaps a drawing for engraving Alvin 393 or 394/ Collector Mark Engau [?] 529 (owner unknown)', and numbered: 'A.5541'.

Stamped with the mark of an unknown collector (Lugt 2508), *recto*.

PROVENANCE: Unknown collector (Lugt 2508); Oppenheimer, sold Christie, 10–14 July 1936 (lot 331 (a)), bt. Sir Robert Witt; Witt Bequest 1952 (2800).

EXHIBITIONS: Courtauld, 1977–78 (13).

Like his father by whom he was taught, Jan Wiericx and his brother Hieronymous (1553?–1619) were by profession engravers. At the age of eleven, Jan was engaged in copying prints after older masters (particularly Dürer) in the father's Antwerp studio: in his maturity, however, he tended to concentrate on engraving his own compositions rather than the work of others.[1] Perhaps a less prolific engraver than his brother,[2] Jan was in addition the author of a corpus of drawings comprising series of Biblical scenes (of which he made replicas),[3] portraits,[4] and mythological subjects.[5] Drawings such as those exhibited here which incorporate extensive land- or cityscapes are the exception in his *œuvre*.

Of small format, the drawings are usually executed on vellum with a fine-nibbed (crow?) quill in brown ink; precise contours sharply delineate each form, while modelling is built up from networks of thin, regular cross or parallel hatching, dashes aligned in rows and fine stippling. All areas of the composition are handled with a minute and equal attention to detail in which effects of light or atmospheric recession are largely ignored. The range of strokes displayed in these works is developed from that employed in engravings; and indeed, the drawings appear to have been created specifically for sale in lieu of prints.

The present composition, whose subject is taken from the Gospel of St John, chapter 5, verses 1–12, is related to that shown in reverse in *The Healing by the Pool of Bethesda*,[6] plate 10 of a series of 12 engravings depicting *The Miracles of Christ*. According to Mauquoy-Hendrickx, the suite was engraved after designs by Martijn van Heemskerk and the obscure Antwerp draughtsman Gerard P. Groenning (active in the latter half of the sixteenth century):[7] the Bethesda subject, however, is the only plate of the series to bear Wiericx's signature, which suggests that the composition was probably his own invention. Although undated, it was engraved in, or prior to 1585, since it is included in the *Thesaurus* published by Gerard de Jode (1509/17–1591) in that year.

In the print of the Bethesda subject, as in the majority of the Wiericx brothers' works, Mannerist figures in the style of van Heemskerk predominate by virtue of their large scale and alignment across the foreground: they are controlled by a perspective system dependent on a vanishing point located at the compo-

sition's centre. The minimal architectural elements indicating the imaginary town in the print are subordinate to the staffage, grouped behind them in such a manner as to reinforce the composition's narrative content. The townscape is observed from a higher vantage point than the figures, but each building is governed by its own perspective system unrelated to any other.

In the drawing exhibited here, the large-scale staffage of the Bethesda engraving is substituted for small figures which are variants of those included in a second scene depicting Christ as healer, *The Healing of the Blind Man*,[8] plate 4 of *The Miracles . . .* suite, and also datable to *c*.1585. As in that engraving, the figures are here located deep within pictorial space, while the townscape is drawn from a comparably elevated vantage point.

By reducing the scale of the figures, the significance of the narrative content is diminished, but the dislocation between perspective systems regulating staffage and those controlling the architecture is minimised. The multiplicity of perspectives governing the urban setting nevertheless creates a pictorial space of fluid, uncertain character. Unlike the Bethesda engraving, this drawing includes in the townscape architecture in the Flemish as well as the Italian style, and detail is now elaborated and recorded for its own sake: the motif of the butcher's shop, for example, cursorily indicated in *The Healing by the Pool . . .*, is here explored with a wealth of detail in which types of meat and poultry, cutting blocks, and even butchers' knives are characterised.

Although the drawing bears a date, the third figure is unclear, and has been read as both '8' and '9'.[9] Since the composition synthesises pictorial constructions and motifs used in two engravings datable to *c*.1585, it is probably a recapitulatory work, which would justify an interpretation of the date as 1590.

1 Biographical details of the Wiericx family are given by L. Lebeer in the introduction to Mauquoy-Hendrickx.
2 The style of the Wieriecx brothers appears to be indistinguishable: Mauquoy-Hendrickx lists all unsigned prints, but does not attribute them to one or other engraver.
3 e.g. 19 illustrations to *Genesis* are in the British Museum (Popham, V, pp. 194–195, Nos. 1–19, and six of a comparable set are in the Staatliche Museen, Berlin (Bock/Rosenberg, p. 59, Nos. 13599–13604). Seven scenes from the Passion in the British Museum (Popham, V, pp. 195–196, Nos. 20–26) are repeated in drawings in the Albertina, Vienna (Benesch, 1928, Nos. 203–210).
4 e.g. in the Staatliche Museen, Berlin (Bock/Rosenberg, p. 59, Nos. 4507, 13605), and in the Albertina, Vienna (Benesch, 1928, Nos. 213–215).
5 A *Diana and Calysto* is in the Albertina, Vienna (Benesch, 1928, No. 211) and a *Diana and her Nymphs surprised* was in the Fenwick collection (Popham, 1935, p. 208, No. 1, pl. XCII): in the same collection was an *Infant Bacchus, a Child with Tambourine, and a Satyr lying on the Ground* (Popham, 1935, p. 209, No. 3).
6 Mauquoy-Hendrickx, No. 98.
7 Also called 'Groennig' or 'Groningus'. Erroneously called 'Gerard Paludanus van Groeningen' in von Wurzbach and Mauquoy-Hendrickx. That author does not identify the author of each design in the *Miracles . . .* suite.
8 Mauquoy-Hendrickx, No. 92.
9 In the Oppenheimer sale catalogue the date was transcribed as '1550', but was read by Sir Robert Witt as 1580.

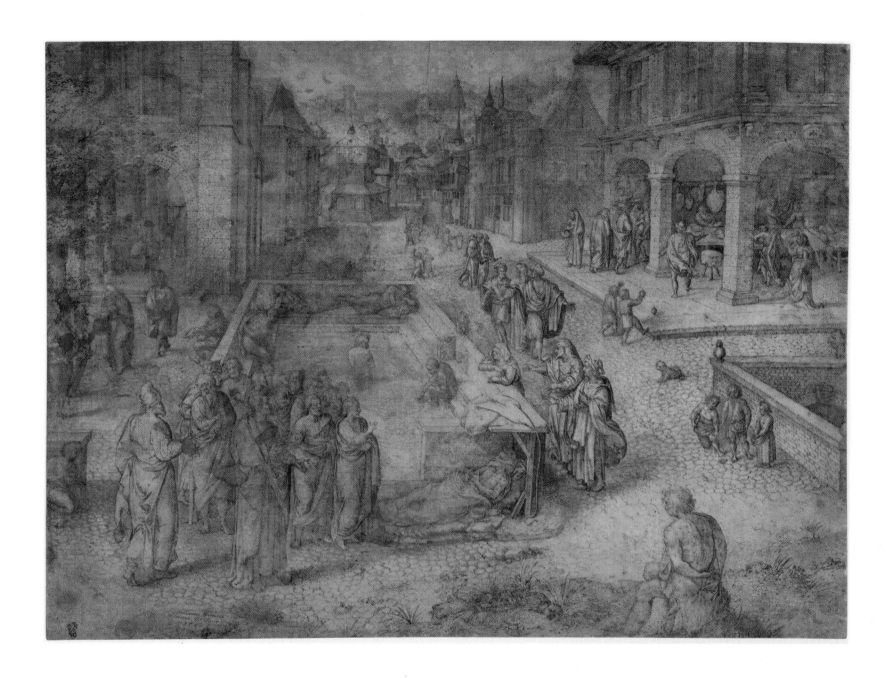

JAN WIERICX
(*c*.1549–after 1615)

28 Landscape with the Conversion of Paul 1613

Pen and brown ink; on vellum. The sheet edged by a later hand with ruled lines in pen and brown ink, and green watercolour. The sheet unevenly trimmed to an irregular shape. Repairs, bottom left of centre.

20.5 × 27.8 cm.

Apparently signed in pen and brown ink, lower left: 'J W' (deliberately obscured by the undergrowth).

Numbered in pen and brown ink, lower left of centre: '. . . 28'.

Dated by the artist in pen and brown ink, *verso*: $\overset{o}{A}$: D :/16: 13: ', and inscribed in a later hand in pen and brown ink: 'Duke of Buckingham Collection/1730'. Stamped with the collector's mark of E. A. Paterson (Lugt supp. 826a), *verso*.

PROVENANCE: Duke of Buckingham, 1730; . . . ; (?E. Peart[1]); E. A. Paterson; Sir Robert Witt (purchased from Colnaghi, no date); Witt Bequest 1952 (4509).

EXHIBITIONS: Arts Council, 1953 (88); Manchester, 1962 (48); Courtauld 1977–8 (12).

The subject of the Conversion of Paul appears once only in the engraved work of the Wiericx brothers, and then as a subsidiary motif in the background of a composition depicting St. Luke,[2] a plate from an unsigned and undated series of *Evangelists*. In that print, as in the present drawing, the conversion takes place adjacent to a church, symbol of God's authority on earth.

The Biblical scene is here located in the middle-distance of an imaginary landscape which fuses Italianate and Flemish motifs. The composition includes landscape elements comparable to those in a similarly large but undated drawing of *The Flight into Egypt* in Vienna,[3] e.g. the foreground road aligned with the lower edge of the sheet; a river flowing counter to it, spanned by a prominent brick-built bridge; and a view of distant coastline. The Vienna landscape is constructed from three distinct lateral zones: the first comprises the road flanked by flat terrain, behind which is located a wooded, hilly middledistance traversed by winding paths which forge links with a background coastal scene. All zones are united at the right by the river which follows a diagonal course to the sea.

The landscape here is of a more complex and flexible character: unlike that of *The Flight into Egypt*, fore-, middle- and background are related by geological structure, and the distant coastal scene is united with the composition's elevated front planes by repetition of undulating hill forms. The road in the foreground curves back at the right to run diagonally through the middleground, echoing the river's course, its contour elided with those of the coast. A path diverging from the same foreground road at the left of the sheet swings to the right around the base of the middleground castle, creating a curve which is echoed by the background shorelines. Fore- and middleground are thus linked by an open, looped system of roads and paths which leads both from and to the background. While staffage dispersed over the landscape reasserts this pattern of roadways, the troops who flee as Paul is blinded by the ray of light are arranged diagonally, in a direction running counter to that of the main road. This subsidiary alignment of figures activates the perspective of terrain uncharted by paths near the centre of the composition. The soldiers in the foreground, physically and psychologically divorced from the drama of Paul's conversion, turn to the left, the rhythm of their raised lances anticipating the curve of the bridge over which indifferent civilians pass. The right-to-left movement along

the road is contained on the left of the composition by the figure of the spear-carrier, through whose *contrapposto* stance movement is directed upwards and back into the middleground.

While the present landscape gains unity and coherence from the disposition of staffage, the location of many of the figures can also be seen to be dictated in some measure by the terrain's physical structure. Figures and landscape are thus to a degree mutualy dependent in this work, unlike that in Vienna (which may be earlier), in which staffage and landscape are conceived as isolated elements. Wiericx's composition nevertheless relies on the Mannerist conventions of the sixteenth century, and the date of 1613 on the *verso* reminds us of the conservatism of his invention.

1 Cf. Sir Robert Witt's files, information communicated by Colnaghi. It seems possible that Paterson's collector's mark was mistaken for that of Peart.
2 Mauquoy-Hendrickx, No. 830; the image of St. Paul also appears in the background of Mauquoy-Hendrickx, No. 585, but is unrelated to the present drawing.
3 Albertina; Benesch, 1928, No. 212: 20 × 31 cm.

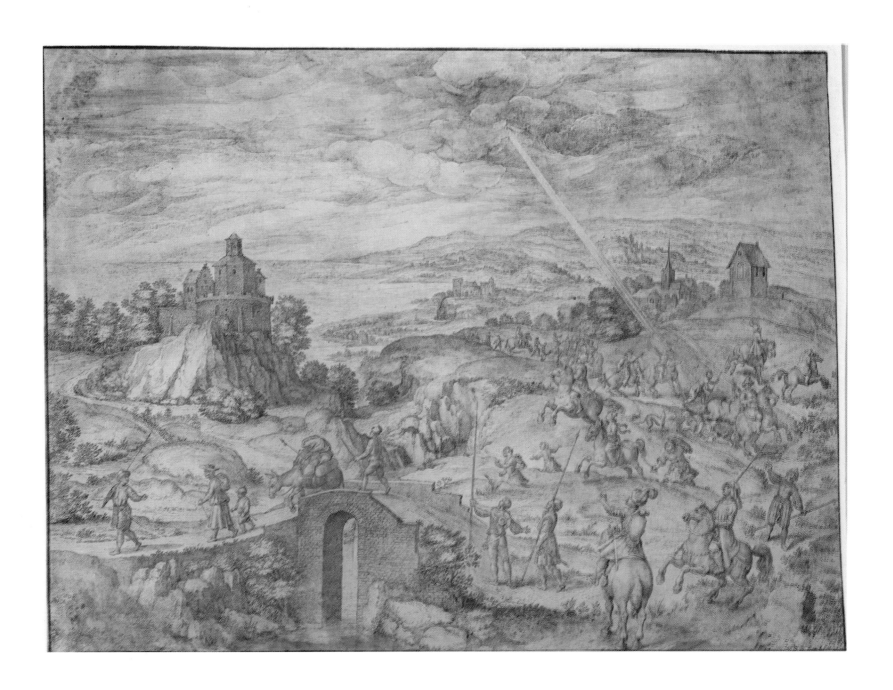

JAN ASSELYN
(1610–1652)

29 Landscape with Ruined Bridge after c.1645

Traces of slight preliminary drawing in black chalk(?); pen and light brown ink; grey (carbon) ink washes, and pale blue-grey made up watercolour or bodycolour washes; on off-white (discoloured) laid paper. The sheet edged with a ruled line in pen and black ink, and unevenly trimmed on all sides. A vertical fold at the centre, and the bottom right corner made up.

28.0 × 37.6 cm.

Inscribed in pen and brown ink, *verso*: 'H: Van Minderhout tot Naerden 1662.' (i.e. 'H: Van Minderhout from Naarden 1662').

PROVENANCE: Sir Robert Witt (purchased from Colnaghi, no date); Witt Bequest 1952 (3429).

EXHIBITIONS: Manchester, 1962 (16).

A number of drawings which may with certainty be attributed to Asselyn has been discussed by Steland-Stief, who notes the problems of ascribing works to this artist,[1] whose style was widely imitated;[2] there are, moreover, few sheets signed by the master[3] with which attributed drawings may be compared. A drawing such as that exhibited here presents additional complications, in that it is neither a preparatory design for an engraving, nor apparently related to a painting.

The removal of the drawing's backing in 1985 exposed the inscription on the *verso*, transcribed above. Its meaning is unclear: it connects Naarden, a town some eight miles from Amsterdam with one H. van Minderhout. That this refers to the Rotterdam-born painter of that name (1623–1696) is unlikely, since from 1652 that artist was resident in Bruges, where he became master of the Guild in 1662, the date on this sheet. The inscription may perhaps be interpreted as the mark of a collector, also called van Minderhout, from Naarden.

The attribution to Asselyn of the Courtauld sheet, although traditional, is based on compositional similarities with paintings such as that in the collection of J. M. Tydeman Ver-Loren van Themat, Ginneken.[4] That the drawing is an original invention, rather than an elaborate record of a composition by the master, is confirmed by the exploratory nature of the preliminary chalk work and by the confidence with which forms are revised or resolved by the pen drawing.

Motifs and handling in this sheet are comparable to those in Asselyn's views of Roman ruins which were engraved by Gabriel Perelle (c.1603–1677).[5] As in those designs, the architecture here is located within a landscape layered back into space by bands of alternating light and shadow. The bridge remains unidentified, and is perhaps an imaginary structure based on the Ponte Molle in Rome.[6] Its sagging arches are closely comparable to those in drawings in Brussels,[7] Rotterdam,[8] London[9] and Windsor,[10] while the two former designs and a sheet in Hamburg[11] also share with the present work the motif of fractured archway, in which details of exposed masonry are rendered with comparable precision, each crack or pit of the brickwork indicated by the tip of the brush with delicate meandering lines, or accented flecks and dots. Typical of Asselyn's treatment of architecture is the application of broad areas of wash which unite all details of an elevation into a simplified pattern of light and shadow;[12] such bold areas of wash also clarify the larger organic forms of decayed masonry, as is demonstrated in the arches here. Wash of a particularly dark tone is often employed to render a small window (such as that on the

tower, right) or shadow cast by a projection or moulding, which punctuates the larger illuminated wall surfaces, enhancing the effects of intense sunlight.[13]

Frequently associated with ruins in Asselyn's designs are the long, triangular clusters of hanging creeper (visible here on the archway, right, and fortifications, left), drawn with a vocabulary of scalloped and hooked strokes,[14] variants of which are employed to describe all foliage other than that in the immediate foreground. Leaves indicated with a related zig-zag contour are conceived as feathery, upward-curving forms (particulary apparent here in the middleground), yet as in other drawings by this artist, all species of vegetation tend to be low and rounded, hugging the architecture from which they sprout.[15]

The handling and formal invention in other areas of the composition also accords with what is known of Asselyn's drawings. For example, the clouds (here, as in other sheets by the master, cumuli modelled with restricted gradations of wash, juxtaposed with softly brushed bands of stratus or stratocumulus) are more fully realised than those in designs which Perelle engraved,[16] yet share with them an upward diagonal movement which contrasts with the thrust of the architecture: characteristic of Asselyn's composition is the closing of the top of the pictorial area with streaks of stratus cloud.

Figures and animals here may also be related to those in works for which Asselyn is convincingly established as author. The cowherd with elongated legs and accented shoulder structure is found in sheets in Berlin,[17] Haarlem[18] and Hamburg,[19] while his thickset mongrel, with similarly exaggerated shoulders, recalls in breed, pose, and the sympathy with which it is observed, the dog in a drawing in Frankfurt.[20] Similar long-bodied cattle, with eyes drawn slightly to the front of the head, appear in a sheet in New York,[21] and in the painting in Ginneken, cited above.

That this drawing is by Asselyn cannot be conclusively proven, yet in all points of imagery and treatment it is so closely comparable with sheets reliably ascribed to that artist that its inclusion in his *œuvre* is justified. Its dating is uncertain, although it appears to be a late work, executed perhaps after the artist left Italy, that is, after c.1645.

1 Steland-Stief, 1980, p. 213. Biographical details of Asselyn are included in Steland-Stief, 1971.
2 Asselyn's imitators are discussed by Steland-Stief, 1971. Thomas Wyck (1616–1670) often came very close to the master's style.
3 A sheet in the Kunsthalle, Hamburg, is signed with interlaced initials; Steland-Stief, 1980, pl. 11.
4 Steland-Stief, 1971, No. 183. The old mount of the Courtauld drawing bore an ascription to Asselyn, and the work was purchased by Sir Robert Witt as from this artist's hand.
5 Hollstein, vol. I, p. 44, Nos. 15–32.
6 The Ponte Molle, otherwise known as the Pons Mulvius, was built on the Via Flaminia in 220 B.C. It was restored by G. Valadier in 1805, partly destroyed in 1849, and rebuilt within a year; Nash, vol. II, p. 191. The bridge as Asselyn would have known it appears in topographical drawings by Claude Lorrain of c.1640 in the National Gallery of Canada, Ottawa, and in a private colection; Röthlisberger, 1968, Nos. 426, 427, respectively.
7 De Grez coll.; Steland-Stief, 1980, pl. 9.
8 Boymans-van Beuningen Museum; Steland-Stief, 1980, pl. 7.
9 British Museum; Steland-Stief, 1980, pls. 21–23.
10 Coll. H.M. The Queen; Steland-Stief, 1980, pl. 8.
11 Kunsthalle; Steland-Stief, 1980, pl. 10.
12. e.g. de Grez coll., Brussels; Steland-Stief, 1980, pls. 15. British Museum; Steland-Stief, 1980, pls. 22, 23.
13 e.g. Kunsthalle, Hamburg; Steland-Stief, 1980, pl. 11. British Museum; Steland-Stief, 1980, pl. 20.
14 e.g. Teylers Museum, Haarlem; Steland-Stief, 1980, pl. 4. Kunsthalle, Hamburg; Steland-Stief, 1980, pl. 10. Pierpont Morgan Library, New York; Steland-Stief, 1980, pl. 5.
15 e.g. British Museum: Steland-Stief, 1980, pls. 20–23.
16 e.g. Teylers Museum, Haarlem; Pierpont Library, New York; Kunsthalle, Hamburg; Steland-Stief, 1980, pls. 4, 5, 11, respectively.
17 Berlin Dahlem; Steland-Stief, 1980, pl. 28.
18 Teylers Museum; Steland-Stief, 1980, pl. 3.
19 Kunsthalle; Steland-Stief, 1980, pl. 10.
20 Städelsches Kunstinstitut; Steland-Steif, 1980, pl. 50.
21 Pierpont Morgan Library; Steland-Stief, 1980, pl. 5.

NICOLAES BERCHEM
(1620–1683)

30 River Landscape with Tower c.1655–63

Slight preliminary drawing in graphite; grey (carbon) ink washes with drawing with the pen and point and flat of the brush; on off-white (now stained) laid paper. The drawing edged with a ruled line in pen and black ink, and unevenly trimmed at all sides.

30 × 51.1 cm.

Signed in pen and black ink, bottom right: 'NꞶ Berchem f: −' (the initials interlaced).

Stamped with the collector's mark of Thomas Dimsdale (Lugt 2426), on the old backing.

PROVENANCE: Thomas Dimsdale; Lord Amherst of Hackney, sold Sotheby, 14 December 1921 (lot 57) bt. Sir Robert Witt; Witt Bequest 1952 (384).

EXHIBITIONS: Empire Art Loans Collection Society, South Africa, 1937–38; V. & A., 1943.

Nicolaes Pietersz., who adopted the surname Berchem,[1] was a pupil of, among others, his father, the still-life painter Pieter Claesz. (1597/98–1661) and Jan van Goyen.[2] Inscribed into the Guild in Haarlem in June 1642, he is said to be recorded in the winter of that same year in Rome, where he apparently remained until 1645.[3] Blankert[4] argues that the documentary evidence for a visit to Italy at this early date is insecure, and that circumstantial evidence would indicate a voyage in c.1653–54.

Italianate motifs incorporated into the present imaginary landscape include the massive, rectangular rock outcrops of the middle- and background (particularly common in Berchem's Mediterranean seaport views,[5] but evident also in landscapes proper[6]) and the fortified bridge. This latter motif may have been partly inspired by a structure such as the Ponte Molle in Rome,[7] which in the seventeenth century incorporated towers at either end, although the rustic wooden architecture visible here has little else in common with that classical monument. Round towers such as those included in this sheet (a second tower, left, is an independent structure unrelated to a bridge) appear frequently in Berchem's painted landscapes.[8] While such motifs may have been observed at first hand in Italy they nevertheless betray a debt to Jan Asselyn's work, the influence of which – despite that master's death in 1652 – continued to exert itself in Bercham's œuvre during the remainder of the decade, and possibly beyond.[9] The debt to Asselyn is manifest here above all in the use of prominent architectural elements to establish over the landscape bold and stately rhythms.

The deep, exaggerated space visible in this drawing is reminiscent of that which appears in Berchem's paintings of the late 1650s.[10] Crisply detailed motifs of pronounced tonal contrast in the fore- and middleground are juxtaposed with closely related, silvery tones of the background, suggesting that forms in that plane are perceived through a distant haze. Comparable perspective exaggerations achieved by analogous means characterise the work of Adam Pynacker, in which Berchem's interest is signalled by paintings datable to c.1656.[11]

The present composition is constructed from a series of lateral bands grouped low on the sheet: that of the foreground is formed by the expanse of water, while bridge and land mass at the right comprise the middleground, beyond which is the vista into deep space. The strong vertical accent of the tower counterbalances the composition's predominant horizontality. The foreground

herdsman and animals, aligned with the lower edge of the sheet, provide both the scale by which the vastness of the landscape may be gauged, and the means by which the spectator gains access to it. A panoramic landscape of exactly similar structure, also executed in carbon ink washes on a sheet of identical dimensions to that exhibited here is in the Albertina, Vienna.[12] That composition (which includes motifs related either to Alpine or Scandinavian landscapes) bears a conspicuous and ornamental signature comparable to that on the Courtauld sheet, and which, according to von Sick,[13] appears on drawings from c.1660 onwards. A more spectacular example of the present banded type of composition is also in the Albertina,[14] while this collection contains in addition a sheet dated 1655[15] in which the present pictorial structure is adumbrated. The Courtauld drawing may thus be assigned a date from the mid-1650s to perhaps the early years of the following decade.

1 Early works are often signed 'Berghem', Berighem' or 'Berrighem'.
2 Houbraken, Vol. II, p. 111.
3 von Sick, p. 7.
4 In exh. cat. Utrecht, 1965, p. 28.
5 e.g. in paintings in the Girardet coll., Kettwig (Ruhr), and City Art Gallery, York (exh. Utrecht, 1965, 93 and 81, respectively) and in the Wallace collection, London (Wallace coll., p. 6, Inv. No. 25), and in paintings sold from the Moltke coll., Winkel & Magnusson, Copenhagen, 1–2 June 1931 (lot. 6), and at Sotheby, 4 March 1970 (lot 57); photos Witt.
6 e.g. in the de Grez coll. (exh. Brussels, 1971 (44)), and the Gemäldegalerie, Dresden (Dresden, Inv. No. 1482).
7 A drawing by Berchem dated 1656 said to be of the Ponte Molle, was sold from the Argoutinsky–Dolgoroukoff coll., de Vries, Amsterdam, 27 March 1925 (lot 15).
8 e.g. in the Hermitage, Leningrad (exh. Manchester, 1974 (9)), Wallace coll., London (Wallace coll., p. 7, Inv. No. 186), in the Sutter coll., Mannheim (exh. Utrecht, 1965 (85)), and Nationalmuseum, Stockholm (Nationalmuseum/Stockholm, p. 14, Inv. No. 317.
9 Blankert in exh. cat. Utrecht, 1965, loc. cit.
10 e.g. in the National Gallery, London, signed and dated 1658; Maclaren, p. 22, Inv. No. 1004.
11 e.g. *Three Herds*, signed and dated 1656, and *Mountainous Landscape with Water-Fall*, Rijksmuseum, Amsterdam; Amsterdam, p. 110, A29 and C. 97, respectively.
12 Schönbrunner/Meder, vol. XI, No. 1257.
13 Benesch, 1964, No. 198.
14 Schönbrunner/Meder, Vol. VI, No. 652.
15 von Sick, No. 85; photo Witt.

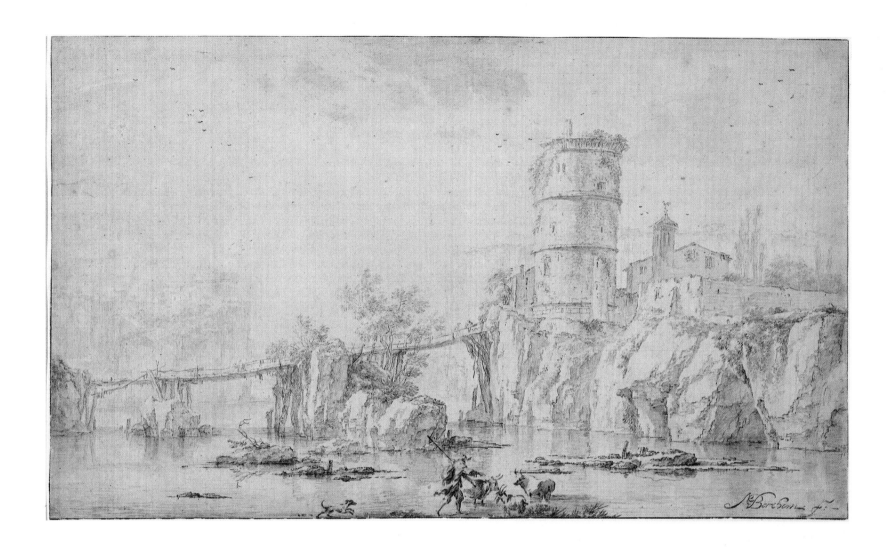

NICOLAES BERCHEM
(1620–1683)

31 Landscape with Ruin and Figures *c*.1670s

Slight preliminary drawing in black chalk; black and red chalk (the red chalk moistened for accents in the foreground) and touches of dark brown fabricated chalk bound with a fatty medium (restricted largely to the trees); on white laid paper. The sheet folded vertically, centre, and unevenly trimmed at all sides to a ruled line in pen and brown ink. Repairs to top right corner.

Watermark: arms of Amsterdam (right), and letters 'I' 'G' (left).

29.3 × 40.8 cm.

Signed in black chalk, lower right: 'C٩ Berchem: f.' (the initials interlaced).

Inscribed in a modern hand in pencil, *verso*: 'Trower/2.2.0'.

PROVENANCE: Sir Robert Witt (purchased from Walker, no date); Witt Bequest 1952 (3790).

LITERATURE: exh. cat. Paris/Antwerp/London/New York, 1980, under no. 103.

The site represented in this drawing, unidentified in the Hand-list,[1] is almost certainly that of Brederode Castle, which is situated near Santpoort, some three miles north of Haarlem. Seat of the Counts of Brederode, who were descendants of the House of Teylingen and rulers over large areas of Holland, the red brick castle was built in the thirteenth century, and finally destroyed in 1573.[2]

Of three drawings of this site catalogued by von Sick, a pen and ink composition in Frankfurt[3] is signed and dated '167...'. A date in the 1670s may perhaps be assigned to the present sheet, which bears the form of signature adopted by Berchem from *c*.1660 onwards.[4] A second, unsigned representation of Brederode, in red and black chalk, is in Weimar;[5] while von Sick's third drawing, in New York,[6] will be discussed briefly below. To this corpus may be added pen drawings of the castle in Groningen[7] and Haarlem,[8] while a view including part of the derelict interior was sold in Amsterdam in 1908.[9] Drawings technically comparable to the work exhibited here, in which red chalk is employed principally to depict a gamut of related local colour (ranging from the pink of flesh tones, through the orange of brick to the brown of cattle), are in Berlin[10] and Copenhagen,[11] while pendants sold in Amsterdam in 1912[12] also probably represent the grounds of Brederode.

The Amsterdam pendants and one of the sheets in Haarlem[13] share with the present drawing similarities of pictorial structure and observation point: in each the view is taken from a valley or depression, looking upwards over dunes or hillocks towards the distant ruins, visible beyond abundant vegetation. Prominently located in the foreground are animals and picturesque Italianate figures, which as Stechow noted,[14] exhibit a playful spirit often reminiscent of staffage in drawings by Berchem's cousin, J.B. Weenix (1621–60). These motifs are frequently disposed, as in the present composition, in a roughly triangular formation.

The precise, nervous and enclosed contours which describe the elegant, highly formalised figures and animals in this sheet are at variance with the softer, more open strokes employed to depict the surrounding landscape, and are the cause of a particular tension between the upper and lower halves of the composition. The preoccupation with the arrangement of figures notable here is also apparent in paintings executed during the 1660s: it reaches its climax in the oil on copper known as *Le Diamant de la Curiosité*,[15] in which the landscape context is reduced to bare essentials in order not to detract from the refinement and precision of the grouping of staffage.

The drawing in New York, mentioned above, has recently been attributed away from Berchem and is now thought[16] to be a skilful pastiche of this master's manner, perhaps by Laurens V. van der Vinne (1658–1729). Stampfle has noted that that drawing 'seems to bear some resemblance' to the work exhibited here: at this stage in our research, however, no sufficient reason with regard to handling or composition has emerged to warrant a similar exclusion of the Courtauld sheet from Berchem's *œuvre*.

1 Hand-list, p. 99, No. 3970, as *Landscape with Cattle and Figures*.
2 Vermeulen, vol. I, pp. 465–66, gives an account and plans of the castle.
3 von Sick, No. 24.
4 von Sick, p. 67.
5 von Sick, No. 25.
6 von Sick, No. 23.
7 exh. cat. Paris/Antwerp/London/New York, 1980, under 103.
8 Teylers Museum, Inv. No. U* 12; exh. V. & A., 1970 (36). Teylers Museum; Scholten, p. 188, No. 15; exh. Brussels, 1961 (107).
9 F. Muller & Co., 16–18 June 1908 (lot 42), signed 'N Berchem'; photo Witt.
10 Staatliche Museen; Bock/Rosenberg, p. 78, No. 320; exh. Berlin 1974 (16).
11 Kobberstiksamling, Inv. No. TU–41–45; photo Witt.
12 F. Muller & Co., 11–14 June 1912, lot 12, as a pair, one of which is fully signed, the other signed with initials; photo Witt.
13 Scolten, p. 188, No. 15.
14 In the unpaginated Foreword to exh. cat. Ann Arbor, 1964.
15 Dorchester House; Hofstede de Groot, IX, p. 123, No. 249.
16 The change in attribution, due to Gerson, van Regteren Altena and Stechow, is recorded by Stampfle in exh. cat. Paris/Antwerp/London/New York, 1980 (103).

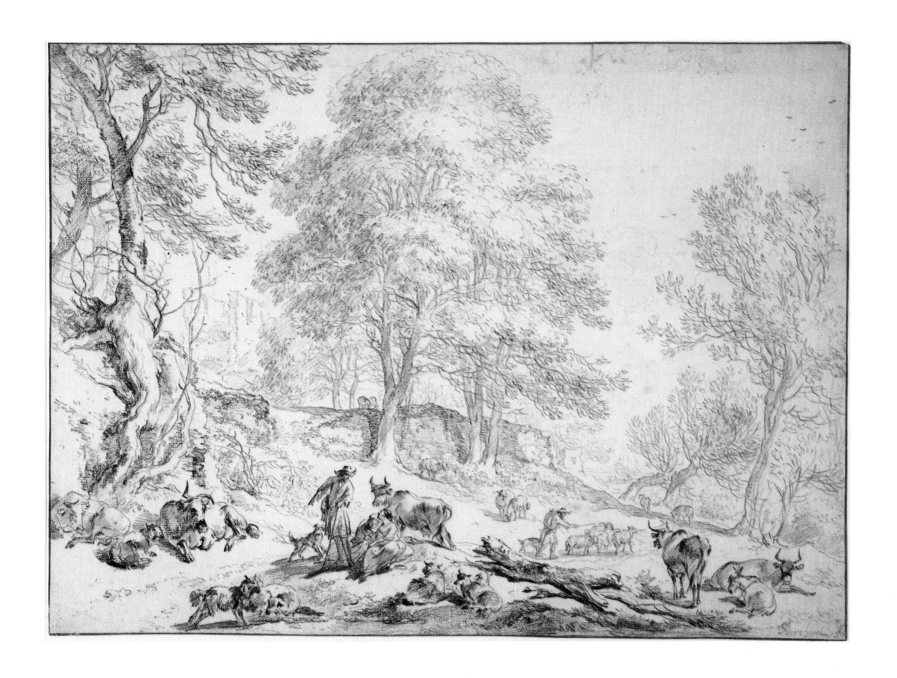

ABRAHAM BLOEMAERT
(1564–1651)

32 Landscape with Cottage after 1630

Extensive preliminary drawing in black chalk; pale brown ink (?) washes, with drawing with the point and flat of the brush; on grey-buff (now stained and discoloured) laid paper. The sheet repaired lower left of centre, upper left, top and bottom edges, the top left corner made up. Unevenly trimmed at all sides, apparently to a ruled line in pen and brown ink (visible left).

Watermark: fleur-de-lis in a shield, surmounted by a crown.

16.6 × 23.1 cm.

Stamped with the collector's mark of Earl Spencer (Lugt 1530), *recto*.

PROVENANCE: Earl Spencer; Winiel, Toulouse;[1] Sir Robert Witt (purchased from Colnaghi, London, no date); Witt Bequest 1952 (3481).

EXHIBITIONS: V. & A., 1943; Australia, 1968 (28); Courtauld, 1972 (6).

For Abraham Bloemaert, a prolific draughtsman and painter, the depiction of landscape formed only part of a large *œuvre* devoted mainly to Biblical, mythological and genre scenes.[2] His strength as a landscape artist, as Stechow noted,[3] resides in his remarkable understanding of the decorative potential of motifs drawn from the countryside, rather than in any pioneering contribution towards seventeenth-century Dutch naturalism which earlier scholars perceived in his work.[4]

The ornamental and essentially Mannerist character of landscapes compositions by this conservative artist is typified by the drawing exhibited here. The subject of cottage or farm in a state of picturesque decay is one Bloemaert treated with a great range of graphic styles throughout his long career, as drawings in printrooms in Berlin,[5] Edinburgh,[6] Leiden,[7] London,[8] Moscow,[9] New York,[10] Paris[11] and Vienna[12] indicate: such compositions, as van Mander noted in 1604,[13] were popular among collectors.

In the example exhibited here, the landscape is conceived as three planes or 'flats' (corresponding to fore-, middle- and background), arranged behind and above each other. There is no consistent linear transition between planes (although diagonals of rocks, fallen tree trunks, and the figure's pointing cane do go some way to unifying fore- and middleground), and little concession to the effects of aerial perspective. The illusion of pictorial depth is instead created by the contrast in scale between small motifs observed from close up (in this and other examples, the dark figures which indicate the foreground plane) and larger motifs (the cottage) observed from a distance. Unity is imposed over the composition by the repetition and variation of elegant curves in all areas of the sheet. The roughly triangular configuration formed by the staffage, for example, is echoed in the areas of rising ground immediately behind and in front of them, is taken up by the hillock on which the cottage stands, and is restated by the curves of the cottage roof. The valley, right, may be regarded as an inversion or negative variant of the same curve, while the composition is closed at the right by a slender tree, the arc of whose trunk paraphrases the contours at the right of the cottage roof.

The handling here is softer than in many of Bloemaert's compositions depicting similar subjects. The drawing with black chalk – at first sketchy in the cottage roof, in which there are many *pentimenti* – is of a generally light, rhythmical touch in which the friable nature of the medium is exploited. Washes are boldly and freely blocked in with a full brush, creating strong contrasts of light and shadow over each motif without establishing a coherent lighting system across the composition as a whole. The washes have a distinctive patchy appearance, perhaps the result of rapid absorption by the paper: this, combined with the nature of the chalk drawing presents an almost fuzzy, 'soft-focus' image. Two sheets in Munich[14] (one of which depicts a similar cottage set in a more extensive landscape) are drawn in the same media as the present work and display analogous characteristics of handling. Both have been assigned by Bolten to a period late in Bloemaert's career, i.e. after 1630, and the present sheet may be similarly dated.

1 cf. Sir Robert Witt's file.
2 Examples of which are found, among other places, in Berlin (Bock/Rosenberg, pp. 10–12, Nos. 221, 224, 225, 265, 267–70, 271, 297, 368, 1409, 5974) and at the Courtauld Institute Galleries (Witt Nos. 337, 2233, 2589, 2781, 3357).
3 p. 26.
4 e.g. Müller, pp. 204–06, sees in the work of Both, van Goyen and Ruisdael a debt to Bloemaert.
5 Staatliche Museen; Bock/Rosenberg, pp. 11, 12, Nos. 237, 288.
6 National Galleries of Scotland, Inv. No. 1084; photo Witt.
7 Prentenkabinet; van Regteren Altena, No. 3.
8 British Museum; Popham, V, p. 93, Nos. 18, 19.
9 Pushkin Museum; exh. Brussels/Rotterdam/Paris, 1972–73 (9).
10 Pierpont Morgan Library; exh. Paris/Antwerp/London/New York, 1979–80 (42).
11 Ecole Nationale Supérieure des Beaux-Arts; Lugt, 1950, Nos. 46–57, 59. Louvre; Lugt, 1929–33, No. 104.
12 Albertina; Benesch, 1928, Nos. 432–34.
13 p. 358.
14 Staatliche Graphische Sammlung; Wegner/München, Nos. 244, 247, who quotes Bolten's opinion.

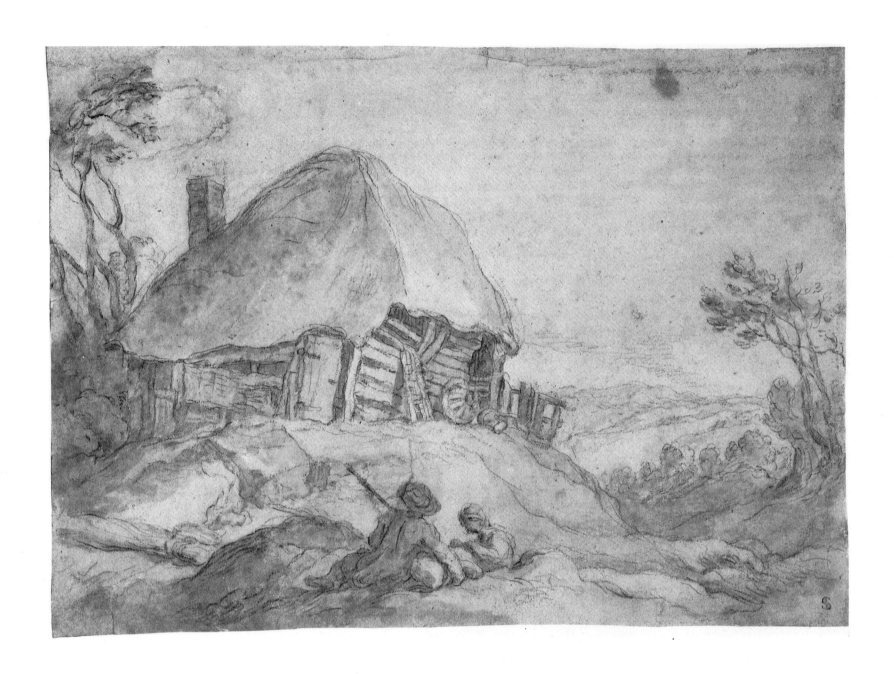

MANNER OF BLOEMAERT
(17th century)

33 A Farmyard

Black and red chalk, with some rubbing; gray (carbon) ink washes (mixing in part with the chalks to form dilute bodycolour), with drawing with the pen and point and flat of the brush; extensive overdrawing in pen and dark brown ink (also mixing with the chalks to form bodycolour); on very pale buff (stained with oil paint, and unevenly discoloured) laid paper. The roof of the dovecote pressed through, vestiges of preparation with black chalk, *verso*. The sheet unevenly trimmed at all sides, the top right corner trimmed to a curve and made up. A tear repaired, top left of centre.

20.7 × 32.5 cm.

PROVENANCE: C. R. Rudolf; Sir Robert Witt (purchased from Colnaghi, no date); Witt Bequest 1952 (3136).

EXHIBITIONS: V. & A., 1943; Courtauld, 1972 (9).

This drawing, from the collection of C. R. Rudolf, was purchased by Sir Robert Witt as a work by Abraham Bloemaert, and was catalogued and subsequently exhibited as such.[1] The present attribution away from this artist is supported by J. Bolten.[2]

The use of coloured chalks and black and brown washes lends the composition a painterly richness: in comparison with Bloemaert's light and wirily elegant contours, however, those evident here are ponderous and heavy (despite the use of a fine-nibbed pen), and a particular uncertainty is notable in the drawing of circular forms in perspective. The interrelationship of motifs within pictorial space is also frequently unclear: the artist displays a tendency to elide contours describing adjacent objects (e.g. those of the wheelbarrow and cart) thus arbitrarily compressing the space which circulates between them. The lighting from the rear left projects over the foreground dramatic shadows which, described with a large, full brush, are rendered as amorphous, generally rounded forms. The shadows appear to indicate a sudden downward slope in the earth's surface at the composition's immediate foreground.

Drawings which are comparable to the work exhibited here, in handling of light, elision of contours of neighbouring forms, and media employed, were sold in Amsterdam in 1981 and 1983[3] with attributions to Adriaen Bloemaert (1609–1666), third son and pupil of Abraham. A sheet in New London,[4] comparable in its treatment of light with both Amsterdam and Courtauld drawings is signed or inscribed: 'A Blomaert'. When the style of these works is compared to that of a sheet in Copenhagen[5] signed by Adriaen, however, few similarities emerge. Perhaps this little-known artist was capable, like his father, of drawing in a wide range of styles.

It is known that Abraham Bloemaert accepted pupils throughout his career. Nine artists who are said at various times to have studied under him are listed by Moes,[6] while some eighteen others made engravings after his designs. Of the engravers, the most famous and prolific were Bloemaert's sons Cornelis (c.1603–after 1684)[7] and Frederik (1610–after 1669),[8] and also Boëtius A. Bolswert (1580–1633)[9] and Claes Jansz. Visscher II (1586–1652).[10] The repertoire of motifs generated by Abraham Bloemaert visible in this drawing would thus have been widely disseminated through the medium of engraving to artists outside his studio or circle, and it is possible that such a draughtsman may have executed the present composition.

3 Sold Sotheby Mak van Waay, 16 November 1981 (lot 213), and 25 April 1983 (lot 7); photos Witt.
4 Lyman Allyn Museum; the drawing passed through Maison, Berlin, 1928. Photos Witt.
5 Kongelige Kobberstik Samling, inv. No. TU 82 a, I; Dr. J. Bolten is gratefully acknowledged for drawing our attention to this work.
6 in Thieme-Becker, vol. IV, p. 216; Hollstein, vol. II, lists 30 artists who engraved after designs by Bloemaert, although not all of these were his contemporaries.
7 Hollstein, vol. II, p. 65, Nos. 52–58, 61.
8 Hollstein, vol. II, p. 66, Nos. 317–320, 321–323, 334–348.
9 Hollstein, vol. II, p. 66, Nos. 409–419, 420–438, 439–442.
10 Hollstein, vol. II, p. 69, Nos. 564–589.

1 Cf. Hand-list, p. 100, No. 3136, and under EXHIBITIONS.
2 Letter to the author, 20 February 1985.

WILLEM BUYTEWECH
(1595–1627)

34 Landscape with Milkmaid and Goats 1617

Graphite; on off-white (stained with pale brown ink) laid paper. The sheet edged by a later hand with double ruled lines in brown ink, and unevenly trimmed at all sides. Prepared on the *verso* in the area of goats and girl with black chalk, these motifs pressed through, *recto*. A vertical fold, centre.

Watermark: dagger (?) (right), and illegible motif (left).

28.3 × 36.4 cm.

Signed and dated in graphite, lower right: 'W... (illegible) 1617' (the final digit rubbed and faint). Numbered in modern hands in pencil, *verso*: 'A15919', and: '66W', and inscribed: '...R...'.

PROVENANCE: From an album made up in England, *c*.1800; ...; Sir Robert Witt (purchased from Colnaghi, 1948); Witt Bequest 1952 (4007).

EXHIBITIONS: Arts Council, 1953 (89); New Zealand, 1960 (56); Rotterdam/Paris, 1974–75 (98).

LITERATURE: Haverkamp Begemann, 1959, No. 106, and pp. 36, 37, 41, and under Nos. 41, 104, 108 and CP22.

The composition of this drawing is indebted to the type invented by the German artist, Adam Elsheimer (1578–1610): indeed, Haverkamp Begemann has argued[1] for its almost total dependence upon the pictorial structure of the German master's painting *Tobias and the Angel*,[2] reproduced by Hendrick Goudt (1573–1648) in an engraving of 1608 known as *The Small Tobias*,[3] with which Buytewech was familiar.

In *The Small Tobias* an unbroken screen of trees following a river bank curves from the left edge of the composition into the background. This uninterrupted, curving line of trees was stressed by Buytewech himself in a drawn variant after that composition of *c*.1614–16.[4] The trees in the drawing exhibited here, by contrast, are arranged in two distinct and opposing planes: those forming a dramatic wedge at the left of the sheet are checked in the background by a row of bushes and smaller trees placed parallel to the picture surface. In order to emphasise the background trees' alignment with the picture plane, Buytewech groups them behind a wicker fence which is observed strictly frontally. The arrangement of trees in contrasting planes here relates more closely to the composition of Elsheimer's painting *The Flight into Egypt*[5] than to that of any other work by this artist. An engraving after this painting, also by Goudt, was executed in 1613.[6]

In the present drawing, Buytewech introduces towards the distant end of the wedge of trees one distinguished by its prominent oval crown of foliage, whose upward-curving rhythms are echoed by the branches of the pollard and lesser vegetation at the right. A similar dominant tree, whose crown also dictates the resonating curved forms of surrounding foliage, punctuates the end of the row of receding trees in *The Flight into Egypt*, a landscape unique in Elsheimer's œuvre in employing this motif to gain such an effect. Further comparison of motifs and formal properties in the present drawing confirm Buytewech's debt to *The Flight into Egypt*. The milkmaid here, for example, relates in both pose and location within the pictorial area to the kneeling cowherd who tends the fire in Elsheimer's work. As in that painting, both figure and animals are contained within a continuous rhythmical contour and are conceived as a compact unit which is recessed into the landscape.

Unlike the general composition which is related to the work of an Italianate German artist, the motifs of the trees with bare, sinuous trunks and sparse canopies of leaves are developed from the work of a native master, Esaias van der Velde (*c*.1590–1630). Buytewech may have been familiar with the latter's drawings (since both artists were members of the Guild of St. Luke in Haarlem during the same period),[7] and certainly knew his suite of landscape etchings of *c*.1614.[8] Some two years later Buytewech himself had combined within a similar series of etchings tree motifs derived from van der Velde with pictorial structures indebted to Elsheimer.[9] The composition of plates 4 and 6 of Buytewech's suite are particularly close to that of the present drawing, and the successful handling of trees in these small-scale works must have provided the artist with confidence to treat the comparable, but more ambitious forms visible here. In Buytewech's hands, van der Velde's trees appear to assume a life of their own, the contorted branches suggesting continuous growth and movement which introduces a fantastic element to the landscape:[10] a curious tension is created between these imaginary tree motifs and the objective manner of their delineation.

The clarity and uniform emphasis of graphite work in all areas of this drawing, which was probably conceived as a pendant to a sheet in Cambridge,[11] and is related by scale and composition to drawings in Washington,[12] suggests that it may have been created as a design for an engraving. A precedent for prints of a comparably large scale is found in Buytewech's work in the etching of a stranded whale of 1615.[13] The Courtauld sheet is, moreover, prepared on the *verso* with black chalk in the area of the figure and animals, the contours of which have been indented with a stylus for transfer to an etching plate: no etching reproducing these motifs has as yet been located. The figures and animals of the Cambridge sheet, similarly prepared for printing, appear within a newly invented landscape context in an engraving by Jan van der Velde II (1593–1641);[14] and it is likely to have been that artist who prepared the Courtauld drawing for transfer.

Both this and the drawing in Cambridge formed part of an album compiled in England in *c*.1800, sheets of which may have come from the collection of Joris Hoefnagel (1542–1600).[15] Two drawings by Pieter Bruegel the Elder in the Princes Gate Collection were also part of the same album.[16]

1 Haverkamp Begemann, 1959, *loc. cit.*, and repeated in Rotterdam/Paris, 1974–75, *loc. cit.* Full biographical details of the artist are included in Haverkamp Begemann, 1959.
2 Historisches Museum, Frankfurt; Andrews, p. 39 and No. 20.
3 Hollstein, Vol. VIII, p. 151, No. 2.
4 British Museum; Haverkamp Begemann, 1959, No. 102.
5 Alte Pinakothek, Munich; Andrews, No. 26.
6 Hollstein, Vol. VIII, p. 153, No. 3.
7 Buytewech and van der Velde were both enrolled in the Haarlem Guild in 1612: Buytewech left Haarlem in 1617, van der Velde in 1618. Examples of the type of van der Velde drawing which may have impressed Buytewech are as follows: a sheet in the J. Q. van Regteren Altena coll., of before 1614; a sheet in the Kröller–Müller Museum, Otterlo, of *c*.1615; a sheet in the Hessisches Landesmuseum, Darmstadt, of *c*.1616 (Keyes, D.66; D.173; D.105, respectively).
8 Keyes, Nos. E.10–E.19.
9 Haverkamp Begemann, 1963, pp. 74–76, Nos. VG 21–30; Hollstein, Vol. IV, p. 75, Nos. 1–10, reproduces the second edition of 1621.
10 Haverkamp Begemann, 1963, p. 62, makes a similar observation regarding the etchings.
11 Fitzwilliam Museum; Haverkamp Begemann, 1959, No. 103.
12 *A Woodland Pond with Fishermen* (black chalk, pen and brown ink: 29.2 × 37.5 cm.) and *Meadow with Shepherd and Cows* (pen and brush and brown ink: 28.3 × 37.7 cm.); Washington, pp. 52, 53, respectively.
13 *The Stranded Whale near Noordwijk* (25.0 × 50.5 cm.); Haverkamp Begemann, 1963, No. VG 9.
14 Franken/Kellen, No. 409.
15 Haverkamp Begemann, 1959, *loc. cit.*, and Dr E. Schilling, quoted under n. 2, p. 25, No. 9, by Seilern.
16 *Landscape with Two Mules*, and *Landscape with an Artist sketching*; Seilern, Nos. 8, 9, respectively.

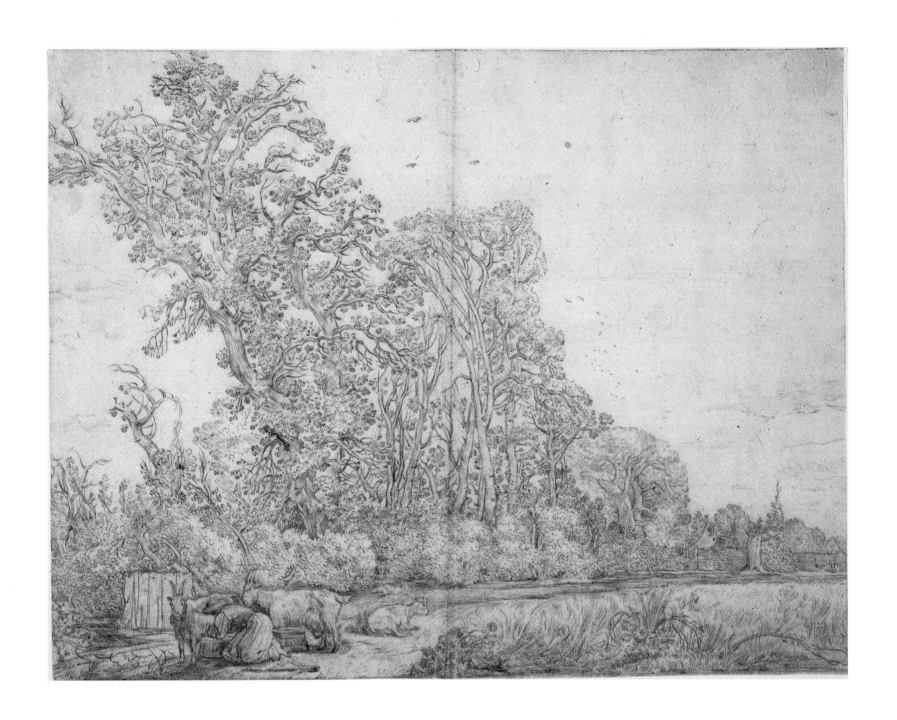

MAERTEN DE COCK
(active 1620–1646)[1]

35 River Landscape 1646

Traces of preliminary drawing in graphite; pens of different nib thicknesses with brown ink washes; on vellum (now stained and discoloured). The pictorial area enclosed within the artist's ruled line in pen and brown ink, a ruled framing line in pen and dark brown ink added by a later hand.

42.4 × 59.4 cm.

Signed bottom left in pen and light brown ink: 'M: le Cocq notavit 1646' (now stained and partly effaced).

An inscription in pencil, *verso*, now erased.

PROVENANCE: Sir Robert Witt (purchased from Parsons, cat no. 38, 1921); Witt Bequest 1952 (31).

EXHIBITION: Berlin/Bochum, 1927–28.

No definite biographical details concerning de Cock are known, although he is thought to have been the son of a goldsmith and a resident of Amsterdam. Primarily a draughtsman, three etchings (one of which is signed and dated) are also recorded from his hand. He is probably to be identified with the painter of a signed composition in Stockholm, dated 1631.[1]

The date on the present sheet is the latest which appears on a work certainly identifiable as being by Maerten de Cock: a series of 17 drawings of views in Paris and Rome in Berlin which are dated 1647 and signed 'Coq', 'Cocq' or 'de Coq' cannot confidently be ascribed to the draughtsman of the work exhibited here.[2]

The Courtauld drawing is remarkable for the minute delicacy and elaboration of its penwork sustained over a sheet of greater dimensions than de Cock habitually used.[3] In defining forms, the artist utilises a range of lively hatchings, hooks, loops, flecks and dots: the greater variety of strokes is visible in the foreground plants and tree, while those describing background forms become increasingly simplified and rectilinear in proportion to the depth at which the motif is located in space. The vocabulary of vertical and horizontal striations and flecks with which the castle, right, is described is adapted from that evolved by Pieter Bruegel the Elder in drawings dating from the early 1550s which depict comparable architectural forms.[4] The tree in the foreground similarly betrays an ultimate debt to the type invented by Bruegel, visible for example in a drawing in Milan,[5] and in prints of *c*.1555–56 by Hieronymous Cock after the master's designs.[6] The motif is interpreted by the present draughtsman as a heavy and slowly rhythmical form, the accretion of detail over which indicates the influence of drawings by Venetian masters such as Muziano: unlike the detail in that artist's work, that included here is used for more purely decorative ends. A comparable Italianate influence is also evident in copies after lost studies of trees by Bruegel attributed to Jan Brueghel I (1568–1625)[7] and to lesser, unidentified artists;[8] but it is unknown whether similar drawings, or engravings after the Venetian masters, would have provided the immediate inspiration for the tree visible here.

The motif of woodland on the left of the composition indicates de Cock's familiarity with the type of forest subject matter pioneered in the work of Bol and Coninxloo. It will have become evident that in employing imagery derived both from these artists and Bruegel, de Cock shows himself a conservative draughtsman whose work continues the landscape traditions evolved during the sixteenth century in Flanders, rather than adopting those of seventeenth-century Holland.

1 The Nationalmuseum/Stockholm and Hollstein give de Cock's dates as *c*.1608–47, without supporting evidence. The etching dated 1620 (recorded by Hollstein, Vol. IV, p. 194, No. 1 of three) appears to be a mature independent composition, rather than the work of a precocious twelve-year old, suggesting that the artist's date of birth may perhaps be *c*.1600. The Stockholm painting is Nationalmuseum/Stockholm, No. 383.
2 Von Wurzbach assigned the drawings, in metalpoint on vellum, to Maerten de Cock, although Springer (in Thieme-Becker, Vol. VII) suggests that they are by a French artist influenced by Callot.
3 The largest drawing by this artist in Berlin (Bock/Rosenberg, p. 108, No. 12647) measures 21.0 × 31.3 cm. That in the Albertina, Vienna, Inv. No. 8587, measures 21.6 × 33.2 cm.
4 e.g. in Berlin, Munich and Besançon; Münz, nos. 38, 44, 47, respectively.
5 Biblioteca Ambrosiana; Arndt, cat. No. 1.
6 Plate Nos. 11, 12 of the series *Twelve Large Landscapes*; Lebeer, 1969, Nos. 11, 12.
7 e.g. Institut Néerlandais, Fondation Custodia (Lugt coll.), Paris, and Boymans–van Beuningen Museum, Rotterdam; exh. Berlin, 1975 (42 and 50, respectively).
8 e.g. Art Institute of Chicago; British Museum; Institut Néerlandais, Fondation Custodia (Lugt coll.), Paris; Louvre; exh. Berlin, 1975 (45, 43, 57, 44, respectively).

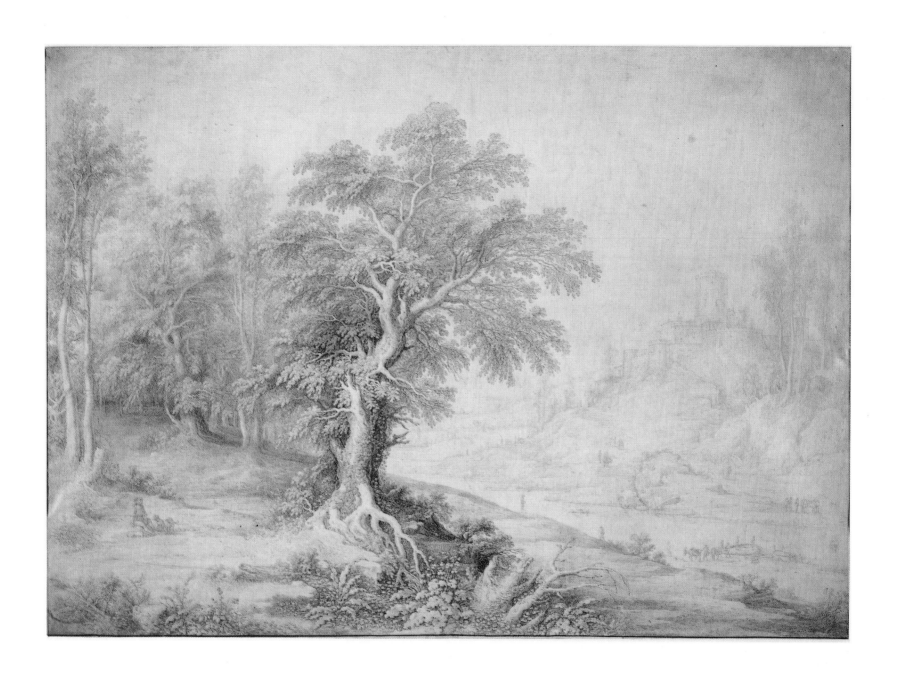

CORNELIS CORT
(1533–1578)

**36 Coastal Landscape with Fortress and Shipping
1565–66 or 1571–72**

Pen and brown ink; on off-white laid paper. The sheet unevenly trimmed at all sides.

19.2 × 27.1 cm.

Verso: Harbour scene with rocks and sunken vessel, in pen and brown ink.

Inscribed in pen and brown ink, bottom right of centre: 'Cornelius Cort von horn'.

PROVENANCE: Ridley, sold Sotheby, 25 July 1928 (lot 18), bt. Sir Robert Witt; Witt Bequest 1952 (2381).

EXHIBITIONS: Courtauld, 1972 (2); Courtauld, 1977–78 (20).

LITERATURE: Bierens de Haan, p. 225, no. 2 and pls. 63, 64.

The compositions on the *recto* and *verso* of this sheet are related by subject and treatment to drawings by Cort in Besançon[1] and Brussels;[2] the latter bears an attribution to the artist in the same hand which inscribed the present work. Both Brussels and Besançon compositions were employed as designs in a suite of four landscape prints,[3] engraved by the same hand and probably that of Joris Hoefnagel (1542–1600); the two pendant engravings of this series, after lost designs by Pieter Bruegel the Elder, are inscribed on the plate with that artist's name and the date 1533.[4] On the basis of this printed date, Bierens de Haan[5] has suggested that the present drawing and the works cited above may also be assigned to the year 1533; that is, to the beginning of Cort's career, shortly after his arrival in Antwerp from Hoorn in northern Holland.[6] Comparison with Cort's 41 small landscape drawings after which engravings by Hieronymous Cock were published in 1559, however, confirms that such an early dating is unacceptable.

In the small landscapes of *c*.1559, Cort emerges as the supreme realist, precisely recording details of houses and foliage of his native land with a crisp and linear manner.[7] The Courtauld drawings, by contrast, represent imaginary scenes, both of which include wrecked boats and ranks of distant vessels: their subject is unclear, but suggests the aftermath of a violent occurrence and perhaps of a naval battle. Handled with rapid, almost scratchy penwork, planes of rock, architecture and cloud are differentiated by long, parallel barbed strokes, frequently horizontal but often relieved by passages of dense vertical or diagonal hatching. Vegetation, indicated by loops and hooks, tends to be of either the compact bush variety or the solitary tree of thin and ravaged appearance (e.g. that on the *verso*). From the cliff-top fortresses' upper storeys fires erupt, cannon are fired and flags wave. Closely related motifs expressive of a comparable turbulence but treated in a less abbreviated manner are found in drawings by Titian (*c*.1485–1576), and particularly in the *Landscape with Roger and Angelica* of *c*.1550.[8] This composition, etched by Cort on his arrival in Venice in 1565, is one of 15 designs by the Italian artist which the Dutchman translated into prints during the periods 1565–66, and 1571–72;[9] and it is in response to Titian's example that the present compositions were executed. Conceived probably as completed works of art, the Courtauld sheet and its cognates may justifiably be redated to either period of Cort's contact with the work of the Venetian master.

2 Bibliothèque Royale Albert 1ᵉʳ; Bierens de Haan, p. 225, and under No. 246.
3 Bierens de Haan, Nos. 246, 247. The inscription reads 'Cornelius Cort the Dutchman made it'.
4 Lebeer, 1969, Nos. 81, 82.
5 *ibid.*
6 Bierens de Haan, p. 3. Cort's life and career are fully discussed in this author's introduction.
7 Stechow, p. 16. The landscape prints are cited in Bierens de Haan, Nos. 248–89.
8 Musée Bonnat, Bayonne; Wethey, cat. no. 25, pl. 137.
9 Bierens de Haan, No. 222. Cort's remaining etchings after Titian are Bierens de Haan, Nos. 17, 23, 111, 123, 133, 134, 139, 143, 144, 145, 156, 157, 192, 193.

1 Musée de Besançon; Bierens de Haan, p. 225, and under No. 247.

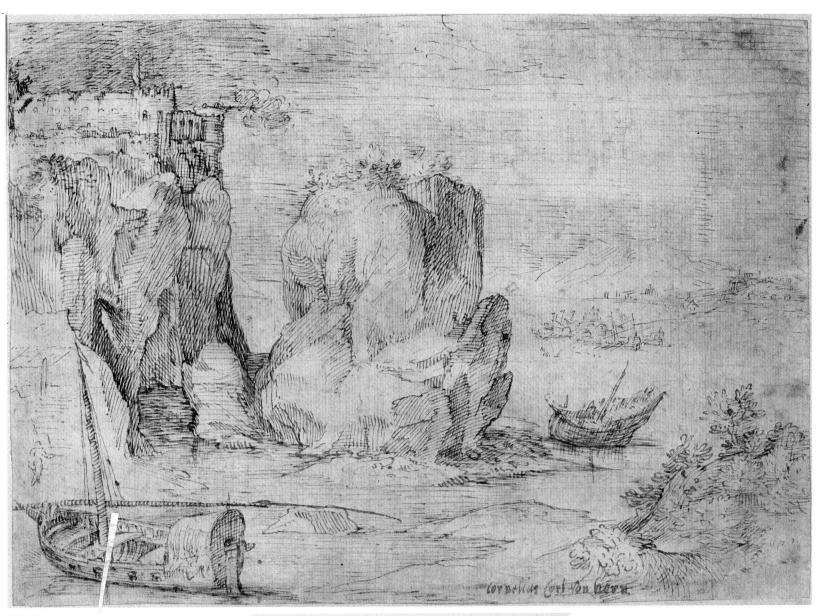

ALLAERT VAN EVERDINGEN
(1621–1675)

37 Scandinavian Landscape with Log Cabins

Preliminary drawing in graphite; pen and brown ink washes (the lightest in the background, the darkest in the foreground) for all contour drawing; brown and grey (carbon) ink, and yellow, red and blue watercolour washes; red, blue and off-white bodycolour (restricted mainly to the shirt of the foreground figure and the sky); on off-white (stained) laid paper. The sheet unevenly trimmed at all sides, apparently to the artist's ruled framing lines in pen and brown ink. Extensive repairs, upper left and lower right.

Watermark: banded shield with illegible device, surmounted by a crown.

19.3 × 31.0 cm.

Signed in pen and light brown ink, bottom left: 'AVE'.

Inscribed and numbered in different modern hands in pencil, *verso*: 'Everdinge', 'pago', and: '485'.

PROVENANCE: Sir Robert Witt (purchased from Holgen, no date); Witt Bequest 1952 (2130).

EXHIBITIONS: R.A., 1929 (709); Courtauld, 1972 (21).

Some time after 1640, van Everdingen travelled to Scandinavia, visiting Sweden, perhaps at the instigation of the Trip family of Amsterdam who had economic interests in that country: the artist may have been accompanied by one of the Trip brothers.[1] A painting by van Everdingen in Amsterdam[2] shows a bird's-eye view of the cannon foundry at Julitabroeck, Södermanland, leased at one time by Hendrick Trip. The inscription on a drawing formerly in the Perman collection, Stockholm,[3] suggests that the artist also journeyed to Mölndal, south-east of Göteborg, while inscriptions on some 11 drawings sold in Amsterdam between 1758 and 1819 (whose present whereabouts are unknown)[4] indicate that van Everdingen spent some time in Göteborg itself. The artist is also known to have visited the Falls of Trolhättan (Nolfallet),[5] while a second annotated sheet in the Perman collection confirms that in 1644 he was in Risør, on Norway's Frisian coast.[6] If, as Houbraken reports,[7] van Everdingen was indeed a pupil of Roelant Savery, his familiarity with the latter's landscape imagery would have provided him with a basis for the handling of analogous motifs encountered at first hand in the Scandinavian countryside.

By 1645, the artist was in Haarlem,[8] where he continued to paint, draw and etch Scandinavian subjects: it was he who was responsible for introducing motifs associated with this region into Dutch seventeenth-century art, and his work had a particular impact upon that of Jacob van Ruisdael (1628/29–82).[9]

The majority of van Everdingen's drawings are signed, but since few extant sheets are dated or otherwise inscribed there are insufficient criteria to establish which among the Scandinavian subjects were drawn on the spot and which were created later in Holland. When compared to the landscapes depicted in van Everdingen's numerous etchings,[10] which were created from memory in his native land, that of the present drawing displays a freshness of vision and an accumulation of specific detail suggesting observation of a particular site. Perhaps too technically elaborate to have been executed in front of the motif, the drawing was probably closely dependent on studies made from nature.

The present type of composition, in which cabins and enclosures form a band across the middleground, is common to many of van Everdingen's prints and is found in drawings of both horizontal and vertical format, examples of which may be seen in print rooms in, among other places, Berlin,[11] Edinburgh[12] and Munich.[13]

1 Stechow, p. 143, suggests that the journey was specifically commissioned by the Trip family. Of the two brothers, Louis (1605–84) and Hendrick (1607–66), the latter may have accompanied the artist.
2 Rijksmuseum; Amsterdam, p. 222, A1510.
3 Exh. Stockholm, 1953 (233); see also Held, 1937, p. 42.
4 For the list of sales, see Steneberg, p. 120.
5 A signed drawing of the Falls is in the Boymans–van Beuningen Museum, Rotterdam (Steneberg, pl. 46a), and a later painting of the same subject is in the Trippenhuis, Amsterdam (Steneberg, pl. 47).
6 Exh. Stockholm, 1953 (232); Bernt, I, No. 221. A copy after a drawing by van Everdingen of a second Norwegian site, Bohns' fastning, is in the Louvre (Steneberg, pl. 45b).
7 Vol. II, p. 95. Van Everdingen is also said to have been a pupil of Pieter Molyn in Haarlem.
8 Van Everdingen may have been in Amsterdam as early as 1651, but was registered as a citizen there only in 1657; Stechow, p. 144.
9 Discussed at length in Rosenberg.
10 e.g. Hollstein, vol. VI, pp. 155, 163–67, 172.
11 Staatliche Museen; Bock/Rosenberg, p. 131, Nos. 2324, 8493.
12 National Galleries of Scotland, Inv. No. 1088; photo Witt.
13 Staatliche Graphische Sammlung; Wegner/München, No. 559.

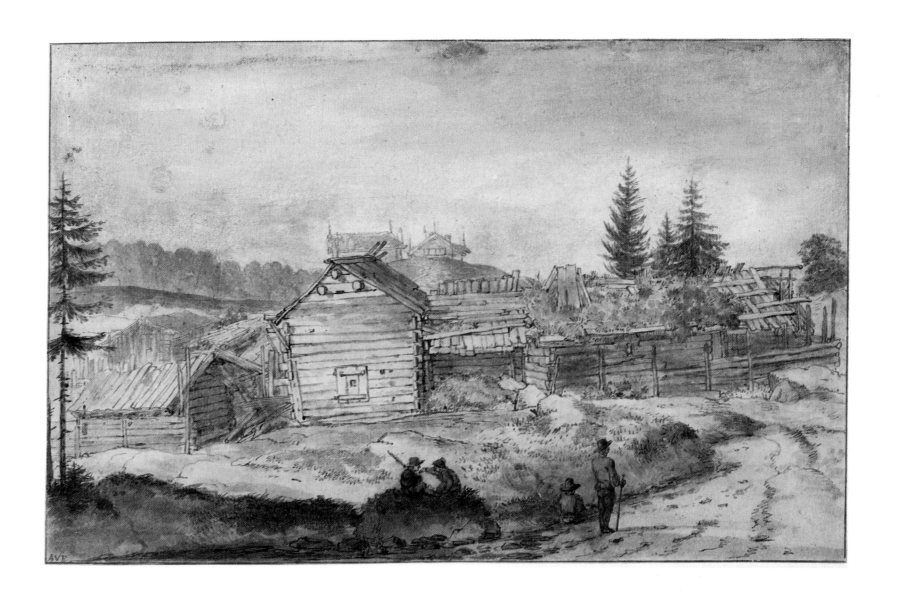

ALLAERT VAN EVERDINGEN
(1621–1675)

38 Scandinavian Landscape with Waterfall

Traces of preliminary drawing in graphite; grey (carbon) ink washes, with extensive drawing with the point of the brush and some drawing with the pen (restricted largely to the foreground rocks); on off-white laid paper. The sheet edged with the artist's (?) ruled framing lines in pen and light brown ink, and by a later hand in pen and dark brown ink. The sheet unevenly trimmed at all sides.

12.1 × 16.6 cm.

Signed in brush and grey ink wash, lower left: 'AVE'.

Inscribed in a modern hand in pencil, *verso*: 'Everdingen', and above a dealer's (?) inscription, now largely erased: 'Ro . . . £10/1638', and numbered in a different hand in pencil: '102'.

PROVENANCE: Sir Robert Witt (purchased from Spink, no date); Witt Bequest 1952 (3873).

EXHIBITIONS: Australia, 1968 (41); Courtauld, 1972 (14).

The spruce trees, dramatic cliffs and waterfall identify the site represented in this composition as Scandinavian, yet the sense of a specific location is not conveyed, which suggests that the drawing was created from memory after the artist's return to Holland. Indeed, the compositional formula employed in this sheet, in which precipitous cliffs, right, contrast with an extensive plain at the left, may also be seen, with varying degrees of elaboration in, for example, a painting sold in Stockholm in 1941,[1] and in drawings in Amsterdam,[2] Berlin,[3] Chantilly[4] and Hamburg.[5] It occurs rarely, however, in the artist's etchings.[6]

Van Everdingen here treats all forms with an unusual breadth and degree of generalisation. In electing to draw with the point of the brush on a sheet of small format, the artist avoids the description of detail in all its minuteness, in favour of organising the landscape's bolder masses and voids into a balanced and harmonious design. As an aid to establishing unity over the composition, van Everdingen employs a rhythmical, double-curving contour, variants of which are echoed in all areas of the sheet. The dominant downward sweep of the waterfall terminated by the outcrop of rock here at the left, for example, is repeated by the contour of the cliff-side as it joins the plain, and is taken up by the elegant undulations formed by the linked branches of spruces at the upper right of the sheet. A comparable procedure for unifying landscape compositions is manifest in the work of Abraham Bloemaert (see cat. no. 32), in which van Everdingen's interest is clearly reflected in a drawing in Paris[7] which includes the motif of a cottage in a state of picturesque dilapidation. The present drawing, and Scandinavian scenes in Amsterdam[8] and the Institut Néerlandais[9] indicate that Bloemaert's work continued to influence van Everdingen during the period of his creative maturity.

1 Bukowski, 8–9 October 1941 (lot 94); photo Witt.
2 With Bernard Houthakker, 1972; photo Witt.
3 Staatliche Museen; Bock/Rosenberg, p. 131, No. 2324, and p. 133, No. 8493.
4 Musée Condé; Bernt, I, No. 224.
5 Kunsthalle; exh. Munich, 1973 (69).
6 Exceptions are Hollstein, Vol. VI, pp. 167, 173.
7 Ecole Nationale Supérieure des Beaux-Arts; Lugt, 1950, No. 177.
8 Rijksmuseum, Inv. No. A.3740; photo Witt.
9 Exh. Brussels/Rotterdam/Paris/Berne, 1968–69 (51).

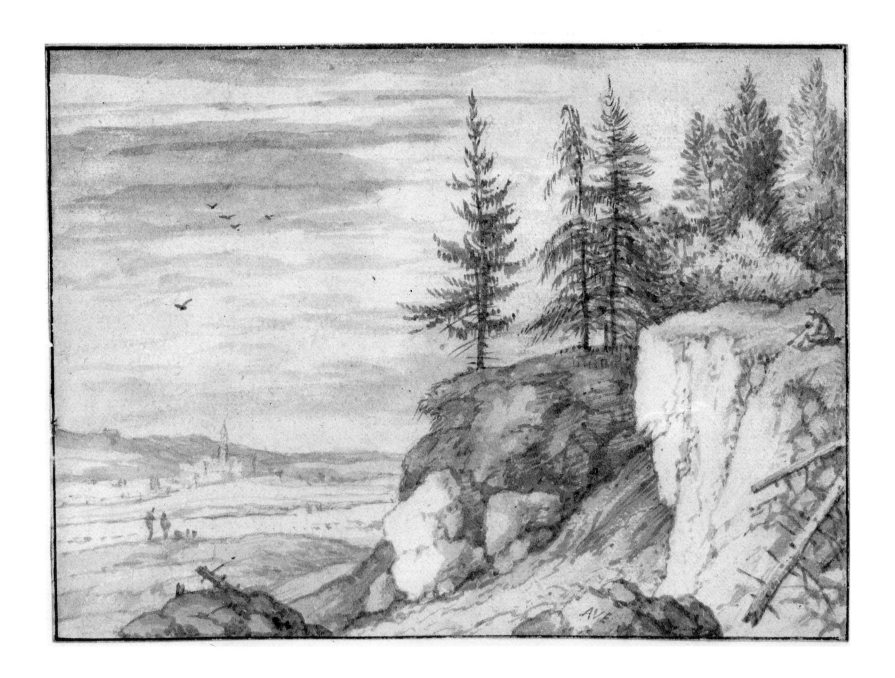

JAN VAN GOYEN
(1596–1656)

39 Dune Landscape *c.*1630

Black chalk; on pale buff (stained) laid paper. The sheet unevenly trimmed at all sides.

12.6 × 21.4 cm.

PROVENANCE: Sir Robert Witt (purchased from Parsons, no date); Witt Bequest 1952 (902).

EXHIBITION: Courtauld, 1972 (10).

LITERATURE: Beck, I, no. 776.

The life and work of Jan van Goyen, perhaps the most renowned pioneer of naturalism in Dutch seventeenth-century landscape painting, has been thoroughly explored in recent publications by Hans-Ulrich Beck. For van Goyen, drawing was the principal means to study landscape from nature, although he appears to have drawn only at certain periods during his career. Beck[1] considers that many of the pure landscape drawings such as the composition exhibited here were intended as works of art in their own right.

There are few works in van Goyen's *œuvre* in which the motif of the sand dune is the principal subject, although dunes rapidly noted from nature appear on two leaves of a sketchbook in the British Museum,[2] datable to the period 1627–33. The studies in this book, like the present work, are executed mainly in black chalk, with which van Goyen had experimented in drawings of 1626 and which he was to adopt for all drawings after 1630.[3] The composition stated in the sheet exhibited here is related to that of the sketchbook drawing no. 170, in which a dune, sloping gently away to the right, occupies the lower third of the pictorial area. The scene is observed from a low vantage point so that only a farmhouse roof and solitary tree are visible above the crest of the sands. That image of quiet drama and isolation is further refined in the Courtauld drawing, which employs fewer compositional elements and was probably created in the studio. The fence at the side of the dune in the British Museum sketch is here suppressed, so that the scale and gradient of the slope, which can no longer be accurately gauged, appears all the more precipitous and imposing. The spindly tree which relieved the horizontality of the sketch is here transposed into the figures of an adult and child. Drawn with the same looped stroke which describes the dune, the figures' lack of characterisation ensures that the spectator's attention is not deflected from the landscape by any possible genre content.

A dune formation similar but in reverse to that of the Courtauld and British Museum drawings appears in the foreground of a painting in Frankfurt,[4] which includes a larger tract of land observed from a more elevated viewpoint. This work is dated 1629, and a comparable date in the late 1620s or early 1630s may also be assigned to the drawing exhibited here.

1 Beck, I, p. 52.
2 Beck, I, Nos. 844/52, 844/170. The sketchbook contains 182 drawings, of which one is by E. van der Velde and four are by an unidentified hand.
3 Beck, I, pp. 52, 54.
4 Kunstinstitut; Beck, II, No. 1077.

JAN VAN GOYEN
(1596–1656)

40 Landscape with Oak Tree 1630s

Black chalk; carbon grey ink washes, with drawing with the point and flat of the brush. The pictorial area framed by the artist with a ruled line in pen and brown ink, the sheet unevenly trimmed at all sides.

13.0 × 15.9 cm.

Numbered in modern hands in pencil, *verso*: 'PJ1306'; 'A16107', and: '10'.

PROVENANCE: Sir Robert Witt (purchased from Colnaghi, no date); Witt Bequest 1952 (4065).

EXHIBITIONS: Leiden/Arnhem, 1960 (76); Manchester, 1962 (23); Courtauld, 1972 (7).

LITERATURE: Beck, I, no. 787.

This drawing, dated by Beck to the 1630s,[1] is of a format unique within van Goyen's *œuvre*, in that it is almost square. The format employed by the artist for paintings in which a single tree predominates (three examples of which are dated 1633[2]) is vertical, while other drawings treating comparable subjects are clearly horizontal.[3] It is in the drawings, rather than in paintings, that van Goyen seems to have felt at liberty to study the motif of the solitary, dominant tree without the intrusion of picturesque staffage, such as washerwomen, birdhunters or shepherds.

The oak in the sheet exhibited here is rendered by a dense network of nervous hooked and curling strokes, reminiscent of those describing the tree in a sheet in the Ames collection, New London, also dated by Beck to the 1630s.[4] Unlike that work, the present example is overlaid by a series of finely gradated carbon ink washes which extends the composition's tonal range and subtlety: the practice of applying such washes becomes habitual in van Goyen's work only in 1647.[5] The degree of realisation and refinement of the Courtauld drawing suggests that, despite the lack of signature, it was conceived as a completed composition in its own right.

In both Courtauld and Ames drawings, the powerful diagonal thrust of the tree trunk is counterbalanced by a gently sloping terrain controlled by a low horizon-line. The oak in the present design, unlike that of the New London drawing, is cropped by the upper and lower edges of the sheet, thus bringing the motif closer to the spectator and enhancing its immediacy. A similar experiment in cropping is visible in a rapid chalk study of a tree, probably on a page from a sketchbook, in the Oehler collection, Kassel.[6] In that work, which is of horizontal format, van Goyen explores a pictorial structure analogous to that stated here (although the tree trunk leans in the opposite direction), but the sheet does not appear to have been trimmed at the edges. The Courtauld sheet, by contrast, seems to have been deliberately cropped by the artist in order to maximise the impact of the dominant diagonal design. The composition may have been cut from a sheet measuring 17 × 27 cm., the larger of two sketchbook formats favoured by van Goyen when creating formal, finished drawings.[7]

1 *ibid*. Beck incorrectly gives the dimensions of this sheet as 13.0 × 17.3 cm.
2 In the W. P. Wilstach coll., Philadelphia; Beck, II, No. 162: G. Ritter Hoschek von Mülheim coll., Prague; Beck, II, No. 163: T. F. C. Frost coll., Beck, II, No. 148.
3 A typical example is Beck, I, No. 642, measuring 8.4 × 13.4 cm. Horizontal sheets have a height/width ratio of approximately 1:2.
4 Beck, I, No. 704.
5 Beck, I, p. 52.
6 Beck, I, No. 642.
7 *ibid*.

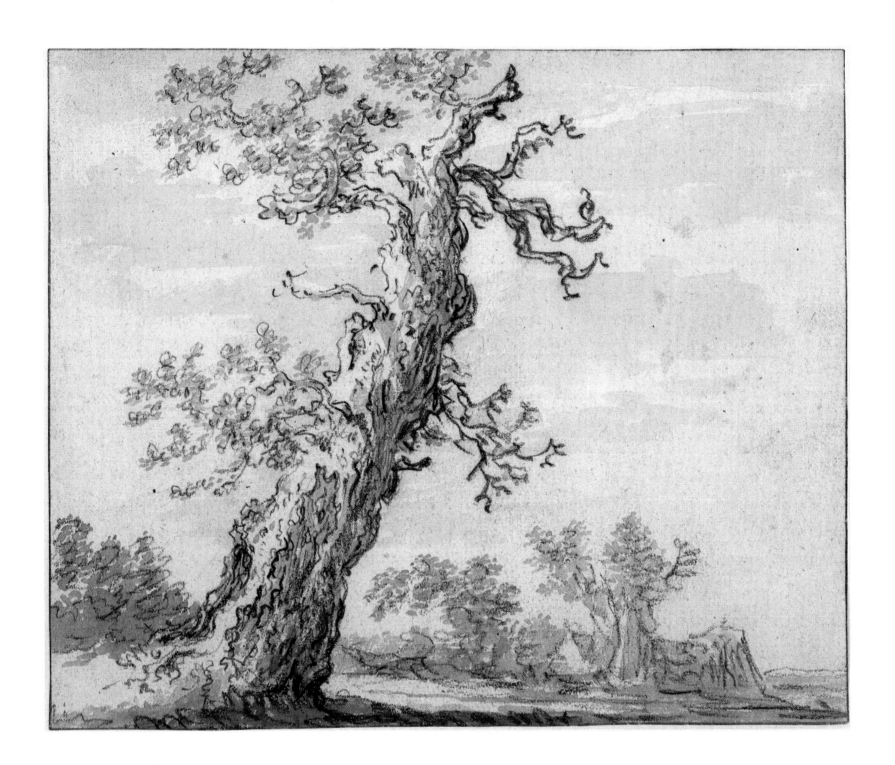

JAN VAN GOYEN
(1596–1656)

41 River Delta 1653

Black chalk; carbon grey ink washes, with some drawing with the brush; on off-white (stained) laid. The pictorial area enclosed within the artist's ruled framing lines in black chalk. Vestiges of ruled lines by a later hand in red chalk. The sheet unevenly trimmed at all sides.

12.1 × 20.6 cm.

Signed and dated in black chalk, bottom right: 'VG 1653'.

Inscribed and numbered by Sir Robert Witt in pencil, *verso*: '900 Goyen'.

PROVENANCE: Sir Robert Witt (purchased from Parsons, no date); Witt Bequest 1952 (900).

EXHIBITIONS: Australia, 1968 (32); Courtauld, 1972 (15).

LITERATURE: Beck, I, No. 502.

The largest group of signed and dated drawings by van Goyen was executed during the period 1651–53; in the latter year particularly, the artist painted little but produced some 250 works on paper.[1] Carefully drawn in black chalk and often tinted with broad strokes of carbon grey ink wash, each sheet presents a composition complete in its own right: the prominence of signature and date on these works suggests that they were created specifically for sale.

 Approximately half the drawings dated 1653 depict scenes based on Holland's waterways, of which a group of 20,[2] including the example exhibited here, represent estuaries or deltas and are formally related. Such compositions are of horizontal format: the horizon-line, drawn low on the sheet, is obscured at one side by an area of rising ground on which is situated a building, typically a watchtower as on the left of the present composition. Tongues of land alternating with stretches of water create lateral bands of varied tone across the middle distance, while located near the centre of each sheet is a strong contrasting vertical accent (in the present example, a slender tower; in other works, a sail) around which diagonals of oars, spars, sails, etc., are balanced. These compositions were probably not drawn directly from nature since they frequently include motifs recorded in earlier paintings, drawings and sketchbooks. The pictorial structure of the delta scenes may rely on that shown in slight sketches on three sheets of a notebook of 1650–51,[3] in which van Goyen records his journeys along the complex of the Rhine from Cleves in the east to Valkenburg and Haarlem on the coast. The landscape represented in the Courtauld composition may be inspired, as Beck suggests,[4] by an area of partly submerged land in Zuid Beveland (Zeeland) from which rise characteristic ruins known as 'de Batsentoren'. The central tower and indications of townscape included in the background, however, are directly related to those in a drawing dated 1644 in Rotterdam,[5] while the group of cows silhouetted in the middle distance recalls in treatment and placing similar motifs included in painted views of Leiden dated 1648[6] and 1651.[7]

1 Beck, I, Nos. 332A–557E.
2 Beck, I, Nos. 436–38, 444, 444A, 446, 447, 450, 452, 462, 465, 471, 485, 496, 503, 510A, 528, 530, 533.
3 W. Suhr coll., New York; Beck, I, Nos. 847/162, 847/171, 847/174. The sketchbook, of some 170 leaves, was split up.
4 *ibid.* A note in Sir Robert Witt's file records Welcker's opinion that the site depicted is Dordrecht.
5 Boymans–van Beuningen Museum; Beck, I, No. 147.
6 Sidney J. van den Bergh coll., Wassenaar; Beck, II, No. 334.
7 C. E. Tryon-Wilson coll., Milnthorpe; Beck, II, No. 339.

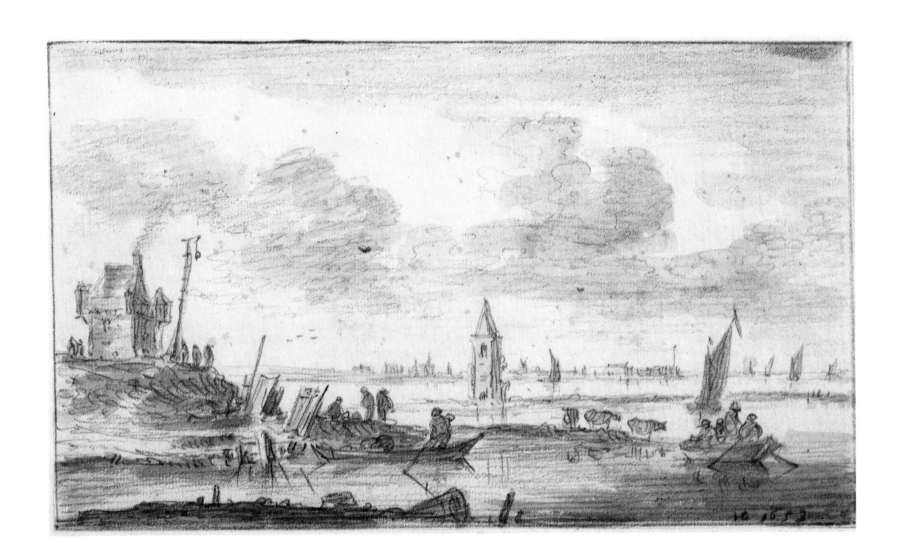

JAN HACKAERT
(*c*.1629–after 1685) after Jan Both

42 Landscape with Trees 1667

Slight traces of preliminary drawing in graphite; pen and light brown ink; grey (carbon) ink washes, with drawing with the pen (restricted to the foliage) and with the point and flat of the brush; on off-white laid paper. The drawing enclosed within the artist's ruled lines in pen and brown ink, and unevenly trimmed at all sides.

20.3 × 18.4 cm.

Dated by the artist in pen and light brown ink, *verso*: $\frac{\text{'i2'}}{67}$, and inscribed by a later hand in pencil: 'e'.

PROVENANCE: Sir Robert Witt (purchased from Colnaghi, no date); Witt Bequest 1952 (3705).

EXHIBITION: Courtauld, 1972 (29).

This drawing, accepted as from the hand of Jan Both (1610/18–52) when purchased by Sir Robert Witt, was later catalogued under this artist's name in the Hand-list and elsewhere.[1] That the sheet is not by Both becomes clear when it is compared with that artist's drawing of an extensive landscape in Stockholm,[2] recently published as the sketch related to the signed painting *Wooded Hillside with Vista* in Minneapolis.[3] Both's sheet depicts the entire landscape of the Minneapolis composition but includes fewer figures: the highly finished work exhibited here, almost certainly executed after the Stockholm drawing rather than the painting, reproduces the central area only of the composition shown in that sheet, and omits all staffage, thus depriving the spectator of the means by which to gauge the landscape's scale. The trees in the background of the present drawing are enlarged when compared to those in Both's sheet, while those in the foreground are here more closely spaced and aligned with the picture surface to form a screen across the right of the composition, which results in compression of the original pictorial space. Although the style of the Courtauld work closely follows that of the drawing in Stockholm, its freer and more calligraphic draughtsmanship is applied with equal emphasis to all areas of the sheet, negating the effects of atmospheric recession and reinforcing the shallow pictorial depth. Similar characteristics of handling and composition are visible in Jan Hackaert's drawing in Groningen,[4] which interprets the entire landscape of Both's signed drawing in Berlin,[5] while again omitting the staffage.

The drawing in Groningen is an important document, since it is signed with Hackaert's initials and dated 1661. It confirms Stelling-Michaud's hypothesis, published in 1936 and 1937,[6] that this artist may have been the author of drawings attributed to Both, and that he probably had ready access to many of the latter's designs: the late date of 1661 (i.e. nine years after Both's death) suggests that Hackaert did indeed retain in his possession a number of the elder artist's drawings. The hitherto unexplained numbering on the *verso* of the present sheet, in the same golden-brown ink as the contour drawing on the *recto*, and in the same hand as the inscription on the Groningen drawing, may now also be interpreted as a date, i.e. December 1667.[7]

The importance of Jan Both – the first of the Dutch Italianising landscapists whose work may be considered classical – has been demonstrated by Blankert.[8] Both may have travelled to Italy as early as 1635, and was certainly in Rome in 1638. There he assimilated the influence of the work of Claude Lorrain (1600–1682), modifying the classical framework and formality of that artist's

landscape compositions. On returning to Utrecht in 1641, Both consolidated the compositional types and style learned in Italy. The grandeur and stateliness of his wooded scenes, the everyday charm of the staffage and the effects of golden southern light and warm atmosphere had considerable impact not only on Jan Hackaert, but also on artists such as Jan Asselyn, Nicolaes Berchem, and Adam Pynacker.

1 Hand-list, p. 101, No. 3705, and exh. Courtauld, 1972 (29).
2 Nationalmuseum; Burke, No. 165.
3 Minneapolis Institute of Arts, Putnam D. McMillan Fund; Burke, No. 74.
4 Museum voor Stad en Lande; Bolten, 1967, No. 35.
5 Bock/Rosenberg, p. 91, No. 12241.
6 Stelling Michaud, 1936, pp. 261–73, also 1937, which deals more specifically with Hackaert's journey through Switzerland.
7 A similar form of dating appears on drawings by Klotz (e.g. Cat. No. 48) and by J. de Grave. Other landscapes catalogued in the Hand-list of the Witt coll. as by J. Both (p. 101, Nos. 1928, 3166), may now also be attributed to Hackaert. Witt No. 4070, also formerly given to Both, may perhaps be ascribed to Pynacker.
8 In exh. cat. Utrecht, 1965.

MARTIJN VAN HEEMSKERK
(1498–1574)

43 The Colossus at Rhodes 1570

Slight traces of preliminary drawing in graphite or black chalk; pen and light brown ink washes; on pale buff laid paper. The pictorial area enclosed within the artist's freehand line in pen and brown ink, a ruled framing line in pen and dark brown ink added by a later hand. Pressed through for engraving. The sheet folded vertically at the centre and twice horizontally, and unevenly trimmed at all sides.

Watermark: scroll, with letters 'NBE'.

20.4 × 26.3 cm.

Signed in pen and brown ink, bottom left: 'Martijn van Heemskerk/inventor', and dated bottom right: '1570', and inscribed by the artist, top left: '5. Colosus Solis.' and numbered, bottom right of centre: '5'.

PROVENANCE: J. P. Zoomer (?); A. G. B. Russell; Sir Robert Witt (purchased from Meatyard, no date); Witt Bequest 1952 (648).

EXHIBITIONS: Oxford, 1929 (7); New Zealand, 1960 (60); Manchester, 1962 (25); British Museum, 1983 (25).

LITERATURE: Duclaux, p. 378, pl. 7.

This and the following drawing are two of four extant designs for the series *Octo Mundi Miracula* (The Eight Wonders of the World) engraved by Philip Galle and published in an edition of 1572 by Ioannes Galle:[1] designs for the *Walls of Babylon* and the *Amphitheatrum* entered the Louvre in 1978.[2] With the exception of the latter sheet, Heemskerk's numbering on the drawings is not followed in the engravings, and the present composition, numbered 5, is the fourth plate of the printed suite.

In a painting in Baltimore dated 1536,[3] Heemskerk had united within a panoramic landscape the seven wonders of the world. By increasing the number to eight in the designs of 1570, the artist followed the tradition established by several medieval compilers of lists of marvels, although the choice of the Amphitheatrum or Roman Colosseum as the world's eighth wonder is unorthodox, since only one classical author, Martial, designated it as such.[4]

The middleground of the present composition is dominated by the Colossus, which, with flaming torch, stands astride Rhodes' harbour. The scene in the foreground is ambiguous: it probably depicts the masons' final polishing of the statue, supervised by its sculptor who consults a design for the completed work, in much the same way that the architect oversees the completion of the Temple of Diana in the following drawing; yet it may alternatively be interpreted as the discovery and cleaning of the remains of the Colossus, since the head and huge finger are conceived in a manner clearly dependent on that visible in Heemskerk's drawings recording fragments of antique statuary in the Roman sketchbooks of 1532–36.[5]

The imaginary view of Rhodes in the background of this drawing includes at the right a domed building, possibly inspired by the Pantheon, sketches of which Heemskerk had executed while in Rome.[6] Situated directly behind the Colossus is a semi-circular, tiered structure whose form is based on that of the Colosseum.[7] The juxtaposition here of motifs of Colossus and Colosseum is significant. When in Rome, Heemskerk would have discovered that the Colossus Neronis, a gilded bronze statue some 133 feet tall, had been located adjacent to the Colosseum, where its brick and concrete base was still visible.[8] He would also probably have been aware of the popular confusion and

connection between this Colossus and that in Rhodes, and between the latter monument and the Colosseum. The confusion was indeed such, as Brett has noted,[9] that the Colosseum was regarded as part of the Colossus of Rhodes which had been transported to Rome. By introducing into the view of ancient Rhodes the Colosseum – Martial's eighth wonder of the world and one which Heemskerk had observed at first hand – a degree of authenticity and historical accuracy which both affirms and is supported by popular belief is conferred upon the imaginary townscape.

A variant after the print of *The Colossus at Rhodes*, drawn by Maerten de Vos (1532–1603) was in turn engraved by Crispijn de Passe I (*c*.1565–1637) with the aid of his sons and daughter,[10] and published in 1614. Later in the seventeenth century de Passe's print served as the basis for the design of a Brussels tapestry, now at Arles.[11] Galle's engraving after the present drawing also inspired a painted variant by Tobias Verhaecht.[12]

1 Hollstein, Vol. VIII, p. 245, Nos. 357–64. The engraving after the present design is No. 360. The date 1572 appears on the first and second states of plate no. 7, *The Walls of Babylon*.
2 cf. Duclaux. The drawings are Preibisz, p. 83, Nos. 7 and 8.
3 Walters Art Gallery; E. F. King, 'A New Heemskerk', *The Journal of the Walters Art Gallery*, 1944–45, pp. 61, 73, pl. 2.
4 Brett, p. 349. The Latin inscription added below Galle's engraving of the *Amphitheatrum* alludes to Martial by mention of his birthplace, i.e. 'Adiicit his vates cuius se Bilbilis orta/ …' ('this poet of whose birth Bilbilis is proud/…')
5 Hülsen/Egger, I Fol., 19r, 23, 24, 25r, 27r, 30v, 32r.
6 Egger, Vol. II, pl. 93A.
7 The Colosseum appears frequently in Heemskerk's Roman sketches, e.g. Hülsen/Egger, I Fol., 3r, 28v, 69v, 70r; II Fol., 47r, 55r, 56v, 71r, 94v, and is included in panoramic sketches in II Fol. 91v and 92r. The Colosseum motif in the present drawing is comparable to that in Egger, Vol. I, No. 99, and on the *verso* of a sheet in a private collection, Amsterdam, exh. Rotterdam/Paris/Brussels, 1977 (73).
8 Originally cited in the vestibule of the Golden House at Velia, Hadrian had the statue moved to where today the Via dei Fori Imperiali opens into the Piazza del Colosseo. The statue is last recorded in A.D. 354, but its base remained near the Colosseum until its removal in 1936; Nash, I, p. 268, pls. 316–18.
9 p. 350.
10 Hollstein, vol. XVI, p. 25, nos. 72–78. De Passe's children were Simon (1595–1647); Crispijn II (*c*.1597–1670); Magdalena (1600 – before 1640).
11 Musée Réattu; Brett, pl. 8.
12 Sold Sotheby, 3 June 1981 (lot 29); photo Witt.

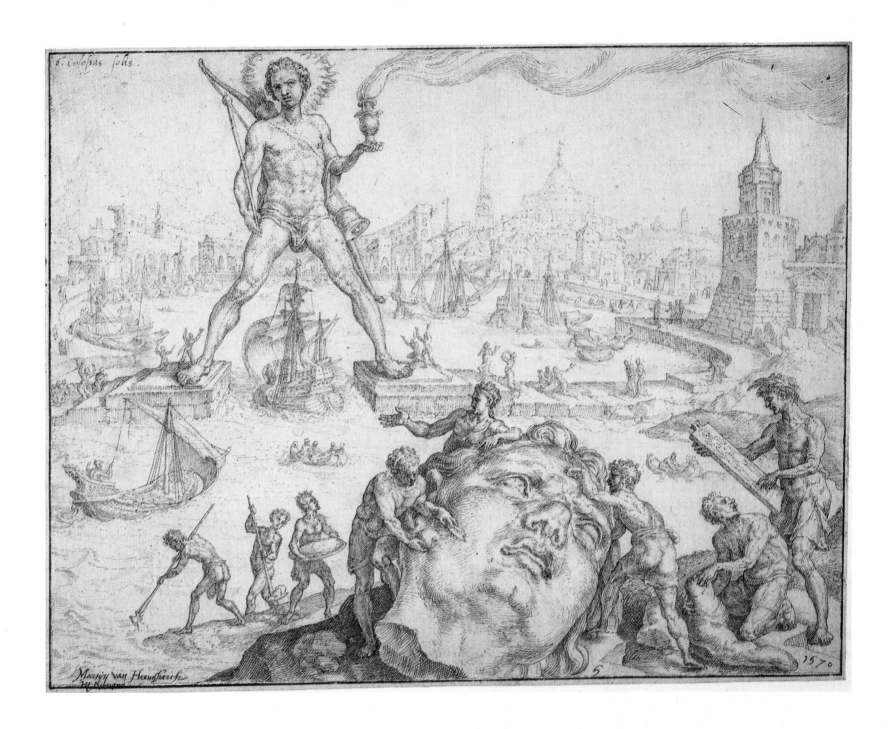

Martyn van Heemskerck

1570

MARTIJN VAN HEEMSKERK
(1498–1574)

44 The Temple of Diana at Ephesus 1570

Traces of preliminary drawing in black chalk, both freehand, and for the orthogonals of the temple, ruled; pen and brown ink; on pale buff (stained) paper. The pictorial area enclosed within the artist's freehand line in pen and brown ink, a ruled line in pen and dark brown ink added by a later hand. The sheet unevenly trimmed at all sides. Pressed through for engraving, the *verso* prepared with black chalk.

20.2 × 26.8 cm.

Signed and dated in pen and brown ink, lower left: 'Heemskerk/inventor/ 1570', and inscribed by the artist, top left: '4. Dianæ Ephesiæ Templum', and numbered lower right of centre: '4'.

Stamped with the collector's mark of J. P. Zoomer (Lugt 1511), *recto*.

PROVENANCE: J. P. Zoomer; A. Russell; Sir Robert Witt (purchased from Meatyard, no date); Witt Bequest 1952 (647).

EXHIBITIONS: British Museum, 1983 (26).

LITERATURE: Duclaux, p. 379, pl. 9.

This composition, numbered '4' by Heemskerk, was engraved by Galle as the fifth plate of the series *Octo Mundi Miracula* (see cat. no. 43).[1]

During its history the Temple of Ephesus was either enlarged or completely rebuilt three times, on the site of a shrine dedicated to the goddess Diana which had been in existence prior to the Ionian occupation of south-west Turkey.[2] The final temple to be constructed, considered to be one of the world's wonders due to its vast proportions, was designed by Denocrates, an architect active during the reign of Alexander the Great. Neither the figures of architect nor king included at the left of the present drawing are identified in the inscription added below the related print, although they may indeed represent Denocrates and Alexander.[3]

For the design of the Temple itself, Heemskerk referred to the type of single-aisled church which had been evolved in Florence during the late Quattrocento. The artist may also have seen similar structures in Lombardy,[4] but not in Rome, since the foundations of the first church of this type were laid in that city only in 1537,[5] the year in which Heemskerk returned to Haarlem.

A variant drawn by Maerten de Vos after the engraving of this composition includes the motif of a circular Temple of that artist's invention, although the figures of the masons in the foreground are closely related to those shown here. Engraved by the de Passe family,[6] de Vos' variant provided the design for three Brussels tapestries now in Amboise, Cleveland, and London,[7] into each of which were introduced further embellishments.

6 Hollstein, vol. XVI, p. 25, No. 76.
7 In the collections of the Château d'Amboise, the Cleveland Museum of Art, Ohio, and Lord Charnwood, respectively; Brett, figs 11–13.

1 Hollstein, vol. VIII, p. 245, No. 361.
2 The first temple of Hellenic form was the work of the Cnossian, Cherisphron, and his son Metagenes in 600 B.C. The second, Croesus' temple, under construction in 540 B.C. was burned down by Herostratus in 356 B.C. (cf. entry in *Encyclopaedia Britannica*, 11th ed.)
3 The inscription: 'Struxit Amazonia hanc Ephesus tibi delia sacram,/idem luxoriose ingens Asiae ornamentum/Fundamenta paius tenuit carbonibus aute/farta, uti telluris starent immota fragore' may be translated as: 'Amazonian Ephesus built this temple sacred to you Delia, the opulent wonder of Asia/a swamp packed beforehand with charcoal held the foundations so that they stood unmoved by the crashings of the earth' (translation: Brendan Prendeville).
4 Heydenreich/Lotz, pp. 106–108.
5 Antonio da Sangallo the Younger's S. Spirito in Sassia, built 1537–1542; Heydenreich/Lotz, p. 273.

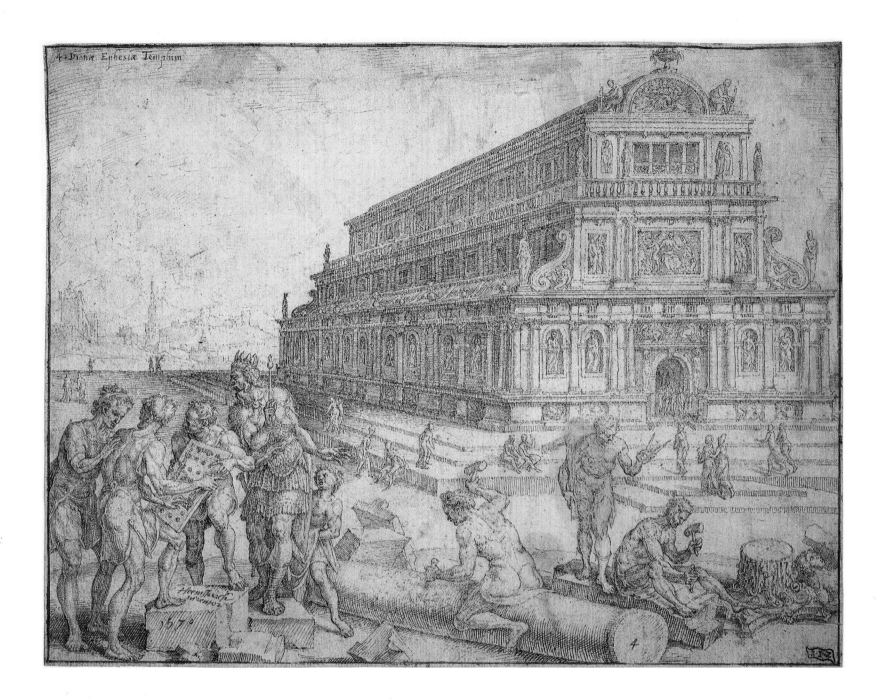

ADRIAEN HONICH
(1644–after 1683)

45 View of Tivoli

Preliminary drawing in red chalk; pen and brown ink; grey (carbon) ink washes with drawing with pen and the point of the brush, and some use of the dry brush; white and pale grey bodycolour (the result of mixing with grey wash), with use of the dry brush; on off-white laid paper, prepared with a dilute grey (now stained and abraded) bodycolour ground. The drawing enclosed within the artist's freehand line in red chalk, and ruled line in pen and brown ink. The sheet folded vertically at the centre, and unevenly trimmed at all sides.

Watermark: bird on a hill with three summits, encircled.[1]

30.5 × 44.3 cm.

Inscribed in graphite, *verso*: 'Lossenbruÿ Roma', and numbered in a modern hand in pencil: 'A15873', and: '–843'.

PROVENANCE: Sir Robert Witt (purchased from Colnaghi, 1949); Witt Bequest 1952 (4008).

EXHIBITION: Courtauld, 1972 (44).

LITERATURE: Röthlisberger, 1963, pp. 123–24, pl. 4; Röthlisberger, 1964, p. 18.

The little that is known of Honich's life and work is the subject of two articles by Röthlisberger.[2] A native of Dordrecht, the artist is recorded in Paris in 1663 but by 1667 had arrived in Rome: after 1683, when apparently still in that city, all records of him cease.

A total of 13 of this artist's drawings have been published, to which may be added a further sheet in Paris[3] and a drawing in the Witt collection, formerly ascribed to Jan Frans van Bloemen (1662–1749).[4] The *verso* of that work bears an old ascription to Honich in graphite by the same round hand which appears on the *versos* of the sheets exhibited here, on a fourth drawing in the Courtauld Institute Galleries,[5] and on a work in Leiden.[6] This latter drawing is the only sheet in Honich's *œuvre* which is inscribed with a date, but this is of little assistance in the chronological arrangement of the artist's work, which displays no marked evolution of style.

Most of the drawings are related by technique. They are frequently executed on manufactured blue or grey sheets,[7] or on white paper prepared with a bodycolour ground of grey: exceptionally, in the case of a drawing in the Gobiet collection,[8] the artist experiments with a dark green ground. Red chalk is usually employed for preliminary drawing, while detail is added with pen and brown ink. Shading is applied with washes of carbon black, and a complementary contrast of strokes of lead white paint is introduced to model those areas of intense illumination or high relief. Such a method of drawing is related to the procedures adopted in the use of metal point, a technique employed as early as the fourteenth century but which by the seventeenth had fallen into disuse.

The majority of Honich's drawings appear to have been executed in Italy. Of these, nine treat subjects at Tivoli, but the present examples record the only panoramic views of this site in the artist's work. In both sheets, deviations between the exploratory preliminary sketch and the minute and specific dealing with the pen are sufficiently great to suggest that the compositions may have been completed in front of the motif.

In the present drawing, Tivoli is observed from a point south-west of the so-called Temple of Vesta (visible at the left), looking north-east. The Temple, constructed in the early decades of the first century B.C.[9] and perhaps during the dictatorship of Lucius Cornelius Sulla (138–78 B.C.), was by 1400 transformed into the Christian church of Sta Maria Rotonda, but in the eighteenth century was restored to its original structure. Behind it, to the right, is situated the ancient Temple of the Sybil, which was until 1884 in use as a church dedicated to St. George.[10]

1 Similar watermarks are on drawings by Honich in the Institut Néerlandais, Fondation Custodia (Lugt coll.), Paris, Inv. Nos. 5834, 8004.
2 Röthlisberger, 1963, 1964.
3 Institut Néerlandais, Inv. No. 1974–T.31.
4 Hand-list, p. 123, No. 1791.
5 Hand-list, p. 106, No. 4146.
6 Printroom of the University; Röthlisberger, 1964, fig. 5.
7 Witt no. 4146 is on blue paper; a drawing in the Albertina, Vienna (Röthlisberger, 1963, fig. 3), is on grey.
8 Seeham bei Salzburg, Austria; Röthlisberger, 1963, fig. 3.
9 Boethius/Ward-Perkins, p. 137.
10 Mosti, pp. 71–73 gives an account of the history of Tivoli's monuments.

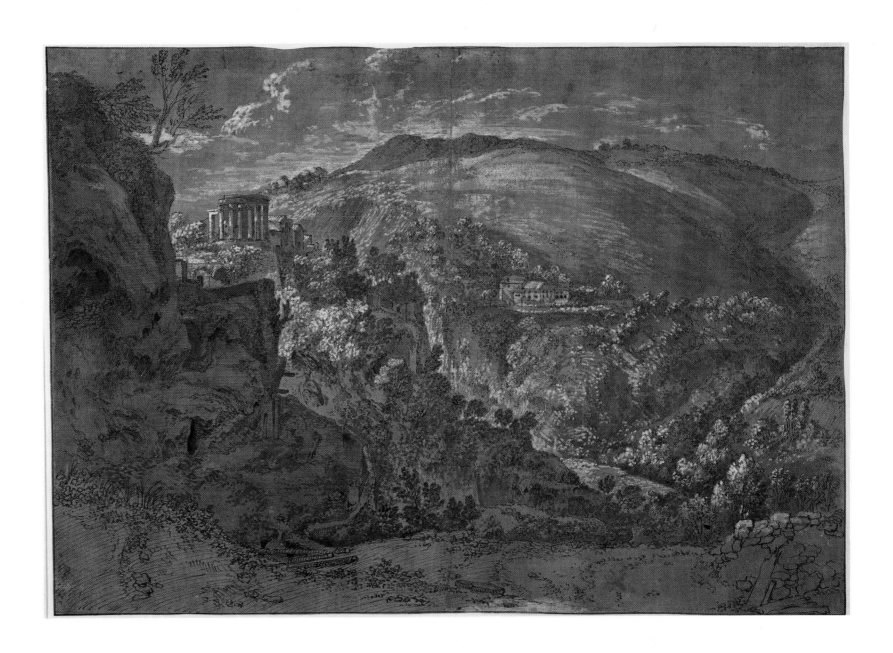

ADRIAEN HONICH
(1644–after 1683)

46 View of Tivoli

Preliminary drawing in red chalk; pen and brown ink; grey (carbon) ink washes, with drawing with the pen and point of the brush, and some use of the dry brush; white and pale grey bodycolour (the result of mixing with grey wash), with extensive use of the dry brush (particularly in the area of river and waterfall); on off-white laid paper, prepared with a dilute grey (now stained) bodycolour ground. The drawing enclosed within the artist's ruled line in pen and brown ink, and unevenly trimmed at all sides.

Watermark: bird on a hill with three summits, encircled.

29.9 × 43.4 cm.

Numbered in black chalk, upper centre: '8'.

Inscribed in graphite, *verso*: 'Honing Aleas Lossenbruy', and numbered in a modern hand in pencil: 'A15843/cc/–/–'.

PROVENANCE: Sir Robert Witt (purchased from Colnaghi, 1949); Witt Bequest 1952 (4009).

EXHIBITION: Courtauld, 1972 (59).

LITERATURE: Bernt, I, no. 304; Röthlisberger, 1963, pp. 123–24, pl. 5; Röthlisberger, 1964, pl. 18.

The Temple of Vesta is here depicted from a greater distance and a more elevated and westerly point of observation than that adopted in the preceding work. The Roman temple also appears in two drawings of vertical format in Paris, one of which, of comparable dimensions to the sheets exhibited here,[1] depicts the motif in close-up and from an easterly vantage point, to include in the foreground a view of the waterfall. The second related vertical composition[2] represents the Temple of Vesta observed from a site located more to the west, and within the context of a tract of countryside which is repeated in less detail in No. 45. The landscape included in that work is in turn incorporated into the left of the composition exhibited here. Such a relationship created between the Courtauld and Paris drawings by the repetition of motifs and forms is further strengthened by a common element of pictorial construction; for in each work, the temple is observed beyond a *repoussoir* at the left, created either by an outcrop of rock or a wall, which is in itself a variant of a particular stepped form. That Honich here utilised the landscape and architecture of Tivoli as the theme for a suite of formal variations (achieved simply as the result of the selection of vantage point and pictorial format) may be somewhat obscured by the complex and composite nature of the motif and by the great divergence of viewpoint from which it is observed. The artist's tendency to work in series in which nature is indeed subject to this almost abstract treatment becomes immediately clear when the motif rendered is less ambitious and the points of observation are more closely related. One such suite of drawings, composed of studies of the same outcrop of rock, is formed by works in Leiden,[3] Paris[4] and Seeham bei Salzburg, while related compositions are in Vienna.[6]

1 Institut Néerlandais, Fondation Custodia (Lugt coll.), Inv. No. 8004, measures 43.1 × 30.5 cm. and bears a similar watermark to the sheets exhibited here. It is catalogued in Brussels/Rotterdam/Paris/Berne, 1968–69 (79) as made up from two sheets, although the drawing has been folded centrally and torn and repaired along the crease (information from C. van Hasselt in a letter to the author, May 1985). The Courtauld drawings are similarly folded at the centre, suggesting that they and the Paris sheet may have been stored in the same portfolio.

2 Institut Néerlandais, Fondation Custodia (Lugt coll.), Inv. No. 1974–T.31. The sheet measures 39.5 × 26.7 cm., but may have been trimmed to this size from the format of the Courtauld sheets.
3 Printroom of the University; Röthlisberger, 1964, fig. 5.
4 Institut Néerlandais, Fondation Custodia (Lugt coll.); Röthlisberger, 1964, fig. 9.
5 Armand Gobiet coll.; Röthlisberger, 1963, fig. 10.
6 Albertina; Röthlisberger, 1963, figs. 3, 8.

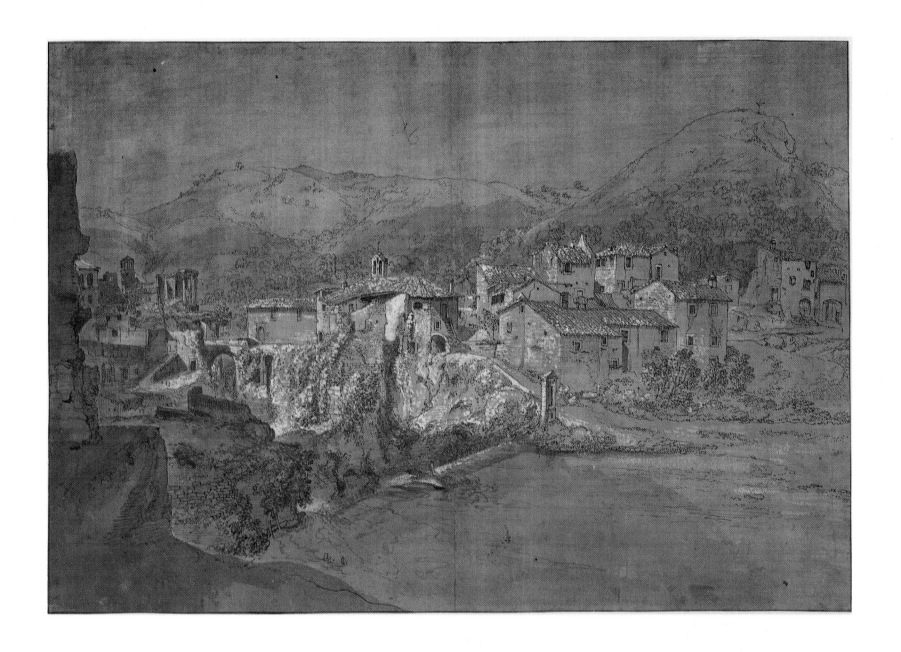

CONSTANTIJN HUYGENS II
(1628–1697)

47 View of the IJssel · 1672

Slight traces of preliminary drawing in graphite; pen and brown ink; brown ink and pale blue watercolour washes, with drawing with the point and flat of the brush; on off-white (stained) laid paper. The sheet unevenly trimmed at all sides to a ruled line in graphite, and laid down on tissue. Extensive breaks, principally in a horizontal line near the bottom of the sheet caused by burning through of brown ink.

11.2 × 17.3 cm.

Inscribed by the artist in pen and brown ink, top right of centre: 'AendYss•l 5 Jun. 1662.' (the date altered by the artist to: '1672'), and on the *verso*: '5 Jun. 1672'

PROVENANCE: (?) J. Stinstra, sold Roos, Amsterdam, 17 February 1823 (one of lots 44 or 47); Lady Phyllis Benton, sold Sotheby, 26 April 1950 (lot 18, with *A Village Street* (*View of Haecht*, of 6 June 1675)); Sir Robert Witt (purchased from Duits, no date); Witt Bequest 1952 (4381).

EXHIBITIONS: Courtauld, 1972 (50); Amsterdam, 1982–3 (50).

LITERATURE: Gerson, 1976, pp. 305, 311, pl. 6.

Son of the statesman, poet and dilletante Constantijn Huygens I (1596–1687), Constantijn II was a gentleman of private means, scholar, collector and amateur draughtsman.[1] He received drawing lessons in the Hague from Pieter Monincx (1606–c.1686), and in Leiden from Pieter Kouwenhorn.[2] In 1649–1650, he toured France, Switzerland and Italy, illustrating the journal of his travels with occasional topographical drawings. During the 1660s, he was instructed in drawing in miniature by Raymond Blavet,[3] and at this time developed an interest in the preparation of artists' materials, particularly of coloured chalks, but later also of inks.

In February 1672, when it was expected that the Dutch would shortly be at war with France, Willem III, Prince of Orange (1650–1702) was appointed Captain-General and Admiral of the Dutch forces: he nominated Huygens to his Secretariat, and by May the latter was in Gelderland where the States' Army was massed behind the 'water-line' (the river IJssel) to counter the threatened invasion.

While travelling in the prince's service, Huygens made drawings of the sites he visited. These, unlike the work of van der Meulen or Klotz (see Nos. 12, 48) were executed for the artist's personal pleasure, and were neither commissioned nor intended as official records of theatres of war.

The sheet exhibited here may have been one of four views of the IJssel sold from J. Stinstra's collection of Huygens' drawings in 1823, although only one other representation of this subject is now known to us.[4] At the left of the composition is the castle of Nijenbeek, which lies some two miles outside the small town of Voorst. The precise date when the castle was built is unknown, but it is mentioned at the end of the thirteenth century, was an installation of strategic importance during the Eighty Years' War, and in 1672 became the headquarters of the High Command of the States' Army. Nijenbeek is here observed from the north.

Smaller in scale than drawings made by Huygens before entry into the Prince's service,[5] the present sheet is of roughly comparable dimensions to landscapes drawn between May 1672–April 1676:[6] no pattern of paper sizes emerges, however, to suggest Huygens' consistent use of sketchbooks of a particular format during this period. Moreover, all sheets appear to have been trimmed to the dimensions of the pictorial area.[7]

The Courtauld sheet displays the use of brown ink mixed and contrasted with blue watercolour washes which first appears in a view of Zaltbommel dated 15 March 1669.[8] Huygens had begun to draw with ink washes in 1664, and during the next two years experimented with a limited range of watercolours,[9] eliminating all but the blue by 1669. The use of this colour, and indeed, brown ink washes, diminished during the period 1672–1675, since in responding to the increased demands of his secretarial post, Huygens was able to devote less time to drawing: as a consequence, his works became less technically elaborate.

Huygens' handling of wash, which is extensively applied to block in or even elide entire forms, is indebted to the working methods of Jan de Bisschop (1628–1671), a family friend and amateur draughtsman whose drawings Constantijn II had copied during the early 1660s.[10]

The pictorial structure of this drawing (in which the principal motif, located near a high horizon-line, is linked by a serpentine diagonal to the foreground, across which is cast a broad shadow aligned with the lower edge of the sheet) is a reworking of that of the Zaltbommel subject mentioned above. As in that composition, a curved wall in shadow is located here on the left, although it is now defined in less detail: the alternating bands of light and shadow of that drawing are in this work consolidated into a broad zone fusing with the dramatic upward-curve of the IJssel's embankment to form a particularly arresting *repoussoir*. Weaker variants of the Zaltbommel composition had also been explored in sheets dated 1671[11] and May 1672.[12]

The technical simplicity of Huygens' later drawings is complemented by increasingly rudimentary compositional formulae. After 1672, for example, the type of *repoussoir* shown in the Courtauld sheet is reduced to a standard wedge-form, emanating from one of the composition's lateral sides,[13] although it is revived in a drawing dated 2 August 1675.[14] After that date, the use of any framing device becomes infrequent, and space-creating diagonals uniting farthest with nearest plane are abandoned, to be supplanted by an elementary, banded pictorial structure.

Huygens' last extant topographical drawing is dated 4 October 1680[15]; ten years later he appears to have given up drawing completely, although he maintained an interest in art until his death.

1 Biographical data drawn from the unsigned article *Constantijn jr. en de teken kunst*, in exh. cat. Amsterdam, 1982–3.
2 No dates of birth or death given in Thieme-Becker.
3 No entry in Thieme-Becker.
4 Rijksmuseum, Amsterdam; exh. Amsterdam, 1982–3 (18).
5 A drawing of 1666, Huygens-Museum, Hofwijck measures 26.2 × 35 cm.; a sheet of 1667, Institut Néerlandais, Fondation Custodia (Lugt coll.), Paris, measures 22.4 × 35.4 cm., while a sheet of 1669 in the same collection measures 20.8 × 33.1 cm.: cf. exh. cat. Amsterdam, 1982–3 (13, 16, 17).
6 Approx. 11.4 × 18.0 cm. A drawing dated November 1673 (exh. Amsterdam, 1982–3 (28)) however, measures 17 × 34.4 cm.
7 There has as yet been no grouping of drawings according to paper type or watermark.
8 Institut Néerlandais, Fondation Custodia (Lugt coll.); exh. Amsterdam, 1982–3 (17).
9 e.g. a drawing of 1666 (Huygens-Museum, Hofwijck; exh. Amsterdam, 1982–3 (13)) includes grey, yellow, green and red-brown watercolour.
10 A copy of de Bisschop's drawing after the antique is in a private collection, Leiden; illus. Amsterdam, 1982–3, p. 33.
11 Rijksmuseum, Amsterdam; exh. Amsterdam 1982–3 (15).
12 Rijksmuseum, Amsterdam; exh. Amsterdam 1982–3 (18).
13 e.g. in drawings of 17 October 1673 (Rijksmuseum, Amsterdam), August 1674 (Universiteitsbibliotheek, Leiden), and from the same collection, a view of Aarschot of 7 July 1675; exh. Amsterdam, 1982–3 (24, 29, 47, respectively).
14 *View of Lembeek*, Musées Royaux des Beaux-Arts de Belgique, Brussels; exh. Amsterdam, 1982–3 (57).
15 *View of Ebsdorf*, Rijksmuseum, Amsterdam; exh. Amsterdam, 1982–3 (125).

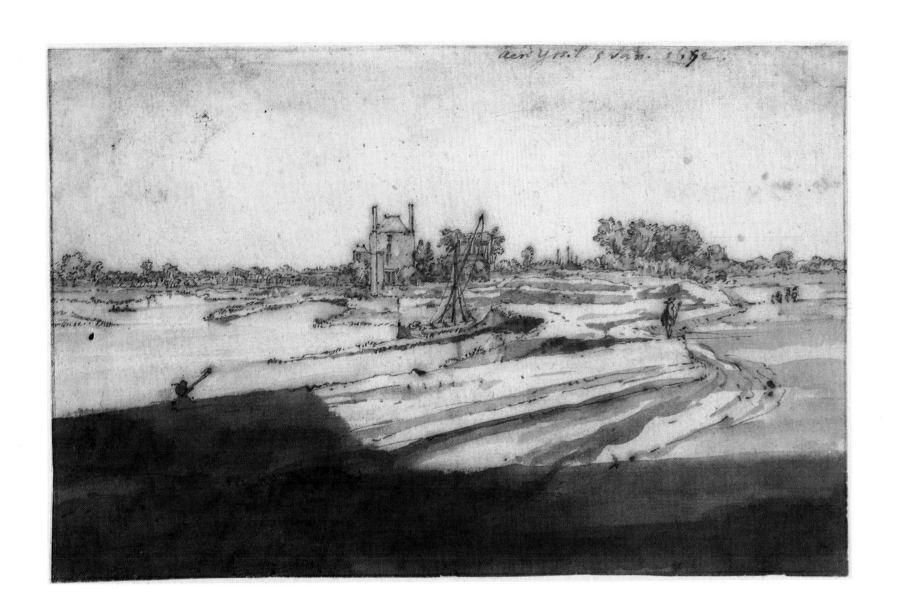

VALENTIJN KLOTZ
(c.1648–after 1716)[1]

48 View of Grave 1675

Slight preliminary drawing in graphite; pen and brown ink; brown and grey (carbon) ink washes, and blue watercolour washes; very dilute off-white, and grey and blue (the result of mixing with ink and watercolour) bodycolour, with some drawing with the point of the brush; overdrawing with the point of the brush and black (carbon) ink in the foreground; on off-white (discoloured) laid paper. The sheet folded vertically, left of centre, and unevenly trimmed at all sides to a ruled line in graphite and pen and brown ink.

Watermark: letters 'IC', or 'IG'.

19.6 × 23.9 cm.

Inscribed by the artist in pen and brown ink, *verso*; 'Tot Grave de $\frac{3m}{2d}$ 1675/6 m. na de belegering' (i.e. 'From Grave the $\frac{3m[onth]}{2d[ay]}$ 1675/6 m.[onths] after the siege').

Priced in a modern hand in pencil, *verso*: '7/'.

Stamped with the collector's mark of N. D. Goldsmid (Lugt 1962), *verso*.

PROVENANCE: N. D. Goldsmid, sold Drouot, Paris, 25 April 1876 (lot 35, with Fitzwilliam Museum Cambridge no. P.D. 428–1963); Anon. sale, Christie, 3 March 1924 (lot 2), bt. Sir Robert Witt; Witt Bequest 1952 (789).

EXHIBITIONS: R.A., 1927 (716); V. & A., 1943; Arts Council, 1953 (97); Australia, 1968 (47).

LITERATURE: Byam Shaw, 1928, pp. 53–55, pl. 41; Byam Shaw. 1929, p. 542;[2] Bernt, I, no. 335; van Hasselt, No. 142, repeated under No. 127.[3]

Grave, a small town situated on the south bank of the river Maas in Brabant, lies approximately 30 miles north-east of 'sHertogenbosch and 30 miles south-west of Arnhem. From 1604–1672, the town was held by the States of the United Netherlands, from whom it was taken in 1672 by Louis XIV, to be used as a storage depôt for captured Netherlandish war material, including guns and mortars. During 1674 it was beseiged by the Dutch under General Rabenhaupt, finally surrendering to Prince Willem III of Orange. The seige lasted from 25 July–27 October 1675.[4]

The town, severely damaged by mortar fire, was the subject of some 18[5] drawings by Valentijn Klotz, a military engineer in the army of the States General. The earliest views of the destruction recorded from inside the town were drawn on 2 March 1675. On that day, three studies were executed; that exhibited here, and drawings in Amsterdam[6] and Brussels.[7] Each composition examines the town's ruined fortress from close quarters, and the viewpoint adopted in the present work is from the north, or north-west, that is from the river side of the town. Rising in the left background here is the church of St Elizabeth, while at the extreme right is located a building identified as the Klooster.[8]

The simplicity and intimacy of vision displayed in this work has been noted by Byam Shaw.[9] The composition is raised above Klotz's normally straight-forward reportage by the manifest delight in the complex and curious forms of devastated buildings, the walls of which are meticulously delineated by nervous and appropriately fractured contours, and by the treatment of planes of architecture as a decorative pattern of warm and cool greys.

Klotz made records of the bombarded town on three other occasions during March 1675,[10] while dated drawings indicate that on 31 January[11] and towards the end of March 1676,[12] the artist again returned to Grave.

1 The latest signed drawing by Klotz, in the Gemeente Archief, The Hague, is dated 30 June 1716; van Hasselt, No. 342. On the basis of dates on unsigned drawings in the Hague, Hind (III, p. 196) suggests that the artist was active until 1718.
2 In which the date is erroneously published as 2 May 1675. Byam Shaw's description of the drawing '. . . the town in ruins six months after the siege . . .' confirms that it is the present work.
3 R. J. van Hasselt here repeats Byam Shaw, and catalogues the drawing as two separate works.
4 Byam Shaw, 1928, and C. van Hasselt (in exh. cat. New York/Paris, 1977–78 (61)) give an account of the siege.
5 Excluding No. 127, R. J. van Hasselt lists 17 drawings. An unsigned drawing of St. Elizabeth's church, Grave, dated: '3 $\frac{}{27}$ 1676', certainly by Klotz, was sold at Sotheby Mak van Waay, Amsterdam, 25 April 1983 (lot 109); photo Witt.
6 Rijksmuseum; van Hasselt, No. 121.
7 de Grez coll.; van Hasselt, No. 147.
8 Byam Shaw, 1928, p. 53.
9 1928, p. 55.
10 Klotz made drawings on 4 March (Rijksmuseum, Amsterdam; van Hasselt, No. 139); 9 March (National Gallery of Canada, Ottawa; van Hasselt, No. 133); 20 March (de Grez coll., Brussels; van Hasselt, No. 148). C. van Hasselt suggests (exh. cat. New York/Paris, 1977–8, No. 61) that Klotz returned to draw Grave in May 1675, citing R. J. van Hasselt's No. 127, which repeats Byam Shaw's error, as proof. This author suggests that Klotz also returned in November 1675, but cites as evidence R. J. van Hasselt No. 136, a drawing attributed to J. de Grave.
11 Fitzwilliam Museum, Cambridge (inv. No. P.D. 428–1963; van Hasselt, No. 141 (with erroneous inventory number)). Institut Néerlandais, Fondation Custodia (Lugt coll.); van Hasselt, No. 142. Both drawings were sold from Sir Robert Witt's collection.
12 A drawing dated 21 March in Prov. Genootschap K&W in Noordbrabant, 'sHertogenbosch; van Hasselt, No. 132. A drawing dated 24 March 1676, sold from Houthakker, Sotheby, 15–16 February 1921 (lot 27); van Hasselt, No. 129. A drawing dated 27 March in the Rijksmuseum, Amsterdam; van Hasselt, No. 122, and the drawing of St. Elizabeth's church, mentioned above.

PHILIPS DE KONINCK
(1619–1688)

49 A Farmyard by a Canal *c.1667–71*

Detailed preliminary drawing with point of the dry brush and brown watercolour; golden-brown ink washes (restricted mainly to the middle- and background, and mixing in certain areas with the watercolour), and brown ink (mainly in the foreground), with drawing with pen and the point and flat of the brush; dilute white bodycolour; slight black chalk overdrawing in the foreground only; on white (now discoloured) laid paper. The sheet edged with a ruled line in pen and brown ink, and unevenly trimmed at all sides.

12.1 × 17.7 cm.

Inscribed and numbered in different hands in pencil, *verso*: 'DG'; '2120', and '842'.

Stamped with the collector's mark of J. P. Heseltine (Lugt 1507), *verso*.

PROVENANCE: I. F. Ellinkhuysen; J. P. Heseltine; with P. & D. Colnaghi & Obach, London, by 1912; H. Oppenheimer, sold Christie, 10–14 July 1936 (lot 260); Sir Robert Witt (purchased from Agnew, no date); Witt Bequest 1952 (3388).

EXHIBITIONS: Australia, 1968 (38); Courtauld, 1972 (40).

LITERATURE: Gerson, p. 65 and Z61.[1]

The farmstead depicted in this composition is that which appears in Rembrandt's drawing in Oxford, *Farm Buildings beside a Road*,[2] which is a preliminary design for the etching *Landscape with Milk Man* of 1650:[3] a copy of the Oxford sheet, also attributed to Rembrandt, was sold at Leipzig in 1931.[4] In Rembrandt's drawing, the farm, which has been identified as that by St. Anthonies or Diemerdijk, Amsterdam,[5] is viewed from the front and occupies the right of the composition: it is contrasted with the deep perspective of a deserted road at the left. In the drawing exhibited here, de Koninck also represents the front elevation of the farmstead, but from an oblique angle so that buildings and haystacks which are aligned across the centre of the sheet contrast with the road which now divides the composition diagonally at the bottom.

A drawing by de Koninck of the rear premises of the Diemerdijk farm is now in New York.[6] A comparable view of the farm by Rembrandt, also in Oxford,[7] was employed as the design for a second etching of 1650.[8] The de Koninck in New York shares with the Courtauld sheet a common pictorial structure, just as the two Rembrandts in Oxford are formally related. While the circumstances under which de Koninck executed the views of the farm are unknown, any suggestion that he and Rembrandt may have worked together from the motif may be discounted, since Rembrandt's drawings date from *c.*1650, while the style of de Koninck's compositions indicates a date of at least a decade later. While it is possible that de Koninck may have known of the drawings now in Oxford, he would almost certainly have been familiar with the related etchings: he may also have been introduced to the motif of the Diemerdijk farm by his brother-in-law, Abraham Furnerius (*c.*1628–1654), a pupil of Rembrandt and the probable author of a composition in which the farm is observed from the same vantage point as that adopted by de Koninck in the New York sheet.[9]

The motif of the farm at Diemerdijk is also included in a drawing by de Koninck in Amsterdam:[10] that composition, the drawing in New York, and the present sheet are exceptional in the artist's work in that they are topographically accurate representations of an identifiable site.[11] Probably executed at a similar date, the drawings are related by style, and one which betrays the influence of de Koninck's brother, Jacob (1610/15–after 1708).

The treatment of foliage in the Courtauld drawing is related by Gerson to that visible in a signed sheet in Berlin, dated 1663.[12] Unlike that work, however, the present sheet includes painterly applications of wash in all areas. The resonant colour of the *repoussoir* device of roadway, for example, is juxtaposed with the delicate and nuanced hues of farmhouse, trees and haystack. Initially drawn as a fragile network of fine lines and hooks with the point of the dry brush in dull brown watercolour, the latter motifs are enlivened by glides of contrasting golden-coloured ink wash, applied with either pen or a full brush: the effect achieved is one of shifting light and enveloping atmosphere. Effects of aerial perspective are further refined by overlaying with dilute white bodycolour those parts of washed forms which lie at both the composition's centre and the deepest point in pictorial space (e.g. the farmhouse roof and chimney). Patches of paper left bare in all parts of the composition heighten the luminosity of the scene. Such a colouristic conception of drawing, while not unknown in de Koninck's work of the 1660s,[13] becomes prevalent in that of the following decade. Since the Courtauld drawing combines formal properties related to works of both the 1660s and 1670s, it may perhaps be assigned a date late in the earlier decade.

1 Gerson, ibid., lists the drawing with incorrect measurements. Sir Robert Witt's file erroneously suggests that the drawing was lot No. 148 in the Ellinckhuysen sale of 16–17 April 1879, a drawing also purchased by Heseltine and now attributed to Leupenius (Gerson, No. ZX). The incorrect provenance for this drawing was published in the Hand-list and repeated in exh. cat. Courtauld, 1972 (40).
2 Ashmolean Museum; Benesch, 1957, Vol. VI, No. 1227.
3 Hind, 1967, No. 242.
4 Sold from the C. Hofstede de Groot coll., Boerner, 4 November 1931; cf. Lugt, 1929–33, under No. 1338.
5 Lugt, 1920, pp. 137–39.
6 Pierpont Morgan Library; Gerson, No. Z 69, reattributed from Rembrandt to de Koninck.
7 Ashmolean Museum; Benesch, 1957, Vol. VI, No. 1226.
8 Hind, 1967, No. 241.
9 cf. Lugt, 1929–33, under No. 1338.
10 Fodor Museum; Gerson, No. Z 2.
11 Gerson, p. 14, notes that de Koninck's landscapes are in the main synthetic views.
12 Staatliche Museen; Gerson, p. 65, and No. Z 12.
13 e.g. those in a private coll., Amsterdam, and in the British Museum; Gerson, Nos. Z 7, Z 51, respectively.

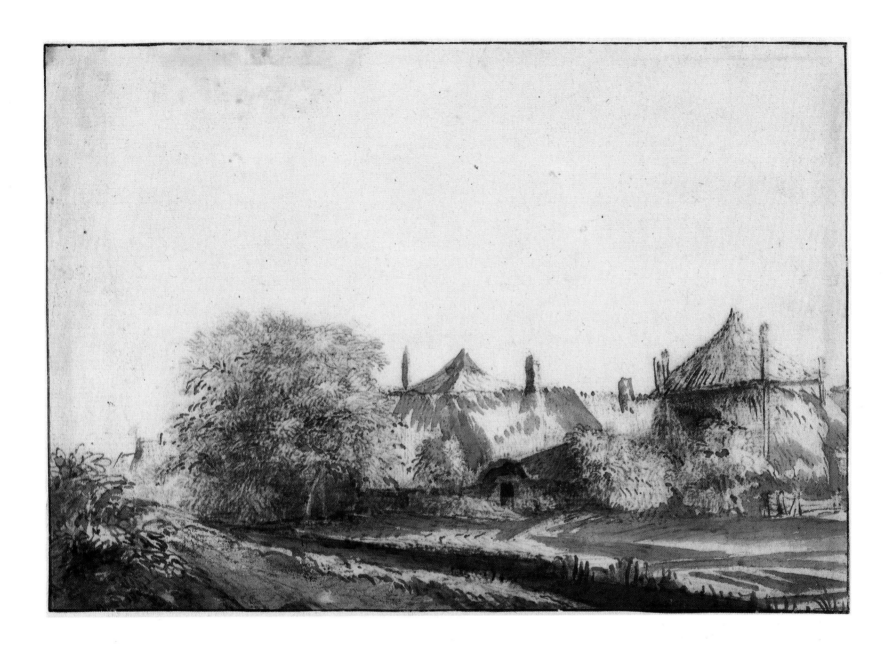

JAN LIEVENS THE ELDER
(1607–1674)

50 Woodland Study *c.1655–65*

Reed pen and brown ink washes; on yellow–buff oriental paper.

22.4 × 34.5 cm.

Numbered in different hands in pen and brown ink, bottom left: 'N 141', and centre: '50', and inscribed with the symbol, top right: '⊖T'.
Inscribed by a contemporary hand in pen and brown ink, *verso*: 'Jan Lievensz. de Jonghe'.

PROVENANCE: Sir Willoughby Rooke; by inheritance to Miss Williams, from whom purchased by Sir Robert Witt through Campbell Dodgson, November 1926; Witt Bequest 1952 (2260).

EXHIBITIONS: R.A., 1929 (650); Australia, 1968 (35); Courtauld, 1972 (46).

LITERATURE: Schneider, No. Z 281; Schneider/Ekkart, pp. 30, 370, No. Z 281.

With the exception of one sheet,[1] Schneider records no drawings signed and dated by Lievens: the numbers or inscriptions frequently visible on many drawings are later additions, probably by collectors as yet unidentified. The old inscription on the *verso* of the present drawing suggests that it is the work of the artist's son, Jan Andries (1644–1680), although in style it is identical to other woodland scenes attributed to the father. A similar old and erroneous ascription to the son appears on a drawing by the Elder Lievens in Rotterdam.[2]

Lievens' draughtsmanship betrays few variations of style, but displays an accomplished and attractive synthesis of the manner of Rembrandt from the late-1630s–1650s with that of Adriaen Brouwer (1602–1638).[3] Despite the absence of dated works, some insight into the development of the artist's manner of drawing may be gained from the approximate dating of those sheets which depict identifiable locations.[4]

Within Lievens' landscapes, which form the major part of his drawings, a corpus of woodland subjects has been identified by Ekkart[5] as dating from the period *c.1658–c.1663*; these works explore three basic compositional formulae. The first, of horizontal format, depicts from a distant viewpoint mighty trees with a full crown of foliage, frequently arranged as a screen across the sheet and related to a low horizon-line. The feathery foliage, often occupying two-thirds or a greater proportion of the pictorial area, is cropped by the upper edges of the drawing. Small figures of hunters or shepherds are frequently included in such compositions, examples of which are to be found in, among other places, Amsterdam,[6] Hamburg,[7] London,[8] New York[9] and Rotterdam.[10]

The second category of woodland composition, infrequent in Lievens' work, is represented by drawings in Berlin,[11] Paris[12] and Rotterdam.[13] Of vertical format, they present intimate studies of tree trunks, leaves and undergrowth in the forest interior.

The drawing exhibited here offers an example of the final compositional type, which is horizontal in format. The scene is typically set in an airy clearing or at the edge of a wood; the horizon is located approximately half way up the sheet, and the artist adopts a downward angle of vision to study the gnarled forms of lower trunks and branches. These are contrasted with sparse foliage, described at the top of the pictorial area with varying emphasis of detail. Undulations of the earth are summarily rendered by single contours, while shadows cast by foliage are indicated by loose patches of swift hatching, of either diagonal or horizontal direction.

Closely comparable in style and structure to the Courtauld work are drawings in Amsterdam[14] and Ottawa:[15] Ekkart assigns to the latter the date

c.1660. A drawing in Berlin depicting the periphery of woodland with the figure of a seated draughtsman[16] is related by composition to the works cited above, and although less fully realised than the present drawing, is nevertheless almost identical in handling. It has been assigned by Ekkart[17] to 1664–5; yet within the approximate guidelines evolved by that author for the chronological arrangement of Lievens' drawings, such a date seems both too specific and too late. There appear to be no stylistic reasons for excluding the composition from the group of forest subjects discussed above.

The present drawing, like many of Lievens' landscapes executed from the mid-1650s–mid-1660s, is on paper of oriental origin.[18] Of yellowish colour, the sheet is composed of several layers of strong, very thin paper: it is well sized and has a smooth, perhaps polished surface facilitating swifter, freer movement with the pen than over many European papers.

1 The drawing is in the Kunstmuseum, Düsseldorf; Schneider, No. Z 12. Schneider includes full biographical details of the artist in his monograph.
2 Boymans-van Beuningen Museum; Schneider, No. Z 317.
3 According to Knuttel, no authentic landscape drawings by Brouwer are extant, although their style may be reconstructed with reference to the styles of the painted landscapes and figure drawings.
4 e.g. A drawing of the Roomhuis, The Hague (Institut Néerlandais, Fondation Custodia (Lugt coll.), Paris: Schneider, No. Z 146) may be dated to Lievens' stay in that town from 1654–1658.
5 Exh. cat. Brunswick, 1979, p. 30 and under No. 72.
6 Rijksmuseum; Schneider, No. Z 304.
7 Kunsthalle; Schneider, No. Z 298.
8 British Museum: Schneider, No. Z 294.
9 Pierpont Morgan Library; Schneider, No. Z 309.
10 Boymans-van Beuningen Museum; Schneider, No. Z 317.
11 Staatliche Museen; Schneider, No. Z 303.
12 Louvre; Schneider, No. Z 299.
13 Boymans-van Beuningen Museum; Schneider, No. Z 258.
14 Rijksmuseum; Schneider, No. Z 315, and Henkel, pl. 160.
15 National Gallery of Canada; Schneider/Ekkart, No. SZ 428, and exh. cat. Brunswick, 1979 (73).
16 Staatliche Museen; Schneider, No. Z 311.
17 exh. cat. Brunswick, 1979 (83).
18 Schneider, *ibid.*, suggests that this is Japanese paper, and although this is perhaps correct, it has not been conclusively proven in the present example.

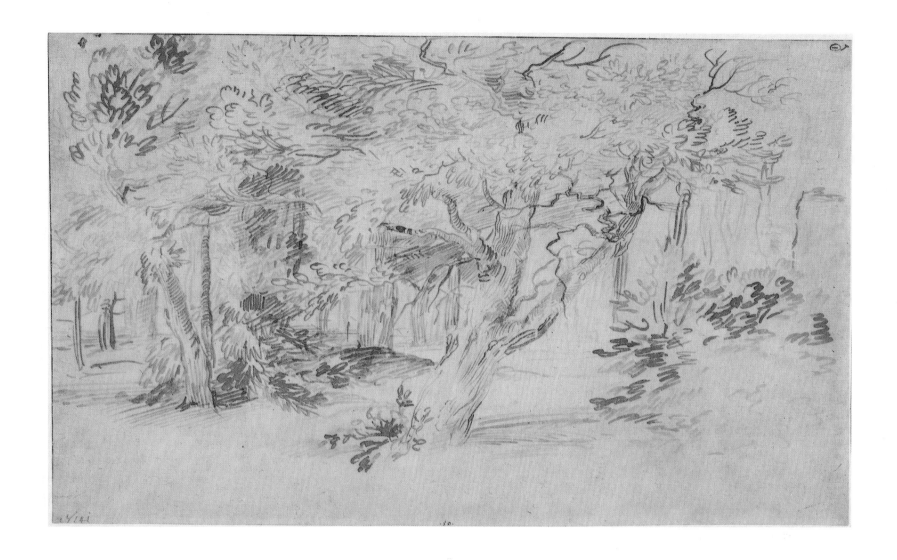

JAN LIEVENS THE ELDER
(1607–1674)

51 Landscape with Farmstead mid 1660s

Reed pen and brown ink washes; brush and brown ink washes; on pale buff laid paper. The sheet edged by a ruled line in pen and black ink, and unevenly trimmed at all sides.

25.4 × 40.5 cm.

Inscribed(?) in pen and brown ink, bottom right: 'jan lievens', and numbered top left of centre: '130'. Numbered in pen and brown ink, *verso*: '4', and '37', and priced: '10 fl'.

Stamped with the collector's mark of J. de Vos Jacobsz. (Lugt 1450), *verso*.

PROVENANCE: J. de Vos Jacobsz.; H. G. Balfour, sold anonymously, Sotheby, 10 June 1932 (lot 53), bt. Sir Robert Witt; Witt Bequest 1952 (2747).

EXHIBITION: Courtauld, 1972 (57).

LITERATURE: Schneider, no. Z 338, Z 338a; Schneider/Ekkart, p. 238, and p. 373, nos. Z 338, Z 338a (as identical).

The present drawing is differentiated from the woodland scenes proper (see cat. no. 50) by a more open composition at the upper edges of the sheet and by a shallow picture space which is limited by the background farm buildings. The forms of tree trunks are here handled with less detail than those of the preceding drawing, or of comparable studies, while considerable differences are also displayed in the treatment of foliage. It is delineated in the woodland scenes by a range of hooked and curled strokes of varied size which enclose small patches of multi-directional hatching to suggest the featheriness and transparency of individual leaves. In the drawing exhibited here, by contrast, contours of foliage are rendered by a more restricted vocabulary of generous looped strokes of uniform scale, either singly or conjoined, while the notation of leaves or clusters within the crown itself is abandoned in favour of a generalised internal modelling of rapid diagonal hatching. In certain hatched areas, strokes of the reed pen become fused, creating patches of dense shadow which are further strengthened by the application of ink wash: such areas of intense graphic activity are relieved by the blank paper indicating sky. Similarly dense areas of hatching are visible in a drawing in Paris which may confidently be dated to Lievens' voyage to Gelderland of 1663,[1] although compositionally that work cannot be compared to the drawing exhibited here.

A generalised treatment of form similar to that observed in the trees is here also evident in the architecture: detail is suppressed in order to emphasise entire planes or silhouettes of buildings, while the unity of the individual plane is established by means of overall horizontal hatching. A comparable handling of architecture is evident in drawings in Berlin,[2] Brunswick[3] and Groningen.[4] Although urban scenes, these compositions also share with the present work the image of buildings viewed through or beyond a screen of trees and the consequent shallow pictorial space, and an analogous treatment of foliage contrasting with the sky. These drawings have been dated by Ekkart to the mid-1660s, and the Courtauld sheet should probably be assigned to a similar period. Rustic scenes comparable in style and composition to the present work were formerly with Houthakker in Amsterdam,[5] and in the collection of Sir Robert Witt.[6]

Eeckhout, by whom a drawing of the same scene is in the Staatliche Graphische Sammlung, Munich; Wegner/München, no. 550.

2 Staatliche Museen; Schneider, no. Z 150.
3 Herzog Anton Ulrich-Museum; Schneider, no. Z 145. Another view of Egmond, also probably by Lievens, is in the Staatliche Graphische Sammlung, Munich; Wegner/München, no. 691.
4 Museum voor Stad en Lande; Schneider, nos. Z 168, Z 383.
5 Schneider, no. Z 356.
6 Inv. No. 2066, sold to Colnaghi, 1938; now Fitzwilliam Museum, Cambridge, Inv. No. P.D. 448–1963; Schneider/Ekkart, No. Z 359.

1 The drawing, of a sandbank with huts, is in the Institut Néerlandais, Fondation Custodia (Lugt coll.); Schneider, no. Z 341. Lievens apparently travelled in the company of G. van

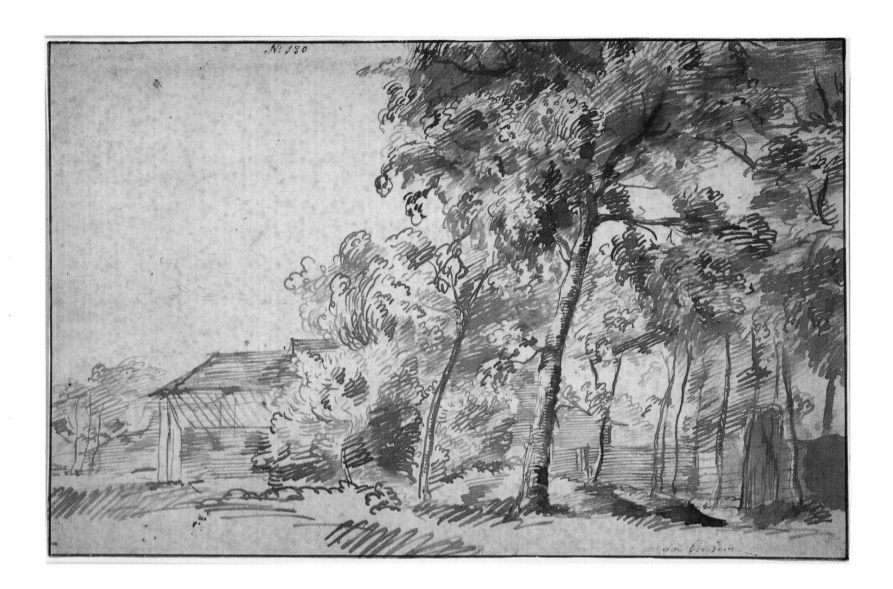

PIETER DE MOLYN
(1595–1661)

52 Landscape with Road and Figures mid 1650s

All preliminary drawing in black chalk, with partial overdrawing in red chalk, with some rubbing, and moistening in places; light brown ink washes with drawing with the pen (restricted to the road) and the point and flat of the brush, and mixing in part with the chalks to form dilute bodycolour; overdrawing with black chalk for foreground accents; on off-white laid paper. The pictorial area enclosed within the artist's ruled line in red and black chalk, a ruled line in pen and brown ink added by a later hand.

18.7 × 30.2 cm.

Signed in black and red chalk, bottom right: 'P Molyn' (the initials interlaced). Numbered in later hands in graphite, *verso*: '337' (the first number deleted with pen and brown ink); '89'; '66' (crossed through in graphite); '⌐Cf40⌐', and with the symbol: ' ⌀ '.

PROVENANCE: Sir Robert Witt (purchased from Colnaghi, no date); Witt Bequest 1952 (4015).

EXHIBITIONS: Courtauld, 1958 (57); Manchester, 1962 (27); Australia, 1968 (31); Courtauld, 1972 (16).

Born in London, the date of Molyn's emigration to Holland is unknown, although he was inscribed in the Guild at Haarlem in 1616. The most decisive influence upon his work was Esaias van der Velde, who was also active in that city. Molyn's innovation as a landscape artist is first seen in the celebrated panel painting *The Sandy Road* dated 1626 in Brunswick.[1] Here, the old conventions of depicting the countryside as a series of lateral zones are abandoned in favour of a composition in which details are observed from a low vantage point, unified by a powerful series of diagonals, and in which local colour is subordinate to an overall tonality. Such a composition anticipates that evolved by van Goyen, who had come to Haarlem in *c*.1617 to study under van der Velde.[2]

By the later 1630s, Molyn's inventive power as a painter was in decline, and he turned increasingly towards drawing, creating variations of his earlier compositions. The drawings are typically executed in black chalk or graphite with carbon black or brown-grey washes,[3] and the example exhibited here is rare in its use of coloured chalks. Many of the drawings are signed, and some bear dates: sheets executed during the 1640s appear to be scarce but those dated in the following decade are particularly abundant.

The composition of this sheet is a variant of that in the Brunswick oil, to which paintings dated 1632 and 1636 and sold in Paris[4] and Brussels,[5] are related. The drawing shares with the Brunswick panel a similar dune landscape through which a road runs diagonally into the distance from the bottom right of the composition, with indications of a branching pathway to the right; the motif of a clump of trees behind a decaying fence in the middleground; and figures on the horizon at the left. The highest point of the painted landscape, however, is at the right, while that in the present drawing is at the left.

Molyn's draughtsmanship does not display marked variations in style. Comparison of the few sheets dated in the 1620s[6] and 1630s[7] with those of two decades later[8] reveal, however, that the drawings created during the first half of the 1650s are generally executed with a greater density of hooked and looped strokes (visible particularly in the drawing of foliage) while all forms, more boldly treated with stronger contrasts of light and shadow, gain in compactness. A greater emphasis is also placed on the depiction of cloud formations, many of which are now dramatically massed. The modifications which occur in Molyn's style at this period may reflect the introduction of similar formal properties into paintings executed by van Goyen and van Ruisdael during the later 1640s.[9] Since the undated drawing exhibited here includes many of the characteristics observed in Molyn's works dated in the early to mid-1650s, it may also be assigned to a similar period.

1 Herzog Anton Ulrich-Museum; Stechow, pl. 24.
2 Stechow, p. 23.
3 Of 28 drawings by Molyn in Berlin (cf. Bock/Rosenberg, pp. 192ff.) 25 are in black chalk and grey wash. All 17 drawings in the British Museum (Hind, III, pp. 146ff.) are in black chalk and grey wash.
4 Galerie Charpentier, 1 June 1956 (lot 90); photo Witt.
5 De Loo sale, Galerie des Beaux-Arts, 29 October 1947 (lot 160); photo Witt.
6 e.g. Berlin; Bock/Rosenberg, p. 192, No. 4330, dated 1629.
7 e.g. Staatliche Graphische Sammlung; Wegner/München, No. 792, dated 1638.
8 e.g. a drawing in the Kunsthalle, Bremen, dated 1650 (Pauli, Vol. III, No. 3); drawings in the British Museum dated 1654 and 1655 (Hind, III, p. 148, Nos. 6, 9–12; p. 149, No. 15); drawings in the Institut Néerlandais, Paris, dated 1654 and 1655 (exh. Brussels/Rotterdam/Paris/Berne, 1968–69, Nos. 101, 103).
9 Discussed by Stechow, p. 28.

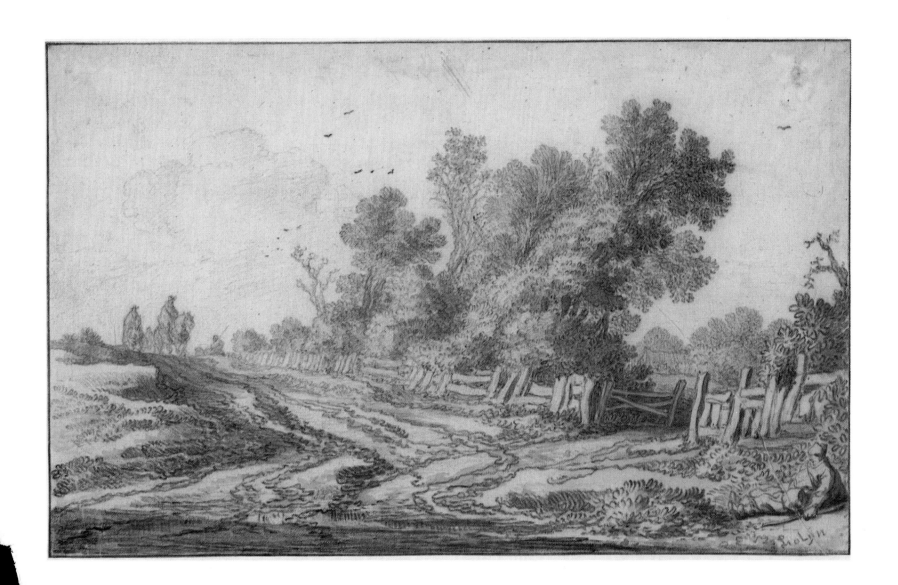

PIETER DE MOLYN
(1591–1661)

53 Landscape with Cottage *c.*1657–59

All preliminary drawing in black chalk, with partial overdrawing in red and yellow (fabricated) chalk (the latter moistened and superimposed over black to form olive-green touches in the foliage, and with the red to form orange, foreground left); overdrawing with moistened (?) black chalk for foreground accents; on off-white laid paper. The pictorial area enclosed within the artist's line in moistened black chalk, bottom, and pen and brown ink, sides and top. The sheet unevenly trimmed at all sides.

Watermark: shield(?), supported by a crown, with letters below (variant of Briquet no. 884).

18.0 × 29.9 cm.

Signed in black chalk, lower left (now partly abraded): 'P Molyn' (the initials interlaced).

PROVENANCE: Sir Robert Witt (purchased from Colnaghi, no date); Witt Bequest 1952 (4014).

EXHIBITION: Courtauld, 1972 (11).

This undated drawing, a second example, of Molyn's use of coloured chalks, is similar in style to sheets in Berlin,[1] Haarlem,[2] London,[3] Paris,[4] and formerly in the collection of Sir Bruce and Lady Ingram,[5] all of which are dated between 1657 and 1659. In common with these works, the present composition displays a lighter, more delicate handling of chalk than is found in drawings dated in the earlier half of the decade; light effects are more subtly rendered, all forms are less weighty and foliage in particular assumes a feathery appearance.

In cat. no. 52 the effect achieved by the combination of red and black chalk and brown washes remains closely allied to that created by the monochrome drawings; despite the introduction into the present work of yellow, that hue is not employed to define local colour (although it is occasionally added to black to form olive touches in the foliage) but rather to heighten and widen the tonal range available to the artist. An undated drawing in Berlin[6] displays a similar use of coloured chalk, although in a sheet executed with coloured chalks and a restricted palette of washes in Vienna[7] – perhaps an early experimental work – Molyn does emphasise the notation of local colour.

In this drawing, a cottage surrounded by trees is located at the left middleground, while in the right distance stands a second house. An extensive, lightly undulating dune landscape is located at the right. The terrain which rises at the left and right edges of the composition is linked in the foreground by a curving *repoussoir* of shadow, whose rhythm is continued upwards by the twisting trunks of middleground trees. Variants of this composition may be found in drawings in Amsterdam,[8] Edinburgh,[9] in the sheet in Berlin cited above, and in a painting formerly with a dealer in Vienna.[10] All are ultimately dependent upon the type of pictorial structure used in the painting *The Cottage* dated 1629, in New York.[11] In these works, however, the cottage is a more angular structure than that included here, and is roofed by tile or slate; thatched cottages more closely comparable to the present type are included in sheets in Berlin,[12] Warsaw[13] and in that in London mentioned above.

1 Bock/Rosenberg, p. 192, No. 4850.
2 Teylers Museum; Bernt, II, No. 412.
3 British Museum; Hind, III, p. 149, No. 16.
4 Louvre; Lugt, 1929–33, Nos. 469, 471.
5 Exh. Rotterdam/Amsterdam, 1961 (60).
6 Bock/Rosenberg, p. 194, No. 12264.
7 Albertina; Schönbrunner/Meder, Vol. XI, No. 1269. A drawing in the Ecole Nationale Supérieure des Beaux-Arts, Paris (Lugt, 1950, No. 392) has watercolour added by a later hand.
8 Rijksmuseum; I. Blok, 'Teekeningen van Esaias van der Velde, Jan van Croyen en P. de Molyn', *Oude Kunst*, October 1917, p. 19.
9 National Galleries of Scotland, Inv. No. 2798; photo Witt.
10 Sold by the Galerie Sanct Lucas to the J. Paul Getty Museum, Malibu; photo Witt.
11 Metropolitan Museum of Art, gift of H. G. Marquand; Stechow, pl. 25.
12 Bock/Rosenberg, p. 193, No. 5395.
13 Printroom of the University Library; exh. Cambridge, 1961 (53).

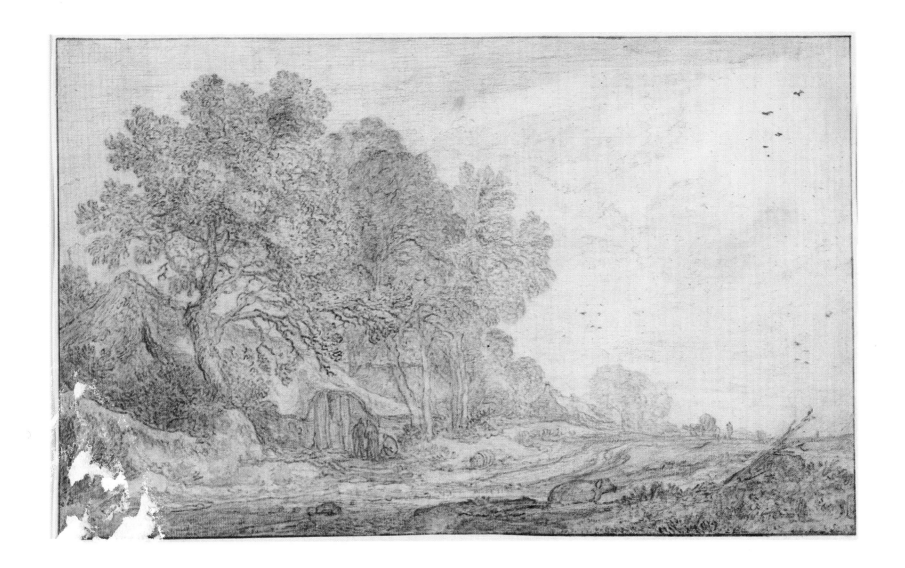

ISACK VAN OSTADE
(1621–1649)

54 Rear View of a Cottage with Protective Roof and attached Well 1646–49

Preliminary drawing in black chalk; pen and light brown ink washes, mixing in certain contours to form darker accents; red and fabricated yellow chalk, with some rubbing; carbon ink and blue watercolour washes (in certain areas mixing with the chalks), with drawing with the brush and some use of the dry brush; some strengthening of contours with black chalk, apparently in part moistened; on cream (stained) laid paper. The drawing made up of three overlapping, unevenly trimmed sheets. Edged with a ruled line in pen and brown ink (visible top and bottom) and unevenly trimmed at all sides, the corners angled. Repairs to slight tears, top. The figures of a man and woman in graphite with touches of red chalk, partly erased and abandoned, right.

Watermark: crown supported by (?) a shield (fragment).

17.9 × 20.3 cm.

Inscribed in pen and brown ink, bottom centre: 'Jf' (the mark of J. J. Faesch,[1] not that of Hugford as stated in Lugt supp. 1468a, 2463a).

Inscribed in a modern hand in pencil, *verso*: 'A v.Ostade', and numbered in different hands: 'HL/–/–' and: 'A14817'.

Stamped with the collector's mark of H. Füssli & Cie (Lugt 1008), *verso*.

PROVENANCE: J. J. Faesch; H. Füssli & Cie; . . .; Sir Robert Witt (purchased from Colnaghi, 1948); Witt Bequest 1952 (3991).

EXHIBITIONS: Colnaghi, 1948 (42); Arts Council, 1953 (98); British Museum, 1983 (50).

LITERATURE: Schnackenburg, no. 571.

The life and work of the van Ostade brothers has been discussed at length in a recent monograph by Bernhard Schnackenburg: the present drawing, purchased by Sir Robert Witt as by Adriaen (1610–84), has been shown by this scholar to be from the hand of the younger brother and pupil, Isack.[2]

Of some 160 drawings known from Isack's hand, the majority have as their subject peasants or other figures, although the artist's early interest in landscape, and particularly in houses and cottages, is signalled by sketches on the *versos* of sheets in the British Museum[3] and Vienna.[4] These are executed with agitated, calligraphic pen strokes indebted to those employed by van Goyen.

The present sheet is one of six studies of details of cottages now in Cambridge,[5] Lille[6] and Rotterdam,[7] which may be grouped with a larger body of drawings of village street scenes, houses and wagons related to paintings executed during the last six years of Isack's short life. The cottage studies themselves are datable to the period 1646–49. In these works, the artist returns to the preoccupations manifest in the earlier sheets mentioned above, although motifs are now examined in isolation from their landscape context: precedents for this type of study are to be found in drawings by Jan van der Velde (1593–1641),[8] while the new delicacy of handling and subtle application of colour visible here betrays a debt to the precise tinted drawings of Hendrick Avercamp (1585–1636).[9]

The six studies of cottages are rendered with a comparable range of media and with a similar attention to the details of local colour. A drawing in Rotterdam of a two-storeyed cottage with pigeon-loft[10] is most closely related in oblique viewpoint and *mis-en-page* of the motif to the work exhibited here: it is also of a similarly nearly square format, but it is not possible to determine whether this is the result of later trimming. At the right of the Courtauld sheet are tentative indications of a male and female figure. A seated couple are also included in the related composition in Rotterdam, although Schnackenburg[11] considers that these may have been added during the eighteenth century. The figures, however, are sufficiently well integrated into that design to suggest that they, like the Courtauld staffage, were lightly stated by van Ostade and merely strengthened by a later hand.

1 Keith Andrews, in letter to the author, 29 March 1983. J. J. Faesch, a collector from Basle, purchased drawings from the Jabach sale, Amsterdam, 1753.
2 *ibid.*
3 Schnackenburg, No. 419, *verso*, attributed by Hind, IV, p. 62, No. 2, to H. H. Sorgh (*c.*1611–70).
4 Albertina; Schnackenburg, No. 421, *verso*.
5 Fitzwilliam Museum; Schnackenburg, No. 556.
6 Musée Wicar; Schnackenburg, No. 567.
7 Boymans–van Beuningen Museum; Schnackenburg, Nos. 568, 569, 570.
8 e.g. Courtauld Institute Galleries, Witt coll., No. 3811.
9 e.g. drawings in Berlin and Hamburg; Bernt, I, Nos. 17, 18, respectively.
10 Schnackenburg, No. 569.
11 *ibid.*

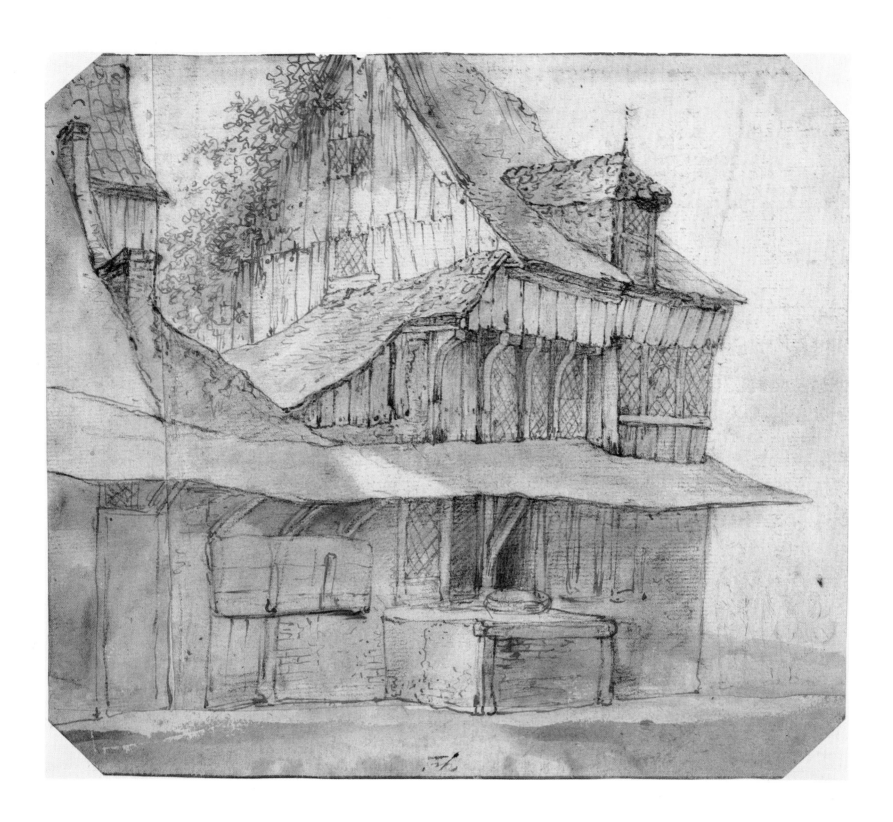

CORNELIS VAN POELENBURGH
(*c*.1593–1667)[1]

55 Landscape with Ruins

Detailed preliminary drawing in graphite; grey (carbon) ink washes, with drawing with the brush and some drawing with the pen (restricted to foreground vegetation); an off-white laid paper. The pictorial area enclosed within the artist's ruled line in graphite, a ruled line in pen and brown ink added by a later (?) hand. Unevenly trimmed at all sides.

Watermark: fools-cap.

19.1 × 28.1 cm.

Verso: Three cows, in graphite.

Inscribed in pencil, *verso:* 'Poelenburg', and numbered in an old hand: 'N.ro. 11', and in a modern hand: 'A 5682'.

PROVENANCE: Sir Robert Witt (purchased from Colnaghi in part exchange, no date); Witt Bequest 1952 (895).

Poelenburgh may be considered as both the initiator and main representative of the style of the first generation of Dutch Italianate landscapists. He was in Rome in 1617, and in 1620–21 worked in Florence, possibly for Cosimo de' Medici II. Returning to the Netherlands by April 1627 at the latest, he settled in Utrecht where he remained for the rest of his life, except for the brief period 1637–41 when employed by the Court of Charles I of England.

Of some 60 paintings now catalogued as from Poelenburgh's Italian period, only eight are dated.[2] The absence of dated works after *c*.1625 does not permit us to establish a satisfactory chronology for the later *œuvre*. The drawings, too, are infrequently signed and dated: those which do bear dates (e.g. in Amsterdam,[3] Florence[4] and Paris[5]) were created in Italy during the early phase of the artist's career. Moreover, Poelenburgh's drawing styles are liable to be confused with those of his contemporary, Bartolomäus Breenbergh (1598/1600–before 1659: in Rome 1619–29),[6] and we are as yet uncertain of the precise character or extent of the artist's works on paper.

In landscapes painted between 1620 and *c*.1625, which frequently betray the strong influence of the work of Paul Bril,[7] Poelenburgh established compositional types and motifs which are consolidated in paintings and drawings executed during the remainder of his career. His compositions are frequently characterised by a one- or two-wing structure in which ruins of classical architecture are prominently located at one or both lateral sides of the picture:[8] the former type of pictorial structure is evident in the drawing exhibited here. Although architecture included in certain works may be identified,[9] it was not Poelenburgh's intention to create accurate records of specific archaeological sites. Instead, the ruins, often a synthesis of motifs derived from any number of Roman sources, are introduced into compositions expressive of an idyllic view of the world in order to suggest a golden past. Those in the present drawing, for example, are reminiscent of the arcaded architecture of the Domus Augustina in Rome,[10] yet are located in a rural setting: furthermore, they cannot be understood as a coherent structural unit, and were probably therefore drawn from memory.

As a means to elide the abrupt demarcations between individual landscape elements, manifest particularly in the work of Paul Bril, and to gain compositional unity, Poelenburgh became the first to depict convincingly the bright light of the south. This was achieved by the precise application of innumerable tonal gradations extending throughout all areas of the composition. In pursuing the effects of light, however, the artist tends to soften the landscape's fundamental geological formations,[11] for which is substituted (principally in the middle- and foregrounds) a more abstract structure created through juxtapositions of crisply defined zones of light and shadow. Such areas are frequently strengthened and terminated at the bottom of the design by a *repoussoir* of sharply detailed rocks and vegetation. These methods of conveying light and constructing landscape are displayed in the drawing exhibited here. Closely related in composition, technique and handling to a signed sheet in Berlin[12] (the hilly background of which is particularly comparable), the Courtauld work also shares similarities with sheets in Düsseldorf,[13] Grenoble,[14] Hanover,[15] London[16] and New York.[17] Its high degree of realisation may suggest that it was conceived as a work of art in its own right, although its composition is faithfully reproduced – but for the inclusion of a group of nymphs at the right foreground and male staffage in the middle distance – in a small painting on panel with the London dealer R. H. Ward in 1931.[18]

1 The location and date of Poelenburgh's birth remains uncertain: Blankert (exh. cat. Utrecht, 1965, p. 60) suggests the date of 1586, but that given here is taken from Sluijter-Seijffert's full biographical account of the artist.
2 cf. Sluijter-Seijffert.
3 Rijksmuseum; Röthlisberger, 1969, No. 2, dated 1622.
4 J. G. Hoogewerf coll.; exh. Laren, 1966 (182), dated 1622.
5 Ecole Nationale Supérieure des Beaux-Arts; Lugt, 1950, No. 451, dated 1620.
6 cf. Röthlisberger, 1969, Nos. 1–6, 8, 10.
7 e.g. *Campo Vaccino*, dated 1620, in the Louvre, Paris; Sluijter-Seijffert, No. 157. In the Prado, Madrid, dated 1621; Sluijter-Seijffert, No. 154; Schaar, pl. 13. In the Centraal Museum, Utrecht, dated 1625; Sluijter-Seijffert, No. 68; Schaar, pl. 22.
8 Stechow, p. 149, gives a detailed description of Poelenburgh's compositional types.
9 e.g. The Campo Vaccino subjects; see above.
10 Nash, Vol. I, pp. 237–38.
11 Waddingham, p. 38.
12 Staatliche Museen; Bock/Rosenberg, p. 211, No. 3923.
13 Kunstakademie; Budde, No. 871.
14 Musée de Grenoble; exh. Grenoble, 1977 (45).
15 Kestner Museum; exh. Hanover, 1963 (95).
16 British Museum; Hind, IV, p. 24, Nos. 5, 6.
17 Metropolitan Museum, inv. No. 65.131.5; cf. *Metropolitan Museum of Art Bulletin*, Spring, 1985, p. 48.
18 Sluijter-Seijffert, No. 151; photo Witt.

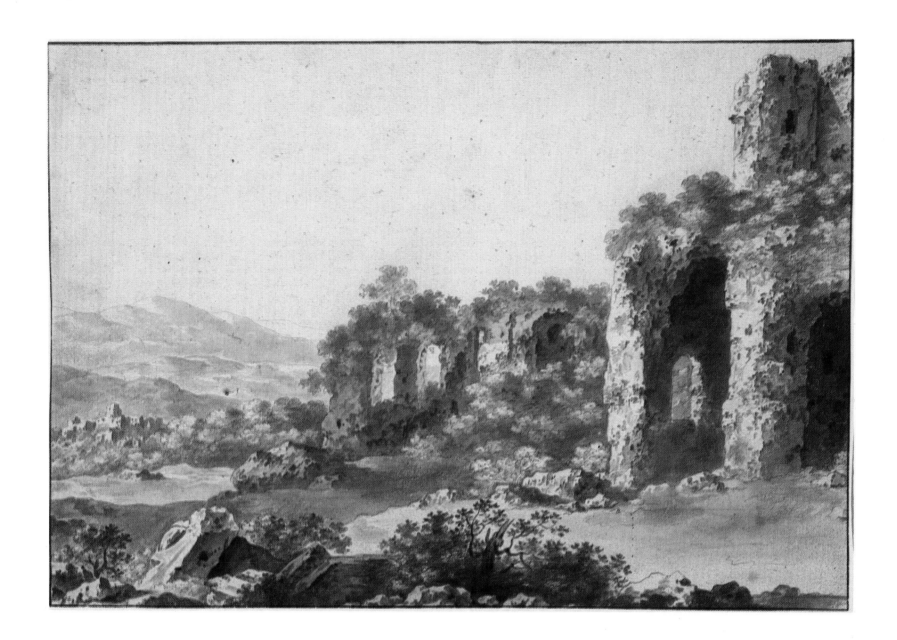

CORNELIS VAN POELENBURGH
(*c*.1593–1667)

56 Landscape with Ruin and Figures

Red chalk, applied with the stump, heightened with white chalk; on grey-blue (now discoloured) flocked laid paper. The sheet unevenly trimmed at all sides, a horizontal fold approximately 2.6 cm. from the bottom.

22.3 × 26.8 cm.

Numbered by a later hand in pen and dark brown ink, bottom left: '269'. Numbered and inscribed in red chalk, *verso*: 'B.55/C.Poelenb...' (trimmed away), and in a later hand in pencil: 'D.1506' (encircled), and by Sir Robert Witt: '1198'.

Stamped with the collector's mark of W. Bateson (Lugt supp. 2604a), *verso*.

PROVENANCE: W. Bateson, sold Sotheby, 26 April 1939 (lot 34), bt. Sir Robert Witt; Witt Bequest 1952 (1198).

EXHIBITIONS: V. & A., 1943; Manchester, 1962 (28).

The use of red chalk heightened with white for the depiction of landscape appears to be rare in Poelenburgh's *œuvre*. The artist employed these media principally for figure studies,[1] although red chalk is found in combination with black in the preliminary drawing of a landscape washed in brown ink in Paris.[2] Equally uncommon is the use of blue, probably Venetian, paper. The first generation of Dutch Italianate landscapists tended to draw on white or off-white sheets, although a drawing by Breenbergh dated 1639[3] – that is some ten years after his return to Holland from Italy – is unique in his work in its use of blue paper. Sheets of this colour appear to have become popular in Holland only during the second half of the seventeenth century; there, it was extensively employed by Jan Asselyn.[4]

The type of composition visible in this drawing, the pictorial area of which is divided diagonally by the ruined architecture, is stated in paintings dated 1621 and 1622 in Madrid and Florence, respectively.[5] The ruins, which include the motif of a ramp rising over a brick substructure (perhaps inspired by the *cavea* of the Circus Maximus, Rome),[6] are comparable to those at the right of a panel datable to 1620–25 in Toledo, Ohio,[7] and are particularly close to those incorporated into a painting attributed to Poelenburgh at Chatsworth.[8]

The undulating, extensively wooded background of the Courtauld drawing is a motif infrequently encountered in Poelenburgh's work, although a comparable background is similarly employed as a foil to a dominant diagonal compositional element in the painting *The Flight into Egypt* of 1625 in Utrecht.[9] The male figure attired in long robes and turban at the left of the drawing contributes to the scene additional mystery and exoticism; similarly clad staffage is located in the foreground of an undated but early painted view of the Campo Vaccino, in Paris,[10] and in a sheet in Hamburg.[11]

1 e.g. in Berlin (Bock/Rosenberg, p. 212, Nos. 11911, 2242–48); Kunsthalle, Hamburg (Bernt, II, No. 467); British Museum, London (Hind, IV, p. 24, Nos. 1, 3, 4); Louvre, Paris (Lugt, 1929–33, No. 556, a red chalk counter-proof).
2 Louvre; Lugt, 1929/33, No. 554.
3 Statensmuseum, Copenhagen; Röthlisberger, 1969, No. 164.
4 Steland-Stief, 1980. p. 256.
5 Prado; Sluijter-Seijffert, No. 154; Schaar, pl. 13. Uffizi; Sluijter-Seijffert, No. 140; Schaar, pl. 15.
6 Nash, Vol. I, pp. 237–38.
7 Museum of Art, gift of E. D. Libbey; Sluijter-Seijffert, No. 163; Stechow, pl. 289.
8 Trustees of the Chatsworth Settlement coll., Inv. No. C.C. 489; photo Witt.
9 Centraal Museum; Sluijter-Seijffert, No. 68.
10 Louvre; Sluijter-Seijffert, No. 157; Schaar, pl. 10.
11 Kunsthalle; exh. Hamburg, 1967 (62).

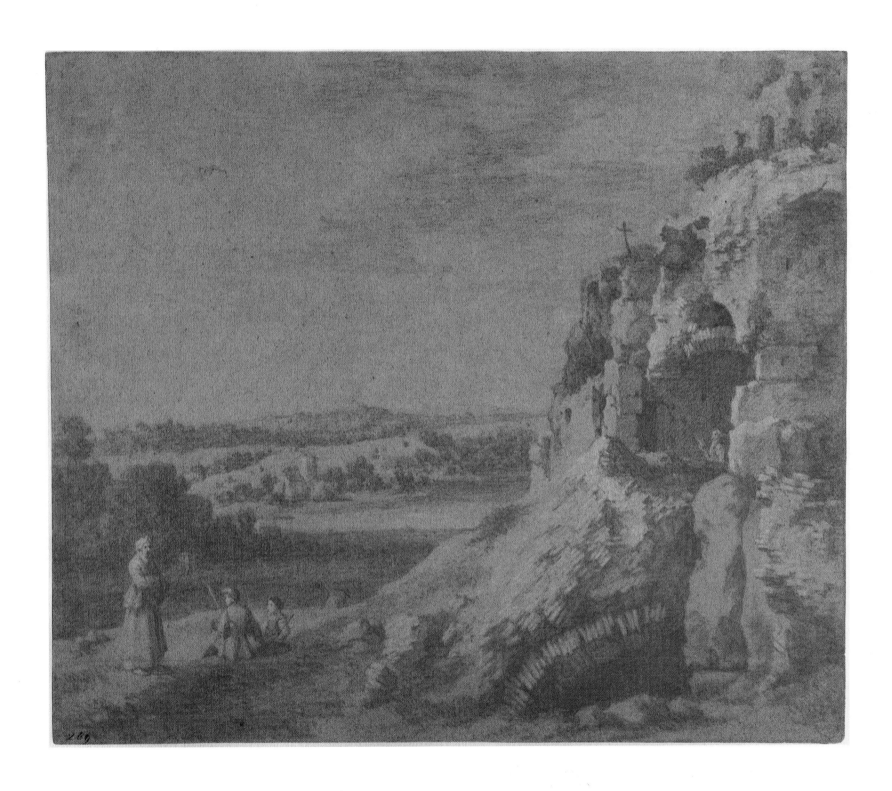

ADAM PYNACKER
(1622–1673)

57 Landscape with Trees c.1660

Preliminary drawing in graphite; pen and golden ink wash (perhaps iron gall mixed with bistre); grey (carbon) ink washes, with drawing with both pen and the point and flat of the brush; on off-white laid paper. The pictorial area enclosed within the artist's ruled line in pen and grey ink wash. The sheet unevenly trimmed at all sides.

Watermark: fleur-de-lis in a shield, surmounted by a crown.

40 × 29.6 cm.

Signed in graphite, *verso:* 'A:Pÿnacker f=' (the initials interlaced: the signature apparently partly erased and re-written).

Stamped with the collector's mark of W. Mayor (Lugt 2799), *recto.*

PROVENANCE: W. Mayor; Sir Robert Witt (no record of acquisition); Witt Bequest 1952 (212).

Pynacker is thought to have travelled in *c.*1645 to Italy,[1] where he remained, according to Houbraken,[2] for three years. By 1649, he is recorded in Delft, and is later mentioned in Schiedam[3] and Amsterdam. Lugt's suggestion[4] that the artist may have been a pupil of Jan Both (1610/18–52) cannot be proven, yet it is clear that the work of that artist provided inspiration for several of Pynacker's drawings and paintings: the work of Jan Asselyn, while influential, appears to have been of lesser significance for him. It is to Both's work that the type of soaring tree with star-shaped leaf formations visible here in indebted, as is the drawing of contours in pen and golden-coloured ink contrasting with the brushed-in range of cool grey washes.

Although few drawings may be attributed with certainty to Pynacker, the present example bears on its *verso* the inscription 'A Pÿnacker' (the initials interlaced) which may be considered as a signature: similar inscriptions by the same hand have been discovered on sheets in Amsterdam,[5] Leiden[6] and Paris.[7] Mainly studies of trees, these works, together with stylistically comparable but unsigned sheets in Chantilly,[8] Berlin,[9] Paris,[10] and in the collection of Maida and George Abrams[11] which may be justifiably attributed to Pynacker, appear to be drawings from nature for their own sake, rather than preliminary sketches for paintings. Unlike these studies, the present drawing has all the attributes of a completed work of art: it was not executed from nature, since its composition repeats, with slight but significant variations, that stated in a sheet in the collection of Dr F. G. Miller, Düsseldorf.[12]

The chalk drawing indicating the contours and planes of background vegetation in the drawing in the Miller collection is here eliminated, creating simultaneously an indefinite, dream-like picture space, and a hazier, flatter foil for the foreground trees. These, in comparison to their counterparts in the Düsseldorf design, are rendered with a more incisive, continuous contour, while modelling, more summarily indicated, is of a harsher value contrast and now suggests a glossiness on the surface of natural forms;[13] all foreground vegetation here also displays a greater degree of contortion. The 'U'-shaped composition of the cognate drawing is consolidated in the present work by relocating the trees at the left and right further in towards the centre of the sheet; by making the linking curve of the bank, left, more insistent; and by suppressing details of the male figure and omitting the female who appears at the extreme right of the drawing in Germany. The adjustments made to the present sheet towards a clearer but less subtle design than that in Düsseldorf suggest that it is the later of the two drawings.

We are unable to gauge how intimately developments of style in Pynacker's drawings are related to those shown in the paintings, yet the present sheet shares with works in oil dated 1659 in Munich[14] and 1661 in Bonn[15] certain formal properties, chief among which is the agitated rendering of foreground vegetation which in both scale and treatment is dislocated from the background: the Courtauld drawing may thus tentatively be assigned to a comparable date in the late 1650s, or early 1660s.

1 Blankert, in exh. cat. Utrecht, 1965, p. 184, fn. 2.
2 Vol. II, p. 96.
3 In 1658; Blankert, in exh. cat. Utrecht, 1965, p. 184.
4 Lugt, 1929–33, in biographical introduction to drawings in the Louvre.
5 cf. C. van Hasselt, in exh. cat. New York/Paris, 1977–78, under No. 82. Fodor Museum; Bernt, II, No. 480, as unsigned. Rijksmuseum, Inv. No. '64:59.
6 Printroom of the University (Welcker coll.), Inv. No. A.W. 1239.
7 Louvre; Inv. No. R.F.34542.
8 Musée Condé; Inv. No. 360.
9 Staatliche Museen; Bock/Rosenberg, p. 216, No. 3929.
10 Institut Néerlandais, Fondation Custodia (Lugt coll.); exh. Brussels/Rotterdam/Paris/ Berne, 1968–69 (113).
11 Exh. International Exhibitions Foundation, 1977 (65)
12 Formerly with Claude Aubry, Paris.
13 A similar observation made by Stechow, p. 157, in relation to certain oil paintings.
14 Bayerische Staatsgemäldesammlungen; Inv. No. 773.
15 Rheinisches Landesmuseum; Stechow, pl. 314.

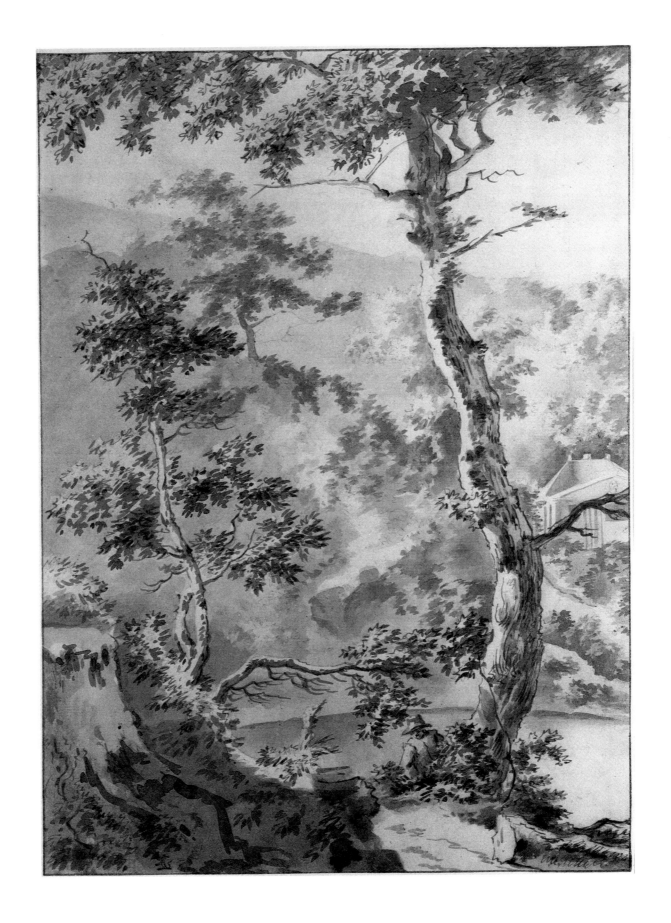

ADAM PYNACKER
(1622–1673)

58 Landscape with Bridge

Detailed preliminary drawing in black chalk, moistened for the darkest accents; grey (carbon) ink washes, with drawing with the pen and point and flat of the brush; on off-white (now stained) laid paper. The sheet folded horizontally, centre, and unevenly trimmed at all sides.

Verso: Two figures, in pen and golden ink wash, over slight preliminary drawing with black chalk.

24 × 16.4 cm.

Signed in pen and grey ink wash, with touches of black chalk, lower right: 'A P' (in monogram). Numbered in pencil, *verso*: '3XX'.

PROVENANCE: Lord Amherst of Hackney, sold Sotheby, 14 December 1921 (lot 67), bt. Sir Robert Witt; Witt Bequest 1952 (387).

EXHIBITION: Courtauld, 1972 (27).

The interlaced initials at the lower right of the drawing exhibited here are in a hand closely comparable to that responsible for the full signature on the *verso* of the preceding sheet: other drawings attributed to Pynacker in the Courtauld Institute Galleries[1] and Haarlem[2] bear similar monogrammed initials. The fragment of a study of two figures on the present *verso* also employs the mannered contours visible in cat. no. 57, to which the style of the *recto* here is but distantly related. A fully signed (on the *verso*) composition in Amsterdam,[3] of large format and executed with the soft touch of the point of the brush over slight preliminary chalk drawing, does, however, display affinities of style with that of the present sheet.

In the background of both drawings, individual leaves are denoted by chalk dashes, while continuous scalloped contours delineate foliage clusters. In this plane of the composition also, delicate glides of wash frequently stop short of the edges of darker foreground motifs, which thus remain isolated against ragged patches of bare paper. The slender birches in the foreground here are comparable in form and treatment to those in the middleground of the Amsterdam sheet: trunks are rendered by long but discontinuous contours, frequently qualified or accented by shorter, bowed strokes, while wrinkled or scarred areas of bark are described by columns of horizontal chalk hatching, reinforced by bolder striations with the point of the brush in wash. The ends of lesser branches diverge to create networks of delta formations, which, although drawn with the brush in the Amsterdam composition, are nevertheless rendered with a similar nervous and exploratory line to that visible here. Broad zigzags of wash overlay short, upward-inflected chalk strokes detailing foliage in the foreground of both sheets.

Examples of similar vertical compositions employing the motif of a wooden bridge observed beyond framing trees are found in the signed and dated painting in Bonn (although the drama and agitation depicted in that canvas is not present in the Courtauld drawing) and in a sheet in Munich.[5]

1 Witt, No. 1976, also dated 1662.
2 Scholten, Portefeuille P*, Nos. 72, 72.
3 Fodor Museum; Bernt, II, No. 480.
4 Rheinisches Landesmuseum; Stechow, pl. 314.
5 Staatliche Graphische Sammlung; Wegner/München, No. 838.

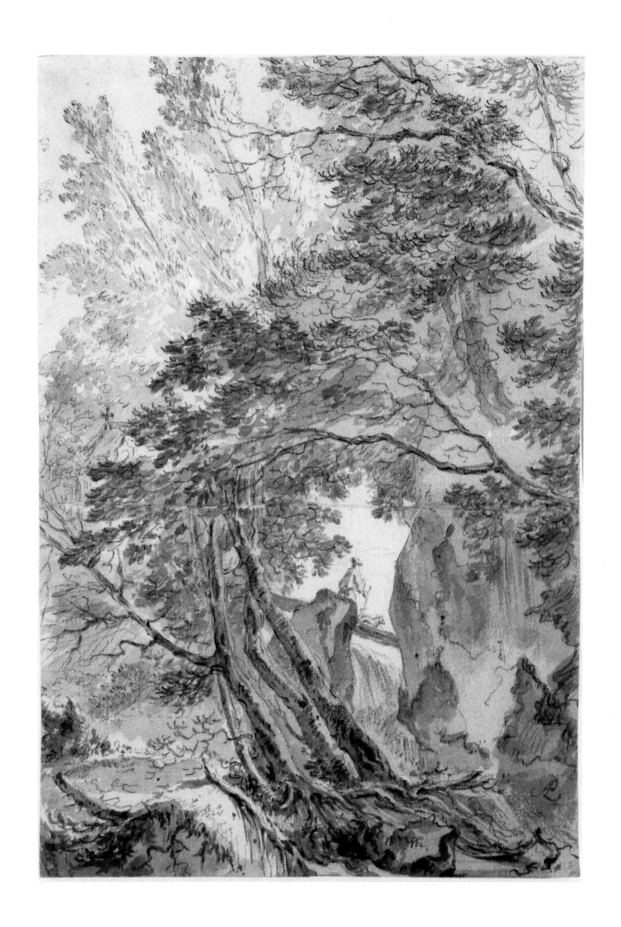

ROELAND ROGHMAN
(c.1620–after 1686)[1]

59 Rocky Landscape with Figures on a Road

Extensive preliminary drawing in graphite; pen and brown ink; grey (carbon) ink washes and restricted watercolour washes, with some drawing with the pen and the point of the brush; on off-white (discoloured) laid paper. The sheet edged by the artist's ruled framing lines in pen and brown ink, and unevenly trimmed at all sides.

Watermark: fools-cap, with numbers below.

15.4 × 23.5 cm.

Signed in pen and brown ink, bottom right: 'R.Roghman'.

PROVENANCE: Sir Robert Witt (purchased from Colnaghi, no date); Witt Bequest 1952 (3437).

LITERATURE: Bernt, II, No. 496.

Few biographical details concerning Roeland Roghman are known for certain: Houbraken[2] reports that he was a good friend of Rembrandt (1606–1669) and also of Gebrand van den Eeckhout (1621–1674), and was probably active for the greater part of his career in Amsterdam, where he is recorded in 1661 and 1664. The subjects of his paintings,[3] drawings,[4] and etchings[5] lead us to suppose that he may have visited Italy, perhaps in c.1640. His drawings range from restrained topographical views of Netherlandish sites (to which category belong a series of 241 sheets datable to 1646–1647, depicting castles in Delfsland, Rhynland, Schieland and Utrecht, dispersed only in 1800 at the Ploos van Amstel sale)[6] to landscapes of an often sombre intensity, many of which appear to be based on memories of the Italian journey, but which follow the tradition initiated by Joos de Momper. The drawing exhibited here belongs to the latter type; its fluid penwork is reminiscent of the more summary draughtsmanship of Rembrandt[7] and of the styles of artists within that master's circle, e.g. Lambert Doomer (1622–1700)[8] and van den Eeckhout.[9] It has been observed[10] that Roghman employed two distinct combinations of drawing materials; either pen and brown ink with brown or carbon ink washes, or black chalk with carbon ink washes. The drawings exhibited here are unusual in conforming to neither type, but in possessing properties of each, and being tinted with watercolour of a restricted but idiosyncratic palette.

The general composition of the present work is comparable to that of a squared-up design in the British Museum.[11] Dominating the fore- and middleground of both sheets is a rounded hill formation with, at its base, a dramatic outcrop of sheer cliff. The foreground plane, receding diagonally from the right corner of the sheet, is generally flat, with at the left a winding road along which figures walk. Similar compositions are also to be found in an etching from a series of eight Tyrolean views after Roghman,[12] and in a painting in the National Gallery, London.[13] That canvas shares with the present drawing the motifs of a distant screen of dark foliage closing off the composition at the left, with indications of a flat landscape beyond, and in front of which are located the larger accents of a pair of trees whose slender trunks are arranged in cross-formation. A related, but more compact composition is also evident in a painting in Amsterdam.[14]

It is tempting to suggest, on the basis of the formal similarities noted between this drawing and the works cited above, that they must have been executed at a comparable date, but our knowledge of Roghman's working methods is too slight to support such a claim. It does seem probable, however, in the light of the unusual techniques of this and the following drawing, that both sheets may have been created at a similar period.

1 Roghman's dates are uncertain. Houbraken, vol. 1, pp. 173–174 states that he was born in 1597, and was still alive in 1686; while Bol/Keyes/Butôt, under No. 57, give the dates, without supporting argument, as 1627–1692. The dates given here are those for which Maclaren, p. 353, argues.
2 Vol. I, pp. 173–174.
3 e.g. Rijksmuseum, Amsterdam; Amsterdam, Nos. A4218, A760; Royal Museum of Fine Arts, Copenhagen; Copenhagen, Nos. 589, 590.
4 e.g. in Berlin (Bock/Rosenberg, p. 248, Nos. 2617 (a drawing of S. Giacomo a Rialto in Venice), 3806): in Frankfurt (inv. No. 3062; Bernt II, No. 498): in London (Hind IV, p. 34, Nos. 1–3): in Munich (Wegner/München, No. 860).
5 Hollstein, vol. XX, pp. 78–81, nos. 25–32.
6 See the entry for Ploos van Amstel in Lugt.
7 e.g., in Berlin (Benesch, 1957, vol. VI, No. 1293): coll. O. Gutekunst, London (Bensch, 1957, vol. VI, No. 1224); Ashmolean, Oxford (Benesch, 1957, vol. VI, No. 1355); Institut Néerlandais, Paris (Benesch, 1957, vol. VI, No. 1333); Akademie der bildenden Künste, Vienna (Benesch, 1957, vol. VI, No. 1320); coll. Capt. and Mrs. E. Speelman (Benesch, 1957, Nos. 1332, 1357); ex coll. F. Koenigs (Benesch, 1957, vol. VI, No. 1323).
8 e.g. in the Rijksmuseum, Amsterdam; Henkel, Nos. 2, 3: 1972–3 in the Hermitage, Leningrad, inv. Nos. 2827, 14948, ex. Brussels/Rotterdam/Paris, 1972/3 (25, 26, respectively).
9 e.g. in the Rijksmuseum, Amsterdam; Henkel, No. 17.
10 Hind, IV, p. 33.
11 Hind, IV, p. 34, No. 1.
12 Hollstein, vol. XX, p. 80, No. 27.
13 Inv. No. 1340; Maclaren, p. 353.
14 Rijksmuseum; Amsterdam, p. 479, A.760.

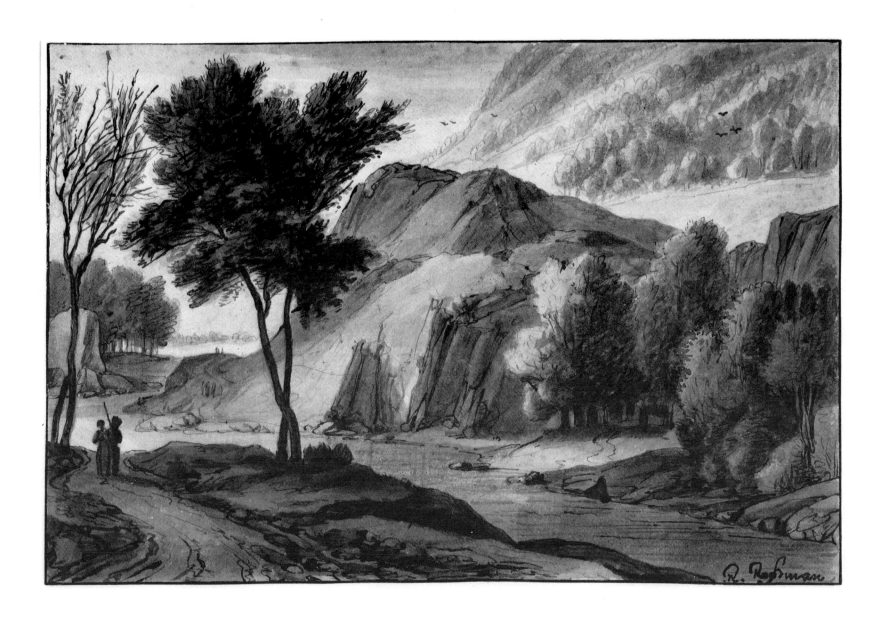

ROELAND ROGHMAN
(*c*.1620–1685)

60 The Porte-Pertuis Pass 1680s

Preliminary drawing in pen and brown ink; grey (carbon) ink and restricted watercolour washes, with some drawing with the point of the brush; extensive overdrawing with black chalk (particularly in the background); on off-white (discoloured) laid paper. The sheet edged by the artist's framing lines in pen and brown ink, and unevenly trimmed at all sides.

15.3 × 23.3 cm.

PROVENANCE: Sir Robert Witt (purchased from Colnaghi, no date); Witt Bequest 1952 (3438).

The drawing exhibited here, comparable in materials and handling to No. 59 may represent the Porte-Pertuis Pass. A naturally arched outcrop of rock some 20 feet thick, the Porte-Pertuis (also known as the Pierre-Pertuis or Steinpfort) is pierced by an irregular tunnel some 32 feet wide and 52 feet high, said to have been enlarged by the Romans. It is situated one mile north-east of Sonceboz in the Canton of Berne, Switzerland.[1]

Eight views of similar subjects by Roghman, also apparently based on the Porte-Pertuis motif, have been discovered[2] in Berlin,[3] Dresden,[4] Groningen,[5] London,[6] Munich,[7] Paris,[8] Rotterdam,[9] and formerly in the Piek collection in the Hague:[10] to these may be added a sheet in the F. C. Butôt collection,[11] which includes the beginnings of the rocky archway beyond which are observed a waterfall and trees.

Roghman may have seen the Porte-Pertuis en route to Italy in *c*.1640, although no drawing from the group cited above suggests that the motif was recorded from nature. Indeed, the great variation in form and conception to which the pierced outcrop is subject in these works (ranging from a close-up view of a small scale tunnel through which only one or two travellers are able to pass, as in the drawing in Groningen, to a panoramic scene of a complex of rock archways whose grandeur dwarfs men and animals, as in sheets in Paris and Munich) would indicate that they were created from memory, or perhaps from the imagination. It may be argued that this subject was inspired in part, if not wholly, by similar motifs in the work of Roghman's contemporaries: Bolten[12] has discovered the Porte-Pertuis image in drawings by, for example, Jan Hackaert, Herman Saftleven, Vincent L. van der Vinne and Anthonie Waterloo.[13]

No drawing by Roghman of the Porte-Pertuis is dated, although van Hasselt[14] has suggested that all representations of this subject may be assigned to a period late in the artist's career.

1 Cf. entry in Knapp/Borel.
2 Cf. Bolten, 1967, under No. 85, and van Hasselt in exh. cat. Brussels/Rotterdam/Paris/ Berne, 1968–9 (121).
3 Bock/Rosenberg, p. 247, No. 3812.
4 Kupferstichkabinett, inv. No. C.1770; photo Witt.
5 Museum voor Stad en Lande; Bolten, *ibid.*
6 Victoria & Albert Museum, Dyce Bequest, inv. No. 456.
7 Staatliche Graphische Sammlung; Wegner/München, No. 859.
8 Institut Néerlandais, Fondation Custodia (Lugt coll.) inv. No. 6693; exh. Brussels/ Rotterdam/Paris/Berne, 1968–69 (121).
9 Boymans-van Beuningen Museum, inv. No. MB 201; photo Witt.
10 Photo Witt.
11 Bol/Keys/Butôt, No. 57.
12 *ibid.*
13 The Hackaert is in the Kunsthaus, Zurich (Album Hackaert): The Saftleven is in Berlin (Bock/Rosenberg, p. 267, No. 13848): the van der Vinne is in the Municipal Archives, Haarlem: the Waterloo is in the British Museum (Hind, IV, p. 104, No. 10).
14 Brussels/Rotterdam/Paris/Berne, 1968–69, *loc. cit.*

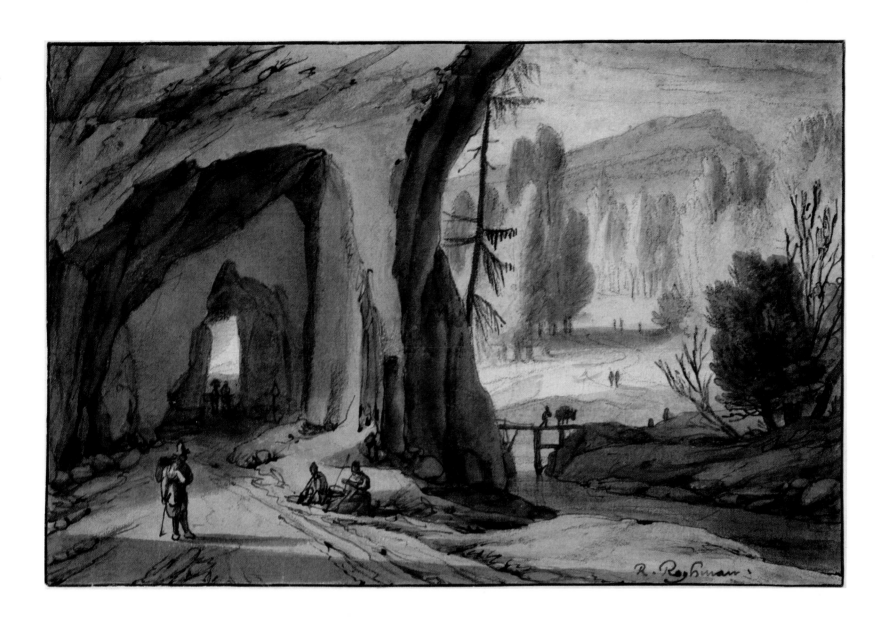

HERMAN SAFTLEVEN THE YOUNGER
(1609–1685)

61 A derelict Cottage (?) late 1630s

Faint preliminary drawing, and overdrawing, in black chalk, moistened for the darkest accents; black (carbon) ink washes; on off-white (stained) laid paper. The sheet unevenly trimmed at all sides to an irregular shape.

17.7 × 28.9 cm.

Signed in black chalk, bottom right: 'H S L' (the initials interlaced).

PROVENANCE: Sir Robert Witt (purchased from Parsons, no date); Witt Bequest 1952 (938).

EXHIBITIONS: V. & A., 1943; Courtauld, 1972 (23).

LITERATURE: Schulz, p. 57, No. 1085.

Son of the obscure painter and perhaps dealer Herman Saftleven I (c.1580–1627), Herman II, younger brother of the artist Cornelis (1607–1681), was born in Rotterdam. In c.1632 he probably moved to Utrecht, where he married in 1633 and remained for the rest of his life.[1] Some 1100 sheets[2] have been catalogued from the hand of this prolific draughtsman, who was capable of working in a variety of styles simultaneously, or reverting after a period of several years to an earlier manner of drawing. He is also known to have made frequent copies of his own designs.

The motif of the cottage in this drawing probably relates to those in the work of Abraham Bloemaert (see No. 32), and Saftleven's interest in this artist's subject matter appears in two sheets in Berlin[3] datable to the end of the Rotterdam period. Unlike the older master's conception of the motif, that displayed by Saftleven here is neither decorative nor idyllic; and the handling, with a vocabulary of bold, unelaborate chalk strokes combined with areas of flatly applied wash, indicates a debt to the pioneers of naturalism in the circle of Esaias van de Velde (1591–1630). The drawing is comparable in style to Saftleven's study in Brussels of an old oak(?) tree.[4] While that composition includes more detailed indications of background landscape than are visible here, its principal motif similarly dominates the centre of the pictorial area, and is presented in an equally blunt manner. Both works treat the theme of vestigial life in the face of decay: smoke rising from the chimney confirms that the hut in the Courtauld sheet remains inhabited despite its derelict condition, while in the Brussels drawing, sparse leaves continue to sprout from the tortured and dying tree trunk. Flocks of birds encircling the motif in both works enhance the mood of eerie desolation.

A date at either the end of the Rotterdam period or during the early years in Utrecht has been proposed for both Courtauld and Brussels drawings, on the basis of their monogram, which is a variant of that used in earlier sheets.[5] Since no dated drawings from the years 1631–1638 exist, however, Schulz's allocation of this sheet to the early part of that period is by no means secure.

A dilapidated peasant's cottage similar to that depicted here also appears in the background of a disquieting painting in East Berlin,[6] in which abandoned household and farm implements dominate a landscape menaced by clouds and enlivened by perched and wheeling birds. The date on this panel has been published as 1638 (although its final figure is difficult to read), and it may be argued that the Courtauld drawing could equally be assigned to a date in the later 1630s.

2 Schulz, p. 48, notes that some 1500 drawings are currently attributed to Saftleven.
3 Staatliche Museen; Schulz, Nos. 331, 332.
4 Museum voor oude Kunst; Schulz, No. 961, and *ibid.*
5 A monogram related to that on the Courtauld sheet appears on a view of Utrecht in Yale University Art Gallery, New Haven; Schulz, No. 444.
6 Schulz, p. 58.
7 Gemäldegalerie; Schulz, No. 4.

1 Biographical details of the Saftleven family (which also includes Abraham, born 1613) are published by Schulz. That author has discovered (p. 5) no proof that Herman II lived in Elberfeld, as is stated in Thieme-Becker.

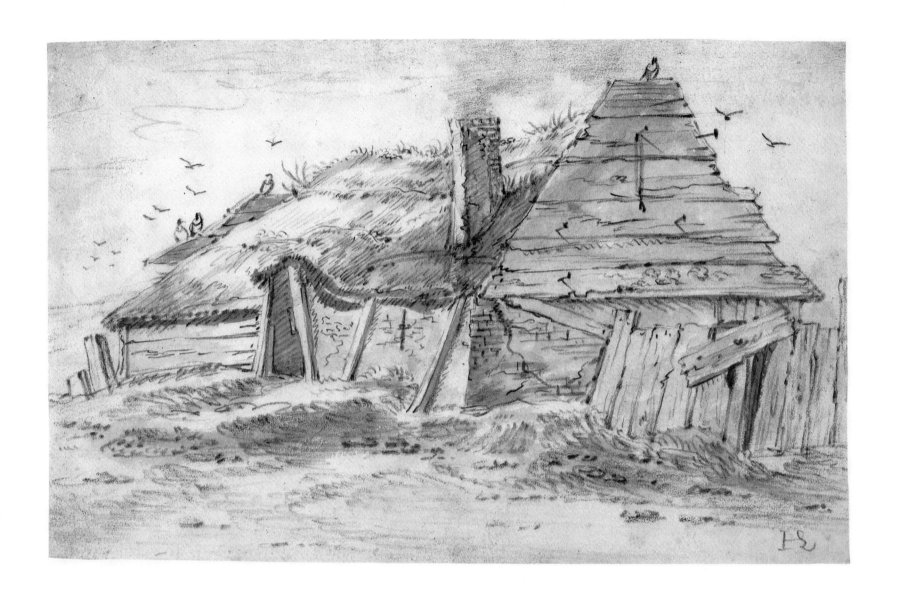

PIETER SANTVOORT
(after 1603–1635)

62 Landscape with Mountain Stream *c.*1625–29

Black chalk, moistened for the darker foreground accents; on pale buff (stained) laid paper. The pictorial area enclosed within a ruled line in pen and brown ink. The sheet folded vertically, left, and unevenly trimmed at all sides.

Watermark: fleur-de-lis, lettered 'H', in a shield surmounted by a crown, with numbers and letters below.

24.6 × 40.3 cm.
verso: hill landscape with trees and cottage, in black chalk.

Inscribed in graphite, *verso:* 'F'.

PROVENANCE: Chariatte; ...; Sir Robert Witt (purchased from Sotheby, no date); Witt Bequest 1952 (1579).

A small number of paintings by Santvoort is known,[1] while his drawings, also rare, have been listed by van Gelder.[2] Few sheets are either signed or dated, with notable exceptions of a drawing in Vienna, which bears a signature and the date 1626,[3] and a drawing formerly in a portfolio in Bremen dated 1623.[4] Santvoort's limited output may perhaps be explained by a certain affluence which relieved him of the necessity of earning a living from art, although it is possible that drawings from his hand are filed under other artists' names: Santvoort is known to have called himself Bontepaert, his father's nickname.[5]

The double-sided drawing exhibited here is one of two sheets by the artist in the Witt collection.[6] The landscape on the *recto* is indebted to imaginary Alpine scenes by Esaias van der Velde, executed during the period *c.*1624–*c.*1628. Van der Velde was himself inspired by the Tyrolean landscapes of Roelant Savery (see No. 18) whose compositions were disseminated by contemporaneous engravings made after his designs by Jacob Matham,[7] Magdalena de Passe[8] and Aegidius Sadeler.[9] Savery had settled permanently in Utrecht in 1619, and it was largely due to his influence that during the following decade Alpine scenes came into vogue in Holland. Keyes has observed[10] that both collectors of this new subject in art and the artists who created it during the 1620s were in the vanguard of fashion.

The Alpine landscape here is sufficiently closely related by motifs and composition to a Savery-inspired drawing by van der Velde in Stockholm, dated 1624,[11] to encourage speculation that Santvoort may have known of that particular example:[12] and this sheet may thus be justifiably dated to the mid- to late-1620s. In the Stockholm drawing, a dominant rock face at the left is separated by a bend in the river from an open, gently rising landscape vista at the right, in which are located motifs of ruined architecture, a bridge, and a curving road with staffage. That composition is reversed in the present work: Santvoort extends the cliff (now at the right) beyond the centre of the composition and closes off the view into the distance at the left by introducing a precipitous far shore. All references to human presence (ruins, road, figures themselves) are omitted, but as the diversity of motifs here is narrowed, so their comparative scale is increased. Much of van der Velde's rendering of sharp detail is suppressed by Santvoort, who instead describes all forms by means of a somewhat crude, uninflected (and in the block-like rock formations, insistently repetitive) contour. The precise and nuanced parallel hatching employed by the senior artist to model intricacies of form (evident particularly in the faceting of cliff faces) is developed here into a vocabulary of broad, loose strokes which are massed over large areas to create a bold interplay of tonal oppositions over the surface of the drawing. Forms in Santvoort's work are bluntly presented to the

spectator, and the artist can here be seen to adjust van der Velde's quietly poetic motifs in order to create robustly dramatic images which combine into a composition of immediate impact.

Comparable Alpine compositions by Santvoort, but which are executed in pen and ink and display an even more abbreviated interpretation of van der Velde's motifs and handling are in Düsseldorf[13] and Paris.[14]

The unfinished drawing on the *verso* may represent a native landscape, but it too is probably an imaginary scene. The motif and treatment of the house at the centre of the composition is dependent upon that included in van der Velde's Dutch views, also of the later 1620s,[15] although the tree type suggests a knowledge of the later work of Paul Bril (see No. 4).

1 A painting in Berlin, signed and dated 1625, is described by Stechow, p. 24, as 'magnificently daring'; Stechow, pl. 23. A snow scene sold from the collection R. H. Ward, in Amsterdam, 15 May 1934 (lot 145) is also dated 1625. A painting in the Frans Hals Museum, Haarlem, inv. No. 260, is a late work. i.e. shortly before 1635: cf. Stechow, p. 90, under fn. 31.

2 Van Gelder, p. 75, fn 1. This author includes in the list a sketchbook of 21 sheets in Weimar dated 1623, although the attribution of this book to Santvoort is now in doubt.

3 Albertina; Schönbrunner/Meder, vol. XI, No. 125.

4 The portfolio, in the Kunsthalle, contained a total of 14 drawings, of which 12 were lost during World War II. Inv. No. 1772 was signed and dated: 'P. D. Santvoort 1623'; photo Witt. The two remaining drawings from Bremen are now in the Institut Néerlandais, Fondation Custodia (Lugt coll.), Paris.

5 The father, the painter Dirk Pietersz. Bontepaert died in 1642. A drawing by Santvoort in the Institut Néerlandais, Fondation Custodia (Lugt coll.), Paris, inv. No. 1911 is signed: 'bontepaert f.'

6 Hand-list, p. 113, No. 1987, also a double-sided drawing. Less turbulent in style than the sheet exhibited here, it is probably a later work.

7 Hollstein, vol. XI, p. 235, No. 360.

8 Hollstein, vol. XVI, pp. 217–8, Nos. 18, 19.

9 Hollstein, vol. XXI, pp. 46–51, Nos. 219–224, 225–230, 231–236, 237–240, 241–246.

10 Keyes, p. 64.

11 Nationalmuseum; Keyes, No. D. 204.

12 It is thought that Santvoort may also have been a collector (cf. exh. cat. Brussels/Rotterdam/Paris/Berne, 1968–9 (134)).

13 Kunstmuseum; exh. cat. Düsseldorf, 1968 (97).

14 Institut Néerlandais, Fondation Custodia (Lugt coll.), exh. Brussels/Rotterdam/Paris/Berne, 1968–9, and inv. No. 1198. Louvre; Lugt, 1929–33, Nos. 706–708.

15 e.g. in the Staatliche Museen, Berlin (Keyes, No. D. 142, of *c.* 1624) and Paris (Gallery A Stein; Keyes, No. D. 130, of *c.*1624) and Institut Néerlandais, Fondation Custodia (Lugt coll.) (Keyes, No. D 202, dated 1629).

HERMAN SWANEVELT
(c.1600–1655)

63 Landscape with the Flight into Egypt c.1641

Pen and bistre; light brown and grey-brown ink washes (bistre mixed in various proportions with carbon black ink), with drawing with the pen (restricted to foreground vegetation) and the point and flat of the brush; on thin white laid paper. The sheet unevenly trimmed at all sides.

Watermark: a phoenix rising from flames, encircled.

19.6 × 26.5 cm.

Inscribed by the artist in pen and bistre, *verso:* 'De frome liefde die daer groeyt/ ghelijck het loff in de lente bloeyt/en doet de liefde vast bestant' (i.e. 'The devout love that grows there/like the love which in spring blooms/and makes the love fast endure')[1]

Inscribed by a later hand in pen and brown ink, *verso:* 'Swanevelt/F.', and numbered in a modern hand in pencil: 'A: 459'.

PROVENANCE: Sir Robert Witt (purchased from Colnaghi, 1936); Witt Bequest 1952 (1245).

EXHIBITIONS: Wildenstein/London, 1955 (76); Courtauld, 1972 (47).

Thought to have been born in Woerden, near Utrecht, Swanevelt may have studied under Abraham Bloemaert. He appears to have left Holland early, since he was in Paris in 1623, and in 1624, in Rome. In his work, the arcadian spirit and intense preoccupation with the effects of light found in compositions by Poelenburgh and Breenberg, the leading Dutch artists of their day in Rome, is combined with a classical pictorial structure similar to that of Claude Lorrain, with whom Swanevelt shared a house from 1627–1629.[2] While the nature of the influence which each artist exerted upon the other during this early period is a matter of speculation, it is evident that by 1630, the date on a painting in the Hague,[3] Swanevelt had developed a landscape style which parallels that of Claude, whose earliest dated painting is inscribed 1631.[4]

During the period 1631–1638, Swanevelt's paintings confront the problems of reconciling a stable, legible landscape structure with the depiction of forms which appear to lose their shape in brilliant sunlight. Heeding lessons gained from Poeleburgh's work of the early 1620s, in which the structure of landscape created from many small compositional units tends to be softened (see No. 55), the artist developed landscapes built up from a restricted number of clearly defined elements. Compositions dating from the end of the 1630s have been characterised by Waddingham[5] as including landscape motifs expressive of thoughts or emotions concerning nature (rather than simply of their appearance), while possessing something of a baroque freedom of interpretation in the theatrical effects of light and ample volume of shadows. The compositions created by Swanevelt in Italy serve as a link between the work of the first generation of Italianate Dutch artists (Breenberg and Poelenburgh) with that of artists such as Jan Both, Asselyn and Berchem. In 1641, Swanevelt left Rome, working first in Paris, and returning later to Woerden: in the later Roman years, the artist's popularity appears to have been such that he was overwhelmed by commissions, which lead to a certain carelessness in the execution of some of his paintings.

Of the six dated drawings in Swanevelt's *œuvre*, the earliest, in Windsor,[6] was created in 1632, and the latest, a genre scene betraying the influence of Pieter van Laer (1592–1642), in 1641.[7] Comparison with the Windsor sheet reveals the Courtauld drawing's overall breadth of treatment. While landscape elements are clearly defined, the delineation of foliage is less lively; the silhouettes of trees tend to be more nearly similar, while interior modelling with dots and striations produced by the pen is abandoned in favour of extensive washes applied with the brush. Nervertheless, this drawing, in which a lucidly structured landscape is observed bathed in the radiance of an early evening light (rendered by the precise juxtaposition of warm bistre tones against the cooler colours obtained from bistre mixed with carbon black ink washes) is the achievement of an artist in full command of his powers.

The Flight into Egypt is treated on many occasions in Swanevelt's work. It is the subject of a painting in Rome, perhaps one of the first datable to 1631–1638;[8] of two drawings of a similar period(?) in Florence;[9] and of a suite of four undated engravings.[10] Formally, however, these works have little in common with the present drawing, whose pictorial structure is related to the engraving *Landscape with the Consolation of Hagar*, the second of a suite of four undated Old Testament subjects published by Audran in Rome,[11] and is also reminiscent of the compositions of plate 15 of the undated series *Variae campestrum fantasiae*,[12] and plate 4 of a suite of 12 landscapes including buildings.[13] A composition of greater width than that of the Courtauld drawing, but in which all principal motifs of its landscape are shown in reverse, is displayed in a painting sold in London in 1976.[14] That signed work bears the inscription 'Paris' and is dated 1641, a period to which the present sheet may also be assigned.

1 We gratefully acknowledge Sebastian Dudok van Heel of the Gemeente-Archief, Amsterdam, who read the inscription.
2 Waddingham, pp. 38, 43.
3 *Jacob's Departure*, Bredius Museum; Waddingham, pl. 20.
4 *Landscape with the Rest on the Flight into Egypt*, The Trustees of the Late Duke of Westminster; Röthlisberger, 1961, No. 241. Stechow, 1960, p. 85, was also of this opinion, but does not support his argument by citing Claude's dated paintings.
5 p. 41.
6 van Puyvelde, No. 961.
7 Courtauld Institute Galleries, Witt coll., 4483. The remaining dated drawings are in the following collections: sold Oppenheimer, Christie, 10 July 1936 (317), dated 1636. Dutuit coll., Paris, dated 1636; Lugt, 1927, No. 73. E. B. Crocker Art Gallery, Sacramento, dated 1639; exh. Sacramento, 1940 (24), Staatliche Museen, Berlin, Inv. No. 26199, dated 1640.
8 Galleria Doria Pamphili; Waddingham, pl. 25a.
9 Uffizi, Inv. Nos. 712, 715; Gernsheim Nos. 12938, 12935, respectively.
10 Bartsch, Bartsch Illustrated, Vol. 2, Nos. 97–100.
11 Bartsch, Bartsch Illustrated, Vol. 2, No. 67, of series No. 66–69, inscribed on the plate: 'H. Swanevelt Fe. Roma'. The publisher was probably Charles Audran (1594–1674).
12 *The House on the Rock*; Bartsch, Bartsch Illustrated, Vol. 2, No. 15, of series No. 1–25.
13 *The Travellers*, Bartsch, Bartsch Illustrated, Vol. 2, No. 88, from the series No. 83–84.
14 Sotheby, 23 June 1976 (lot 41); photo Witt.

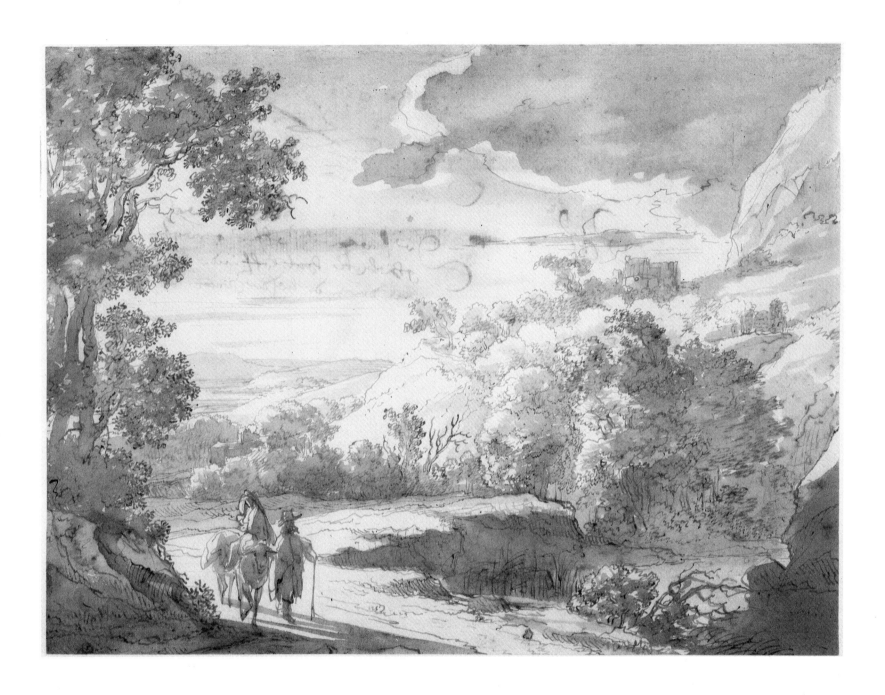

WILLEM VAN DE VELDE II
(1633–1707)

64 Estuary Scene: Pinks, Barges and a Frigate firing a Salute early 1670s

Graphite, with some rubbing; on off-white (now stained and discoloured) laid paper. A tear repaired, upper left. The pictorial area enclosed within a freehand line in pen and black ink by a later hand. The sheet folded diagonally, lower right, and unevenly trimmed at all sides.

Watermark: fleur-de-lis in a shield, surmounted by a crown.

29.3 × 35.8 cm.

Signed in pen and brown ink, lower left: 'W.V.V.J.', and inscribed in graphite with the colour note: 'L' to the left of the mast of the frigate, and in the cannon smoke.

Numbered in a later hand in pencil, *verso*: '3/d'.

PROVENANCE: Lord Amherst of Hackney, sold Sotheby, 14 December 1921 (one of lots 99, 100, 103, 105, 108, 110, 112, comprising 90 drawings), bt. Sir Robert Witt; Witt Bequest 1952 (1237).

EXHIBITION: Courtauld, 1972 (64).

Willem van de Velde was taught principally by his father, also Willem (1611–93), a specialist in ships' portraiture and the leading exponent of the grisaille technique of 'pen painting' on panel.[1] It is thought that in *c.*1648 the Younger van de Velde travelled to Weesp to study under Simon de Vlieger, whose marine paintings, remarkable for their cool tonalities and acute observation of light, must have had a profound effect on the young artist. On his return to Amsterdam, the Younger van de Velde worked in collaboration with his father. During the winter of 1672–73 both father and son emigrated to England, and by 1674 were in the service of King Charles II.[2]

There is no conclusive proof that this drawing represents either Dutch or English vessels. Details of pennants and flats are omitted, although there is a suggestion of a lateral division on the pennant of the middleground frigate's mizzen mast, which might signify that the vessel is Dutch.

The handling of the frigate is characterised by a concentration on the silhouette of the hull, with frequent minor revisions and restatements of its contours (visible particularly in the bow) and the suppression of detail in favour of a tight overall diagonal hatching indicating the play of light and water's reflections over the form. Sails and rigging are drawn with a freer touch, often a single generous curved stroke (describing completely such pliable and light-weight structures) while hatching in these forms is more open than in the hull. Similar stylistic properties are shared by studies of individual Dutch vessels in the National Maritime Museum, dated by Robinson to 1672?[3] and by sheets from the John MacGowan collection, sold in London in 1974.[4] A type of draughtsmanship reminiscent of that in the present sheet, but employing a more accented contour appears in isolated drawings dated by Robinson to 1675?[5] and in one sheet assigned to the date of 1700.[6] A date in the early 1670s, however, may probably be given to the Courtauld drawing.

The drawing is not closely related to a painting, and indeed, sketches identifiable as preliminary studies for larger works rarely occur in van de Velde's *œuvre*: it has been pointed out[7] that the drawings served rather as a formative prelude to the making of the final picture. The present drawing's compositional type, however, is reminiscent of that stated in a small canvas in the Ellesmere collection, Bridgewater House,[8] and in its variant from the Heseltine collection sold in London in 1935.[9]

The drawing appears to have been created in front of the motif, but is nevertheless a complete and harmonious work of art in its own right; that it was also to be employed as an *aide-mémoire* in the studio is signalled by the note 'L' (i.e. 'licht' or 'light')[10] in the sky and cannon smoke, a reminder that for this artist, the notation of effects of light and atmosphere was of equal importance to the accurate portrayal of shipping.

1 The technique is fully explained by W. Percival-Prescott, in exh. cat. N.M.M., London, 1982, p. 24.
2 Biographical data from Robinson, I. pp. 5ff.
3 e.g. Robinson, I, Nos. 358–68, 362–64.
4 Sotheby, 21 March 1974 (lots 123, 124); photos Witt.
5 Robinson, I, Nos. 468, 470.
6 Robinson, I, No. 688.
7 Percival-Prescott, p. 24.
8 *The Signal Gun*; Hofstede de Groot, Vol. VII, No. 113.
9 Sotheby, 27–29 May 1935 (lot 99), purchased A. Spero; photo Witt.
10 Similar notes are found in drawings in the National Maritime Museum, e.g. Robinson, II, No. 1254.

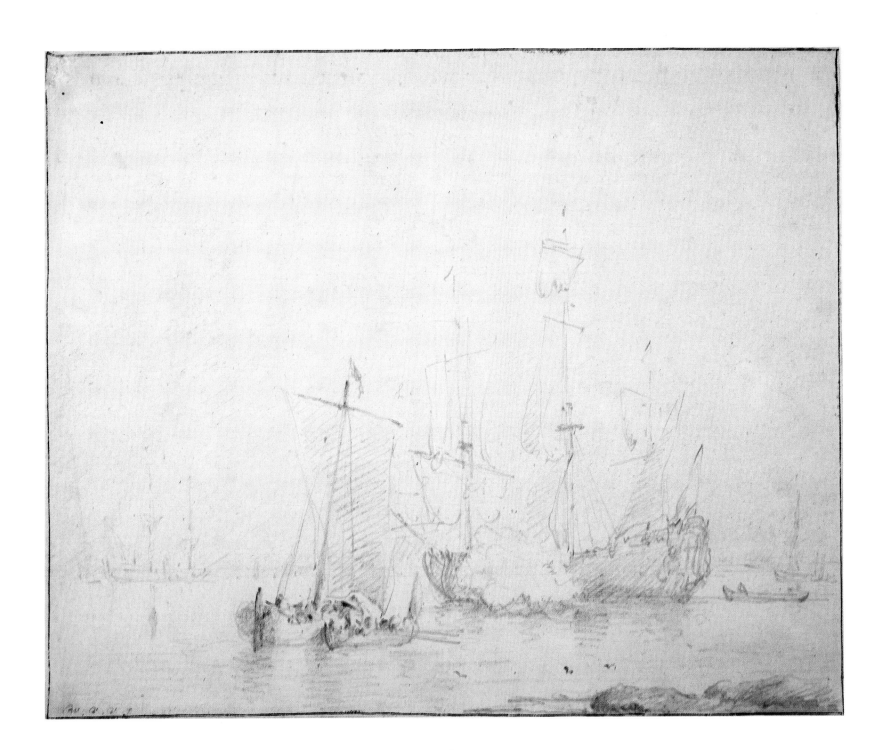

WILLEM VAN DE VELDE II
(1633–1707)

65 Estuary Scene: three Galliots, a Barge and a Frigate firing a Salute mid 1670s

Graphite; on white (now stained) laid paper. The sheet unevenly trimmed at all sides and backed with Japanese tissue.

Watermark: letters 'IM' (right), and a fleur-de-lis in a shield, surmounted by a crown, with letters and numbers below (left) (variant of Robinson, watermark No. 19).

37.1 × 50.6 cm.

PROVENANCE: Lord Amherst of Hackney, sold Sotheby, 14 December 1921 (one of lots 99, 100, 103, 105, 108, 110, 112, comprising 90 drawings), bt. Sir Robert Witt; Witt Bequest 1952 (1256).

EXHIBITIONS: Brussels, 1937 (150); British Museum, 1983 (60).

This drawing, like cat. no. 64 includes no distinctive pointers to the nationality of the vessels portrayed. Of a similar subject to the previous sheet, the handling here is broader and more linear. The foreground galliots are rendered by open, suggestive strokes, many of which, particularly those describing the masts and rigging, are thickened and accented at their ends. Hatching, rapidly and summarily executed, is lightly applied to restricted areas. A comparable manner of draughtsmanship is visible in the portrait of the yacht *Kitchen*,[1] a drawing which also includes figures of sailors rendered by discontinuous, sharply curved and angled contours analogous to those describing the staffage of the present work.

The looped, cursive line employed here in the cannon smoke and background vessels (whose decorative forms are contrasted with the severe cross formations of foreground masts) recalls that used to note at first hand the battle of Schooneveld in a drawing of 1673.[2] It reappears in extreme form in a drawing in Massachusetts,[3] which is apparently an on-the-spot record of the King's departure in the *Harwich* for The Downs, and in sheets datable to 1675? in the National Maritime Museum.[4] A similar date in the mid-1670s may also be assigned to the work exhibited here, the vigorous and notational handling of which may indicate that it, too, was rapidly executed to seize the moment of a scene witnessed by the artist. The present composition is closely comparable to that of a signed canvas sold in Frankfurt in 1937.[5]

1 National Maritime Museum; Robinson, I, No. 507.
2 National Maritime Museum; Robinson, II, No. 1073.
3 Now Wellesley coll.; exh. Colnaghi, 1968 (25).
4 Robinson, II, Nos. 1112–14. Nos. 1124–28 are washed, although the character of the line is very close to that of the present drawing.
5 Halm, 26–27 October 1937 (lot 148); photo Witt.

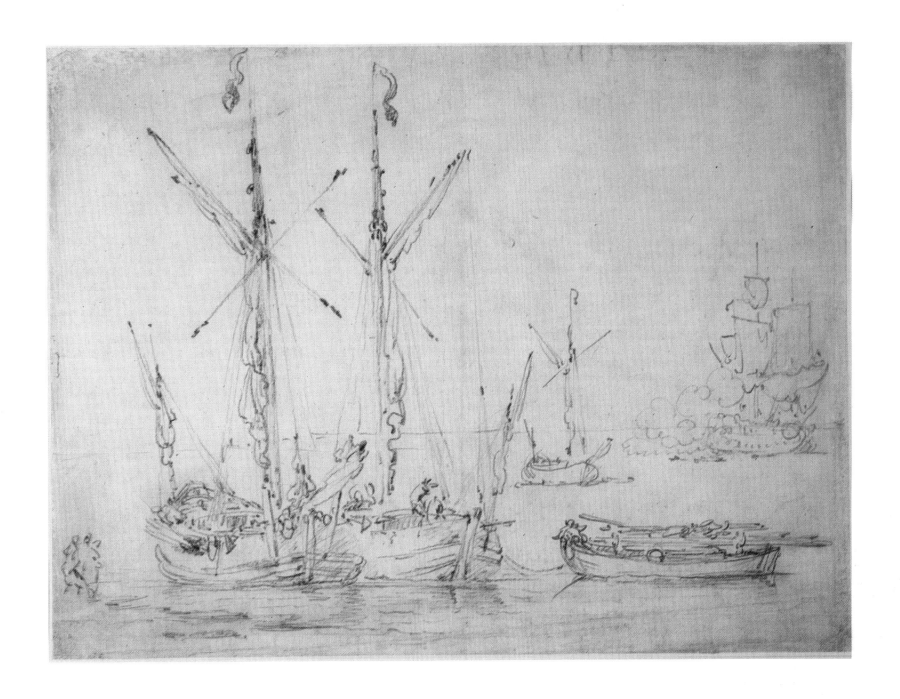

SIMON DE VLIEGER
(*c*.1600–1653)

66 Rijnsburg Abbey 1630s

Detailed preliminary drawing in graphite; black chalk, moistened for the darkest accents, and applied mainly in the architecture; grey (carbon) ink washes, with drawing with the point and flat of the brush; on very pale buff (stained) laid paper. The pictorial area faintly indicated by the artist's freehand line in black chalk, a ruled line in pen and brown ink a later addition (?) by the artist. The sheet unevenly trimmed at all sides.

27.2 × 26.7 cm.

Inscribed in pen and brown ink, *verso*: 'S. de Vlieger/6: Abdye van Rhynsburg', and numbered in different modern hands in pencil: '/c,mii', and: '3783', and: 'LG. TR/–/–'.

PROVENANCE: Sir Robert Witt (purchased from Colnaghi, no date); Witt Bequest 1952 (3355).

Rijnsburg is situated in northern Holland, approximately 2½ miles inland from Katwijk and 5 miles north-west of Leiden. The abbey was founded in 1122 by Petronella, widow of Duke Floris II, who donated both grounds and principal buildings, which were consecrated in 1133. A tower was added later as a gift from Sophia, wife of Prince Dirk IV. The abbey was initially created for Benedictine nuns of noble birth (the first of whom came from the order at Stötterlingenburg), although during the course of four centuries many of Holland's princes and noblemen were buried in its grounds.[1] Its importance in Holland's religious and cultural life was matched only by the royal abbey at Egmont.[2] The abbey building – apparently a beautiful and noteworthy structure[3] – was largely destroyed when Leiden was besieged by the Spanish forces of the repressive Duke of Alba in 1573–74, although the grounds continued as a place of religious significance until 1620, when the last abbess was buried there.[4] All that survives of the buildings today is the tufa base of the tower, although Simon van Leeuwen, writing in the *Batavia Illustrata* of 1685[5] records that at that date the ruined walls were still standing.

The drawing exhibited here, identified as a view of Rijnsburg by an eighteenth-century hand on the *verso*, shows part of the old cloister walls with an attached pigeon-loft at the right. A larger drawing by de Vlieger of the same motif, in black chalk and wash, is in Edinburgh:[6] the artist's viewpoint in that work is from the rear of the pigeon-loft, i.e. from a location situated beyond the right edge of the present composition. Identical in style to the present drawing, the Edinburgh sheet bears on its *verso* a similar attribution to de Vlieger.[7]

The firmness of handling and lucid conception of architecture, in which details of masonry, fenestration, etc., are unified with the building's planes through the application of broad areas of flat wash, is similar to that visible in a signed view of Delft, formerly in the Welcker collection.[8] This drawing is probably datable to *c*.1634–37/38, the period of the artist's stay in that city. A drawing dated 1639, sold in Amsterdam in 1975,[9] displays stylistic traits analogous to those in the Welcker drawing and in the Courtauld and Edinburgh studies of Rijnsburg. These latter works may also therefore share a date in the 1630s.

6 National Galleries of Scotland, Inv. No. D1132: particulars of the drawing kindly communicated by Duncan Bull.
7 Keith Andrews has suggested that the hand may be that of Goll van Frankenstein (communicated by Duncan Bull).
8 Bernt, II, No. 656.
9 Sotheby Mak van Waay, 9 June 1975 (lot 142). A copy of this drawing is in the Printroom, Leiden, No. PK2 192.

1 The history of the abbey and its nuns is recounted in van Leeuwen, pp. 1317–21.
2 Vermeulen, p. 160.
3 According to van Leeuwen, p. 1317, 'Dit Clooster was van seer schoone structure en seer vermaart....'
4 Schotel, p. 207.
5 Van Leeuwen, p. 1321.

SIMON DE VLIEGER
(c.1600–1653)

67 An Oak

Black chalk, moistened for the darkest accents, with white chalk heightening, applied both dry, and as bodycolour, with the brush; on blue (stained) laid paper. The sheet edged with ruled lines in pen and brown ink, and unevenly trimmed at all sides. A tear repaired, left.

37.7 × 26.4 cm.

Verso: slight sketch of the same tree, in black chalk.

Numbered and inscribed in different modern hands in pencil, *verso*: '28'; '*Lip*'; 'A 15837/TL/–/–', and: '30='; '*ex Liphart Coll*'; 'N⁰. 10', and: '*S. de Vlieger/1601–1653*', and numbered in pen and black ink: '912'.

Stamped with the collector's marks of K. E. von Liphart (Lugt 1687), and R. von Liphart (Lugt 1758), *verso*.

PROVENANCE: K. E. von Liphart; R. von Liphart; Sir Robert Witt (purchased from Colnaghi, no date); Witt Bequest 1952 (4018).

LITERATURE: Bolten, 1965, under no. 103.

The unsigned drawing exhibited here was purchased by Sir Robert Witt as a work by Simon de Vlieger. A replica of the composition, in which the tree leans slightly more to the right and the girth of the bole is marginally increased, is in Groningen.[1] Executed with the same materials as the Courtauld drawing, that work is also unsigned, but is attributed by Bolten to the Amsterdam painter Jan van Kessel III (1641/42–80) on the basis of comparison with a signed and dated drawing by the artist in Berlin.[2] That work, which includes at the right the motif of a gnarled oak with fractured upper trunk, is executed on white paper with the brush in carbon ink washes, which creates a softer image than that in either the Courtauld or Groningen sheets. While van Kessel's tree motif undeniably bears a resemblance to that shown here, comparison of conception and handling reveal clear differences.

Van Kessel, for example, indicates leaves with short diagonal dashes with the point of the brush, filling in small foliage clusters – irregular star-shaped forms – whose boundaries are initially outlined with black chalk. The completed clusters tend to remain silhouettes, since the artist employs for these forms wash of a narrow tonal range. The draughtsman of the Courtauld sheet and its cognate, by contrast, constructs large crowns of foliage from the accumulation of strokes denoting individual leaves – inflected zigzags for those of the rear planes, broader loops for those closer to the spectator: foliage masses are here conceived three-dimensionally, frequently as dense convex forms which are boldly highlighted.

The author of the present drawing plots the twists and tensions in the bark reflecting tortuous growth with a vocabulary of accented curves and dashes of varied density and length; whereas van Kessel's treatment of a similar form is less emphatic, with more evenly spaced hooked strokes failing to convey completely the power of the tree's upward thrust. The trunk in the Berlin sheet is a more static, less vigorous compositional element than that of the present drawing; and indeed, the cautious sense of design, allied to a quasi-decorative handling evident in van Kessel's treatment of the oak in Berlin is manifest in other tree studies by this artist, also in black ink on white paper, in collections in London[3] and Paris.[4]

Arguments for van Kessel's authorship of the work exhibited here which depend on comparison with the Berlin sheet thus provide insufficient justification for revising the traditional ascription away from de Vlieger. The attribution of the drawing in favour of this artist, however, is supported by comparison with works signed by the master in Berlin[5] and London,[6] which betray characteristics of style and handling analogous to those noted above. Unsigned drawings attributed to de Vlieger also related by style to the work exhibited here are in, among other places, Haarlem,[7] New York[8] and Sacramento,[9] while one of two tree studies on light brown paper in Ottawa[10] is closely comparable in its conception and handling.

This drawing was almost certainly executed from nature, since it bears on the *verso* a small, abbreviated study of the same oak, probably jotted down to enable the artist to grasp the thrust and relationship of the principal limbs. Such a rapid preliminary (?) sketch may indicate that of the two drawings, the Courtauld work precedes the Groningen replica.

1 Museum voor Stad en Lande; Bolten, 1965, No. 103.
2 Staatliche Museen; Bock/Rosenberg, p. 169, No. 2854, dated 1666.
3 British Museum; Hind, III, p. 126, No. 1.
4 Ecole Nationale Supérieure des Beaux-Arts; Lugt, 1950, No. 305, signed and dated 1666.
5 Staatliche Museen; Bock/Rosenberg, p. 310, No. 5751.
6 British Museum, Hind, IV, p. 98, No. 1.
7 Teylers Museum; Bernt, II, No. 655.
8 Pierpont Morgan Library; exh. Paris/Antwerp/London/New York, 1979–80 (65).
9 E. B. Crocker Art Gallery; exh. Sacramento, 1971 (56).
10 National Gallery of Canada; Popham/Fenwick, No. 152. No. 151 is less close to the motif of the Courtauld drawing, but also displays similarities of style.

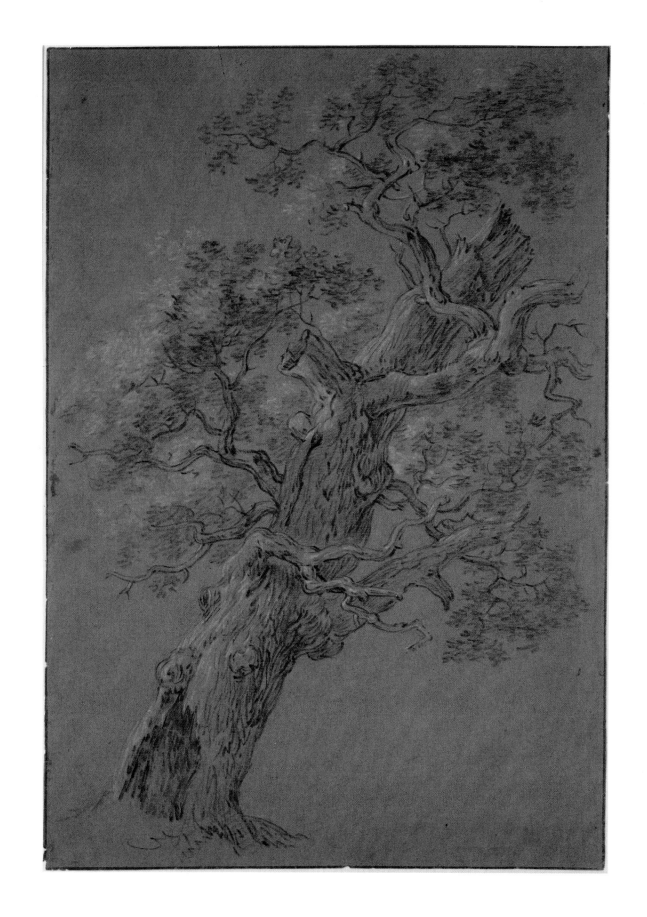

ANTHONIE WATERLOO
(*c*.1610–1690)

68 Landscape with Waterfall after 1659/1660s(?)

Grey (carbon) ink washes with drawing with both pen and the point and flat of the brush, and some of the dry brush; on off-white laid paper. The drawing edged with a ruled framing line in pen and dark brown ink, and unevenly trimmed at all sides. Tears repaired, top.

29.7 × 27.5 cm.

Inscribed in a modern hand in pencil, *verso*: 'fr, ho', and: 'A.Waterloo'.

Stamped with the collector's mark of J. P. Mariette (Lugt 1852), *recto*.

PROVENANCE: J. P. Mariette; ...; Sir Robert Witt (purchased from Holgen, no date); Witt Bequest 1952 (2129).

A dealer as well as an artist, Waterloo was probably self-taught. His work is composed mainly of drawings and etchings, although a few paintings by him are known. Widely travelled, he visited Germany,[1] Poland,[2] France[3] and Flanders,[4] and perhaps also Italy.[5] Since the drawings are seldom dated, there is no secure basis upon which the *œuvre* may be chronologically arranged.

The present composition depicts a mountain torrent, overhung by a dramatic cliff on which is perched a watermill. Watermills appear in other works by this artist: drawings in Berlin[6] and Paris,[7] for example, record the narrow black and white buildings near Lüneburg and Hamburg, while paintings in London[8] and Blandford Forum (Dorset),[9] and sheets in Paris[10] and the Maida and George Abrams[11] collection include a smaller cottage type of mill, often roofed with thatch. This latter type of structure is reminiscent of the watermills which appear in the paintings of Jacob van Ruisdael (1626–82) shortly after a journey of *c*.1650 to Bentheim on the Dutch–German border; and indeed, while Waterloo may also have seen similar motifs on his travels, those compositions which include cottage-watermills nevertheless appear to be closely dependent on van Ruisdael's paintings, examples of which date from 1653 to the 1660s.[12]

While it cannot be discounted that Waterloo may also have witnessed scenes similar to that depicted here (perhaps in Eastern Europe?), the unusual log construction of the mill, the powerful waterfall cascading over mighty boulders, its dense forest planted with spruces, and suggestions of logging industry are motifs associated with Scandinavia.

In 1659, van Ruisdael painted his first 'Scandinavian' landscape,[13] the motifs of which, particularly the centrally located waterfall, are derived from the work of Allaert van Everdingen (see No. 37). This and related oils of the 1660s are of vertical format.[14] It has been noted that Waterloo was probably influenced by van Ruisdael's mill subjects of the mid-1650s–early 1660s, and the subject and format of the drawing exhibited here may be interpreted as a response to that artist's van Everdingen-inspired compositions of the same period: the drawing may therefore be dated to 1659 at the earliest. Watermills or any other log structure, however, are absent from van Ruisdael's 'Scandinavian' compositions, and it would seem that in creating the present landscape, Waterloo also referred back to the source of van Ruisdael's inspiration in the work of van Everdingen, and beyond, to drawings by that artist's master, Savery, which Waterloo had copied in the 1640s.[15]

1 A view of Augsburg is in the Albertina, Vienna; Bernt, II, No. 674.
2 Views of Oliwa, near Gdánsk, are in the Kunsthalle, Hamburg, Inv. No. 17752, and in Staatliche Graphische Sammlung, Munich (Wegner/München, No. 1058).
3 A view of Lyons is in a private collection, Amsterdam; exh. Rotterdam/Paris/Brussels, 1977 (154).

4 See No. 70.
5 Mongan/Sachs, under Nos. 542, 543.
6 Staatliche Museen; Bock/Rosenberg, p. 316, Nos. 4018, 14443, Lugt/J.P.K., p. 77 and pls. 27, 35.
7 Ecole Nationale Supérieure des Beaux-Arts; Lugt, 1950, No. 742.
8 Apsley House, Inv. No. R.84; photo Witt.
9 F. Escombe coll.; photo Witt.
10 Louvre; Lugt, 1929/33, No. 886.
11 Exh. International Exhibitions Foundation, 1977 (49).
12 e.g. private coll.; Slive/Hoetinck, No. 23. Rijksmuseum, Amsterdam; Slive/Hoetinck, No. 46.
13 Formerly Hermitage, Leningrad, present location unknown; Rosenberg, p. 49 and pl. 93.
14 e.g. in Fogg Art Museum, Cambridge, Mass. (Slive/Hoetinck, under pl. 34); Herzog Anton Ulrich-Museum, Brunswick (Slive/Hoetinck, pls. 44, 45); Rijksmuseum, Amsterdam (Slive/Hoetinck, pl. 46); coll. H. Girardet, Kettwig (Ruhr) (Slive/Hoetinck, pl. 47).
15 A drawing by Waterloo in the Fitzwilliam Museum, Cambridge (exh. International Exhibitions Foundation, 1976–77 (90)) is a copy after the drawing Atlas van der Hem XLVI, folio 2, in the Nationalbibliothek, Vienna (Spicer Durham, C. 23). Spicer Durham, p. 71, suggests that Waterloo may have owned the Atlas van der Hem in *c*.1640.

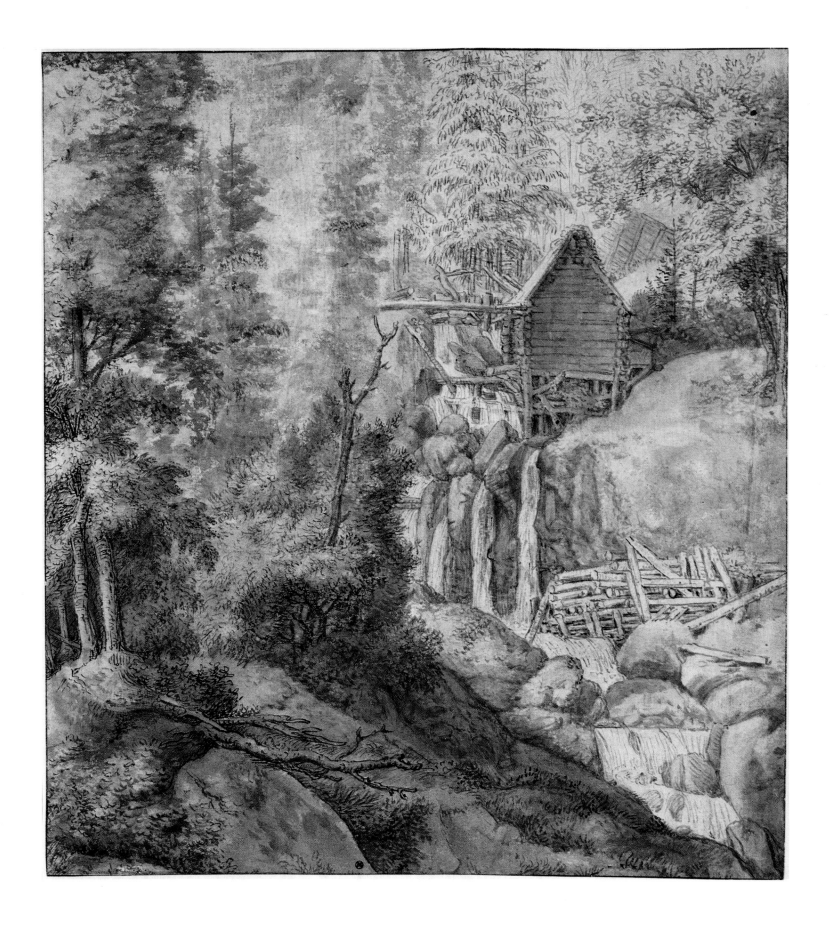

ANTHONIE WATERLOO
(*c*.1610–1690)

69 Landscape with a Willow Tree

Black chalk, and slight use of red chalk with some rubbing (principally for the distance and at the lower left of the composition); grey (carbon) ink washes, with extensive drawing with the point of the brush; off-white, pale yellow and pale blue bodycolour of varying dilutions; on pale buff laid paper. The sheet unevenly trimmed at all sides, extensively 'skinned', *verso*, and backed with Japanese tissue. Traces of gold paint, upper right edge, from a previous mount.

35.5 × 29.3 cm.

PROVENANCE: Earl of Aylesford; Sir Robert Witt (purchased from Colnaghi, no date); Witt Bequest 1952 (4021).

Woodland scenes executed in a manner close to that employed by Simon de Vlieger for similar subjects account for a large proportion of Waterloo's *œuvre*. Within this group of works are tree studies of vertical format, among which may be identified a corpus of drawings exploring a similar compositional type, which are nevertheless surprisingly varied. An example of this particular pictorial construction is provided by the drawing exhibited here.

Typical of these compositions is the close-up view of a limited number of trees of varied species and contrasting trunk formations, whose foliage is often cropped by the top of the sheet. These form a dominant group at one side of the drawing, counterbalanced at the other by lesser trees, root stumps or an area of elevated ground which closes the composition. The trees' upward curves are contrasted in the lower area of the sheet by a horizontal element (which may take the form of either branches or undergrowth, as in the present drawing, or logs,[1] fences[2] or bridges[3]) which stabilises and unites the two halves of the design. Frequently, a distant vista is lightly indicated, framed by the gap in the foliage. Variants of this compositional model are applied equally to summer[4] and winter[5] scenes, and to studies of trees in urban[6] as well as rural[7] settings.

Comparable to the present design is a study (with Baskett & Day of London in 1981[8]) which employs similar motifs of a sturdy willow whose contorted trunk is juxtaposed with straight, slender saplings, and a distant view of open countryside with faintly outlined background mountains rising to the left. Similar motifs also occur in sheets in Bremen[9] and Düsseldorf,[10] in which the composition is in reverse to that stated here. The Courtauld study differs from these works in its breadth of execution and generous and painterly application of wash and bodycolour. This latter medium is used in the sky and landscape here principally to efface the washed-in tree trunk (now emerging) at the left of the design, thereby avoiding a closed and top-heavy composition. In those works in which boughs do interlock in an arch at the top of the sheet, the trees tend to be bare, in order to preserve the balance between the upper and lower halves of the design: branches meshed in this manner are thus most frequently encountered in winter scenes.[11]

The type of black chalk visible here is commonly found in Waterloo's tree studies. Employed in conjunction with wash, its softness is exploited to depict forms with slightly blurred edges, suggesting the effects of a hazy, shifting light cast by a low sun and filtered through foliage. In adopting this combination of media, Waterloo was able to suggest the quiet mystery of copses or the periphery of woodland.

1 Louvre, Paris; Lugt, 1929–33, No. 888.
2 Institut Néerlandais, Fondation Custodia (Lugt coll.), Paris; exh. Brussels/Rotterdam/ Paris/Berne, 1968–69 (179).
3 Formerly Sir Bruce and Lady Ingram coll., now Fitzwilliam Museum, Cambridge; exh. Rotterdam/Amsterdam, 1961 (116).
4 Sold from the A. J. Potter coll., Sotheby, 10 December 1968 (lot 64); photo Witt.
5 Institut Néerlandais, Fondation Custodia (Lugt coll.), Paris; exh. Brussels/Rotterdam/ Paris/Berne, 1968–69 (178).
6 A sheet formerly in the H. Reitlinger coll.; photo Witt.
7 Lehman coll., New York; exh. New York, 1972 (51, 52a).
8 Photo Witt.
9 Kunsthalle; exh. R.A., 1929 (702).
10 Kunstakademie; Budde, No. 888.
11 Institut Néerlandais, Fondation Custodia (Lugt coll.), Paris, Inv. No. 3463.

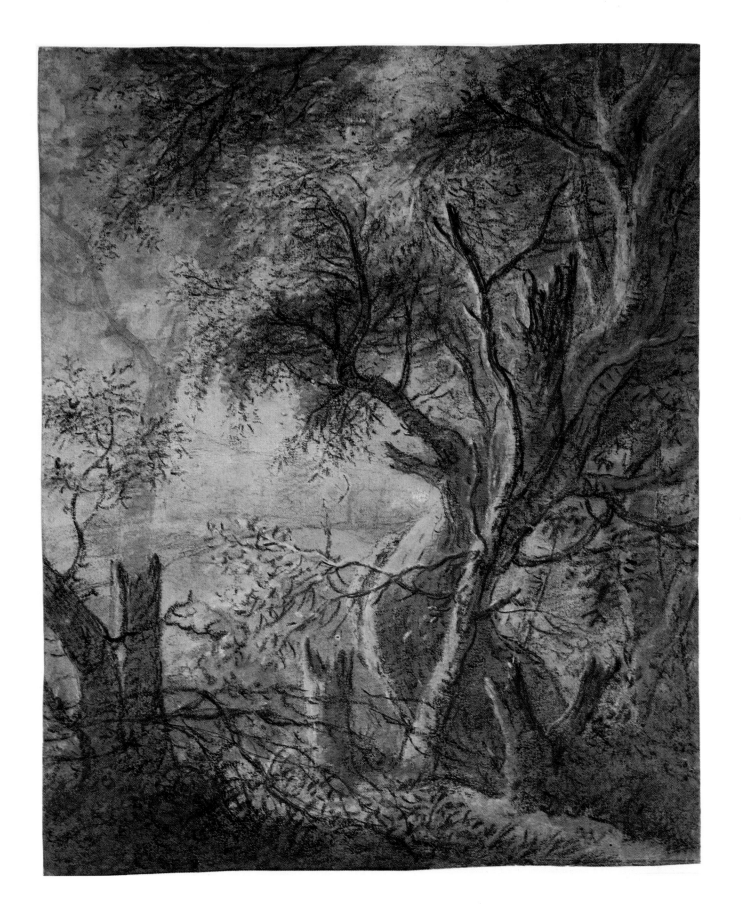

ANTHONIE WATERLOO
(*c*.1610–1690)

70　Rocky Landscape with Artist

Extensive preliminary drawing in black chalk; grey (carbon) ink washes, with some drawing with the pen, and extensive drawing with the point and flat of the brush, and some use of the dry brush; pen and brown ink for the figure; on buff laid paper. The sheet folded vertically, centre, and unevenly trimmed, top. A pinhole at the bottom left and right corners. The sheet laid down.

39.3 × 51.1 cm.

Inscribed by the artist in pen and brown ink on paper pasted to the drawing, top left: 'buijten Brussel', and inscribed in different hands (?) in pen and brown ink over red chalk: 'D,S,'.

PROVENANCE: Sir Robert Witt (purchased from Colnaghi, no date); Witt Bequest 1952 (3275).

This scene, as the inscription indicates, is a record of the environs of Brussels. Drawings in Paris[1] and the British Museum[2] of a comparably large format and similarly inscribed depict the woodland scenery of the same region.

The motif of vast outcrops of rock appears infrequently in Waterloo's *œuvre*, although similar forms occur in another drawing by this artist in the Witt collection;[3] that work, however, represents an imaginary scene in the tradition of de Momper and van Everdingen.

The ambitious size and degree of realisation of the drawing exhibited here might indicate that it was worked up in the studio from sketches made from nature. The draughtsman which Waterloo includes in the composition, however, works directly from the motif on paper of a scale comparable to that of the present sheet which is apparently attached to a large drawing board. Pinholes at the lower corners of the Courtauld sheet (those at the top have probably been trimmed away: see below) suggest that Waterloo may have adopted a similar practice to create this work in front of nature.

The diminutive scale of the draughtsman here does not accord with that of the background foliage, although the figure's smallness, reduced further by the seated pose, does enhance the grandeur of the surrounding landscape and particularly of the triangular formation of foreground boulders. The figure is almost certainly a later addition, since it is described with brown ink contours not found in any other area of the drawing, while the carbon black wash with which the form and shadow is modelled is of a particular granular consistency, unlike that employed in the rest of the sheet. Waterloo's rendering of figures, as Bartsch observed,[4] is frequently unconvincing or even crude, and the artist appears to have avoided introducing them into compositions wherever possible. In depicting the figure here, Waterloo employs rounded contours which simplify the form: a similar convention is followed in the drawing of equally small-scale seated staffage in a tree study in Vienna.[5]

The inscription pasted to the upper right of this work is on the same paper as the drawing, and was probably trimmed from the top of the sheet. The letters 'D,S,', originally added by a later hand in red chalk, have subsequently been traced over in brown ink. Their meaning is unclear, but they may be an erroneous attribution, or more probably, the initials of an early collector.

1　Louvre; Lugt, 1929–33, No. 880, on buff paper.
2　Hind, IV, p. 104, Nos. 13, 14.
3　Hand-list, p. 118, No. 889.
4　Vol. II, p. 51.
5　Albertina; Bernt, II, No. 675.

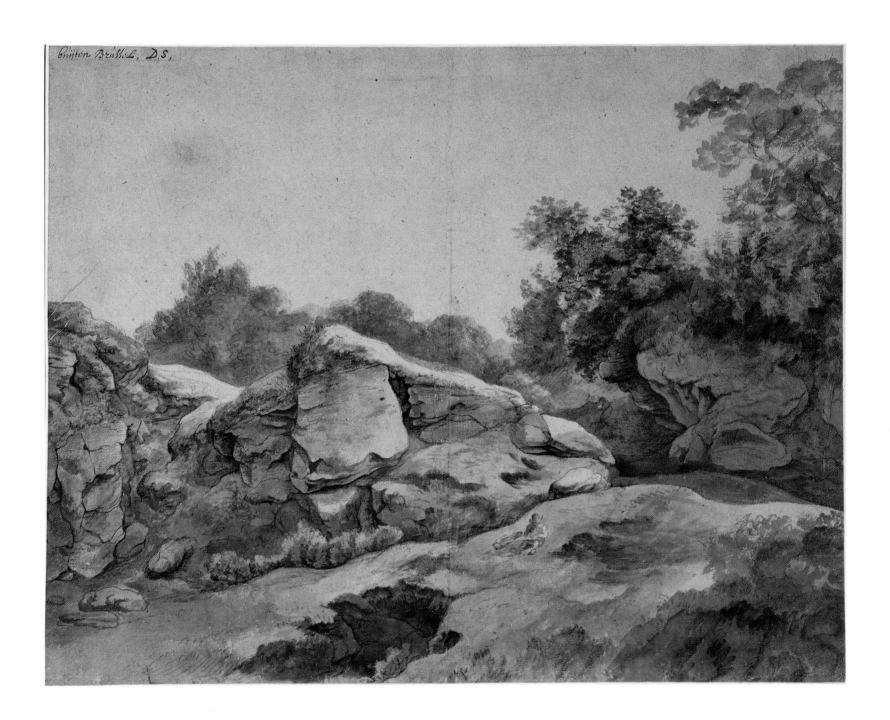

GASPAR VAN WITTEL
(1652/3–1736)

71 View of Tivoli 1700–10

Slight preliminary drawing in graphite; pen and brown ink; brown ink washes with drawing with the brush, and some use of the dry brush; blue-grey bodycolour (mixing in many areas with the ink washes) with drawing with the brush; on cream (stained) laid paper, squared-up in graphite and red chalk. The sheet folded into four, and lightly trimmed, left and right. Tears repaired, top and centre.

Watermark: fleur-de-lis, encircled twice.

37.3 × 35.8 cm.

Inscribed by a later hand in graphite, lower left edge: 'Paropus f 69'.

PROVENANCE: Cavaceppi; Pacetti; Paul Fatio; with Jeudwine and ffrench, London, from whom purchased by the Courtauld Institute of Art (Witt Fund) 1961 (4705).

EXHIBITIONS: Jeudwine and ffrench, 1961 (30); Courtauld, 1965–66 (33).

This squared-up drawing is a study for the left section of an oil composition in Viterbo, *The View of Tivoli and the Temple of Vesta*,[1] probably the first painting of this scene by van Wittel: a replica of that composition, also by van Wittel, was formerly in Munich.[2] Both Tivoli subjects are dated by Briganti to 1700–1710, and the sheet exhibited here may be assigned to the same period. A squared up preliminary sketch for the central area of the paintings, recording the town of Tivoli, is in the Rust collection, Washington.[3] No drawing corresponding to the extreme right of the painted composition, which includes the Temple of Vesta, has yet been discovered.

In the drawings and related paintings, Tivoli is viewed from the edge of the Temple of Vesta, looking south-east across the town and the Aniene river. The scene today has totally changed due to alterations in the course of the river and waterfall after the disastrous flood of 1826.[4] The present sheet depicts the outskirts of the town, right, the Plain of the Porta Sant'Angelo, and the beginnings of the Via Valeria which advances along the foothills of Monte Catillo on the left.

The slightly elevated vantage point from which this and other cityscapes by van Wittel are observed, and the frequent location of the motif of the town in the middle distance betrays the influence of the Flemish topographical artist Lievin Cruyl (c.1640–c.1720). In contrast to that draughtsman's somewhat airless studies (for example, those of Rome and its environs, after which a series of 50 engravings was published in 1665 and 1667),[5] van Wittel's drawings render the intensity of southern light and warm atmosphere, the effects of which tend to 'dissolve' forms, as is shown in the example exhibited here.

Briganti conjectures[6] that this type of preliminary study was made either entirely in the studio from small sketches (none of which have been discovered), or was initially drawn in chalk or graphite in front of the motif, to be worked up later in the studio. The slight graphite drawing underlying the present work conveys only the most general information regarding the principal divisions of the landscape, and was probably therefore executed from nature: had it synthesised existing sketches, it would almost certainly have been more detailed. The radical nature of revisions and additions to the graphite drawing carried out here with pen and ink suggests that this stage of the work also could only have been completed by observation direct from the motif.[7]

The majority of van Wittel's studies for cityscapes are of horizontal format: some, over 1 metre in length, are made up of three or more sheets conjoined.[8]

That van Wittel pasted together the sheets before beginning to draw is the assumption underlying Briganti's account of the artist's working methods.[9] The Courtauld and Washington sheets, then, offer an important example of sketches forming a larger preparatory design but which are separate. There are, moreover, no indications (i.e. residual glue, traces of additional layers of adhering paper, or a peeling away of the paper's surface) at the right edge, either *recto* or *verso*, of the present drawing to suggest that it was ever glued to its pendant;[10] nor is there evidence of rigorous trimming to eliminate such blemishes caused by separating the two sheets. More importantly, there is no trace at the upper right of this drawing of the wash which extends over the background mountains of the Rust sheet to its left (i.e. 'joining') edge, while the motif of the house included here at the extreme right reappears at the left of the pendant. Had the Courtauld and Rust drawings initially been pasted together, washes applied to one sheet would certainly have been brushed over to the sheet adjacent: and the duplication of a motif – a means to ensure both continuity of scale and mis-en-page of the scene between separate sheets – would not have been necessary. That van Wittel individually completed each component sheet of a larger preliminary sketch is not only borne out by the example of the Tivoli drawings, but may also be deduced from conjoined sheets in New York[11] and those making up five large designs in Naples,[12] in which there is a common discontinuity of contours and washes; and indeed, the town of Urbino in the New York study also includes the church of San Francesco duplicated on adjacent sheets. That each sheet of a larger design was also individually squared-up for transfer to the painting surface is confirmed by similar breaks and misalignments of ruled grids between papers now pasted together; examples of this are also found in the drawings cited above. The number and inconsistencies of the squarings-up on the drawing exhibited here indicate the flexibility of van Wittel's process for transferring the design to canvas or panel.[13]

While it now appears probable that in certain instances the artist did not, at any time during the working process, paste the component parts of the preliminary study together, it is not known who did. It may have been his architect son, Luigi (1700–1773), or an early collector who prized the drawings for their own sake, rather than as mere designs for the larger oil compositions.

1 Private coll.; Briganti, No. 154. Briganti's monograph includes full biographical details of van Wittel.
2 Formerly with Böhler, present location unknown; Briganti, No. 146.
3 Briganti, No. 21d. The Courtauld drawing is unrecorded by Briganti.
4 Mosti gives an account of Tivoli's history, and the changes to its topography after flooding.
5 Hollstein, vol. V, p. 99, Nos. 27–76.
6 exh. cat., Ottawa, 1977, p. 15.
7 Only the architecture at the centre of the sheet retains its original position during the pen drawing stage.
8 e.g. drawings in the Museo di San Martino, Naples; Briganti, Nos. 102d, 103d, 104d, the longest of which measures 112 cm., the shortest 110 cm.
9 exh. cat., Ottawa, 1977, *loc. cit.*
10 Glue on the *verso* does indicate, however, that the sheet was 'tipped' to a mount.
11 Pierpont Morgan Library; exh. Paris/Antwerp/London/New York, 1979–80 (129).
12 e.g. in the Museo di San Martino, Naples; Briganti, Nos. 101d, 103d, 118d, 126d, 134d.
13 The initial graphite squaring-up covers the lower centre of the sheet only; distances between verticals vary between 5 and 5.2 cm., and between horizontals between 4.8 and 5.4 cm. Spaces between the chalk lines are more consistent, generally 5.4 cm., but with slight variations.

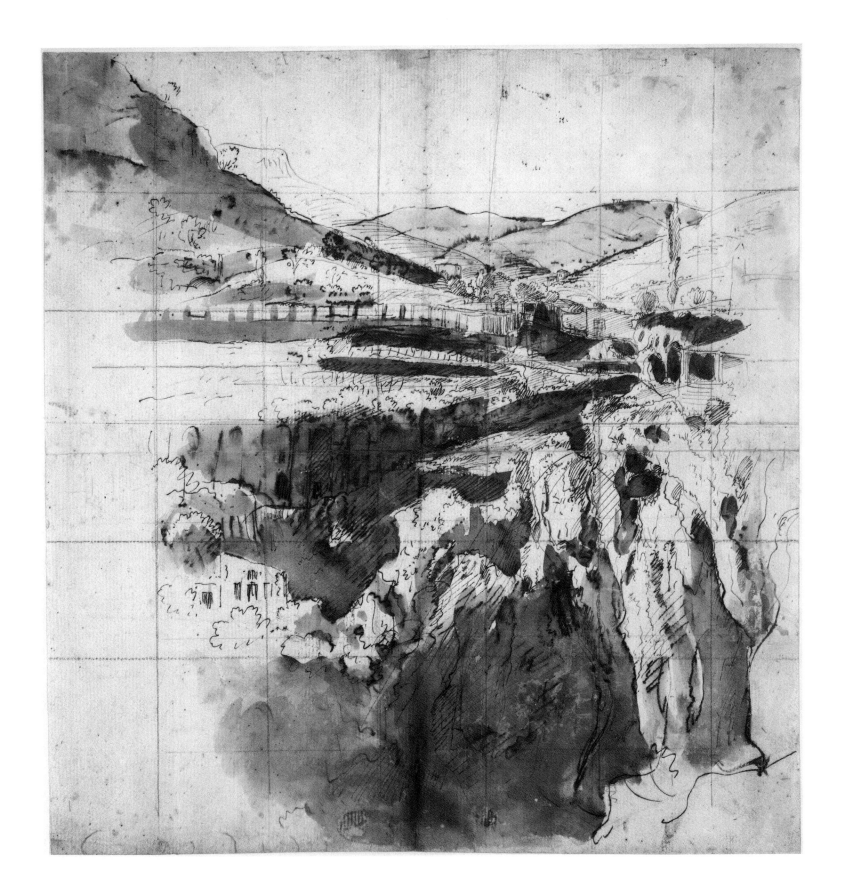

GASPAR VAN WITTEL
(1652/53–1736)

72 Imaginary Landscape *c.*1716

Pen (restricted to the background), reed pen, and point of the brush (in the foreground) in grey (carbon) ink washes; restricted watercolour washes, with some drawing with the brush; on off-white (stained) laid paper. The sheet unevenly trimmed at all sides, apparently to the artist's ruled line in pen and carbon ink.

25.9 × 37.6 cm.

Verso: slight sketch of mountainous wooded landscape with houses, in graphite.

Signed in pen and brown ink, lower centre: 'Gasparo/van Witel'.

Inscribed and numbered in a later hand in graphite, *verso:* 'Van vittell/,5000'.

PROVENANCE: Sir Robert Witt (purchased from Colnaghi, no date); Witt Bequest 1952 (3604).

This is one of a number of imaginary landscapes (*veduta ideata*) which occur in van Wittel's *œuvre* after his stay in Naples from *c.*1699 to 1702. The earliest dated imaginary views, two paintings in tempera on parchment, were created in 1713,[1] while the earliest dated drawing of this type was executed in 1716.[2] The present example, unknown to Briganti, may also be assigned to the second decade of the eighteenth century.

Briganti plausibly suggests[3] that this type of drawing, executed when van Wittel was at the height of his success, was conceived as a work of art in its own right and created specifically for sale to patrons whose requests for larger landscapes in oil the artist was unable to satisfy. A slow and meticulous painter of townscapes, van Wittel was unwilling to speed up production of those works to comply with public demand.[4] While the penwork in the present sheet is consistent with the lively and fluid draughtsmanship displayed in the near-monochrome preparatory sketches for the cityscapes (see cat. no. 71) the colour of the washes – cool greys and blues contrasting with buffs, acid-greens and yellows – reflects the palette van Wittel habitually employed in the finished oil compositions.[5]

The general lie of the land depicted in the present work may have been inspired by the Amalfi coastal area, or even by the landscapes to the north of Rome, and is reminiscent of that in a sheet in Munich.[6] Van Wittel would probably have been familiar with the motif of a naturally arched outcrop of rock through which a road passes, visible here on the right, from drawings by earlier Netherlandish draughtsmen (see, for example, cat. no. 60) and perhaps saw comparable geological formations when travelling through Switzerland to Italy in *c.*1673. In this instance, however, the motif may have been directly inspired by the rock archway on the volcanic peninsular of Nisida in the Gulf of Pozzuoli, approximately 6½ miles south-west of Naples. This motif, first recorded at the centre of van Wittel's topographical sketch of this site,[7] was subsequently repeated in several imaginary landscapes in both oil[8] and watercolour.[9]

The steep-sided mountain, visible here at the left, occurs rarely in van Wittel's work, but may have been inspired by the type of towering promontory recorded in a drawing now in Rome,[10] or that in a sheet exhibited in London in 1961.[11]

While certain motifs in the *vedute ideate* probably originated in the topography of the Naples area, the manner in which they are recorded and organised into imaginary compositions is indebted to the art of Abraham Genoels (1640–1723). A native of Antwerp, Genoels was the author of many decorative landscape drawings and prints:[12] he had taught van Wittel in Rome, and it is thought to be he who introduced the young Dutch artist to the technique of drawing in watercolour.[13]

1 Mrs N. Nuti Pucci coll., Florence; Briganti, Nos. 215, 216.
2 Earl of Leicester coll., Holkham Hall; Briganti, No. 50d.
3 Exh. cat. Ottawa, 1977, pp. 16–17.
4 cf. the letter from van Wittel to a patron, quoted in exh. cat. Ottawa, 1977, p. 16.
5 e.g. *View of the Villa Medici, Rome*, Galleria Nazionale, Rome; *The Campovaccino from the Aracoeli*, Colonna coll., Rome; Briganti, Nos. 9, 25, respectively.
6 Staatliche Graphische Sammlung, Munich; Briganti, No. 94d.
7 Gabinetto Nazionale delle Stampe, Rome; Briganti, No. 229d.
8 e.g. those in the coll. Conte Aldrighetto di Castelbarco Albani, Milan; Briganti, Nos. 219, 220.
9 e.g. those at Holkham Hall (Briganti, No. 48d); Munich (Briganti, Nos. 66d, 75d, 81d); Naples (Briganti, No. 228d); Rome (Briganti, No. 243d).
10 Gabinetto Nazionale delle Stampe; Briganti, No. 247d.
11 Exh. Agnew, 1961 (12); Briganti, No. 16d.
12 cf. the drawing in the Courtauld Institute Galleries, Witt No. 1078, and the engravings catalogued by Hollstein, Vol. VII, pp. 98, 99, e.g. Nos. 13, 14, 16, 21, 39–42, 45–50, 56–59, 60–65.
13 Bodart, Vol. I, p. 337.

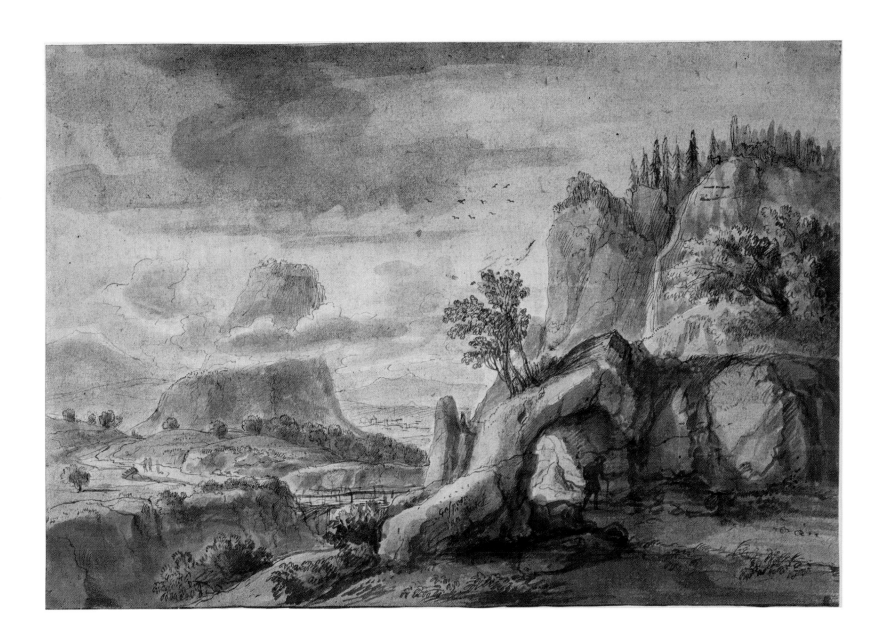

JOHN CONSTABLE
(1776–1837)

73 ## Willy Lott's Cottage viewed from the East
1812–13

Pencil; on white (now unevenly discoloured and stained) wove paper. The drawing made up of three sheets, the central sheet unevenly trimmed to a ruled line in pencil, right, and roughly torn at the left. The right side of the drawing unevenly trimmed.
The sheet on left bears watermark: 'STROUD & CO'; the central sheet has watermark: 'RUSH MILL/1807'.

19.9 × 28.3 cm.

PROVENANCE: Leggatt Bros., bt. Sir Robert Witt; Witt Bequest 1952 (1505).

EXHIBITIONS: Constable Bicentenary, Tate Gallery, 1976 (115); British Museum, 1983 (113).

The sheet has been dated by Leslie Parris and Ian Fleming-Williams to 1812 for the central sheet, and 1813 for the additions at either side.[1] The drawing is the first to show Willy Lott's house at the centre of a composition, and is closely related to the painting of 1835, *The Valley Farm* (Tate Gallery 327). The first known Constable painting of Willy Lott's Cottage dates from *c.*1802,[2] and the building was to feature frequently in his work up to 1835. Willy Lott was a farmer, who inhabited this house at Flatford on the River Stour, throughout the artist's lifetime.

1 Constable Bicentenary, Tate Gallery 1976 (115).
2 *ibid.*, 1976 (35).

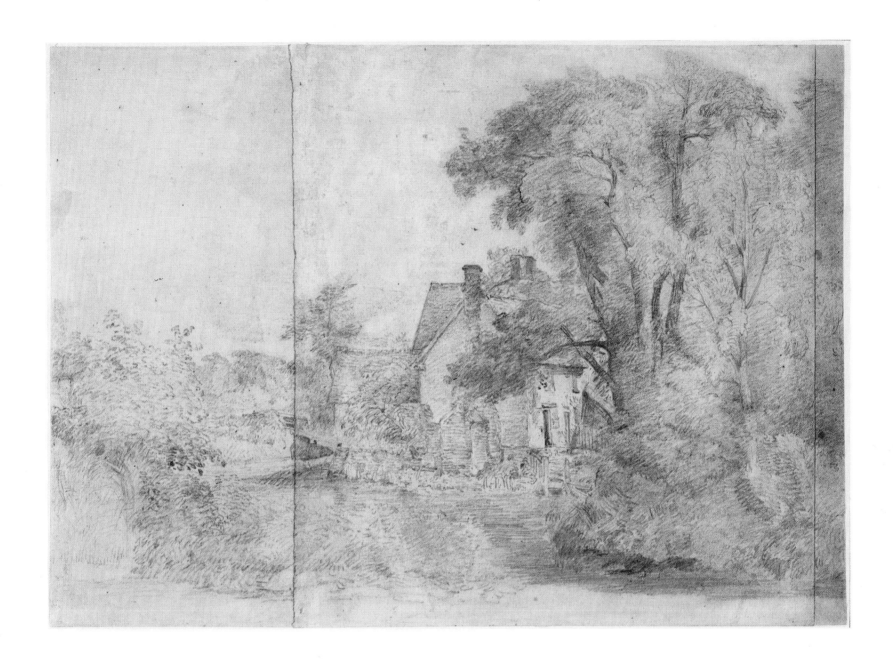

JOHN CONSTABLE
(1776–1837)

74 East Bergholt Church *c*.1817

Hard and soft pencil; with use of the ruler; on off-white (now unevenly discoloured) wove paper. The sheet unevenly trimmed at all sides, apparently to a ruled line in pencil.

31.7 × 23.8 cm.

PROVENANCE: Charles Golding Constable; Mrs A. M. Constable; C. G. Constable sale, Christie, 11 July 1887 (lot 23); Agnew; Sir Cuthbert Quilter; P. M. Turner; Gilbert Davis; Mr & Mrs W. W. Spooner; Spooner Bequest 1967 (S.16).

EXHIBITIONS: South Kensington, 1880–83 (109); D. C. T. Baskett exhibition, Colnaghi, July 1963 (56), lent Mr & Mrs W. W. Spooner; Courtauld, 1968 (71); Harrogate, 1968 (51); Bath, 1969 (15); Bristol, 1973 (9); Constable Bicentenary, Tate Gallery, 1976 (155); *Constable's Country*, Sudbury, 1976 (18); British Museum, 1983 (114).

LITERATURE: MS. list of Captain Charles G. Constable's collection compiled by W. W. May for the action Constable Constable v. Blundell (Public Record Office, 1880, C.1621); Harold Day, *John Constable Drawings* (1975), p. 117 (plate 120, as *c*.1840); Leslie Parris, Ian Fleming-Williams and Conal Shields, *Constable Paintings, Watercolours & Drawings*, Tate Gallery, 1976 (155); Graham Reynolds, *The Later Paintings and Drawings of John Constable*, New Haven and London (1984), p. 12, No. 17.32.

Constable was born in East Bergholt, Suffolk, the son of a prosperous mill-owner. The Rector of East Bergholt church, the Reverend Durand Rhudde, D.D., maternal grandfather of Maria Bicknell (1788–1827), who was to become Constable's wife in 1816, had steadily opposed the marriage since 1810.

Reynolds (*op. cit.*) sees this sheet as contemporary with two other drawings of East Bergholt church, all of 1817: one in the Henry E. Huntington Library, San Marino, *Elm Trees in old Park, East Bergholt* (Reynolds 17.31); and *East Bergholt Church: the ruined tower from the south* (Victoria & Albert Museum, Reynolds 17.33), which shows a different view of the tower and porch. All three drawings would have been done during Constable's long stay at East Bergholt that year, when he would have recorded as many details of his homeland as possible. Now married and with family commitments, his opportunities to visit Suffolk would become fewer.

Reynolds also observes that the time of day shown on the clocktower, ten past five, and the angle of the sun slightly from the north-west, suggest late summer or early autumn.

Parris and Fleming-Williams (*op. cit.*) suggest it may have been shown at the Royal Academy in 1818 (446), under the title, *A Gothic Porch*, and as such, would have been a pendant to the equally impressive pencil drawing of *Elm Trees in old Park, East Bergholt* (Reynolds 17.31) also exhibited that year, and referred to above. In fact, Reynolds considers the San Marino sheet to be the one shown at the R.A. in 1818, not the Spooner sheet.

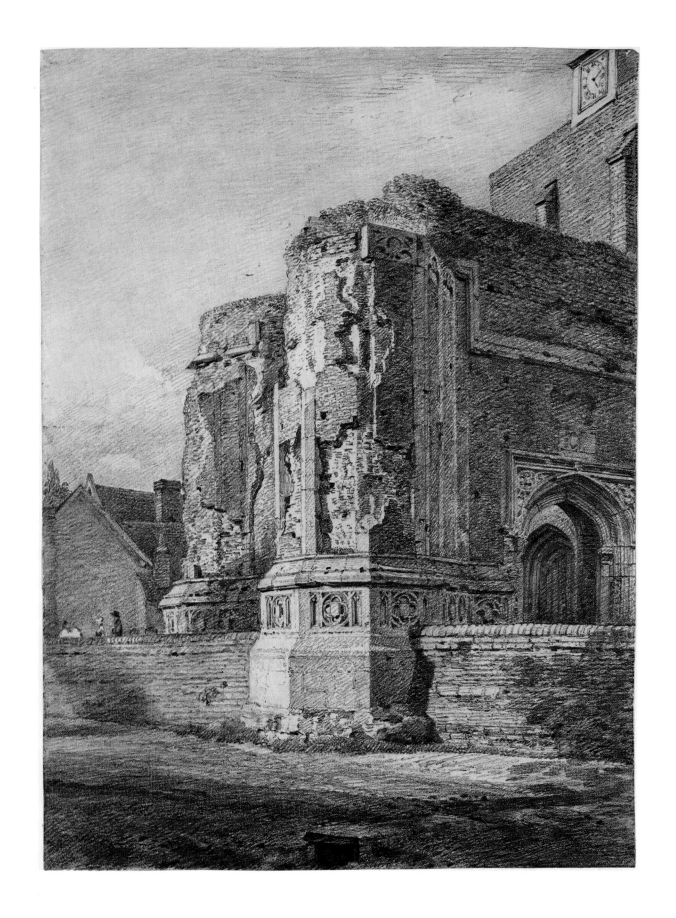

JOHN CONSTABLE
(1776–1837)

75 Seven Cloud Studies after Alexander Cozens
(Nos. 14 to 20) *c.*1822–23

Pencil; on white (now discoloured) wove paper, with inscriptions in brown ink. The twenty studies have been drawn on what were originally three sheets (two of them 37.3 × 23 cm., one 23 × 18.65 cm.), the larger two were each single-folded sheets, stamped and used as ordinary writing paper, the smaller a half-sheet of the same. The two stamping dies 'BATH' used here are of different design.

The sheets were then again folded and neatly torn into two sets of eight and one of four sheets, each approximately 9.3 × 11.5 cm.

Each study has been numbered and inscribed by the artist, as described below.

PROVENANCE: Viscount Lee of Fareham; presented by Lord Lee to the Courtauld Institute, December 1932 (29.32 to 48.32).

EXHIBITIONS: *Constable. The Art of Nature*, Tate Gallery, June–July 1971 (60) Nos. 13 to 16 of the series; *'The Cloud Watchers' – Art & Meteorology 1770–1830*, Herbert Art Gallery & Museum, Coventry, 1975 (35); Constable Bicentenary, Tate Gallery, 1976 (210); *Turner und die Landschaft seiner Zeit*, Kunsthalle, Hamburg, 1976 (146).

LITERATURE: Louis Hawes, 'Constable's Sky Sketches', *Journal of the Warburg and Courtauld Institutes*, XXXII (1969), pp. 349–50; Reynolds, *Later Paintings and Drawings* (1984), pp. 129–30, Nos. 23.55–74.

14. 9.3 × 11.5 cm.

Inscribed: '14. All cloudy. except one large opening with/others smaller – the lights of the Clouds/lighter – and the shades darker than the plain/part. and darker at the top than the bottom./The Tint once over the openings & twice in the Clouds'

15. 9.2 × 11.4 cm.

Inscribed: '15 The same as the last. but darker/at bottom than at the top'

16. 9.2 × 11.4 cm.

Inscribed: '16 All cloudy except a narrow opening at the/bottom of the Sky with others smaller. the Clouds/lighter than the plain part. and darker at the/top than at the bottom/The tint twice in the openings and once in the Clouds.'

17. 9.3 × 11.3 cm.

Inscribed: '17. All the Cloudy except a narrow opening at the/top of the sky the others smaller. the Clouds lighter/than the plain part. & darker at the bottom than/top/The Tint twice in the openings & once in the Cloudes.'

18. 9.3 × 11.3 cm.

Inscribed: '18 – All cloudy except a narrow opening at/the bottom of the Sky. with others smaller/the clouds darker than the plain part &/darker at the top than the bottom/The Tint twice over

19. 9.2 × 11.3 cm.

Inscribed: '19. All cloudy. except a narrow opening at/the top of the Sky. with others smaller. the/clouds darker than the plain part – and darker/at the bottom top than the bottom/The Tint twice over'

20. 9.3 × 11.3 cm.

Inscribed: '20. The same as the last but darker/at the top bottom than the top.'

These are seven of twenty copies which Constable made after the engravings of sky types included in Alexander Cozens' *A New Method of Assisting the Invention in Drawing Original Compositions of Landscape* (1785), and numbers 1–20 of Constable's copies follow numbers 17–36 in Cozens' manual in the same sequence.[1] All twenty were acquired by Lord Lee sometime between the early 1920s and 1932.

The studies have usually been assigned to the artist's early career, but Parris and Fleming-Williams have pointed out that he copied another set of Cozens' schematic designs ('Circumstances of Landskip', BM Print Room 1881–1–16–9–2...5; Tate Gallery; and Mr Denys Oppé) in about 1823.[2] Reynolds (*op. cit.*) suggests that these copies were made while Constable was staying with Sir George Beaumont at Coleorton in 1823. They could thus equally well date from his own period of intensive study of skies ('skying', as he called it), which he began at Hampstead in 1821 and continued there in the following year. The importance to Constable of his sky studies is also discussed in the Introduction. Although there is no evidence that an individual sky study was transferred to a more complete painting, Constable's detailed studies, with their explanatory texts, show how profound his understanding was of this most transient aspect of landscape painting.

There are a number of variations in the outlines of these copies and it would appear that the studies represent a diurnal sequence of cloud formations, moving from the build up of cumulus throughout the day, followed by their dissipation in the evening. The shading may be governed more by artistic considerations than based on accurate observation.[3]

1 Alexander Cozens' treatise, *A New Method ... Landscape*, is reprinted in A. P. Oppé, *Alexander and John Robert Cozens* (1952); also in facsimile in Michael Marqusee, *Alexander Cozens. A New Method of Landscape* (1977).
2 Constable Bicentenary, 1976 (210); Hawes, op. cit., p. 349, dated the copies after Cozens' *A New Method ... Landscape*, to 'probably the early 1810s'.
3 See Coventry catalogue (1975).

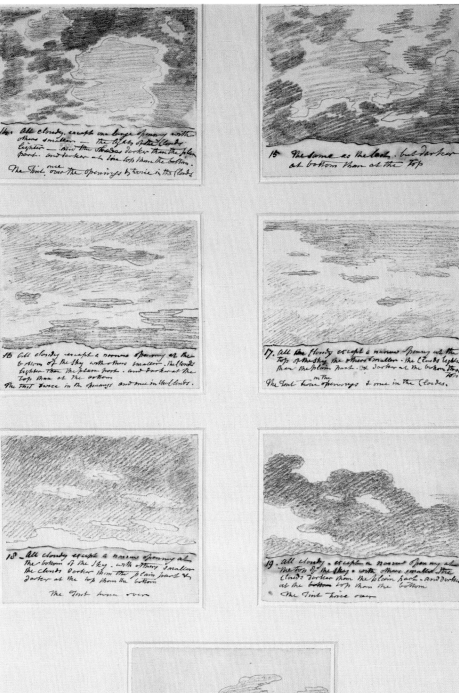

14. All cloudy, except one large opening with others smaller — the lights of the Clouds lighter — and the Shadas darker than the plain part. and darker at the top than the bottom.
The Tint one over the Openings twice in the Clouds

15 The same as the last, but darker at bottom than at the top

16 All cloudy except a narrow Opening at the bottom of the Sky with other smaller. the Clouds lighter than the plain part. and darker at the top than at the bottom.
The Tint twice in the Openings and once in the Clouds.

17. All the cloudy except a narrow Opening at the top of the Sky the others smaller. the Clouds lighter than the plain part. & darker at the bottom than the top.
The Tint twice over openings & once in the Clouds.

18 — All cloudy except a narrow opening at the bottom of the Sky. with other smaller the Clouds darker than the plain part & darker at the top than the bottom
The Tint twice over

19. All cloudy. except a narrow Opening at the top of the Sky. with other smaller the Clouds darker than the plain part. and darker at the bottom top than the bottom
The Tint twice over

20. The same as the last but darker at the top bottom than the top.

JOHN CONSTABLE
(1776–1837)

76 Colliers off the Beach at Brighton 1825

Pencil; on white (now unevenly stained and discoloured) laid paper. The sheet unevenly trimmed at all sides.

Watermark: '... ATMAN/... Y MILL ... 21' (i.e. J. Whatman, Turkey Mill, 1821).

11.6 × 18.6 cm.

Dated by the artist in pencil, bottom left: 'Brighton/friday 14 Oct. 1825'.

PROVENANCE: Hugh Constable (the artist's grandson), from whom acquired by Leggatt Bros. 1899; ...; Sir Harry Baldwin, sold Sotheby, 19 July 1933 (lot 125, one of a group of three landscapes and seascapes, 'and eleven others'), bt. Meatyard; Sir Robert Witt; Witt Bequest 1952 (2541 M).

EXHIBITIONS: Oxford Art Club, 1937; V. & A., London, 1943; *John Constable, 1776–1837*, Manchester City Art Gallery, 1956 (125); Courtauld, 1958 (52); New Zealand, 1960 (5); Rye, 1971; Constable Bicentenary, Tate Gallery, 1976 (241); British Museum, 1983 (115).

LITERATURE: Harold Day, *John Constable Drawings* (1975), p. 151 and pl. 153; Graham Reynolds, *Later Paintings and Drawings* (1984), p. 162, No. 25.20.

Constable first visited Brighton in May 1824, when he took his wife there for the sake of her health. An almost identical view, though seen from a more distant point on the shore, is shown in the small oil on paper sketch, dated 19 July 1824, in the Victoria and Albert Museum.[1] The two square-rigged brigs also appear in both oil sketch and drawing. The brilliant, highly personal, flickering pencil stroke which Constable uses in this drawing seems to anticipate, fortuitously, the Normandy sketches by Eugène Boudin of over fifty years later. Parris and Fleming-Williams observe that 'the colliers on the shore at Brighton had a particular fascination for Constable, perhaps because the shipping and retailing of coal formed part of the family business'.[2]

Writing to his friend, Archdeacon John Fisher, on 29 August 1824 (JCC VI, 171), Constable remarked: 'Brighton is the receptacle of the fashion and offscouring of London. ... the beach is only Piccadilly ... by the sea-side. ... In short there is nothing here for the painter but the breakers – & sky – which have been lovely indeed and always varying.'

Reynolds (*op. cit.*) notes that this drawing is on a sheet from a Whatman 1821 sketch book, which Constable used in 1825 and again in 1828.

1 Graham Reynolds, *op. cit.*, 1973 (266).
2 Constable Bicentenary, 1976 (241).

Brighton
Friday 14 Oct. 1825.

JOHN SELL COTMAN
(1782–1842)

77 Doorway to the Refectory, Kirkham Abbey, Yorkshire 1804

Pencil and watercolour; detailed preliminary drawing in soft pencil; restricted colour washes, with some drawing with the point of the brush; touches of dilute white and pale green body colour; some slight additions of gum or varnish in the darks of the foreground foliage; on off-white wove paper. The sheet laid down (? by the artist) on buff wove paper.

37.8 × 26.6 cm.

Signed in pen and brown ink, bottom right: 'J. S. Cotman/1804–'. Inscribed by the artist in pencil on the backing paper: 'Kirkham Abbey/Yorkshire'. Inscribed in pencil in different hands on backing paper: 'Cotman', 'H. G. Green', and 'Colnaghi'.

PROVENANCE: Turney Abbey; H.C. (*sic*) Green, sold Sotheby, 10 October 1962 (lot 66) bt. Colnaghi; Mr & Mrs W. W. Spooner; Spooner Bequest 1967 (S.24).

EXHIBITIONS: Courtauld, 1968 (54); Colnaghi, 1970 (27); Rye, 1971; Bristol, 1973 (10); New Zealand & Australia, 1976–78 (45); Cotman Bicentenary, 1982–83 (27).

Cotman first visited Kirkham Abbey with Paul Sandby Munn in July 1803, and made 'some exquisite drawings of it' according to their hostess, Mrs Cholmeley of Brandsby Hall. She and Cotman spent the day there on 30 August. Cotman made a second tour of Yorkshire in 1804, and a final one in July 1805. This watercolour was presumably based on a drawing made on his first visit. It was etched for his *Miscellaneous Etchings* 1811 (Popham 11).[1]

1 A.E. Popham, 'The Etchings of John Sell Cotman', *The Print Collectors' Quarterly*, October 1922.

JOHN SELL COTMAN
(1782–1842)

78 The Window between St. Andrew's Hall and Blackfriar's Hall, Norwich 1808

Pencil and watercolour; detailed preliminary drawing in soft pencil, with washes in grey (dilute Indian (?) ink) and blue watercolour, on white wove paper.

25 × 17.2 cm.

PROVENANCE: (?) Colnaghi; W. W. Spooner; Spooner Bequest 1967 (S.18).

EXHIBITION: *Exhibition of Old Master Drawings*, Colnaghi, 1955 (58); Courtauld, 1968 (54); Rye, 1971; Bristol, 1973 (11); New Zealand and Australia, 1976–78 (44); Cotman Bicentenary, 1982–83 (74).

This belongs to Cotman's first extended stay in his native city of Norwich, following his return from London in 1806, and has been dated to 1808.[1] It shows the three-light perpendicular window in the south wall of the cross-space of St. Andrew's Hall, a Church of the Dominican, i.e. 'black' friars, the nave of which was turned into a public hall in the sixteenth century and the chancel made use of as a church for the city's Dutch community. A signed version belongs to the National Gallery of Victoria, Melbourne; another, probably a copy, in the British Museum, is entitled *Window in Greyfriars Church, Norwich*.

1 Cotman Bicentenary catalogue 1982 (74).

JOHN SELL COTMAN
(1782–1842)

79 Domfront, seen from the rock of Tertre Grisière
1823

Pencil and watercolour; detailed preliminary drawing in soft pencil; watercolour washes and brown ink wash; extensive use of off-white, cream and other coloured bodycolours; drawing in pen and brown ink in middleground, and in pen and point of the brush and brown ink with additions of gum or varnish for foreground and areas of shadow; extensive scraping in sky and background rocks and foliage; on off-white wove paper.

29.5 × 41.3 cm.

Signed in brush and red-brown wash, bottom left: 'J S Cotman/1823'.

PROVENANCE: (?) The Artist's Sale, Christie, 1 May 1824 (lot 109, one of two views of Domfront); Charles Hampden Turner; sold Christie, 9 June 1873 (lot 176) bt. Sir Westrow Hulse; ...; W. W. Spooner; Spooner Bequest 1967 (S.22).

EXHIBITIONS: Courtauld 1968 (82); Harrogate, 1968 (61); Bath, 1969 (18); Cotman Bicentenary, 1982–83 (90).

LITERATURE: Miklos Rajnai and Marjorie Allthorpe-Guyton, *John Sell Cotman Drawings of Normandy in Norwich Castle Museum*, Norfolk Museums Service (1975), p. 67.

Cotman stayed at Domfront between 20 and 26 August 1820, during his last tour of Normandy. In the intervals between torrential rain and fierce storms, he made sketches of the church and 'Views of Town and Rocks extremely grand'. He noted that wolves still roamed the neighbouring countryside.

The view shown here is of Domfront Castle and town seen from the northwest, from the top of Tertre Grisière, looking across the 200 feet deep Val des Rochers in which the River Varennes flows round the castle. The Tertre Grisière was traditionally said to be the site of a gallows. Rajnai and Allthorpe quote from Cotman's letter of 17 September 1820 where he alluded to the Domfront saying:

> Domfront, Ville de malheur,
> Arrivé à midi, pendu à une heure;
> Pas seulement le temps de dîner!

The man with two mastiffs on the left of the composition is based on an encounter during the artist's visit to the Phare de Bonvouloir, where he met an armed man clad in leather buskins and waistcoat, accompanied by four large dogs, of a type which the local farmers kept as a protection against the wolves.

There are several other versions of this subject listed by Rajnai and Allthorpe.

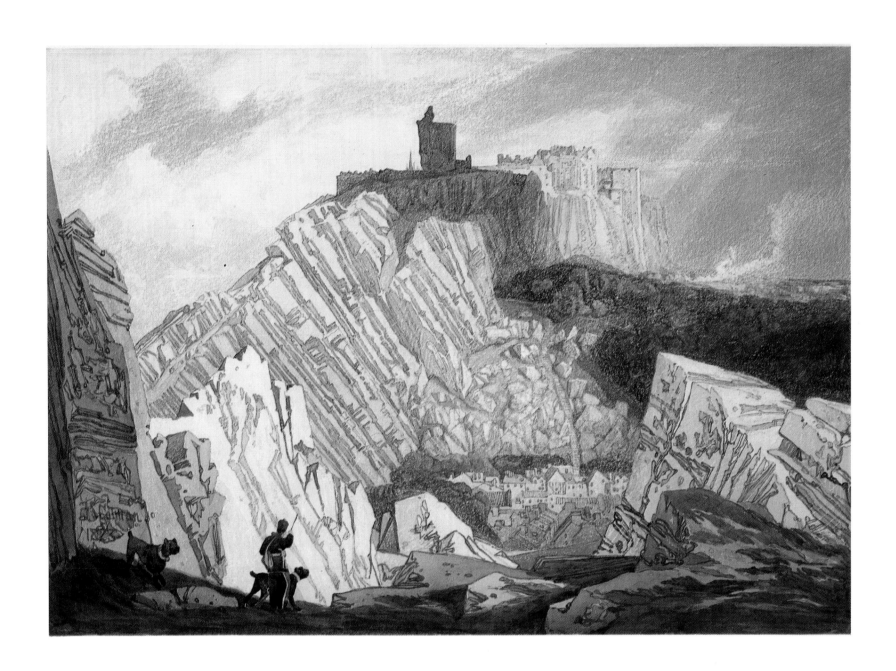

DAVID COX
(1783–1859)

80 The Beach at Blackpool 1840

Pencil and watercolour; extensive preliminary drawing in pencil; watercolour washes, with drawing with point of the brush, and some use of the dry brush; very dilute buff, grey, and pale blue bodycolour, and touches of red bodycolour; on off-white wove paper (? sheet from a sketchbook). The sheet unevenly trimmed on all sides. The drawing extended apparently from a ruled vertical line, now largely erased, lying 4.3 cm. from the right edge. Inscribed by the artist with colour notes in pencil on sides of houses: 'W' [? white]: 'W/S' [? white/ ? 'stone' or 'stained'].

Verso: slight drawing in pencil of part of the front and side of two houses (related to the houses on the *recto*), and below, a drawing of a door, inscribed by the artist: 'Door of Royal Ho[tel]'.

19.2 × 36.7 cm.

PROVENANCE: (?) William Roberts; . . . ; W. W. Spooner; Spooner Bequest 1967 (S.27).

EXHIBITION: Courtauld, 1968 (73); Bath, 1969 (19); Bristol, 1973 (13); Courtauld, 1974 (54); New Zealand and Australia, 1976–78 (47); Cox Bicentenary, 1983–84 (100).

Cox visited Blackpool with his fellow artist, William Roberts, in August 1840, but found little there worth painting. Solly records that he made two sketches of the sea-front (including their lodgings) which he gave to Mrs Roberts.[1] Formerly identified as *Rhyl Sands, North Wales*, this watercolour was correctly identified as Blackpool Beach by Mr Harry Hodgkinson, following its showing at the David Cox bicentenary exhibition in 1983. The Spooner watercolour shows the same beach and esplanade, although seen from a different angle, as in the Birmingham City Museums and Art Gallery's *Blackpool Beach* (274′25), also included in the same exhibition.

There are two engravings of the esplanade and its buildings, dating from *c.*1836 and 1845, which closely relate to the two views shown in the Birmingham and Courtauld watercolours. Mr Stephen Wildman, of Birmingham Art Gallery, has surmised that Cox might have made drawings of the site available to a local engraver, and points out that this was the period of his illustrations for William Radcliffe's *Wanderings and Excursions in North Wales.*[2] The Royal Hotel appears in the 1836 engraving to the right of the furthermost building visible in Cox's watercolours, but the drawing and inscription on the *verso* of the Courtauld sheet referring to 'Door of Royal Ho[tel]' would seem to be conclusive evidence of location.

1 Nathaniel Neal Solly, *Memoir of the Life of David Cox* (1873), pp. 97–98.
2 Correspondence in Gallery archives, November 1983.

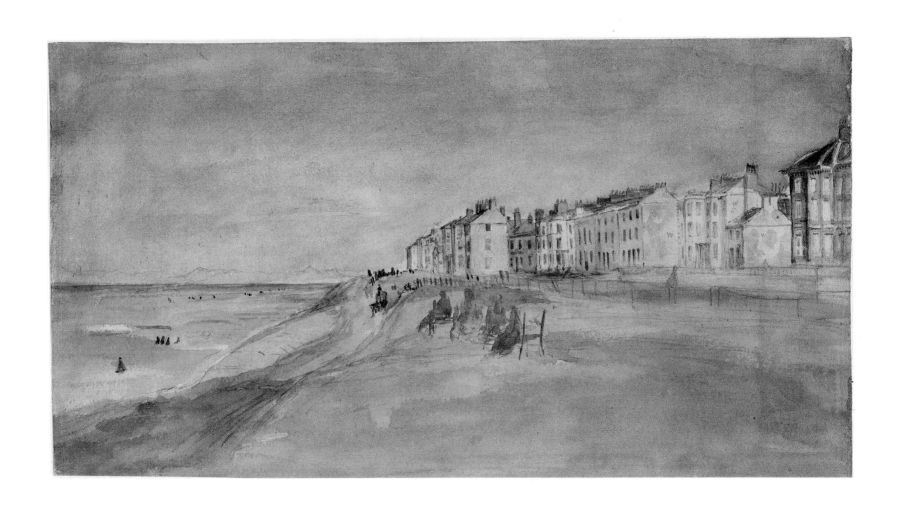

DAVID COX
(1783–1859)

81 **Barmouth Sands, with figures on horseback**
*c.*1840–45

Pencil and watercolour; slight preliminary drawing in soft pencil; watercolour and black ink washes, with extensive drawing with point of the brush; blue bodycolour in dress of girl on the left; some scoring into the wet paint to indicate texture of the cockle basket, centre, and some rubbing for the reflections on the sand, cast by the group of people on the left; on off-white wove paper.

18.3 × 29.1 cm.
Signed in brush and grey-brown wash, bottom left: 'David Cox'.

PROVENANCE: Mr & Mrs W. W. Spooner; Spooner Bequest 1967 (S.26).

EXHIBITIONS: Courtauld, 1968 (77); Harrogate, 1968 (62); Royal Academy Bicentenary, 1968–69 (584); Bath, 1969 (20); Bristol, 1973 (14).

The artist first visited Wales in 1805 and returned to that country frequently during his later career. In 1836 he was in North Wales producing illustrations from Thomas Roscoe's *Wanderings and Excursions in North Wales* (published later that same year), and a similarly entitled volume was published for South Wales in 1837. He was again in Wales in 1842 and 1844, when he based himself at Bettws-y-Coed. Thereafter, from 1845 to 1856 he made regular annual summer visits to Bettws-y-Coed, and even considered buying a property there.

Barmouth Sands lie on the Barmouth Estuary, near Dolgelley in North Wales, and stylistically, this watercolour, with its rather tightly controlled technique and luminous effects, suggests a date in the early 1840s. The subject relates to other beach scenes of this period, both oil and watercolour, where figures, mounted and on foot, are crossing the sands. Here, the mood is one of tranquillity in contrast to the stormy skies and almost expressionist technique which feature in much of the artist's later work.

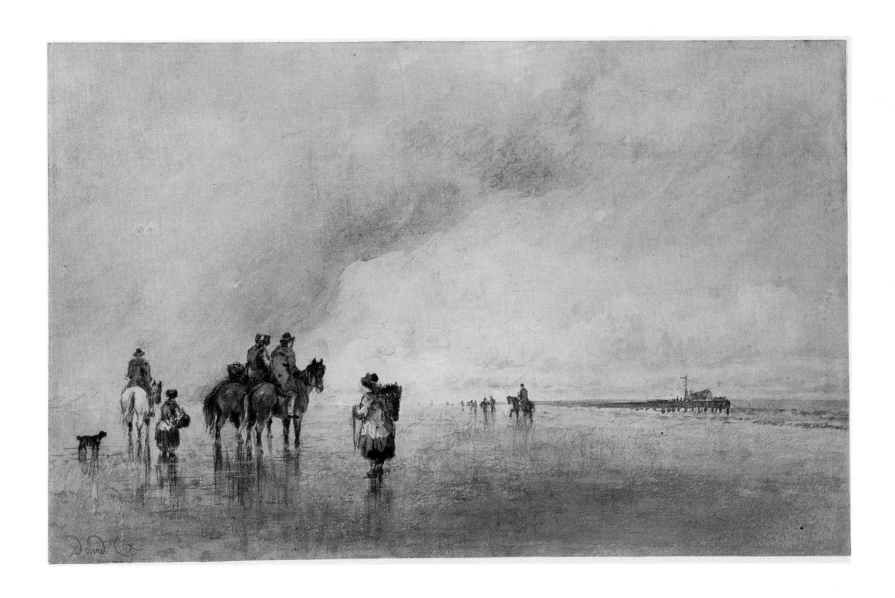

ALEXANDER COZENS
(1717–1786)

82 A Mountain Lake or River among Rocks
1775–80

Brush and black ink wash; on pale buff laid paper, prepared with a ground of pale brown ink (?) wash. The sheet unevenly trimmed on all sides, and laid down on the artist's mount.
Signed in pen and pale grey ink on the mount, bottom left: 'Alex.ʳ Cozens.', and numbered by the artist in pencil, top right: '54', the '4' over a '0'.

23.2 × 31.2 cm., on artist's mount 30.2 × 38.3 cm.

Collector's mark: 'RMW' (Lugt 2228b) on *verso*, bottom right.

PROVENANCE: Home Drummond Murray; Agnew, bt. Sir Robert Witt; Witt Bequest 1952 (1152).

EXHIBITIONS: San Francisco, 1933 (73); Sheffield and Tate Gallery, 1946 (48); Canada and U.S.A., 1949–51 (15); Courtauld (20 Portman Sq.), 1956 (4); Berlin, 1963; Courtauld, 1965 (20); Rye, 1971; New Zealand and Australia, 1976–78 (15); British Museum, 1983 (80).

Although this drawing is not a 'blot' image of the most abstract type (such as those demonstrated in the artist's *A New Method of Assisting the Invention in Drawing Original Compositions of Landscape*, 1785), it is schematic, and shares many compositional characteristics of 'Blot 13' – 'a hollow or bottom'. The drawing is on fairly thin paper, and while there is a possibility that this has been worked up as a tracing from a 'blot', it seems more likely to have been directly 'blotted' on to the sheet. The alteration of the numeration at the top of the sheet is consistent with Cozens' continually arranging, mounting, and classifying his drawings.

Cozens had begun experimenting with 'blot' images as early as 1759, when he published a short pamphlet, *An Essay to Facilitate the Inventing of Landskips*.[1] However, he probably did not fully develop the technique until much later. The present sheet has stylistic affinities with the *Mountainous Landscape*, which Andrew Wilton dates *c.*1780 in the exhibition catalogue, *The Art of Alexander and John Robert Cozens*, Yale Center for British Art, New Haven (1980), No. 23. He there argues for an earlier date than had been proposed by H. Clifford Smith in 1923,[2] and sees in *Mountainous Landscape* a more 'settled, balanced, and conclusive quality,' although he prefers to confine the adjective 'classical' to those works which contain overt classical subject matter, such as antique ruins or remains. The Witt sheet, which seems less resolved than *Mountainous Landscape*, may well be still earlier in date, and is here ascribed to 1775–80.

1 Referred to by A. P. Oppé, *Alexander and John Robert Cozens* (1952), p. 23, but no copy of it had then been found. A. Wilton noted in the 1980 catalogue that a copy was preserved in The Hermitage, Leningrad, and Kim Sloan published it in *The Burlington Magazine*, CXXVII (February and June, 1985): *see* Introduction.
2 *Drawings by J. R. Cozens*, Burlington Fine Arts Club (1923), where it was entitled 'Mountainous Classical Landscape'.

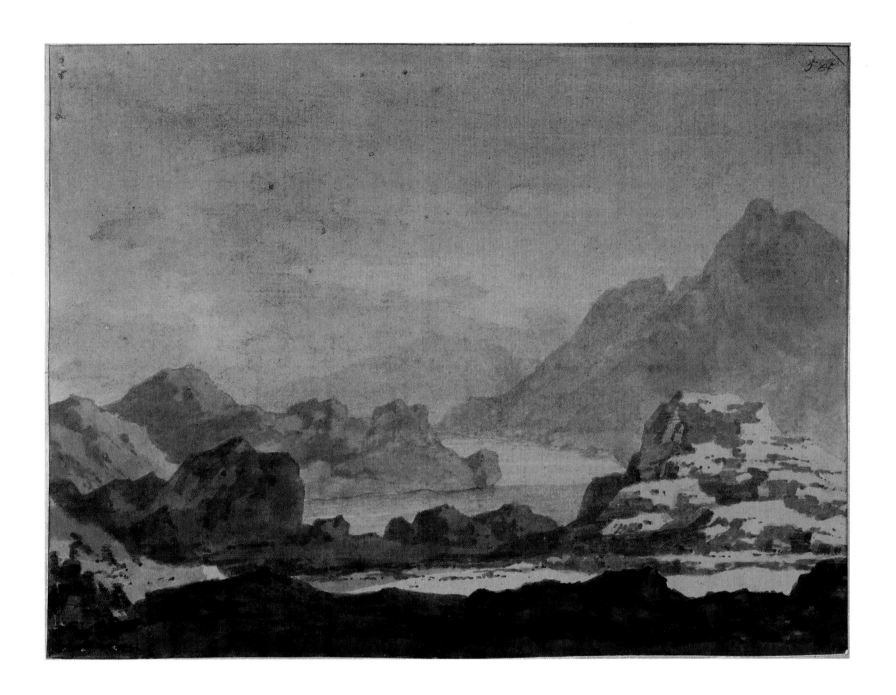

ALEXANDER COZENS
(1717–1786)

83 A Blasted Tree in a Landscape *c.*1780

Traces of preliminary drawing in graphite; washes in brown ink, with drawing with pen and the point of the brush; slight additions of gum or varnish in the foreground darks; on very thin laid paper, prepared with a ground of dilute varnish. The drawing edged with vestiges of a ruled line in pen and black ink, and laid down on the artist's mount, unevenly trimmed.

The sheet watermarked: 'D & C / B' set within a shield; the mount watermarked: 'W U A . . . C (inverted)' ' . . . D' (inverted).

31.5 × 40.5 cm., on mount 32.2 × 41.3 cm.

Signed in pen and grey ink on the mount, bottom left: 'Alex! Cozens.'.
Inscribed (? by the artist) in pencil, top right of drawing: 'B'. Numbered in a modern hand on the back of the mount: 'A 21365'.
Collector's mark, blind stamp: 'B·W' (Lugt 419) bottom left, above artist's signature.

PROVENANCE: Benjamin West, P.R.A.; . . .; J. H. Reverley; Mr & Mrs W. W. Spooner; Spooner Bequest 1967 (S.29).

EXHIBITIONS: Courtauld, 1968 (3); Royal Academy Bicentenary, 1968–69 (677); Rye, 1973; Bristol, 1973 (15); British Museum, 1983 (81).

This highly detailed drawing, in its scale near to the largest on which Cozens worked (which is approximately 45 × 62 cm.), is in the artist's more graphic manner. He has combined in this drawing the imagery of the *Classical Landscape* (formerly A. P. Oppé Collection, exhibited *Alexander Cozens*, Sheffield and London, 1946, No. 56) with that of the small drawing of *Dead Trees* (collection Sir H. Theobald, also shown in the *Cozens* exhibition of 1946, No. 58).

The paper has been made semi-transparent probably by the addition of a ground of turpentine or mastic varnish mixed with spirit of turpentine, the recipe set out in Rule II of *A New Method* (see previous entry) 'To make Transparent Paper', and it is almost certain that the present drawing was initially traced through from a 'blot'.

In 1771 Cozens published *The Shape, Skeleton and Foliage, of Thirty two Species of Trees. For the use of Painting and Drawing 1771*. These thirty-two engraved plates (of which there is a set in the BM Print Room) were intended as a 'manual' of characteristic tree types or species, and were not freely invented forms. Nevertheless, this publication provides an insight into his attempt at rationalising and codifying natural phenomena. The present sheet shows an oak tree which has survived a lightning blast, and combines detailed observation with a suggestion of the sombre mood that the sight of such a riven tree might provoke in the viewer's mind.

The assured technique and finely balanced composition of *A Blasted Tree* would indicate a mature work, *c.*1780.

JOHN ROBERT COZENS
(1752–1797)

84 The Castel Sant'Angelo, Rome 1780

Graphite; black ink, and blue watercolour washes; some slight scraping out; on white (now unevenly discoloured) laid paper. The sheet unevenly trimmed on all sides, and laid down on the artist's mount, also unevenly trimmed.
The sheet watermarked with a shield bearing the design of a fleur-de-lis, surmounted by a crown. The mount watermarked 'J WHATMAN'.

36 × 52.6 cm., on mount 41.5 × 58 cm.

Signed in pen and black ink, bottom left of centre: 'Jnº Cozens 1780'.
Inscribed in a later hand in pencil, on the back of the mount: 'Castel of St Angelo *Rome*/J. R. Cozens 1780'.

PROVENANCE: Sir Thomas Barlow Bart.; G. D. Harvey Samuel; Fine Art Society (1946); W. W. Spooner; Spooner Bequest 1967 (S.31).

EXHIBITIONS: Courtauld, 1968 (10); Bath, 1969 (24); Whitworth Art Gallery and V. & A., 1971 (19); Bristol, 1973 (17); British Museum, 1983 (83).

LITERATURE: C. F. Bell and T. Girtin, 'J. R. Cozens', *Walpole Society*, XXIII (1934–35), No. 117; Philip Troutman, 'The Evocation of Atmosphere in the English Watercolour', *Apollo*, 88 (July 1968), p. 51, repr. pl. 2.

The drawing, dated 1780, was executed in England after the artist's first journey to Switzerland and Italy (1776–79) in the company of the collector and connoisseur, Richard Payne Knight. Although it is the only published drawing of this subject, there are traces of ruled graphite lines spaced at regular intervals underlying the area of the castle which suggests a partial squaring up, and almost certainly from a detailed preliminary drawing.

This subject, of the Castel Sant'Angelo, presented less majestically and seen from a different viewpoint, was treated by J. R. Cozens in one of his rare etchings, published posthumously by J. F. Thompson in *Original Studies from Nature by Various Artists*, April 1801.[1]

1 Andrew Wilton, *The Art of Alexander and John Robert Cozens*, New Haven (1980), No. 3 (repr.), expresses the opinion that the etching is by J. R. Cozens' father, Alexander Cozens, and observes that it seems to have been etched on the spot out-of-doors, an unusual procedure for the period, since it is in reverse. He dates it tentatively to 1746. The Spooner drawing shows the scene in the correct sense of direction.

JOHN ROBERT COZENS
(1752–1797)

85 In the Canton of Unterwalden *c*.1780

Graphite; black and brown ink, and watercolour wash, with drawing with the point of the brush; touches of dilute white and other coloured bodycolour; slight scraping and rubbing in the smoke and figures, left; on off-white laid paper, watermarked 'J WHATMAN'. The sheet unevenly trimmed on all sides, apparently to a ruled line in graphite.

34 × 50.8 cm.

Numbered by the artist (?) in brush and grey wash *verso* top left: '3', and in graphite, centre: '3g' or '39', and inscribed, centre: 'To be copied'.

PROVENANCE: J. H. Reverley; sold anonymously, Sotheby, 16 February 1949 (lot 96, repr.), bt. Fine Art Society; Fine Art Society, bt. by W. W. Spooner (1951); Spooner Bequest 1967 (S.32).

EXHIBITIONS: Leeds, 1958 (26); Courtauld, 1968 (8); Whitworth Art Gallery and V. & A., 1971 (9); Petit Palais, Paris, 1972 (84); Bristol, 1973 (16); Tokyo, 1978 (44); British Museum, 1983 (84).

LITERATURE: C. F. Bell and T. Girtin, 'J. R. Cozens', *Walpole Society*, XXIII (1934–35), No. 29, i and ii; Francis Hawcroft, *Watercolours by John Robert Cozens*, Manchester and London (1971), No. 9.

One of four versions of the subject, this drawing may be the third if the inscription is an indication, and was executed after Cozens' first Swiss and Italian tour of 1776–79. Other versions are at Leeds City Art Gallery (Lupton Bequest); National Gallery of Ireland, Dublin; and Cecil Higgins Museum, Bedford. The Courtauld sheet is almost identical in composition with, though larger than, the Leeds drawing. The Dublin drawing may be the first of the series.

T. Girtin (in Bell and Girtin, *op. cit.*) attempted to reconstruct Cozens' first journey through the Swiss Alps by using as a guide the artist's own numeration on the sheets. He noted the difficulties encountered in tracing the artist's route in the Unterwalden district, and was unaware of the Spooner drawing, which, as noted above, appears to bear the numbers '39' and '3'.

JOHN ROBERT COZENS
(1752–1797)

86 London from Greenwich Hill *c.*1791–93

Graphite; black and brown ink, and restricted watercolour washes; with some drawing with the point of the brush, and the use of the dry brush; re-drawing of foreground detail with pen and point of the brush in blue-grey wash, and black and brown ink; on off-white (now unevenly discoloured) wove paper. The sheet unevenly trimmed on all sides, apparently to a ruled line in graphite.

36.9 × 53.5 cm.

Signed in pen and black ink, bottom left of centre: 'Jnº Cozens'.

PROVENANCE: P. H. Pleydell-Bouverie; Pleydell-Bouverie Sale, Sotheby, 27 June 1956 (lot 75, repr.), bt. Fine Art Society; Mr & Mrs W. W. Spooner; Spooner Bequest 1967 (S.30).

EXHIBITIONS: Courtauld, 1968 (12); Bath, 1969 (23); Tokyo and Kyoto, 1970–71 (73); Whitworth Art Gallery and V. & A., 1971 (94); Rye, 1971; Courtauld, 1974 (16); New Zealand and Australia, 1976–78 (8); British Museum, 1983 (82).

LITERATURE: C. F. Bell and T. Girtin, 'J. R. Cozens', *Walpole Society*, XXIII (1934–35), No. 441, i and ii, and *Notes*, No. 441; Francis Hawcroft, *Watercolours by John Robert Cozens*, Manchester and London (1971), No. 94.

A view of London and the River Thames seen from Greenwich Hill, above the Royal Naval College (formerly Naval Hospital), Greenwich, the twin domes of which are visible in the middle distance. Bell and Girtin (*op. cit.*) record three versions of the subject, to which can be added three more, including the present sheet.[1] All versions of the drawing, which differ principally in the number and arrangement of deer in the foreground, belong either to the year 1791, for which there is a dated drawing,[2] or at the latest to 1792–93, after which Cozens was unable to work through illness.

1 One is in the collection of H. G. Balfour (Hawcroft, *op. cit.*, No. 94); the second belongs to the Yale Center for British Art, New Haven (cf. Andrew Wilton, *The Art of Alexander and John Robert Cozens*, Yale Center, 1980, No. 137).
2 Bell and Girtin, *op. cit.*, No. 441, i.

EDWARD DAYES
(1763–1804)

87 St. Botolph's Priory, Colchester 1795

Graphite and watercolour; extensive preliminary drawing in graphite, and, for the doorway, with compasses; black, brown and grey ink, blue and green watercolour, with drawing with the pen and the point of the brush; on off-white laid paper. The sheet unevenly trimmed to a ruled line, top right, and laid down. The sheet torn and made up by the archway, lower right of centre, and small damages repaired in eleven areas.

26.6 × 39.7 cm.

Signed in pen and brown ink, bottom left of centre: 'Edw.d Dayes 1795'.

PROVENANCE: Mrs W. W. Spooner; Spooner Gift 1967 (S.38).

EXHIBITIONS: Bath, 1969 (27); Rye, 1971; Bristol, 1973 (21); Courtauld, 1974 (29); New Zealand and Australia, 1976–78 (26).

Dayes was one of Girtin's masters and influenced Turner's early topographical work. This drawing may be compared with Girtin's *Peterborough Cathedral from the West Front* (No. 93) and Turner's *Chepstow Castle* (No. 110). The subject of St. Botolph's Priory was also treated by Cotman in 1804, and an etching published by him in 1811.[1]

1 Compare: Victor Rienaecker, *John Sell Cotman 1782–1842* (1953), figs. 26 and 27, Norwich Castle Museum and Norman Lupton collections respectively.

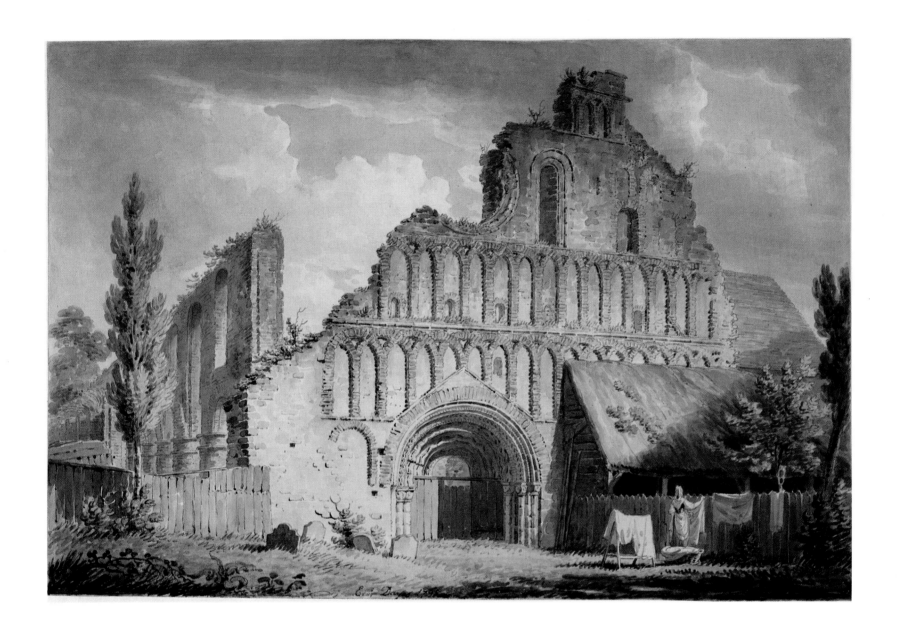

EDWARD DAYES
(1763–1804)

88 View of Ullswater, Lake District *c.*1795

Graphite; brown ink, and restricted watercolour wash, with some drawing with the point of the brush; on off-white (now stained) laid paper. The drawing framed by a feigned mount in buff and buff-grey washes, with ruled lines in pen and grey-brown ink. The sheet unevenly trimmed on all sides, the corners angled.

Sheet: 12.2 × 18.2 cm.; pictorial area: 8.5 × 14.5 cm.

Signed in pen and dark brown ink below the pictorial area, left: 'Edw.d Dayes' and in pencil (in modern hand) 'K 6032' below artist's signature; inscribed (in artist's hand?) in graphite, *verso*: 'Ullswater Westmorland'.

PROVENANCE: Squire, bt. Sir Robert Witt; Witt Bequest 1952 (4535).

EXHIBITIONS: Courtauld, 1965 (35); New Zealand and Australia, 1976–78 (27); British Museum, 1983 (85).

This drawing, the freshness of which is probably due to Dayes' refusal to experiment with new paints and techniques,[1] is one of many Lakeland subjects executed by him from *c.*1790 to his death. His first Lake District scene, *Keswick Lake*, was exhibited at the Royal Academy in 1791.[2] The small scale of the present sheet is exceptional, since most of the Lakeland subjects are over twice as large, and it may have been partly influenced by Dayes' activities as a book-illustrator. The drawing and its contemporary feigned mount are particularly decorative in character.

The view is identical to that shown in Dayes' *An Angler on Ullswater*,[3] except that in the Witt drawing the lightly wooded foreground bank is extended completely across the sheet.

1 Compare: J. Davis, 'Edward Dayes 1763–1804', *Old Water-Colour Society Club*, 34 (1964), 54.
2 Iolo Williams, *Early English Watercolours*... (1954, republished Bath, 1970), 98.
3 Sold Christie, 8 June 1976 (lot 80), and measures 25 × 39.5 cm.

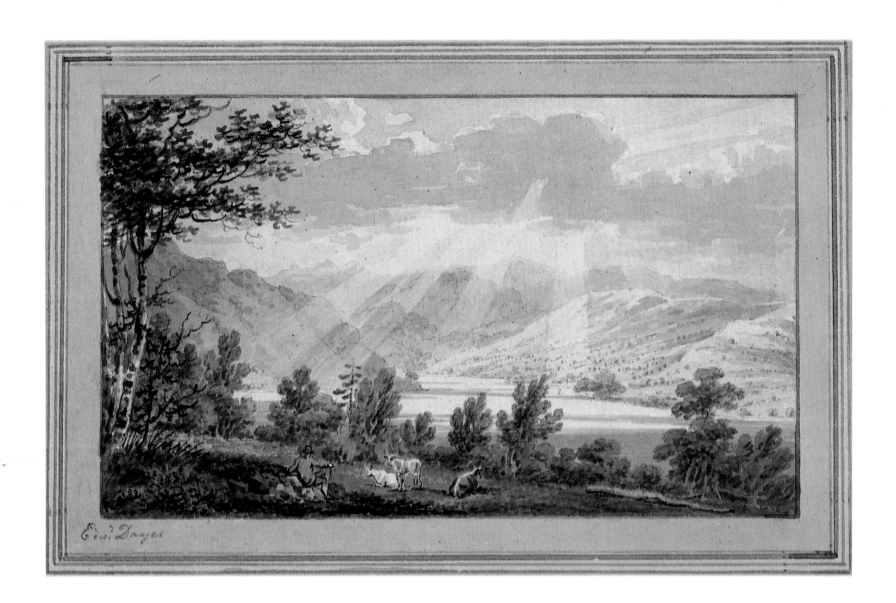

Edwd Dayes

THOMAS GAINSBOROUGH
(1727–1788)

89 Wooded Landscape with Figures, Donkeys and a Cottage mid-1750s

Graphite; on off-white (now unevenly discoloured and stained) laid paper. The sheet unevenly trimmed at the top, bottom and left side.

21.8 × 28.8 cm.

Inscribed in pen and brown ink, *verso*: 'Jos. Baldreys given Me Dec.ʳ 1776 by J:K: Sen.ʳ Gent'.

PROVENANCE: J.K.; Joshua Kirby Baldrey (Dec. 1776); ...; Frank Gibson; T. P. Grieg, sold anonymously, Christie, 11 May 1928 (lot 6, as a study for 'the Great Cornard Wood'), bt. Sir Robert Witt; Witt Bequest 1952 (2369).

EXHIBITIONS: Ipswich, 1927 (120); Huddersfield, 1946 (160); Arts Council, 1948 (27); Aldeburgh, 1949 (31); New Zealand, 1960 (11); Arts Council, 1960 (4); Nottingham, 1962 (33); Courtauld, 1965 (7); Rye, 1971; Sudbury, 1977 (4); British Museum, 1983 (87).

LITERATURE: Mary Woodall, *Gainsborough's Landscape Drawings* (1939), No. 371; John Hayes, *The Drawings of Thomas Gainsborough* (1970), No. 131 (where the inscription on the *verso* was unknown to the compiler), pl. 377.

Although formerly identified as a preliminary study for the painting *Great Cornard Wood*, this sheet is an independent work, which Hayes has dated to the early to mid-1750s. Both Hayes and William Bradford have noted the tight handling and repetitive curves of the branches of the tree in this sheet which they relate to Gainsborough's *Wooded Landscape with Herdsmen, Cattle and Farm Building* in the Pierpont Morgan Library.[1]

The 'Jos. Baldreys' mentioned in the inscription on the *verso* of this sheet is almost certainly Joshua Kirby Baldrey (1754–1828), who is described in the *Dictionary of National Biography* as an engraver and draughtsman who practised in London and Cambridge 1780–1810. He died 6 December 1828 in 'indigent circumstances, leaving a large family'.

1 British Museum catalogue (1983), No. 87 and cf. Hayes, *op. cit.*, No. 128.

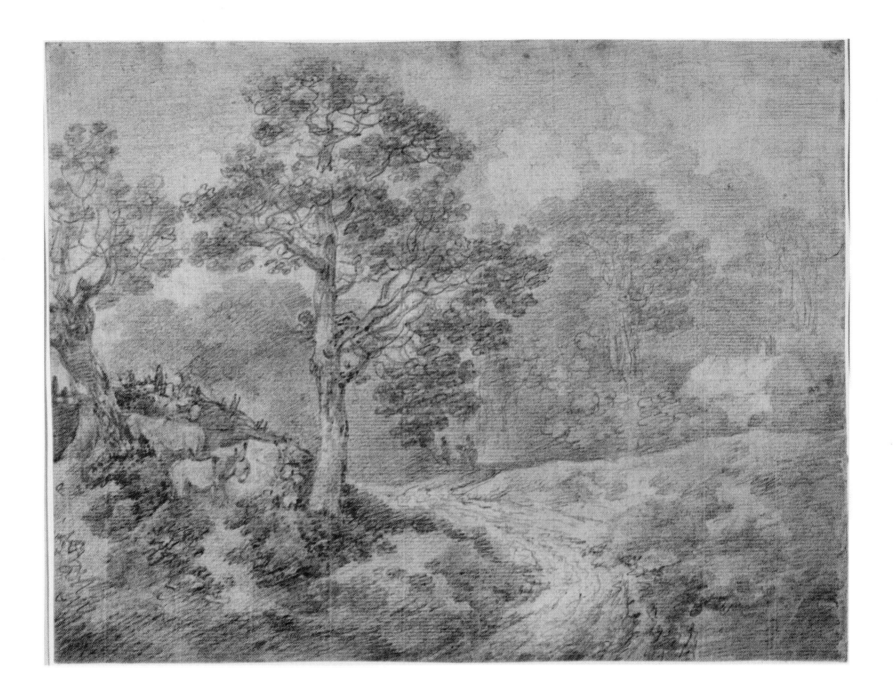

THOMAS GAINSBOROUGH
(1727–1788)

90 Wooded Landscape with Two Peasant Boys,
Donkey and Cottage 1759

Graphite; on pale cream (now unevenly discoloured and stained) laid paper; deeply scored lines in shadowed areas of foreground and vegetation. The sheet unevenly trimmed on three sides to a ruled line in graphite, bottom edge left untrimmed.

Sheet: 30.4 × 38.7 cm.; pictorial area: 28.1 × 38.7 cm.

Signed in graphite in the margin below the pictorial area, left of centre: 'Gainsborough fec: 1759', and numbered by the artist, bottom right: '1'. Faint traces of graphite drawing on *verso* (? outline of a pond).

PROVENANCE: Sir J. C. Robinson; probably Robinson Sale, Christie, 21 April 1902 (lot 116), bt. Parsons; . . .; John Mitchell; John S. Newbery, presented by him to the Courtauld Institute 1961.

EXHIBITIONS: *Old Master Drawings*, Newark Museum, 1960 (56); *Newly Acquired Drawings for the Witt Collection*, Courtauld, 1965–66 (53); New Zealand and Australia, 1976–78 (10); British Museum, 1983 (88).

LITERATURE: Hayes (1970), pp. 34, 38, 42, 75, and 164, No. 238, pl. 74.

This drawing, which was probably executed at Ipswich, is one of two dated sheets from 1759. The other is *Wooded Mountain Landscape with Herdsman and Cows crossing a Bridge over a Stream* (Desmond J. Morris collection, Malta).[1] Both sheets combine breadth of treatment with precise drawing of detail, features which, with the artist's clear signature and, in the present sheet, his numbering in the bottom margin, indicate that they were intended as preliminary drawings for a projected series of prints, not carried out.[2]

1 Hayes, *op. cit.* (1970), No. 243.
2 Hayes, *ibid.*, No. 238 and index, erroneously listed as a Witt drawing.

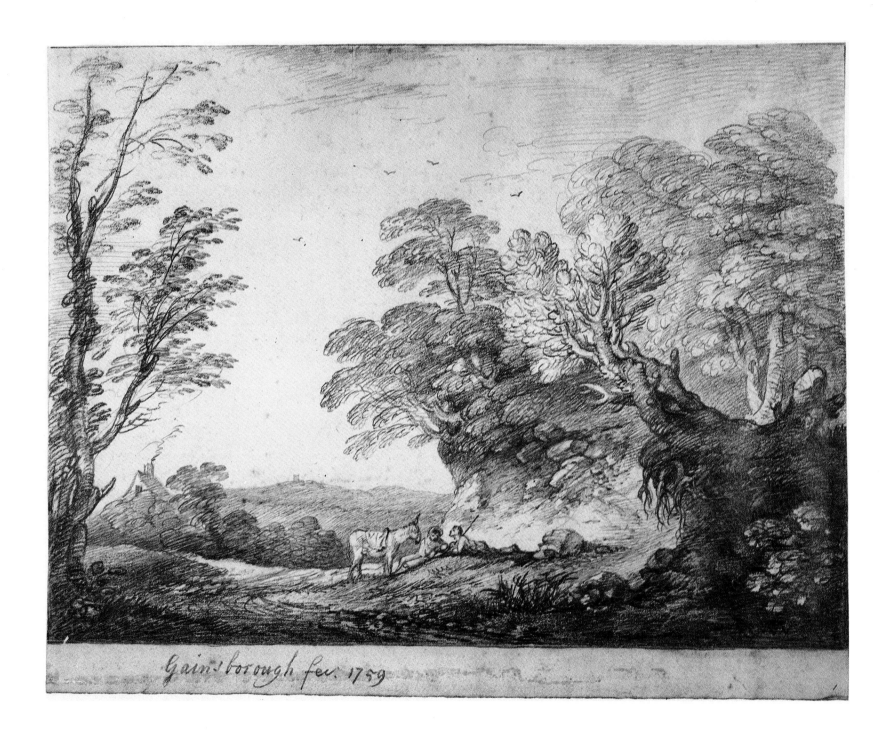

Gainsborough fecit 1759

THOMAS GAINSBOROUGH
(1727–1788)

91 Wooded Landscape with a Herdsman driving Cattle over a Bridge, Peasants and a Ruined Castle *c.*1781

Black ink, with extensive drawing with the brush; black chalk, heightened with white chalk; on pale buff (now stained) laid paper. The sheet unevenly trimmed to an oval, and laid down twice.

Maxima: 28.5 × 35.1 cm.

PROVENANCE: Susannah Gardiner (Gainsborough's sister), thence by descent to Miss R. H. Green, (sold anonymously), Christie, 1 April 1949 (lot 34), bt. Colnaghi; Sir Robert Witt; Witt Bequest 1952 (4181).

EXHIBITIONS: *Old Master Drawings*, Colnaghi, April–May 1949 (52); Arts Council, 1960 (37); Nottingham, 1962 (54); Courtauld, 1965 (8); *Angelica Kauffmann und seine Zeit*, Bregenz, 1968–69 (240); British Museum, 1983 (89).

LITERATURE: Hayes (1970), pp. 38, 45, 62, and 223–24, No. 498, pl. 288; Hayes (1971), No. 66.

This is a study for the oval oil painting exhibited at the Royal Academy in 1781 (formerly in the collection of C. M. Michaelis), and is also closely related to a soft-ground etching published by J. & J. Boydell in 1797.[1] Hayes has suggested that the present sheet marks an intermediary stage between the detailed etching, and the more abstract and rhythmical painting. The figures to the left of the bridge in the etching, which are identifiable as rustic lovers, appear in the Witt drawing so generalised as to make their sex and relationship almost irrelevant.

1 E. K. Waterhouse, *Gainsborough* (1958), No. 959; Hayes, *op. cit.* (1971), No. 66.

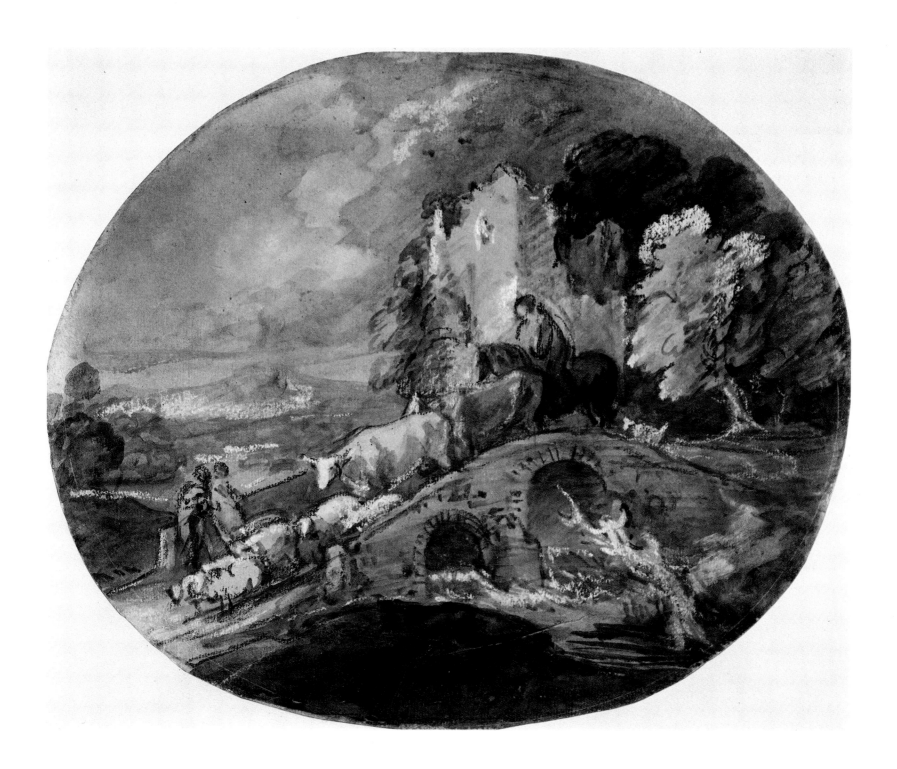

THOMAS GAINSBOROUGH
(1727–1788)

92 A Road through a Wood, with Figures on Horseback and on foot mid-1780s

Black chalk; brown and grey ink, with drawing with the point of the brush; heightening with white oil paint; yellow varnish; on pale buff laid paper.

22.1 × 30.5 cm.

Numbered by the artist (?) in graphite, *verso*: '1'.

PROVENANCE: Holloway, from whom purchased by Sir Robert Witt (by 1925); Witt Bequest 1952 (1681).

EXHIBITION: Ipswich, 1927 (165); Sassoon, London, 1936 (73); Amsterdam, 1936 (218); Grosvenor Square, London, 1937 (478); Paris, 1938 (201); V. & A., 1943; Hamburg, Oslo, Stockholm and Copenhagen, 1949–50 (50); Bath, 1950 (58); Arts Council, London, 1951 (76); Paris, 1953 (50); Arts Council, 1953 (11); Courtauld, 1958 (60); New Zealand, 1960 (9); Arts Council, 1960 (48); Calais, 1961 (57); Manchester, 1962 (5); Milwaukee, 1964; Nottingham, 1966; Rye, 1971; New Zealand and Australia, 1976–78 (12); British Museum, 1983 (86).

LITERATURE: C. H. Collins Baker, 'Some Eighteenth-Century Drawings in the Witt Collection', *The Connoisseur*, 62 (January 1926), p. 45, col. repr. facing p. 3; Woodall (1939), No. 372; Hayes (1970), pp. 274–75, No. 724; John Hayes, *Gainsborough as Printmaker* (1971), pl. 73.

This drawing, which dates from the mid-1780s, was the subject, with variations, of an aquatint published by J. & J. Boydell in 1797, as No. 12 of a series of twelve.[1] The drawing demonstrates Gainsborough's keen interest in various media and materials and technical experiment, so much so, that in his later career he often combined the practice of drawing and painting in the same work.

1 Hayes, *op. cit.* (1970), No. 724; and Hayes, *op. cit.* (1971), No. 73.

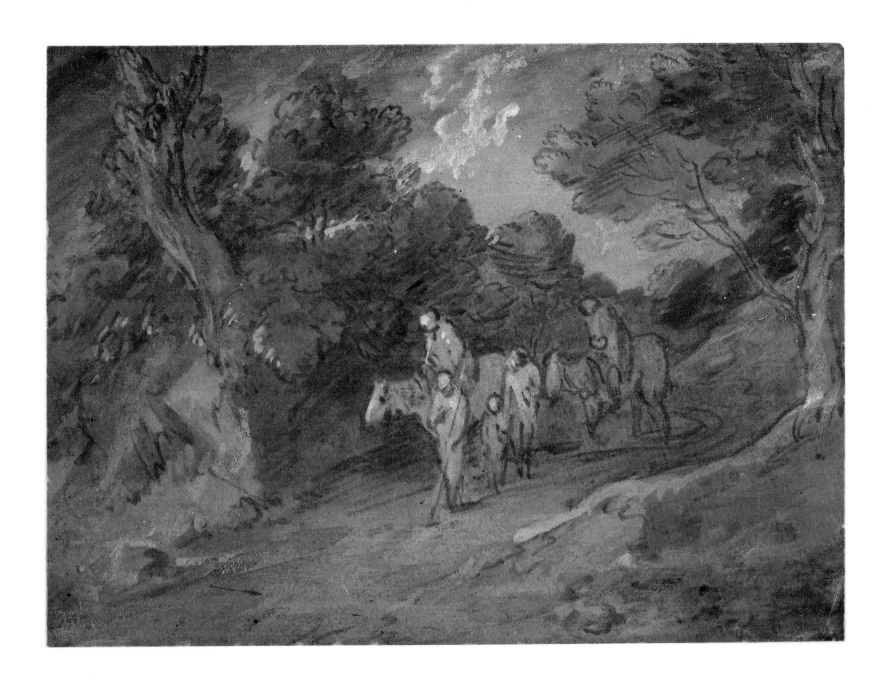

THOMAS GIRTIN
(1775–1802)

93 Peterborough Cathedral from the West Front
 *c.*1794

Graphite and watercolour; preliminary drawing in soft graphite, both free-hand, and, in the foreground, ruled; red, brown, blue and grey watercolour washes, with drawing with the point of the brush; possibly a very dilute blue bodycolour in the sky; extensive drawing of architectural details with pen and the point of the brush in black, grey and brown ink washes; on white wove paper (the drawing faded except at the edges where protected by an earlier mount).

40.7 × 27.1 cm.

PROVENANCE: W. W. Spooner; Spooner Bequest 1967 (S.48).

EXHIBITIONS: Courtauld, 1968 (46); Bath, 1969 (38); Rye, 1971; Bristol, 1973 (28); Girtin Bicentenary, Whitworth Art Gallery and V. & A., 1975 (9).

LITERATURE: T. Girtin and D. Loshak, *The Art of Thomas Girtin* (1954), No. 84, where five versions of the subject listed, but not the Spooner sheet.

Girtin accompanied the artist, James Moore, on a tour of the Midlands in 1794, when he visited Lincoln, Lichfield, Stratford-upon-Avon, and Warwick, as well as Peterborough. His drawings of Peterborough Cathedral show a remarkable mastery of perspective and an unusual maturity for an artist of only nineteen. This composition, and its variants, discussed below, is one of his boldest and most imaginative conceptions.

Of the five versions listed by Girtin and Loshak (*op. cit.*), one, formerly in the collection of Sir Edward Marsh (*ibid.*, No. 84 ii), shows only part of the left-hand West tower; the remaining four (No. 84, i, iii to v inclusive) contain most of the West Front. Hawcroft suggests that the Spooner sheet was the first of the watercolours to be based on the pencil study now in the Mellon Collection (84 i).[1] Two of them (No. 84 iii and iv) are signed and dated 1794 (ex-coll. Tryon, and Ashmolean Museum, respectively). The Spooner watercolour, which is not listed in Girtin and Loshak, appears to pre-date the version in the Whitworth Art Gallery (*ibid.*, No. 84 v). In the Spooner sheet, the artist has drawn a horizontal ruled line in graphite at 2.5 cm. from the bottom of the watercolour, which probably indicates his intention to crop the composition at this point. An intention that is carried out in the Whitworth composition, which finishes at exactly the same point, and the Cathedral spire has also been completely eliminated from this version, presumably to avoid a top-heavy composition. These refinements support the idea that the Spooner watercolour, which shows the whole of the West Front as viewed from a more distant vantage point, is earlier than the Whitworth sheet, where a more dramatic close-up view is depicted.

A diagonal is also drawn in graphite at an angle to the lower edge of the sheet and at a point 15.5 cm. from the left-hand corner.

1 F. Hawcroft, *Watercolours by Thomas Girtin*, Manchester and London (1975), No. 9.

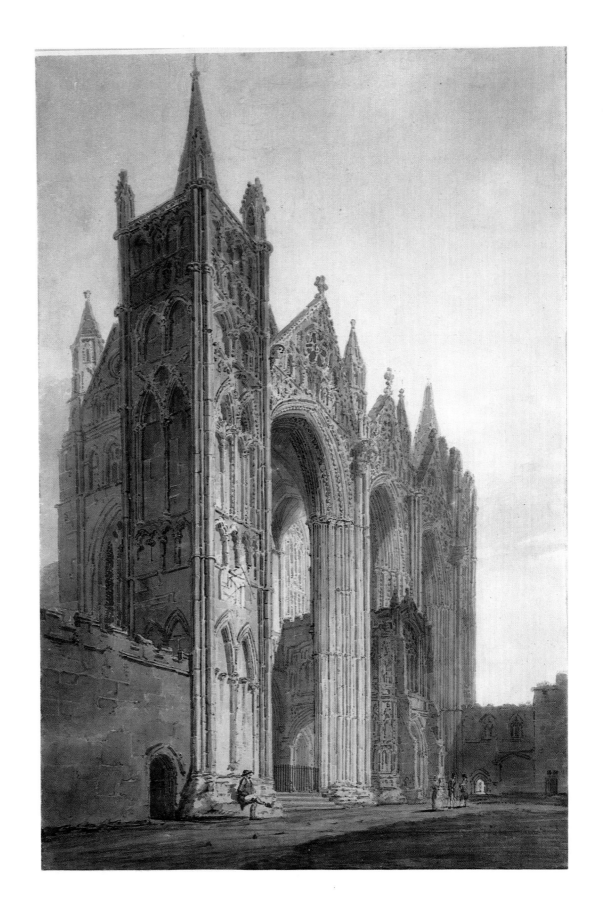

THOMAS GIRTIN
(1775–1802)

94 Appledore, North Devon *c*.1798

Graphite; pen and brown ink, restricted watercolour washes, with drawing with the pen and point of the brush; white and other coloured bodycolour; on pale buff laid paper. The sheet unevenly trimmed on all sides.

24.5 × 47.2 cm.

Signed with brush in dark grey ink, bottom centre left: 'Girtin.'

PROVENANCE: Palser (1913); Agnew (1914), bt. Sir Robert Witt; Witt Bequest 1952 (846).

EXHIBITIONS: Vienna, 1925; Tokyo, 1929; Agnew, 1931 (107, as 'Exmouth'); R.A., 1934 (752); Amsterdam, 1936 (222); Paris, 1938 (133); Agnew, 1953 (29); Arts Council, 1953 (15); Courtauld, 1958 (50); Calais, 1961 (68); Tokyo and Kyoto, 1970–71 (76); Rye, 1971; Tate Gallery, 1973 (186); Girtin Bicentenary, Whitworth Art Gallery and V. & A., 1975 (36); New Zealand and Australia, 1976–78 (35); British Museum, 1983 (91).

LITERATURE: *The Connoisseur*, 55 (December 1919), colour repr. p. 201; T. Girtin and D. Loshak (1954), pp. 66, 168, No. 254 (erroneously described as of 'Exmouth') and repr. fig. 37.

Girtin visited the South-West of England in 1797, and this panoramic view of Appledore, seen across the mouth of the River Torridge from Instow Sands and looking west, was probably a studio work based on sketches Girtin had made on that tour. It is a remarkable evocation of limpid atmosphere and reflections in the water.

Francis Hawcroft has noted the relationship of this drawing to other coastal views by Girtin of the same period.[1]

1 *Watercolours by Thomas Girtin* (1975), No. 36.

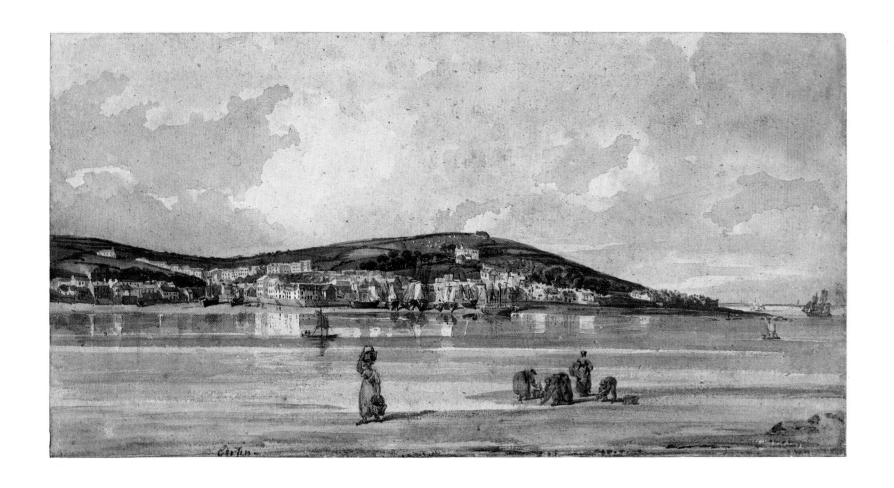

THOMAS GIRTIN
(1775–1802)

95 Farmyard with barns, ladder, and figures 1800

Soft graphite; brown ink, and restricted watercolour washes, with some drawing with the point of the brush; pink and yellow bodycolour; drawing of detail in pen and the point of the brush in brown ink; on pale buff laid paper. The sheet unevenly trimmed on all sides.

23 × 28.9 cm.

Signed in brush and brown ink, bottom left of centre: 'Girtin 1800'.
Verso: A Sky (unfinished), watercolour.

PROVENANCE: Sir Edward Marsh; W. W. Spooner; Spooner Bequest 1967 (S.52).

EXHIBITIONS: Courtauld, 1968 (51); Bath, 1969 (35); Rye, 1971; Bristol, 1973 (30); Girtin Bicentenary, Whitworth Art Gallery and V. & A., 1975 (78); New Zealand and Australia, 1976–78 (34); British Museum, 1983 (90).

LITERATURE: T. Girtin and D. Loshak (1954), No. 408.

Both Girtin and Loshak (*op. cit.*) and Francis Hawcroft (Girtin Bicentenary catalogue, No. 78) accept that this is a work of 1800, but consider it to be a reversion to the style Girtin used *c.*1798, when under the influence of Canaletto's dot-and-dash drawing technique. The unfinished watercolour of a sky on the *verso* was revealed when the sheet was removed from its mount in 1979.

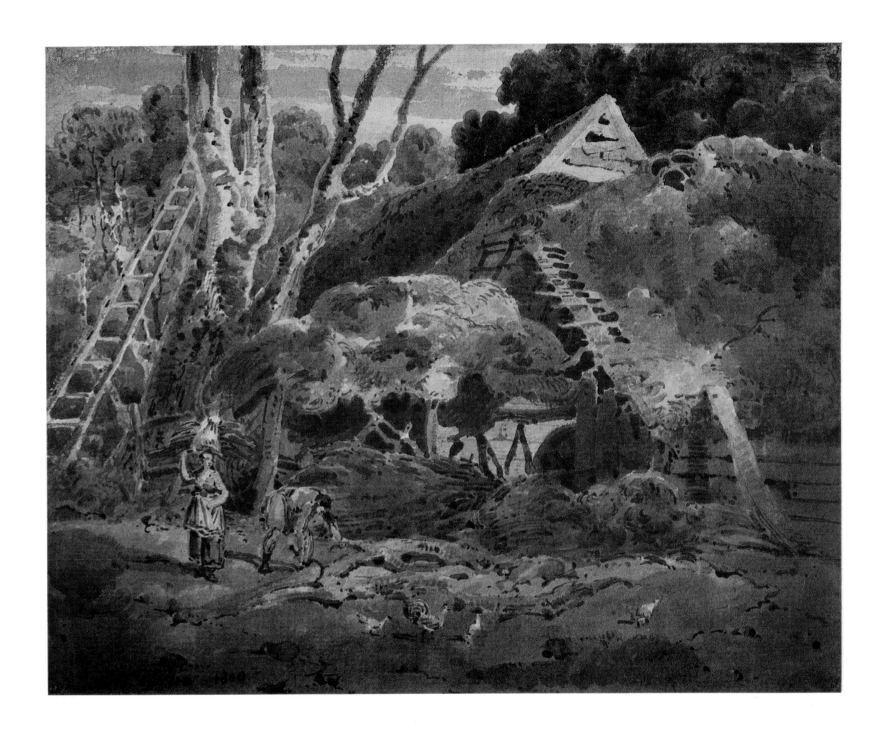

THOMAS JONES
(1742–1803)

96 The Coast near Vietri 1778–82

Detailed preliminary drawing in soft graphite; black ink washes, and restricted watercolour washes, with extensive drawing with the point of the brush particularly in the foreground and in the details of castles and rocks; on off-white laid paper, watermarked with a shield bearing the device of a hunting horn, surmounted by a coronet and below: 'L V GERREVINK'. The drawing slightly faded, except at top, where previously protected by a mount. The sheet unevenly trimmed on all sides.

25 × 38.5 cm.

Inscribed by the artist in pencil, top, right of centre: 'near Vietri', and on the wall, upper left: 'wall', and above the town, right: 'vietri' (the inscription partly effaced).

PROVENANCE: Mr & Mrs W. W. Spooner; Spooner Bequest 1967 (S.57).

EXHIBITIONS: Courtauld, 1968 (14); Bath, 1969 (42); Bristol, 1973 (34); New Zealand and Australia, 1976–78 (7).

LITERATURE: A. P. Oppé, 'Memoirs of Thomas Jones', *Walpole Society*, XXXII (1946–48), pp. 87–88, 110.

Probably executed between 1778–82 on one of the occasions the artist was in Naples, the view appears to be of Vietri sul Mare, in the distance, across the Gulf of Salerno with, on the left the Torre della Marina di Albori. The volcanic peak rising behind Vietri is presumably Le Creste.

Thomas Jones left England for France and Italy in October 1776, and returned in October 1783. He settled in Rome and made two visits to Naples, from 11 September 1778 to 26 January 1779, and again from 24 May 1780 to 3 August 1783. We have an unusually detailed account of his life and travels, in the form of his *Memoirs*, the manuscript of which was edited by A. P. Oppé and published by the Walpole Society in 1948.

In April 1779 Jones recorded a 'List of Pictures I have orders for – some of them nearly finished – Others not yet begun –', and among these appears:
'8th A View of Vietri in the bay of Salerno (Morning) on a four palm cloth for Sr
 W'm Molesworth to be delivered to & pay'd for by Mr Jenkins . . . 20.0.0
 [i.e. £20]'[1]
On 21 March 1782, he records a payment of £20 from Sir William Molesworth drawn on Jenkins' account.[2] Thomas Jenkins (died 1798) was a painter and dealer in antiquities, living in Rome, who acted as an agent for Molesworth and other patrons.

The picture referred to in the artist's *Memoirs* is, of course, an oil painting which has not yet been identified with any known surviving work. While it is tempting to see the Spooner sheet as a possible preliminary study for Sir William's painting, we cannot be certain whether the oil was among those completed on the first Naples visit, or 'not yet begun' by May 1780, when Jones arrived there for his second visit. It seems likely that the Spooner watercolour was painted sometime between September 1778 and before March 1782, when he received payment for the oil.

Jones inherited the family estate at Pencerrig in Radnorshire, on the death of hs elder brother John in 1787, and in 1789 he left London for his Welsh estates. He was elected High Sheriff of Radnorshire in 1791.[3]

1 Oppé, *Memoirs of Thomas Jones*, p. 88. For the dates of his departure for France and Italy, and of his return to England, *see* pp. 39 and 125; and for details of the two Naples visits, *see* pp. 77–84 and 95–125.
2 *ibid.*, p. 110.
3 *ibid.*, pp. 141–42.

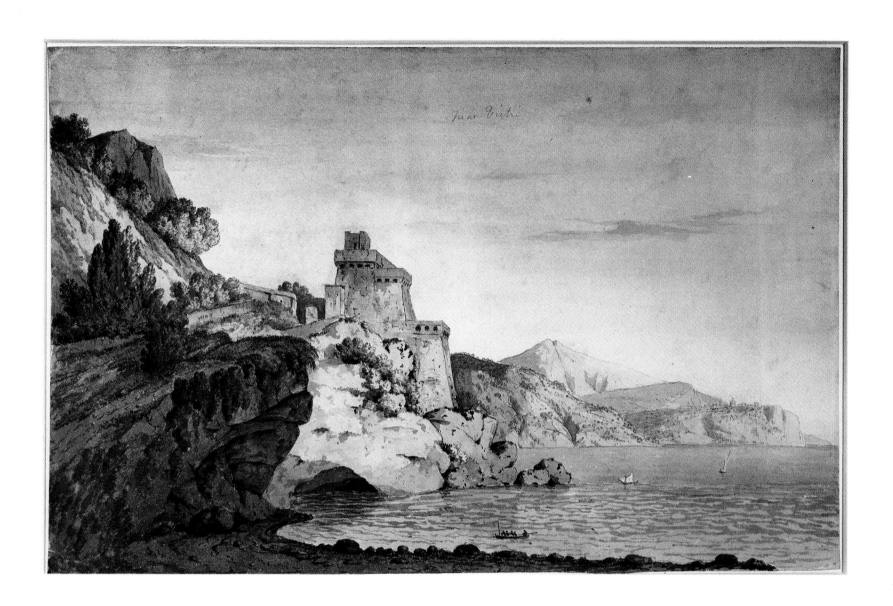

SAMUEL PALMER
(1805–1881)

97 From the Castle Hotel, Lynton, North Devon
 1834

Extensive preliminary drawing in pencil; restricted watercolour washes, with extensive drawing with the point of the brush; white, pale yellow and pale green bodycolour, with drawing with point of the brush; on very pale buff (now unevenly discoloured) wove paper. Sheet evenly trimmed, to a ruled pencil line traces of which are visible on bottom edge.

23.1 × 34.2 cm.

Inscribed by the artist in pencil, bottom left: 'From Castle Hotel Linton [*sic*] D.N. Devon.'; and lower right, above a small pencil sketch of the same valley: 'rather young Trees/but with the dark hollows/under them looking up/– stems –'; and bottom right, in brush and grey wash: 'Nightingale' (?).

PROVENANCE: Mr & Mrs W. W. Spooner; Spooner Bequest 1967 (S.70).

EXHIBITIONS: Sheffield, 1961 (33); Courtauld, 1968 (68); Bath, 1969 (52); Rye, 1971; Bristol, 1973 (39); New Zealand and Australia, 1976–78 (50); *Samuel Palmer and 'The Ancients'*, Fitzwilliam Museum, Cambridge, 1984 (30).

Palmer was particularly fond of the counties of Devon and Cornwall – South Devon he called 'the loveliest of lands!'[1] and, from the evidence of his surviving letters, we know he visited the West Country in 1834, 1848, 1849, and 1859.[2] Raymond Lister, in his catalogue to the Fitzwilliam Museum's exhibition of 1984, ascribes this sheet to the summer of 1834, and observes that 'there is still a vestige of Palmer's Shoreham vision in this drawing, but it is also close to the landscape drawings of Linnell. Indeed, it is almost as if it were a drawing by Linnell, made under Palmer's influence...' Certainly the Spooner sheet has little in common with *Trefriew Mill* of 1835 (No. 98), nor with his more dramatic and idealised landscapes of the 1840s and 1850s.

Palmer exhibited *Scene from Lee, North Devon* at the 1835 Royal Academy;[3] Lee Bay and Lee Abbey lie less than two miles to the west of Lynton, overlooking the Bristol Channel, and this seems proof enough of his visit to the town in 1834. Castle Hotel still exists and is situated high on a hill overlooking the gorge through which the East River Lyn flows. Lynton lies to the right and Lynmouth to the left of the gorge, and the artist appears to have chosen a view looking East towards Watersmeet.

1 Letter to an unknown addressee of (?) July 1849 (Lister, *Letters* (1974), I, p. 474: *see* LITERATURE for No. 98).
2 A. H. Palmer, *The Life and Letters of Samuel Palmer* (1892), p. 106, says his father visited Devon and Cornwall 'four times' between 1848 and 1859, and refers to the 1834 visit (p. 55) as '... the first record of a series of visits to a country which, even before he had explored it, seems to have commended itself to my father's affections, and afterwards became his ideal of English scenery'. Lister, *op. cit.*, I, p. xiii, warns us that a considerable number of Palmer's letters were destroyed by his only surviving child, Alfred Herbert Palmer, and others were lost in a fire.
3 A. H. Palmer, *ibid.*, p. 55.

From Knott Hotel Lynton 3, N. Devon.

SAMUEL PALMER
(1805–1881)

98 Trefriew Mill, on the Road from Bettws y Coed to Conway, North Wales 1835

Soft pencil or black chalk; brown ink and restricted watercolour washes; white and other coloured bodycolour; traces of gum in dark foliage centre right; drawing of detail with the point of the brush in watercolour and brown and black ink; over-drawing with soft pencil or black chalk; on pale buff (now discoloured) wove paper. Vestiges of a ruled line in black chalk on the left and right sides of the sheet. The bottom edge irregular.

40.1 × 48.6 cm.

Inscribed by the artist in pen and brown ink, lower left: 'Trefriew Mill on the Road from Bettws y Coed to Conway N. Wales/Samuel Palmer 4 Grove Street Lisson Grove Marylebone', and dated below: '1835', and inscribed in pencil below the date: 'at Trefriew NW', and numbered bottom right: '12'.

PROVENANCE: Sir John Ramsden; Mr & Mrs R. J. Tapp; Fine Art Society (1965); Mr & Mrs W. W. Spooner; Spooner Bequest 1967 (S.68).

EXHIBITIONS: Society of British Artists, 1836 (640); Courtauld, 1968 (64); Royal Academy Bicentenary, 1968 (586); Bristol, 1973 (38); British Museum, 1983 (119).

LITERATURE: Raymond Lister (ed.), *The Letters of Samuel Palmer* (1974), I, pp. 71–75.

The inscription on this highly finished drawing would suggest that Palmer worked it up in London from notes and sketches made during his tour of Wales, in the company of Henry Walter and Edward Calvert, during August 1835, but in the catalogue entry for the Society of British Artists exhibition of 1836, this work is described as 'drawn on the spot'.

The Welsh tour was a disappointment to Palmer; he wrote to George Richmond from Tintern on 19 and 20 August complaining of the expense he had incurred: 'Had I conceived how much it would cost I would have soon have started for the United States as Wales . . .'; of the (for him) uncongenial weather: '. . . but unfortunately when we were near Snowdon we had white light days on which we could count the stubbs and stones some miles off – we had just a glimpse or two one day thro' the chasms of stormy cloud which was sublime –'; and of his laziness: '. . . I have not worked hard . . .'[1]

Nothwithstanding the 1836 catalogue note, this sheet was probably completed in late September 1835 in a burst of energy possibly stimulated by Palmer's association with Hannah Linnell, whom he was later to marry, and partly by his increasingly dire financial position.[2]

1 Lister (ed.), *op. cit.*, I, pp. 71–72.
2 Letter to John Linnell (Hannah's father), 18 September 1835 (Lister, *ibid.*, pp. 73–75), and letter from Hannah Linnell to Palmer of 14 June (? 1835) published by Lister, *ibid.*, p. 74.

Trefriw Mill, on the road from Betws-y-Coed to Conway, N. Wales
1835

WILLIAM PARS
(1742–1782)

99 Sallanches, Haute Savoie (?)1770

Extensive preliminary drawing in graphite; black and brown ink washes, and restricted watercolour washes; some very dilute off-white bodycolour and pale pink and pale blue bodycolour; detailed drawing in graphite and in pen and ink especially in foreground foliage and in the figures and goats; on off-white laid paper. The sheet unevenly trimmed on all sides, apparently to a ruled line in pen and ink, visible at bottom and right edges.

27 × 42.4 cm.

Pencil inscription in modern hand, *verso*: 'Salanche' [*sic*], and numbered: '2221' and '17' (enclosed within a triangle).

PROVENANCE: (?) Lord Palmerston; ...; Mr & Mrs W. W. Spooner; Spooner Bequest 1967 (S.71).

EXHIBITIONS: Courtauld, 1968 (5); Bath, 1969 (53); Bristol, 1973 (40); New Zealand and Australia, 1976–78 (6).

LITERATURE: A. Wilton, *William Pars: Journey through the Alps*, Zürich (1979), pp. 11, 13, and 64 (repr. p. 13).

William Pars exhibited eight Swiss views at the Royal Academy in 1771 (143–50), which were described in the R.A. catalogue as 'painted for Lord Palmerston who took Pars with him to illustrate his tour'. This sheet does not seem to have been included in the eight, as none of the exhibited works fits its description.

The artist visited the Swiss Alps and Haute-Savoie in the entourage of his patron, the 2nd Viscount Palmerston (1739–1802). They left London on 25 June 1770, and arrived in Geneva on Sunday, 15 July, where they were joined by Horace Bénédict de Saussure, the famous alpine naturalist and physicist.[1] This sheet shows the village of Sallanches, with the ancient humped-back bridge of St. Martin over the River Arves. In the background rises the majestic peak of Mont Blanc, seen from the west. If, as seems likely, this drawing was done on the 1770 journey, it can be dated fairly precisely. Palmerston and his party left Geneva on Saturday, 21 July *en route* for Chamonix, which they reached on Monday, 23 July, passing through Bonneville and Sallanches. They stopped overnight at Bonneville on the Saturday, so Pars presumably was able to execute this drawing on the Sunday.

1 Wilton, *op. cit.*, p. 11, who quotes from Palmerston's 'A Journal kept during a Journey thro France Switzerland and some part of Germany in 1770'. The Journal consists of three small pocket-sized books which are preserved among the Palmerston Papers, Hampshire County Record Office.

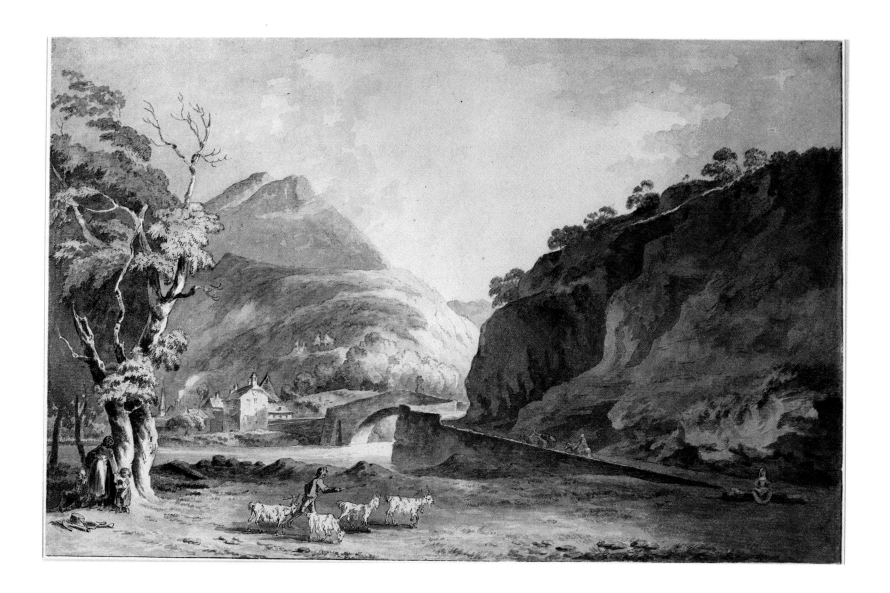

WILLIAM PARS
(1742–1782)

100 The Falls of Velino *c.*1775–82

Preliminary drawing in soft graphite; restricted brown ink and grey watercolour washes, some drawing with the point of the brush in foliage and rocks; on off-white laid paper. Sheet unevenly trimmed to a ruled graphite line on three sides (except top).
Watermark: 'I KOOL'.

20.1 × 30.7 cm.

PROVENANCE: Randall Davies; Squire, from whom bt. by Sir Robert Witt; Witt Bequest 1952 (4364).

A view of the famous gorge between Borgo Velino and Antrodoco in the valley of the River Velino, some 15 km. east of Rieti (and 80 km. north-east of Rome), below the Reatine Hills in Lazio. Pars conveys, by means of the 'bleached-out' appearance of the rocks and vegetation and short cast shadows, the burning midday heat of high summer in this region.

 The drawing was presumably executed during the artist's second stay in Rome from 1775 to 1782, where he was sent at the expense of the Society of Dilettante. He died in Rome in the winter of 1782 from a chill caught at Tivoli.

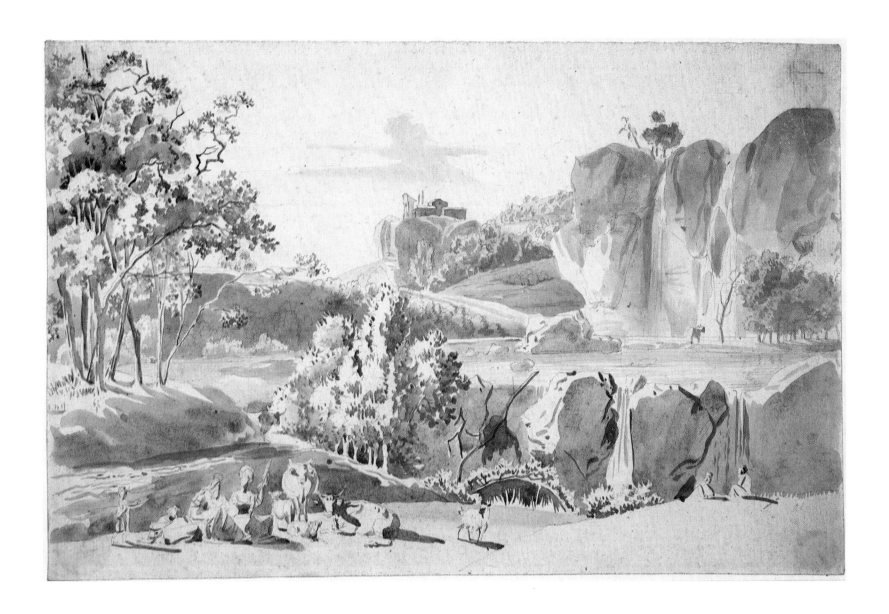

THOMAS ROWLANDSON
(1756–1827)

101 Coombe Bridge, Devon 1795–1800

Preliminary drawing in graphite; drawing with pen and the point of the brush in grey washes and restricted watercolour washes; pen and black ink for figures and horses; on white (now unevenly discoloured and faded) wove paper. The sheet unevenly trimmed at the bottom. A vertical fold at 8.3 cm. from the right edge of the sheet (apparently the left side of the intended pictorial area of the sketch on the *verso*).
Pentimento in graphite of a figure standing at the water's edge, left.
Verso: graphite drawing of embracing lovers, with, on left, a woman apparently weeping; behind a curtain of what appears to be the outlines of a four-poster bed, right, a (?) male figure eavesdropping and revealing himself to the lovers.

24 × 38 cm.

Inscribed by the artist in pencil, bottom right; 'Coombe Bridge' (the inscription now largely effaced and cut away at bottom).

PROVENANCE: W. W. Spooner; Spooner Bequest 1967 (S.78).

EXHIBITIONS: Harrogate, 1968 (19); Bath, 1969 (60); Rye, 1971; New Zealand and Australia, 1976–78 (14).

Rowlandson was a great friend of the banker, Matthew Mitchell, at whose home, Hengar House, near Bodmin, Cornwall, he was a frequent visitor from the mid-1790s until Mitchell's death in 1819.[1] It seems likely on stylistic and historical grounds that this sheet belongs to the period 1795–1800.

1 John Hayes, *Rowlandson Watercolours and Drawings* (1972), p. 20. John Riely, *Rowlandson Drawings from the Paul Mellon Collection*, Yale Center for British Art, New Haven (1977–78), p. xiii gives Mitchell's year of death as 1817.

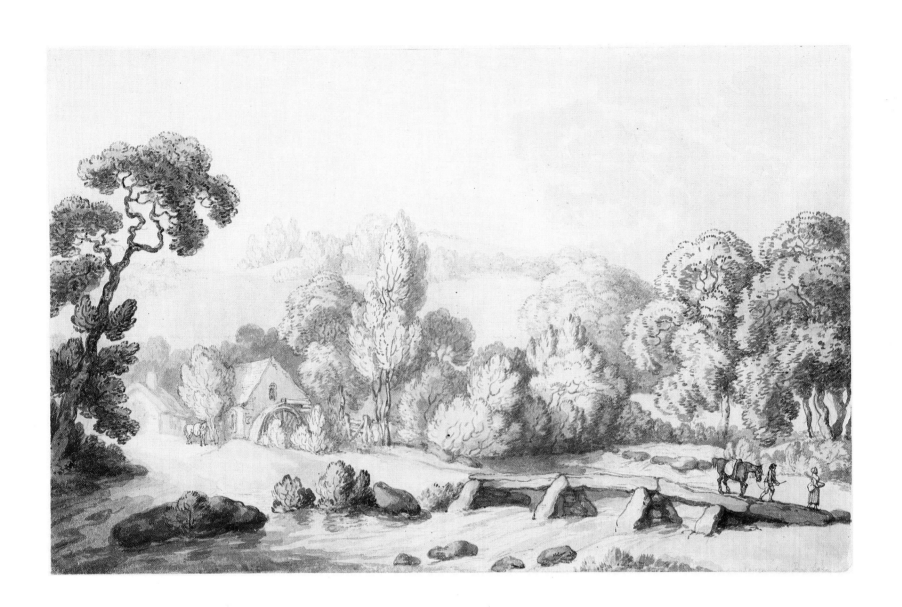

THOMAS ROWLANDSON
(1756–1827)

102 Swansea Castle 1797

Extensive preliminary drawing in graphite; drawing in pen and grey wash, with pen and black ink on contours; black and brown ink washes, also watercolour, with some drawing with the point of the brush; on off-white wove paper. The sheet unevenly trimmed on three sides, apparently to a ruled pencil and black ink line, the bottom edge uneven. The drawing appears to have been folded vertically at the centre.

An area on the left of the sheet, 9.4 cm. × 19.3 cm. and including the motif of the castle, has been framed by the artist with ruled lines in graphite. The verticals are set 6.9 cm. and 26.2 cm. from the left side of the sheet; the horizontal at 3.9 cm. from the bottom.

The drawing remains unfinished on the right.

15.3 × 43.1 cm.

Inscribed by the artist in pen and black ink, bottom left: 'Swansea Castle', and right: 'T. Rowlandson', and in pencil on the *verso*: 'Swansea Castle'. Numbered in a different hand in pencil, *verso*: '104' (in circle), and '1–10–70'.

PROVENANCE: W. W. Spooner; Spooner Bequest 1967 (S.79).

EXHIBITIONS: Courtauld, 1968 (23); Bath, 1969 (62); Rye, 1971; Bristol, 1973 (42); New Zealand and Australia, 1976–78 (15).

LITERATURE: An aquatint by I. Hill (? Thomas Hill) after this drawing was published in Henry Wigstead, *Remarks on a Tour to North and South Wales, in the Year 1797* (1800), facing p. 56 as 'Swansey' [*sic*].

Rowlandson made a tour of Wales in August 1797 accompanied by the caricaturist Henry Wigstead, who subsequently published aquatints after drawings by Rowlandson, 'Pugh, Howitt &c' (including some by himself), as illustrations to his *Remarks on a Tour to North and South Wales*, published in 1800. In a prefatory note, Wigstead wrote: 'The romantic and picturesque scenery of North and South Wales, having within these few years been considered highly noticeable and attractive, I was induced to visit this Principality with my friend Mr. Rowlandson, whose abilities need no eulogium from me. We left London in August 1797, highly expectant of gratification: nor were our fullest hopes in the least frustrated. ... as several of the subjects amongst our scenery have become topics of admiration, ... I have ... endeavoured to give a faint idea of their beauties; ...'[1]

Rowlandson contributed eight views, including those of Cardiff Castle, Caerphilly Castle, and 'Ragland' (i.e. Raglan), as well as of Swansea Castle, for which the Spooner sheet is a preparatory drawing (see: LITERATURE above). It will be noted that the artist, or possibly Wigstead, ruled off an area on the sheet to give prominence to the motif of the castle. Careful comparison of this sheet with the aquatint does show that this ruled-off area corresponds with the image that appears in the aquatint, at least as far as the left and bottom margins are concerned. The right hand side of the composition has been compressed by the omission of the unfinished landscape vista and by moving the sailing boat lying grounded on the right of the group of boats in the middle distance, centre right, to a spot next to the stern of the third boat along in that same group. Other free adaptations include moving the group in a rowing boat in the middle distance to a more central position, and giving greater prominence to the centre group of figures and horse on the foreshore; raising the shoreline to form a near horizontal foreground setting for these figures; and accentuating and simplify-

ing the outlines of the castle; the masts of the boats lying in the harbour immediately below the castle also appear to have been reduced in height and repositioned.

Wigstead wrote of Swansea Castle: '... The ruins of the castle are very picturesque: This was a favourite retreat of *Oliver Cromwell*'[2] It is obvious from his comments in the Preface and throughout the book, of which the quotations here give a fair flavour, that the notion of the Picturesque was still flourishing in the minds of guidebook compilers. See also the entry for Turner's *Chepstow Castle* (No. 110).

1 Wigstead, *op. cit.* (1800), pp. v–vi. According to the itinerary described by Wigstead, their chosen route took them first to North Wales, via Coventry, Wolverhampton, Llangollen, Conway, Caernarvon; then southwards to Cardigan, Carmarthen, and Swansea.
2 *ibid.*, p. 56.

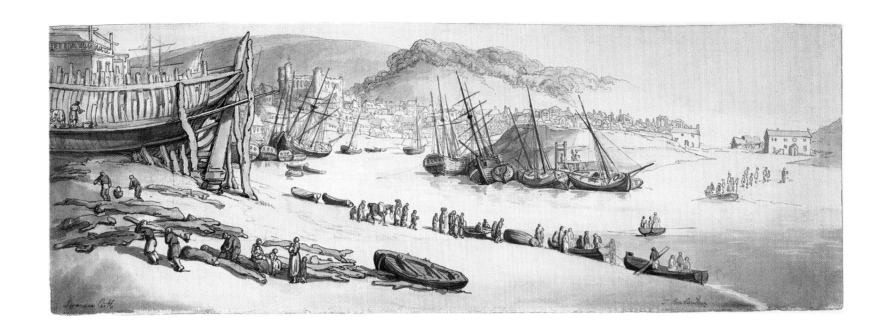

PAUL SANDBY
(1725–1809)

103 Old Windsor Green 1762

Graphite; watercolour, drawing with pen and the point of the brush on foliage; some ruled lines on architectural detail; on two sheets of joined white laid paper. The sheets unevenly trimmed on all sides.

Watermark on larger sheet: '$\frac{I}{IHS}$/I VILLEDARY'

35 × 79.5 cm.; left sheet: 35 × 55.3 cm.; right sheet: 35 × 24.2 cm. Left sheet has vertical fold at 40.3 cm. from left margin.

Inscribed (? by the artist) in graphite, bottom left: 'Old Windsor Green'; and inscribed and signed by the artist, in brown ink, bottom right: 'At Old Windsor P.S 1762'. Numbered, in grey ink, top centre right: '212'. The inscription on the inn sign is illegible.
Verso: fragmentary sketch of a tree, in graphite, on the smaller sheet.

PROVENANCE: (?) Colnaghi; (?) Knoedler; Mr & Mrs W. W. Spooner; Spooner Bequest 1967 (S.85).

EXHIBITIONS: Leeds, 1958 (85); Courtauld, 1968 (16).

The drawing is unfinished, and on the right a group of two adults and three children, for example, are drawn only in outline. The left foreground of the composition also appears incomplete. Sandby began exhibiting views of Windsor at the Society of Artists in 1763 (see also No. 104), and this sheet might perhaps be a careful preparatory drawing for a more finished work, which either was never executed or has not survived. The view is of the Green in the centre of old Windsor.

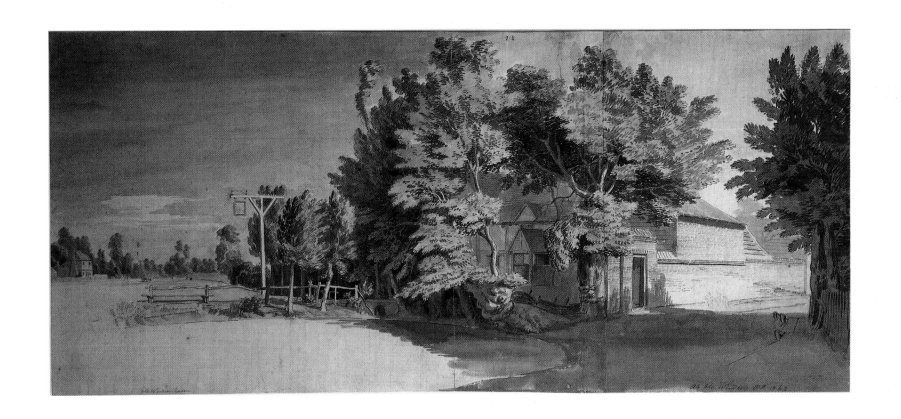

PAUL SANDBY
(1725–1809)

104 The Henry VIII Gateway, Windsor 1767

Graphite, grey watercolour wash; extensive use of white and other coloured bodycolour; some scraping and retinting on left side of arch and on tower; extensive drawing of detail with pen and point of the brush in grey and brown wash, both freehand and ruled; touches of gold paint; on white wove paper. The drawing enclosed within ruled lines in pen and brown and grey wash. The sheet unevenly trimmed on all sides, and laid down on artist's mount.

37 × 47.1 cm.; mount: 39.5 × 49.9 cm.

Signed in brush and gold paint, bottom left: 'P Sandby Pinxt 1767', and inscribed by the artist on the notice on the left of the tower: 'WINDSOR/AND/EATON. MACH[*sic*]/Sold out', and on the notice on the right of the tower: 'Pray Remember/the Poor Confin'd/Debtors'.
Inscribed in a modern (?) hand in pencil, on the back of the mount: 'The Town Gate & Debtors' Prison/Windsor Castle/P. Sandy 1767'.

PROVENANCE: Mrs J. B. Young; Mr & Mrs W. W. Spooner; Spooner Bequest 1967 (S.84).

EXHIBITIONS: Society of Artists, 1768 (277, as 'The town-gate of Windsor'); Courtauld, 1968 (15); Bath, 1969 (63); Bristol, 1973 (48); New Zealand and Australia, 1976–78 (9); British Museum, 1983 (93).

LITERATURE: A. P. Oppé, *The Drawings of Paul and Thomas Sandby in the Collection of His Majesty the King at Windsor Castle* (1947), pp. 8, 24, Nos. 27 and 28.

Oppé records that Paul Sandby exhibited a view of Windsor for the first time at the fourth exhibition of the Society of Artists, in London, in 1763: 'A gateway in Windsor Castle'. He notes that four more were shown there in 1765, and two each in 1676 and 1768.[1] It seems likely that the highly finished signed and dated Spooner sheet, which was unknown to Oppé, may have been exhibited at the Society of Artists in 1768. Two related drawings (Oppé, Nos. 27 and 28) in the Royal Collection, *Henry VIII Gateway from just within the Lower Ward*, were regarded by Oppé as preliminary and finished works respectively, but both may be considered as preliminary to the Spooner sheet, which contains compositional elements from both drawings, but is closest to Oppé, No. 27.
The Debtors' Prison was removed between 1790 and 1805.

1 Oppé, *op. cit.*, p. 8. The Society of Artists of Great Britain, established in 1760, was a precursor of the much more prestigious Royal Academy of Arts, founded in 1768. The Society of Artists ceased to exist in 1791. Paul Sandby's *View of the Castle from Datchet Lane on a rejoicing Night*, is also signed and dated (1768) in gold, the only landscape before 1792 in the Royal Collection to be so. There was 'A View of Windsor on a rejoicing night' shown at the Society of Artists in 1768 (145).

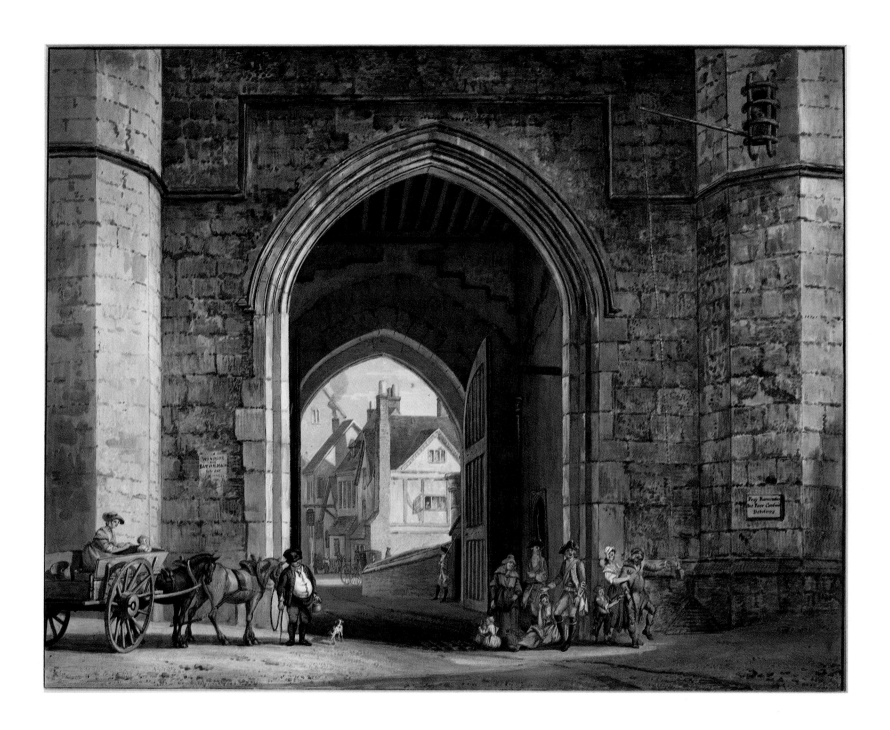

JONATHAN SKELTON
(c.1735–1759)

105 Italianate Landscape with Buildings c.1758

Detailed preliminary drawing in graphite; red-brown and ochre watercolour washes, and black ink washes, with drawing with the point of the brush in the foreground; possibly some very dilute bodycolour in the cloud; on white (now unevenly discoloured) laid paper. The sheet, which has been folded vertically at the centre, unevenly trimmed on all sides and laid down on the artist's mount. The mount, a design of eight bands drawn in pen and grey ink of varying shades; on off-white wove paper, unevenly trimmed at all sides.

19.3 × 26.2 cm; on mount, 27.5 × 34.2 cm.

PROVENANCE: Mr & Mrs W. W. Spooner; Spooner Bequest 1967 (S.86).

EXHIBITIONS: Courtauld, 1968 (1); Harrogate, 1968 (2); Bath, 1969 (65); Bristol, 1973 (49).

The view has not been identified, but appears to be Italian, possibly Roman. Skelton arrived in Italy late in 1757, by 19 January 1759 he was dead. A series of letters he wrote in 1758 from Rome and Tivoli to his patron, William Herring, give us an insight to his response to the landscape of the Roman Campagna and his working methods.[1] In particular, his palette lightened considerably from the subdued brown-grey-green of his English watercolours, his handling becomes freer and more fluent, with enhanced exploitation of the effects of aerial perspective.[2] He attempted to paint in oils directly from nature, a practice adopted by Claude on a few occasions, and it has been suggested that Skelton may also have painted in watercolour direct from the motif.[3] While Skelton adopted certain Claudian forms of composition in his more idealised views of the Roman Campagna, he was never a mere pasticheur, and the Spooner sheet shows him capturing the brilliant light cast over a scene in which formal composition is subtly combined with spontaneity of technique.

 This sheet cannot be related with certainty to any of the works listed by S. Rowland Pierce in 1960, but it may be one of those grouped under Nos. 81–84 'Landscape (in sepia)'.[4]

1 Brinsley Ford (ed.), 'The letters of Jonathan Skelton written from Rome and Tivoli in 1758', *Walpole Society*, XXXVI (1960), pp. 23–82.
2 Deborah Howard, 'Some Eighteenth-Century English Followers of Claude', *Burlington Magazine*, CXI (December 1969), pp. 728–31.
3 Howard, *ibid.*, p. 731.
4 S. Rowland Pierce, 'Check List of the Drawings of Jonathan Skelton', *Walpole Society*, XXXVI (1960), pp. 10–22.

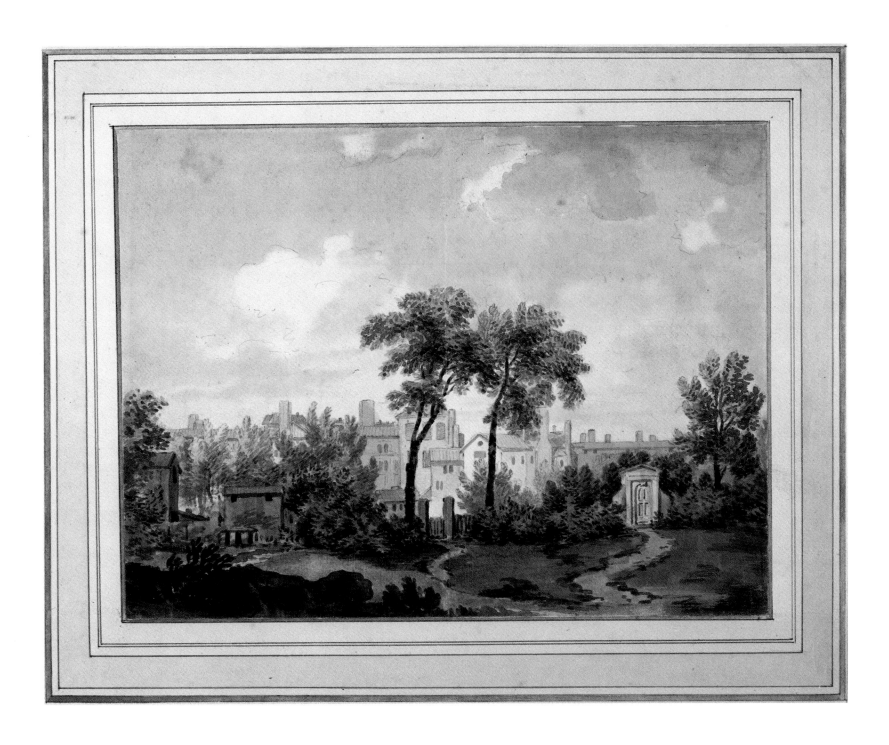

WILLIAM TAVERNER
(1703–1772)

106 Hampstead Heath (?)1765

Extensive preliminary drawing in soft graphite; restricted watercolour washes, with some drawing with the point of the brush especially in darker areas of foliage; on white (now discoloured) laid paper. Three separate sheets, joined vertically at intervals of 13.4 cm. and 15.7 cm. from left margin, the whole unevenly trimmed on all sides and laid on modern backing.

31.4 × 38.8 cm.

Inscribed, bottom right: 'T' (?).
Inscribed on old mount, *verso*: '89b. Query Taverner ... [rest erased]' in late eighteenth- or nineteenth-century hand in ink; and in pencil: 'Hampstead Heath 1765/William Taverner', in a modern hand.

PROVENANCE: Sir H. F. Wilson; L. G. Duke (by 1933); (?) Colnaghi; Mr & Mrs W. W. Spooner; Spooner Bequest 1967 (S.88).

EXHIBITIONS: R.A., 1934 (919); Courtauld, 1968 (2); Bristol, 1973 (50); New Zealand and Australia, 1976–78 (1).

If the inscription is to be relied on, the dating of this drawing would appear to be 1765. A drawing of the Leg of Mutton Pond, Hampstead, by this artist, is in the Tate Gallery. Taverner was a lawyer by profession, and an amateur of the arts. Besides being a watercolourist, he was also a playwright.

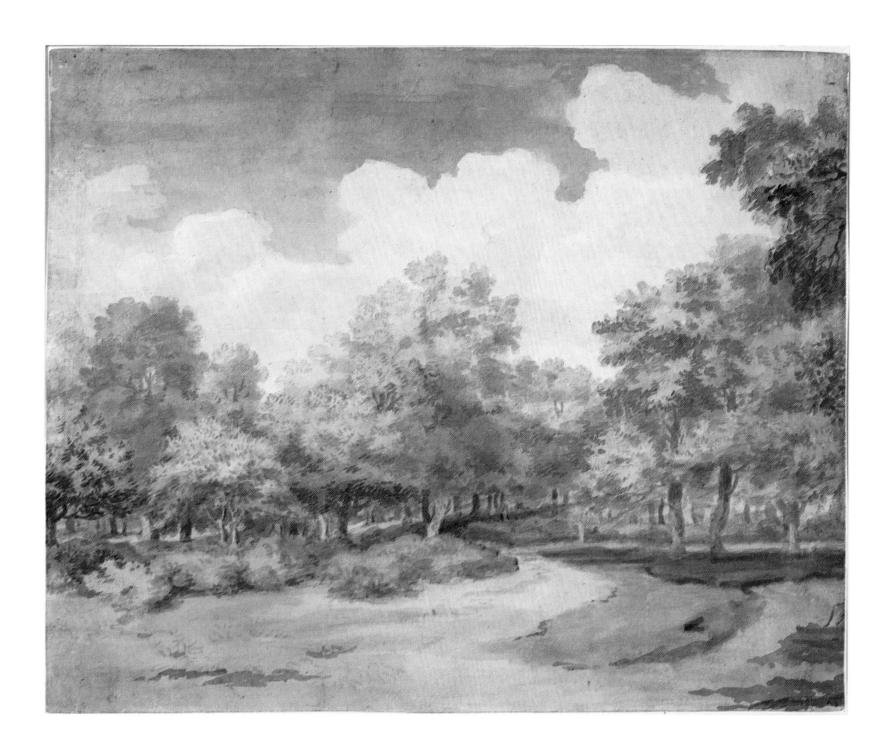

FRANCIS TOWNE
(*c.*1740–1816)

107 In the Valley of the Grisons 1781

Traces of preliminary drawing in graphite; drawing with pen and brown-grey ink in foreground; yellow, green, brown and blue watercolour washes and grey ink wash, with some drawing with the point of the brush; additions of gum or varnish to enhance the darks of foreground shadows; on white laid paper. The sheet laid down on the artist's mount.
The mount, a design of five ruled bands in graphite; alternate bands in dark and pale grey wash; on pale buff laid paper. The mount unevenly trimmed on all sides, the bottom right corner cut.
The main sheet watermarked with a shield with fleur-de-lis design, surmounted by a coronet.

28.7 × 46.7 cm.; on mount 38.8 × 57.2 cm.

Signed in pen and black ink, bottom left of centre: 'F. Towne delt/N.19 1781', and inscribed by the artist in pen and brown ink on the back of the mount: 'N.º 19/In the Valley of the Grisons looking on (?) [apparently altered by the artist from "to"] Tusis .../in the morning drawn by Francis Towne on the Spot.' (the 'n' of 'on' and 'Tusis' strengthened by a later hand in black ink; after 'Tusis' an area of erasure, although the tail of a 'g' or 'y' is still visible).

PROVENANCE: W. W. Spooner; Spooner Bequest 1967 (S.89).

EXHIBITIONS: Courtauld, 1968 (17); Harrogate, 1968 (8); Bath, 1969 (68); Bristol, 1973 (52).

From the artist's own description of the site of this drawing, it would seem to show a view looking south and upstream along the River Viamala to Thusis (the 'Tusis' of the artist's inscription) in the Graubünden (the German name by which the Canton of Grisons is now known). The high peaks in the distance are probably Curver, Grisch and Platta. The town of Reichenau, on the Upper Rhine of which the Viamala is a tributary, would lie behind the artist as he sketched this scene from a vantage point above the road on the west bank of the river. Towne visited Italy in 1780 returning through Switzerland in 1781, and this highly finished sheet would seem to have been executed on the spot, rather than worked up in the studio from preliminary sketches.

The sheet size of this drawing does not appear to correspond in any way to those which came from Towne's own collection, and described by Oppé as used by him for his Italian and Swiss drawings. He also describes them as, 'practically all are fully dated'.[1] Nor do the numbers correspond to those recorded by Oppé, although he refers to one series, on thin laid paper, $8\frac{1}{4} \times 6\frac{1}{8}$ ins. (21 × 15.5 cm.), with a numerical sequence 16 to 59.

Oppé refers to the 'severity' of Towne's Swiss views. There is no sentiment or 'prettiness', and the mountains are seen as 'hard and cruel and too imminent and hostile to permit any thought of rustic bliss or primitive innocence in the valleys at their base. He is overpowered, almost obsessed, by the mountains themselves.'[2]

1 A. P. Oppé, 'Francis Towne, Landscape Painter', *Walpole Society*, VIII (1920), p. 116 note 1.
2 *ibid.*, p. 117.

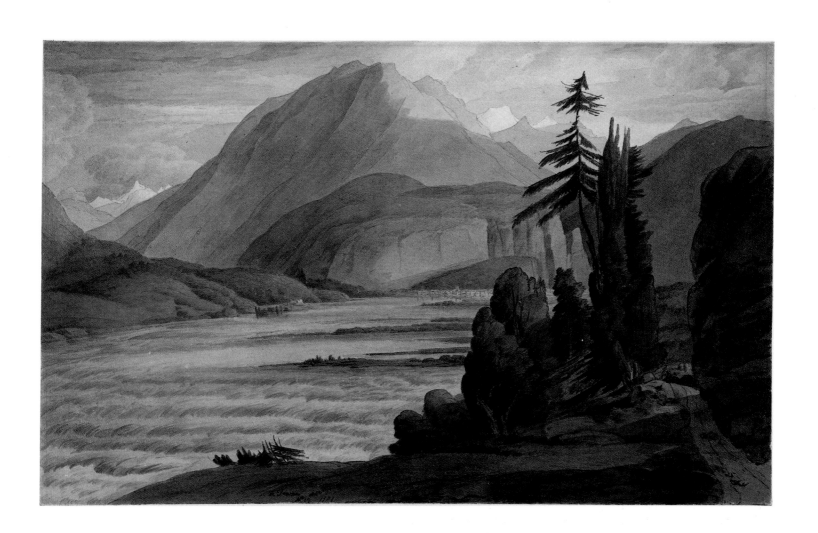

FRANCIS TOWNE
(*c*.1740–1814)

108 The Forest of Radnor, with the Black Mountains in the distance *c*.1810

Traces of pencil; contour drawing in pen and grey ink wash; black ink wash, and restricted watercolour washes, with some drawing with the point of the brush; re-drawing of foreground detail with pen and the point of the brush in dark grey ink; on off-white wove paper. The drawing made up of two sheets, trimmed at the edges and laid down, each 17.1 × 25.3 cm.
Both sheets watermarked '[WH]ATMAN/1808'.

17.1 × 50.6 cm.

Inscribed by the artist in pen and brown ink, *verso* of right sheet: 'The Forest of Radnor the blackmountains in the lefthand distance', and numbered on *versos* of both sheets: '3 & 4'.

PROVENANCE: W. W. Spooner; Spooner Bequest 1967 (S.90).

EXHIBITIONS: Courtauld, 1968 (20); Royal Academy Bicentenary, 1968 (666); Bath, 1969 (70); Bristol, 1973 (54); New Zealand and Australia, 1976–78 (16); British Museum, 1983 (94).

See No. 109 below.

109 Near Devil's Bridge, Central Wales *c*.1810

Traces of pencil; contour drawing in pen and grey ink; black and brown ink washes, and restricted watercolour washes, with some drawing with the point of the brush; orange bodycolour; on off-white wove paper. The drawing made up of two sheets, trimmed at the edges and laid down, each 17.1 × 25.6 cm. The right sheet watermarked '[WH]ATMAN/1808'.

17.1 × 51.2 cm.

Inscribed by the artist in pen and brown ink, *verso* of right sheet: 'near the Devil's Bridge', and 'Join', and in pencil on the *verso* of the left sheet: 'Join'. Numbered in pencil on the *verso* of the right sheet: '1 & 2'.

PROVENANCE: W. W. Spooner; Spooner Bequest 1967 (S.91).

EXHIBITIONS: Courtauld, 1968 (19); Bath, 1969 (69); Bristol, 1973 (53); New Zealand and Australia, 1976–78 (17); British Museum, 1983 (95).

LITERATURE: Philip Troutman, 'The Evocation of Atmosphere in the English Watercolour', *Apollo*, 87 (July 1968), p. 55, repr. pl. 5.

Both this sheet and the preceding, *The Forest of Radnor ... in the distance*, might have been conceived as a pair, and they almost certainly date from Towne's Welsh tour of 1810. Stylistically, the intense blues of the sky and the use of bodycolour indicate a much later date than the artist's Welsh tour of 1777, as proposed by Troutman (loc. cit.). The watermarked date of 1808 on both sheets is further corroborative evidence for the later date.
 Oppé noted that the Misses Merivale collection from Barton Place had five Towne sketchbooks, including those from his Cornish and Welsh tours of 1809 and 1810.[1]

240 1 A. P. Oppé, loc cit., p. 124 note 1.

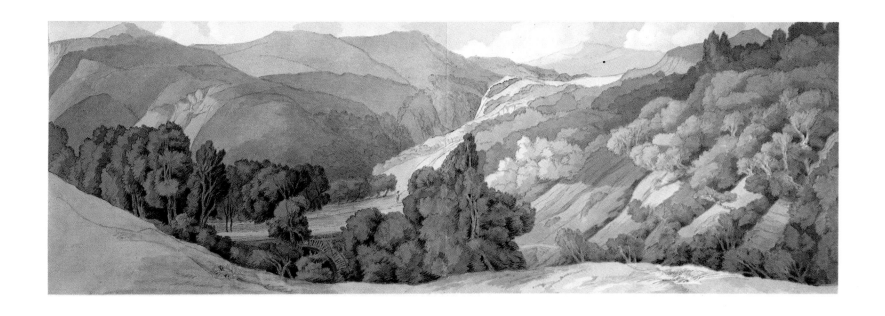

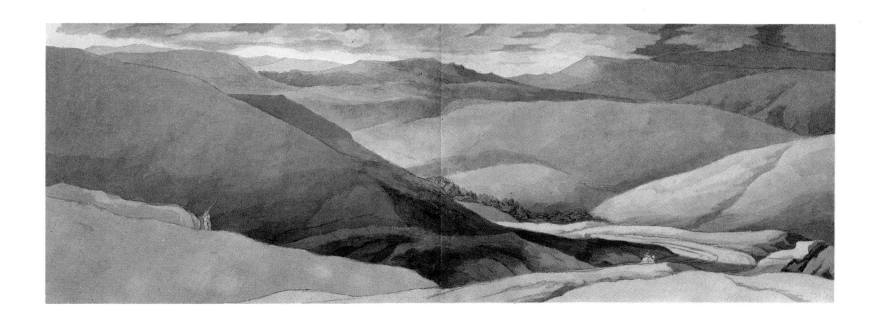

JOSEPH MALLORD WILLIAM TURNER
(1775–1851)

110 Chepstow Castle *c*.1793

Detailed preliminary drawing in graphite; blue, grey, and brown watercolour washes, with extensive drawing with the point of the brush and, in parts, pen; on thin white laid paper. The sheet trimmed at all sides, apparently to a ruled line in graphite.

21.0 × 30.0 cm.

Signed in brush and grey wash, bottom left: 'Turner' (the 'e' a large cursive Greek 'ε').

Verso: broad washes of the dominant colours (blues, greys, and brown) to correspond with principal elements of the composition on the *recto*. Executed presumably by holding up sheet against the light to achieve register with the composition on the *recto*. These washes revealed when sheet was lifted off its old backing in July 1985.

PROVENANCE: (?) R. Chambers, sold Christie, 29 March 1859 (lot 7, as 'Chepstow Castle and Bridge'), bt. Gambart; sold anonymously, Foster, 19 November 1860 (lot 88); Sir Joseph Heron, sold Christie, 9 June 1890 (lot 75); bt. Walford; Cotswold Gallery; Sir Stephen Courtauld; presented to the Courtauld Institute by the family of Sir Stephen Courtauld in his memory 1974 (S.C.1).

EXHIBITIONS: Turner Courtauld, 1974 (1); Courtauld, 1980 (1); British Museum, 1983 (120).

LITERATURE: published as an engraving in *The Copper-Plate Magazine*, 1 November 1794; Andrew Wilton, *The Life and Work of J. M. W. Turner* (1979), No. 88.

This watercolour, which was published as an engraving in *The Copper-Plate Magazine* in November 1794, was only the second of Turner's works to be engraved.[1] The first, a *View of Rochester*, appeared in the same magazine on 1 May 1794.[2] From 1794 to 1798 Turner produced fifteen drawings for engraving in this small, short-lived periodical, which was typical of the cheaper, illustrated topographical magazines of the day. Turner was subsequently to establish his financial independence as a result of the income he derived from topographical work in the earlier part of his career.

Girtin also worked for the magazine, and Kitson points out that the present watercolour may show the beginnings of the association between the two artists. He notes the relatively minute handling which is in contrast to Turner's earlier breadth of treatment; and in the picturesque approach to the subject and the distinctive blue-and-grey colour scheme, the influence of Girtin's master, Dayes, is apparent. Girtin, too, had been producing this type of picturesque topographical watercolour representing medieval castles and cathedrals since 1791, at the instigation of the antiquarian James Moore.

Turner's pencil sketch of Chepstow Castle in the British Museum (T.B. XII), seen from a slightly different viewpoint, is provisionally dated 1792–93.[3] The Courtauld sheet may be dated 1793, and was probably worked up from a similar on-the-spot sketch. It is less advanced in style than *Tintern Abbey*, exhibited at the Royal Academy in 1794. Chepstow Castle, which lies near the mouth of the River Wye at its confluence with the Severn, was a favourite haunt of English watercolourists of the period, and was again in fashion with Philip Wilson Steer at the beginning of the present century. Although Turner's depiction of the castle is architecturally accurate, his silhouetting of the keep against the sky and the roughening of the edges of the forms betray that enhancement of the motif characteristic of the Picturesque.

1 This note and the four following are largely based on the catalogue entries by Michael Kitson, *Turner Watercolours from the Collection of Stephen Courtauld* (1974), Nos. 1, 3, 6, 8, and 11.
2 W. G. Rawlinson, *The Engraved Works of J. M. W. Turner, R.A.*, I (1908), p. 2 (where he refers to the drawing in the Heron sale).
3 'TB' refers to A. J. Finberg's *A complete Inventory of the Drawings of the Turner Bequest*, 2 vols. (1909).

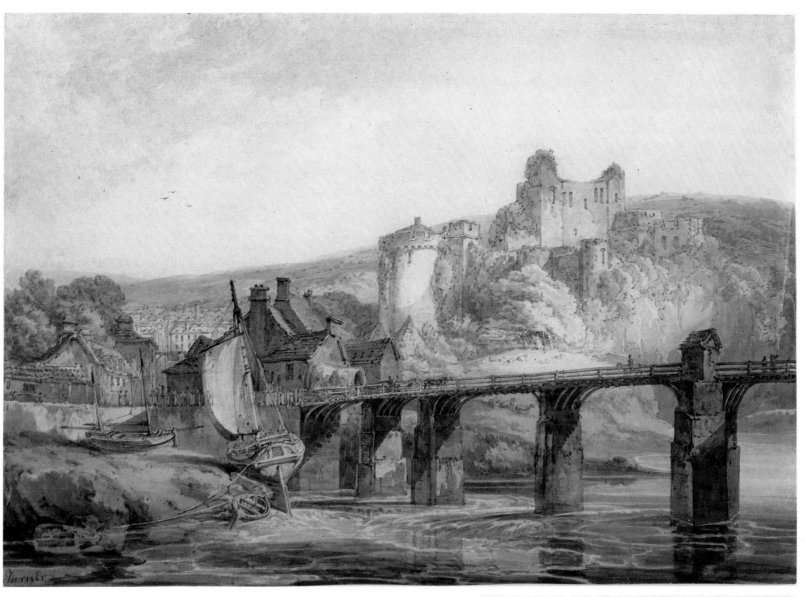

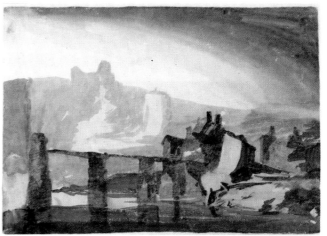

JOSEPH MALLORD WILLIAM TURNER
(1775–1851)

111 The Upper Falls of the Reichenbach 1802

Extensive preliminary drawing in soft pencil; restricted watercolour washes and some bodycolour; some scoring of paper in highlights of the waterfall and extensive scraping and rubbing in highlights of the rainbow. Traces of gum arabic or varnish in dark green areas of foliage (?) on left side of the composition. Grey wash on *verso*. On white wove paper, unevenly trimmed and now inlaid.

32 × 47.3 cm.

Inscribed in pencil on the *verso*: 'This drawing is the property of/H. V. Tebbs Esq/26 August 1871', and by a different hand 'JMWS (or T)' (the M and W in monogram).

PROVENANCE: H. Virtu-Tebbs (by 1871), sold Christie, 10 March 1900 (lot 35), bt. Agnew; Mrs Rachel Beer, sold Christie, 22 July 1927 (lot 25), bt. A. J. Finberg; Sir Stephen Courtauld (by 1929); presented to the Courtauld Institute by the family of Sir Stephen Courtauld in his memory 1974 (S.C.3).

EXHIBITIONS: *Water-Colour Drawings*, Agnew, 1901 (211); *La Peinture anglaise*, Brussels, 1929 (184, lent by Sir Stephen Courtauld); R.A., 1934 (804); Turner Centenary, Agnew, 1951 (13); Turner Courtauld, 1974 (3); Courtauld, 1980 (3).

LITERATURE: Michael Kitson, *Turner Watercolours from the Collection of Stephen Courtauld* (1974), No. 3; A. Wilton, *Turner in Switzerland*, Zurich (1976), p. 66 (repr.).

After the Peace of Amiens, Turner made his first visit to France and Switzerland, probably under the patronage of the Earl of Yarborough and Walter Fawkes. He arrived in Upper Savoy probably early in August 1802. This, and three other sheets in the Stephen Courtauld collection (*Bonneville*; *The Mer de Glace, Chamonix, with Blair's Hut*; and *Courmayeur*), were executed during or as a result of this visit.

This drawing is a sheet from the grand 'St Gothard and Mont Blanc' sketchbook (TB LXXV), and was no doubt sketched in pencil on the spot and coloured in the artist's hotel room in the evening. The almost monochrome grey tint, even more pronounced than in *Bonneville*, underlines Turner's preoccupation with tone rather than colour on his 1802 Alpine tour. He reached the Reichenbach Falls, where J. R. Cozens had preceded him in 1776 (compare No. 85), after passing through Chamonix and Courmayeur; afterwards he continued by way of Lake Lucerne to the Pass of St. Gothard, the final point of his tour.

A finished drawing was made from this watercolour for Turner's patron, Walter Fawkes (now in the Paul Mellon Center for British Art, New Haven),[1] which is brighter in colour and lighter and more atmospheric in effect. Stylistically, this would seem to fit a date between 1810 and 1815.

1 Evelyn Joll, *English Drawings and Watercolours 1550–1850, in the Collection of Mr. and Mrs. Paul Mellon*, Pierpont Morgan Library and Royal Academy, 1972–73 (104).

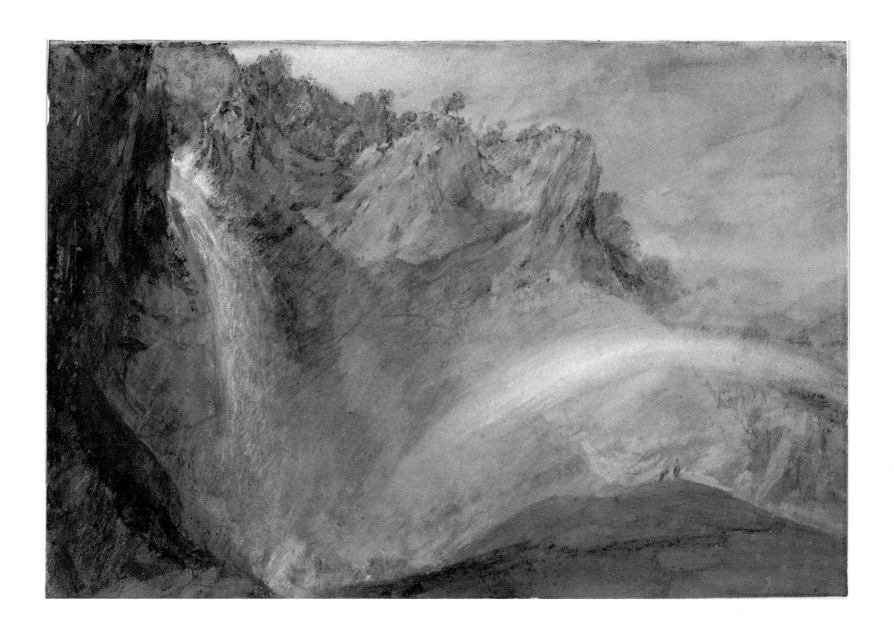

JOSEPH MALLORD WILLIAM TURNER
(1775–1851)

112 The Crook of Lune, looking towards Hornby Castle c.1816–18

Traces of preliminary drawing in pencil; watercolour, with use of the dry brush and drawing with the point of the brush; touches of white and other coloured bodycolour, especially in the foliage, bridge, figures and animals; extensive scraping out in the whites (especially in the river), some retinting and some rubbing, also scoring with the point of the brush handle (in vegetation and trees on left of middle-ground); traces of gum or thin varnish in the foreground; some black chalk (in rocks, centre foreground); slight use of finger-printing in grey and brown watercolour; on white wove paper, now backed. Two tears repaired; paper made up in sky.

29.1 × 42.9 cm.

PROVENANCE: Messrs. Longman, by whom commissioned (see LITERATURE); C. Orme (a member of Longman's), sold Christie, 7 March 1884 (lot 41), bt. Agnew; the Revd W. MacGregor (by 1886), sold Christie, 23 April 1937 (lot 11), bt. Fine Art Society; Sir Stephen Courtauld; presented to the Courtauld Institute by the family of Sir Stephen Courtauld in his memory 1974 (S.C.6).

EXHIBITIONS: *Old Masters*, R.A., 1886 (Watercolours by Turner, No. 14, lent by W. MacGregor); *Pictures and Drawings by J. M. W. Turner and some of his Contemporaries*, Guildhall, 1899 (123); *Water-Colour Drawings by J. M. W. Turner*, Agnew, 1913 (32); Turner Courtauld, 1974 (6); Courtauld, 1980 (6); *Turner and Dr. Whitaker*, Townley Hall Art Gallery and Museums, Burnley, 1982 (60); British Museum, 1983 (124).

LITERATURE: Engraved on copper by John Wykeham Archer (1806/8–64) for *The History of Richmondshire* (1821); J. Ruskin, *Pall Mall Gazette* (letter), 24 April 1885 (reprinted in Cook & Wedderburn (eds.), *The Works of John Ruskin*, XXXIII, p. lvi); Cook & Wedderburn (eds.), *Works*, XXXVII, pp. 476, 478; W. G. Rawlinson, *Engraved Works of J. M. W. Turner*, I, p. 103, No. 183; Rawlinson and A. J. Finberg, *The Watercolours of J. M. W. Turner* (1909), pl. XIII; A. Wilton, *The Life and Work of J. M. W. Turner* (1979), No. 575.

This is one of Turner's watercolours for twenty views engraved after his designs for *The History of Richmondshire*, published by Longman's between 1819 and 1823. He received the commission from the antiquarian and topographer, Dr Thomas Dunham Whitaker, early in 1816, and executed the finished watercolours between 1816 and 1818 at a fee of 25 guineas each. It was a high-quality publication, and the engravers were paid between 60 and 80 guineas per plate. However, the original intention of producing a much larger series covering the whole of Yorkshire was abandoned because of the cost, although the publication in its final form was regarded a success. The twenty plates, with a new commentary, were last reprinted as late as 1891.

The series deals with that part of the North Riding bordering on Westmorland and Lancashire, of which the town of Richmond is the centre, and includes some of the finest dales and valleys of the region. It was also a part of the country that J. S. Cotman had painted. The present sheet shows a wide panoramic view of the River Lune, with a glimpse of Hornby Castle in the distance. The high viewpoint, technical complexity and virtuosity of this watercolour is characteristic of the whole series. The range of delicate hues of green-blues, golds and browns suggest a landscape seen through a heat haze suffused by brilliant sunlight.

Ruskin much admired this group of watercolours, and praised them for their warmth of feeling, sense of mass and fidelity to the minutiae of nature. He tried to persuade, unsuccessfully, the University of Oxford to purchase this sheet and *Kirby Lonsdale* (from the same series) in 1884, at the time of his resignation from the Slade Professorship, when they were put on the market by C. Orme, a member of Longman's the publishers.

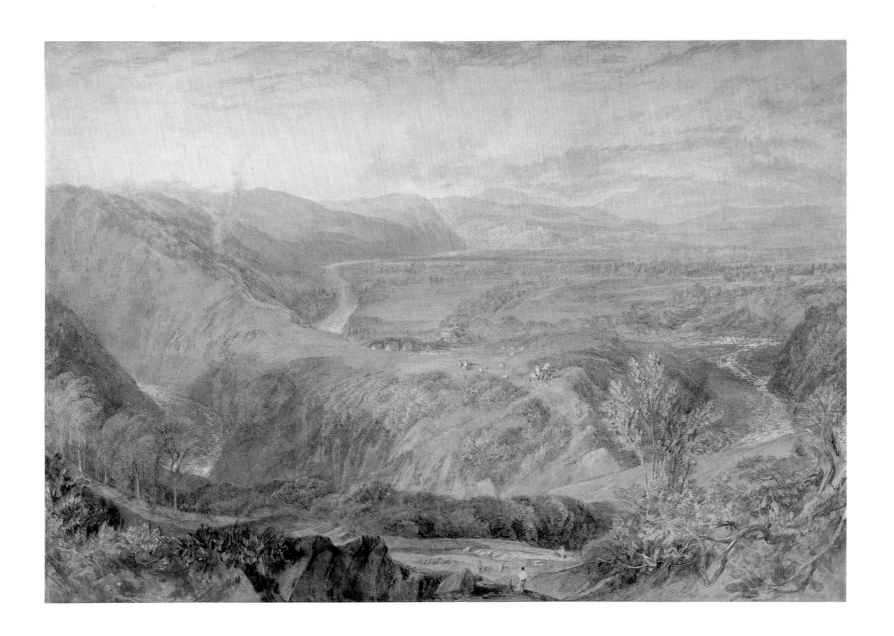

JOSEPH MALLORD WILLIAM TURNER
(1775–1851)

113 Colchester *c.*1825–26

Traces of preliminary drawing in pencil; watercolour, with drawing with the point of the brush and use of the dry brush; white and other coloured bodycolour; touches of white, red, and other coloured chalks; scraping out, and scoring into the wet paint with the point of the brush handle; on white laid paper, the upper half of which, except for the area of the sun, given a very pale grey wash. The sheet laid on pale grey-green paper.

28.8 × 40.7 cm.

PROVENANCE: J. H. Maw (by 1829); Miss James, sold Christie, 22 June 1891 (lot 160), bt. Agnew; Locket Agnew; C. Fairfax Murray (by 1908), from whom bt. by Agnew; bt. from Agnew by Sir Stephen Courtauld, 11 February 1918; presented to the Courtauld Institute by the family of Sir Stephen Courtauld in his memory 1974 (S.C.8).

EXHIBITIONS: Egyptian Hall, London, June 1829 (34); Birmingham Society of Artists, 1829 (388); *Drawings by J. M. W. Turner RA, expressly made for his Work … of 'Views in England and Wales'*, Moon, Boys and Graves Gallery, 6 Pall Mall, 1833 (56), lent to all three exhibitions by J. H. Maw; *Old Masters*, R.A., 1891 (Watercolours, No. 84); *Old Masters*, R.A., 1908 (226, lent by C. Fairfax Murray); *Water-Colour Drawings by J. M. W. Turner*, Agnew, 1913 (67); *Annual Exhibition of Water-colour Drawings*, Agnew, 1924 (33); Turner Centenary, Agnew, 1951 (71); Turner Courtauld, 1974 (8); *Turner's Picturesque Views in England and Wales*, Agnew, 1979 (6); Courtauld, 1980 (9); British Museum, 1983 (123).

LITERATURE: Engraved on copper by R. Wallis for *Picturesque Views in England and Wales*, Part II, No. 1 (1827); J. Ruskin, *Modern Painters*, I (1843: see Cook & Wedderburn (eds.), *Works*, III, pp. 266, 298 and note 2, also XIII, p. 439, XV, p. 75 note); W. Armstrong, *Turner* (1902), p. 247; Rawlinson, *Engraved Works*, I, pp. 121–22, under No. 213; A. J. Finberg, *The Life of J. M. W. Turner R.A.* (2nd edn., 1961), pp. 297, 344, 488 (No. 326), 494 (No. 390); Eric Shanes, *Turner's Picturesque Views in England and Wales 1825–1838* (1979), p. 25, No. 6, repr. pl. 6; A. Wilton, *The Life and Work of J. M. W. Turner* (1979), No. 789.

This is Turner's finished watercolour for one of the subjects in the largest and most ambitious series of engravings ever produced from his designs, the *Picturesque Views in England and Wales*, which was published in 96 plates between 1827 and 1838. Turner received the commission from Charles Heath (1785–1848), probably in the summer of 1825.[1] He is said to have received from the publishers 60 to 70 guineas for each of the watercolours,[2] but despite their high quality and the technical excellence of the prints, which were executed by a team of engravers under the artist's close supervision, the series was a commercial failure almost from the start, unlike *The History of Richmondshire*, and virtually bankrupted the principal publisher, Heath.

Colchester was one of the first prints to be published in an engraving by Robert Wallis (1794–1878) of 1827. The pencil studies for it (in the 'Norfolk, Suffolk and Essex' sketchbook, TB CCIX) were probably done a few years earlier, but Turner only loosely adhered to them, preferring, as was his custom, to treat even quite familiar subjects in a fresh manner, not by falsifying nature but rather enhancing it.

The view shown here is looking south across the River Colne to the town of Colchester, straddled up Middle Hill, with the sunlight streaming through the trees and illuminating the smoky haze above the rooftops of the town. The time of day has been a matter of debate, most commentators have suggested late afternoon, and if so, Turner has either deliberately lowered the sun or lit the scene from imagination.

However, the presence of the sun on the left of the drawing that is in the south-east, would suggest that the time of day is early morning, in winter.[3] This observation is supported by Ruskin who, in commenting on the tonal exactitude of Turner's watercolour, asserted that he could '… select from among the works named in Chap. V of the next section, pieces of tone absolutely faultless and perfect, from the coolest greys of wintry dawn to the intense fire of summer noon'.[4] In a footnote to this passage, he illustrates Turner's gamut of tone by referring to three watercolours, of which only *Colchester* fits the description of 'wintry dawn'.[5] He later praises Turner's minute and subtle variations of colour and tone by specific reference to this watercolour: 'The drawing of Colchester in the England series, is an example of this delicacy and fullness of tint together with which nothing but nature can be compared.'[6]

The broad sweeping curve of the foreground composition, contrasted with the column of light reflected in the water, anticipate the dramatic effects he was to deploy in his four oils for the dining room at Petworth of the early 1830s. The 'drama' of the hare being chased across the empty foreground, watched by excited spectators, at once animates the scene and unites the two sides of the composition. Turner uses this motive in other works, notably *Apollo and Daphne* (BJ, No. 369), and *Rain, Steam and Speed* (BJ, No. 409).

1 Shanes, *op. cit.*, p. 10 and note 2. The only dated drawing, *Saltash*, is 1825.
2 Rawlinson, *op. cit.*, p. xlvii; but Finberg, *op. cit.* (1961), p. 299, considered this to be an exaggeration. See also note by E. Joll in *J. M. W. Turner*, Grand Palais, Paris (1983–84), pp. 255–57.
3 W. Bradford and P. Troutman, *Turner, Prout, Steer: Three Bequests to the Courtald Institute of Art* (exh. catalogue, 1980), p. 5.
4 Cook & Wedderburn (eds.), *Works*, III, p. 266.
5 *ibid.*, XIII, p. 439.
6 *ibid.*, III, p. 298 note 2.

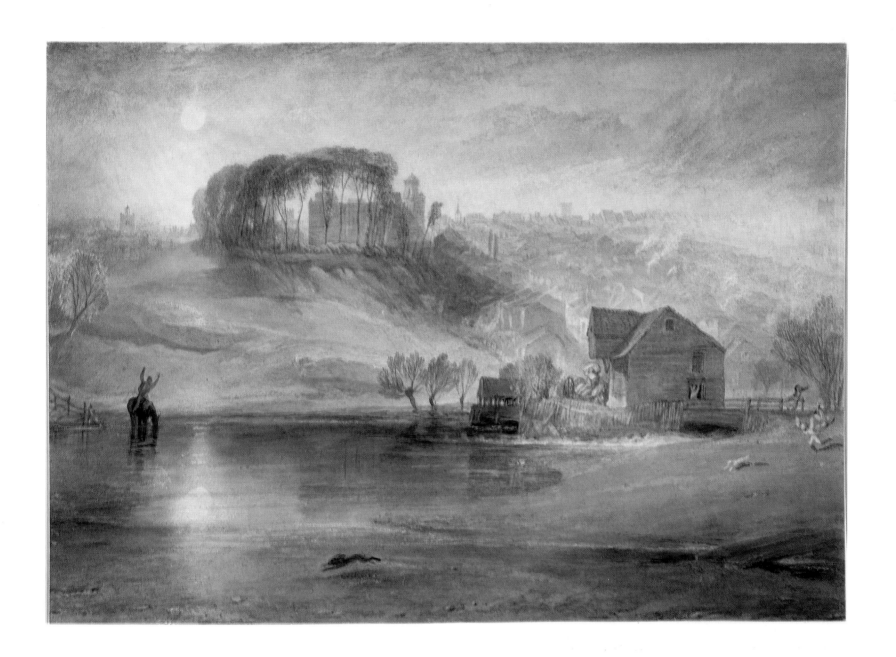

JOSEPH MALLORD WILLIAM TURNER
(1775–1851)

114 Dawn after the Wreck *c.*1841

Some preliminary drawing in pencil; watercolour, with drawing with the point of the brush; white and other coloured bodycolour; touches of red chalk; rubbing and retinting; on white laid paper. The drawing edged with a ruled line in pen and brown ink. The sheet laid on pale green-grey paper.

25.1 × 36.8 cm.

PROVENANCE: The Revd W. Kingsley; Mrs Kingsley, sold Christie, 14 July 1916 (lot 27), bt. Agnew; bt. from Agnew by Sir Stephen Courtauld, 5 July 1917; presented to the Courtauld Institute by the family of Sir Stephen Courtauld in his memory 1974 (S.C.11).

EXHIBITIONS: *Old Masters*, R.A., 1892 (Watercolours, No. 3); *Annual Exhibition of Water-colour Drawings*, Agnew, 1924 (91); *La Peinture Anglaise*, Brussels, 1929 (26); R.A., 1934 (887); Turner Centenary, Agnew, 1951 (94); Turner Courtauld, 1974 (11); *William Turner und die Landschaft seiner Zeit*, Kunsthalle, Hamburg, 1976 (121); Courtauld, 1980 (12); British Museum, 1983 (122); *J. M. W. Turner*, Paris, 1983–84 (228).

LITERATURE: J. Ruskin, *Modern Painters*, V (1860: see Cook & Wedderburn (eds.), *Works*, VII, p. 438 and note); W. Armstrong, *Turner* (1902), p. 249; A. P. Oppé, *The Water-colours of Turner, Cox & de Wint* (1925), p. 20, pl. XII; A. Wilton, *The Life and Work of J. M. W. Turner* (1979), No. 1398.

Although this sheet has certain affinities with such oils as *Calais Sands* of 1830 (BJ, No. 334), probably done partly in rivalry with, and partly in homage to Richard Parkes Bonington (1802–28), whom Turner had much admired, Ruskin associated it with Turner's 'last years', and a date of about 1841 is generally agreed. The density of paint and the suggestion of colour symbolism both point to the later date, and Dr John Gage has noted that a similar palette appears in the oil, *The New Moon*, shown at the Royal Academy in 1840 (BJ, No. 386, Tate Gallery, No. 526).

Ruskin may perhaps have read more into the work than Turner intended, but the symbolism of death and destruction, of the dog howling in grief at the death of his drowned master, must certainly have been in the artist's mind. Ruskin describes the painting: 'The scarlet of the clouds was his symbol of destruction. In his mind it was the colour of blood. So he used it in the Fall of Carthage . . . So he used it in the Slaver [*Slavers throwing overboard the Dead and the Dying – Typhon coming on*, 1840], in the Ulysses [*Ulysses deriding Polyphemus*, 1829], . . .; again in slighter hints and momentary dreams, of which one of the saddest and most tender is a little sketch of dawn, made in his last years. It is a small space of level sea shore; beyond it a fair, soft light in the east; the last storm-clouds melting away, . . .; some little vessel – a collier, probably – has gone down in the night, all hands lost; a single dog has come ashore. Utterly exhausted, its limbs failing under it, and sinking into the sand, it stands howling and shivering. The dawn clouds have the first scarlet upon them, a feeble tinge only, reflected with the same feeble bloodstain on the sand.'[1]

1 Ruskin, *Modern Painters*, V, part IX, chap. XI (*Works*, VII, p. 438).

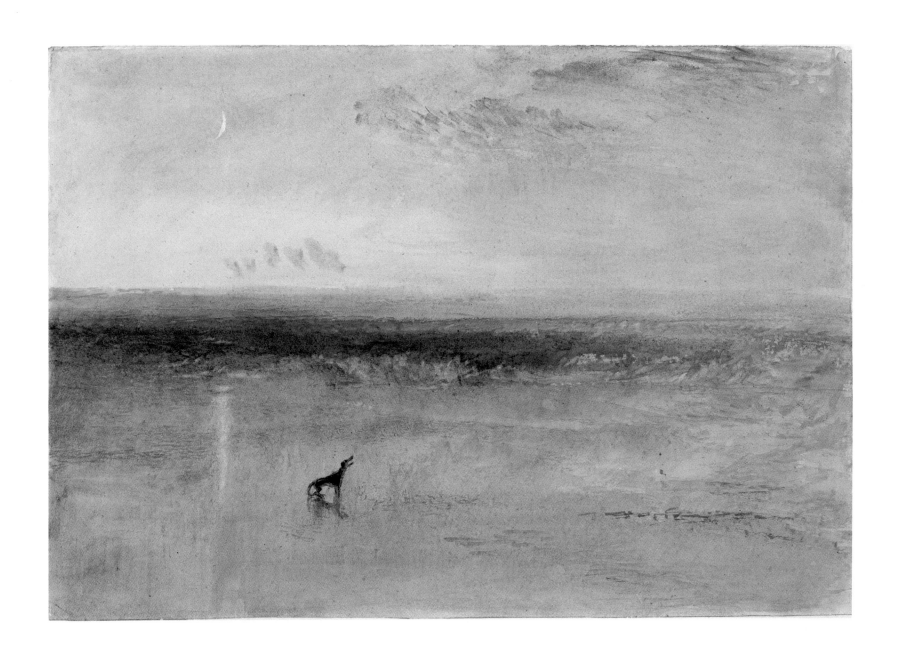

JOHN VARLEY
(1778–1842)

115 The Royal Naval College and Seamen's Hospital,
Greenwich, viewed from the north-east
*c.*1822–24

Preliminary drawing in pencil, both free-hand, and for the Hospital, ruled;
black ink and brown ink washes, and watercolour, with drawing with the point
of the brush; pale grey, orange, and cream bodycolour; rubbing, especially in
the area of water on the right; on white (now unevenly yellowed and faded)
wove paper. The sheet torn and repaired in two areas, lower left, and unevenly
trimmed on all sides.
Watermark: 'J WHATMAN/1816' (the date partly cut away).

33.5 × 48.5 cm.

A pentimento in pencil shows a dome above the end of the east wing of the
College, another pentimento above the end of the west wing reveals an irregular
architectural structure.
Inscribed in a modern hand in pencil, *verso*: 'D25563AX'.

PROVENANCE: W. W. Spooner; Mrs M. Spooner; presented to the Courtauld
Institute by Mrs Spooner, 1979 (S.97).

EXHIBITIONS: Harrogate, 1968 (49); Bath, 1969 (77); Bristol, 1973 (64);
John Varley: A Bicentenary Exhibition, Hackney Library, London, 1978 (67).

A list of works exhibited by John Varley at the Old Water-Colour Society,
published by C. M. Kauffmann, shows that the artist sent views of Greenwich to
each of the annual O.W.C.S. exhibitions in 1822, 1823, and 1824.[1] Other
London scenes included views of Chelsea (1811) and Millbank (1816). It seems
reasonable to suppose that the Spooner sheet belongs to the group of Greenwich
subjects of the early 1820s, and, in view of the watermark date it bears, certainly
not earlier than 1816. Varley's later work, especially of the late 1830s and early
1840s, is no longer purely topographical but conveys a strong pastoral, almost
elegaic mood akin to that found in Edward Calvert and Samuel Palmer.

1 C. M. Kauffmann, *John Varley 1778–1842, with a catalogue of works by John Varley in the
Victoria & Albert Museum* (1984), p. 81: O.W.C.S. 1822 (150) 'Greenwich from the
Observatory'; 1823 (72) 'London, from Greenwich'; 1824 (236) 'London, from Greenwich
Park'.

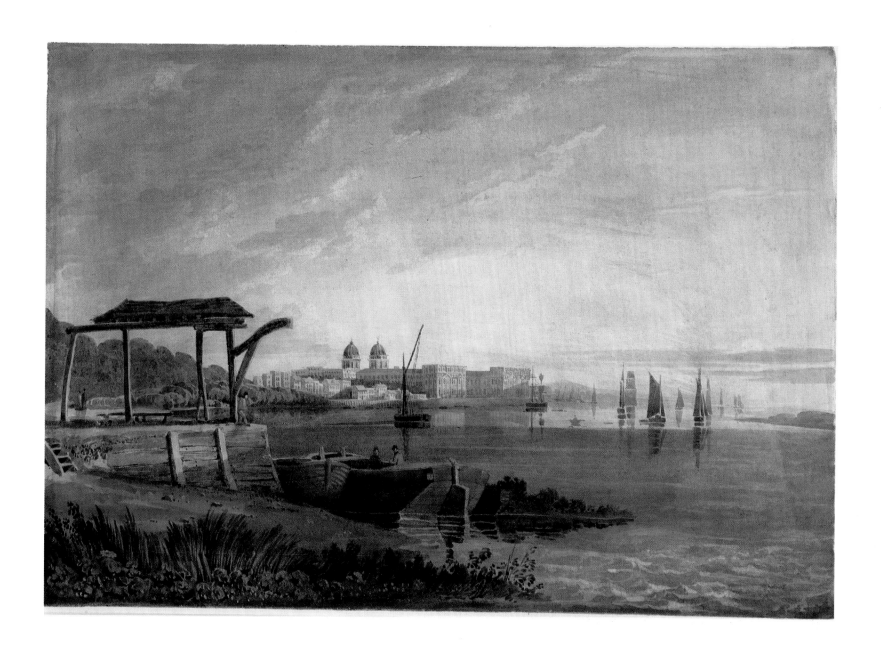

JOHN VARLEY
(1778–1842)

116 Landscape Idyll – Sunset *c.*1840–42

Watercolour and some bodycolour; some drawing with the point of the brush, and some rubbing and blotting of paper in foreground of sky; some scoring on foliage; extensive additions of gum or varnish applied to trees in middle ground and to foliage in the foreground; on cream wove paper. An extensive area of middle ground has been covered by a thin layer of paper, rougher in texture than the main support, to provide a variation in texture.
Signed in pen and point of the brush, bottom left: 'J Varley'.

16.7 × 36.6 cm.

PROVENANCE: Squire Gallery (no date), from where bt. by Sir Robert Witt; Witt Bequest 1952 (4293).

EXHIBITIONS: Courtauld, 1965 (25, as 'Evening Landscape'); New Zealand and Australia, 1976–78 (21).

As noted in the previous entry, John Varley's style changes in the 1830s up to his death in 1842, and he moves away from the purely topographical record to convey a sense of mood. At the Old Water-Colour Society in 1841, for example, he showed paintings with generalised titles such as 'Landscape – Evening' and 'Landscape, with Ruins'. In the Witt drawing, the title by which it is known (and which may be the artist's own) suggests pastoral tranquillity and matches the subject matter of a shepherd tending his flock at eventide. The glorious sunset can also be read as a portent of impending death.

RICHARD WILSON
(1714–1782)

117 View in Rome, with the Basilica of Constantine
c.1752–56

Black chalk, with drawing both free-hand and ruled; on blue-grey laid paper. Watermark: Fleur-de-lis within an oval.

25.9 × 39.6 cm.

Collector's marks: 'P.S' (Lugt 2112); 'WE' (Lugt 2617); bottom left; and on old mount: 'RJ' within a belt inscribed 'VIRTUS PATIENTIA VERITAS' (Lugt 2216) bottom left.

PROVENANCE: Paul Sandby, (?) sold Christie, 2–4 May 1811; William Esdaile (sold 1840); Richard Johnson; Dr John Percy; . . .; Meatyard, bt. by Sir Robert Witt; Witt Bequest 1952 (239).

Wilson has chosen a view, looking towards the Via Sacra, of the three huge barrel vaults on the north side of the ruined Basilica of Maxentius (or Constantine). In the right foreground is an end-on perspective of the columns of the façade, added to the ancient church of S. Maria Nova by Carlo Lombardi in 1615. The Basilica, one of the great architectural achievements of classical antiquity, was begun by the Emperor Maxentius in AD 307–12, and completed in the reign of Constantine, who supplanted him. Only the right nave arches survive, the central nave vault and left nave collapsed in an earthquake in the ninth century.

The drawing must date from Wilson's stay in Rome from January 1752 to August 1756, and its quality is such as to rule out the possibility of it being by a lesser pupil-imitator like the Dublin-born Robert Crone (died 1779). Crone studied with Wilson in Rome, along with John Plimer, who was active there 1755–61 and whose drawings have sometimes been attributed to Wilson.[1]

1 Basil Skinner, 'A Note on Four British Artists in Rome', *Burlington Magazine*, XCIX (July 1957), p. 237; see also: W. G. Constable, *Richard Wilson* (1953) and Brinsley Ford, *Drawings of Richard Wilson* (1951).

RICHARD WILSON
(1714–1782)

118 The Thames looking towards Syon House
(?)1762–65

Preliminary drawing in graphite; black chalk, with extensive use of the stump and rubbing; heightened with white chalk, touches of red chalk on heads of the three figures; on grey laid paper. The sheet unevenly trimmed on all sides, and tears repaired bottom, right, and bottom left corner.
The sheet watermarked with an oval.

32.5 × 52.7 cm.

Collector's mark: 'W' surmounted by an Earl's coronet, all contained within an oval (Lugt 2600), bottom right.

PROVENANCE: 4th Earl of Warwick (1816–93); (?) 7th Earl and Trustees of late (6th) Earl of Warwick, sold Sotheby, 17 June 1936 (lot 152), *Classical Landscape* (black chalk) and three others, bt. Meatyard; Mr & Mrs W. W. Spooner; Spooner Bequest 1967 (S.102).

EXHIBITIONS: Courtauld, 1968 (6); Harrogate, 1968 (1); Bath, 1969 (81); Rye, 1971; Bristol, 1973 (67); New Zealand and Australia, 1976–78 (4); British Museum, 1983 (96).

On his return to England in 1757, Wilson painted a number of views of the great country houses including, for example, Syon House, Marble Hill, Moor Park, and Wilton House. This highly finished drawing, with Syon House clearly identifiable on the distant right bank, was unknown to Brinsley Ford and W. G. Constable, and is not directly related to the two oil versions of *Syon House from Richmond Gardens*.[1]

The diagonal composition, with repoussoirs of trees grouped on the left and a sailing boat on the river, right, with, in the foreground, a group of figures, broadly follows the pattern Wilson used in *View on the Thames near Twickenham* (Marble Hill House, Twickenham) of *c*.1762.[2] There is also a link, compositionally, with the drawing of *Wilton House viewed from the South-East*, where a wide expanse of water occupies the middle-distance and sets off foreground figures.[3] The Spooner sheet may be tentatively ascribed to 1762–5; since Wilson was not only in the habit of repeating compositions, but also of synthesising them either from several viewpoints or entirely arbitrarily composing from imagination, the relationship of drawings to finished oils is a complex one and their chronology difficult to establish.

1 Constable, *op. cit.*, Nos. 54a and b.
2 David H. Solkin, *Richard Wilson. The Landscape of Reaction*, Tate Gallery (1982), No. 102, who identifies this picture with that exhibited at the Society of Artists, 1762 (133); an unrecorded version of the painting referred to by Constable, *op. cit.*, pp. 187–88, pl. 57a.
3 Constable, *ibid.*, No. 58a: the comparison was made by W. Bradford, *Mantegna to Cézanne*, British Museum (1983), No. 96.

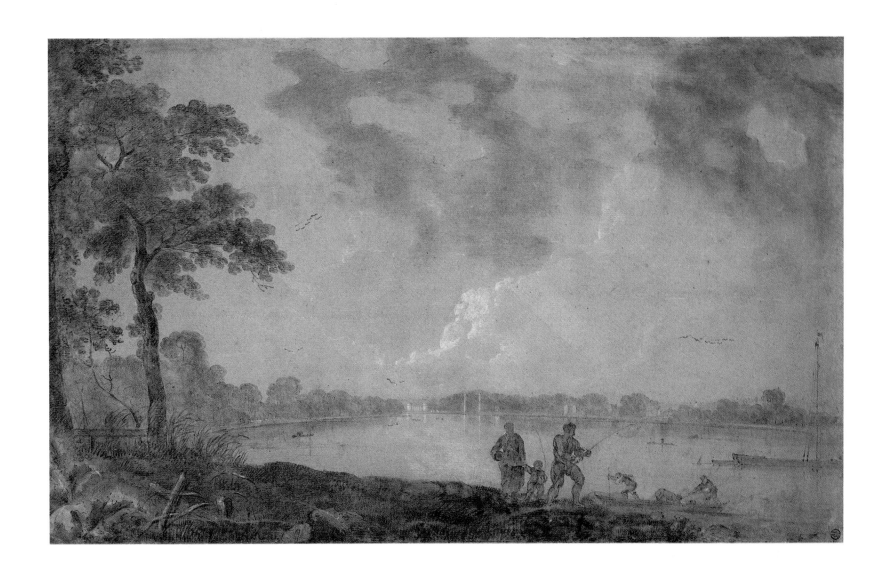

PETER DE WINT
(1784–1849)

119 Study of a Windmill and Sailing Barge
*c.*1830–35

Watercolour; washes and some drawing with the point of the brush; on white wove paper. The sheet trimmed to a ruled line on all four sides.

23.8 × 10 cm.

PROVENANCE: Agnew, bt. by Sir Robert Witt; Witt Bequest 1952 (4317).

EXHIBITIONS: Rye, 1971; *English Landscape Drawings and Watercolours*, Courtauld, 1977 (47).

These are two separate studies on one sheet. It is a tribute to the artist's sureness of touch that he has dispensed with any preliminary drawing and worked direct in watercolour. Peter de Wint was a pupil of John Varley, but the strongest influence was that of Girtin, to whose watercolours he was introduced by Dr Monro.

The artist's mature technique is discussed in the entry for *View of Oxford* (No. 120), and much more fully in the de Wint exhibition catalogue compiled by David Scrase for the Fitzwilliam Museum in 1979.[1] The few signed and dated works by de Wint, and the paucity of documentation for his relatively uneventful professional career, make it difficult to construct a secure chronology. Stylistically, the Witt sheet would appear to fit a work such as *Windmill and Boatman*,[2] which admirably demonstrates the artist's increasing freedom of handling during the early 1830s.

1 David Scrase, *Drawings & Watercolours by Peter de Wint*, Fitzwilliam Museum, Cambridge (1979).
2 *ibid.*, No. 50.

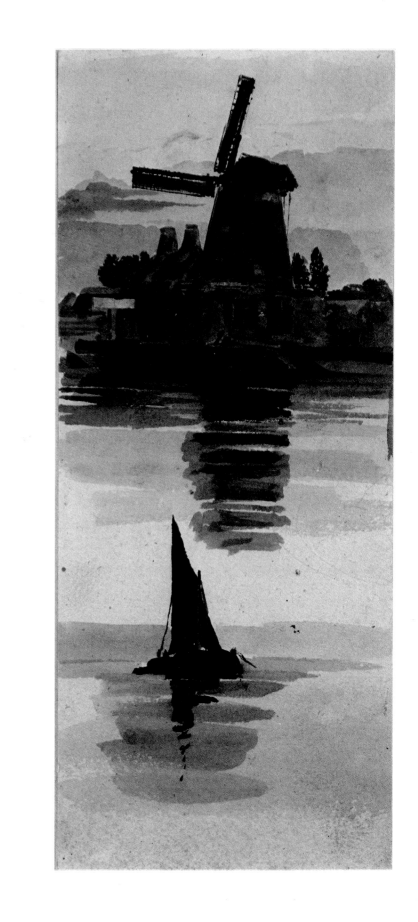

PETER DE WINT
(1784–1849)

120 View of Oxford *c*.1840

Traces of preliminary drawing in soft pencil; watercolour washes, with extensive drawing with both the point and the flat of the brush; touches of yellow, ochre, red, and blue bodycolour; on heavy pale buff wove paper.

28.2 × 47 cm.

Numbered in pencil on *verso*: 'No 1 –', and in different hands: '35' and '50'; and in pen and black ink: '6415' (last digit altered from a '6'), and, in pencil: 'G'.

PROVENANCE: Spink's;[1] Mr & Mrs W. W. Spooner; Spooner Bequest 1967 (S.104).

EXHIBITIONS: Courtauld, 1968 (72); Bath, 1969 (84); Rye, 1971; Bristol, 1973 (68); New Zealand and Australia, 1976–78 (48); *English Landscape Drawings and Watercolours*, Courtauld, 1979 (59).

A view of Oxford from the south-east; prominent landmarks on the skyline are, from left to right: Tom Tower of Christ Church and the spire of the cathedral; the tower of Merton College; the spire of the University Church of St. Mary the Virgin; with the dome of the Radcliffe Camera in the centre; and to the right, the tall tower of Magdalen College.

David Scrase has noted that the Clarendon Press, Oxford, commissioned several drawings and watercolours from de Wint, which were engraved and published for *The Oxford Almanack*.[2] A view of *Folly Bridge from the South East*, a brown wash drawing, was so published in 1827, and in 1841 a watercolour *View of Iffley from the River* was engraved by W. Radcliffe and appeared as a headpiece for that year's *The Oxford Almanack*. Both works still belong to the Delegates of The Clarendon Press (i.e. Oxford University Press). The *View of Iffley* is fussier in technique than the Spooner sheet, but this may be due to the demands of the engraver.[3]

A more robust and densely coloured work, *Cornfield, Windsor*, signed and dated 1841 (Fitzwilliam Museum, PD.129–1950),[4] shows a similar technique to the Spooner watercolour, and in both the artist has used the format of a view across cornfields to a distant landmark. These similarities, and the fact that the artist adopted a more opulent palette from the 1830s, suggest a date of *c*.1840 for *View of Oxford*.

1 Witt photograph (no date).
2 D. Scrase, *op. cit.*, Nos. 44 and 83.
3 *ibid.*, No. 44.
4 *ibid.*, No. 94.

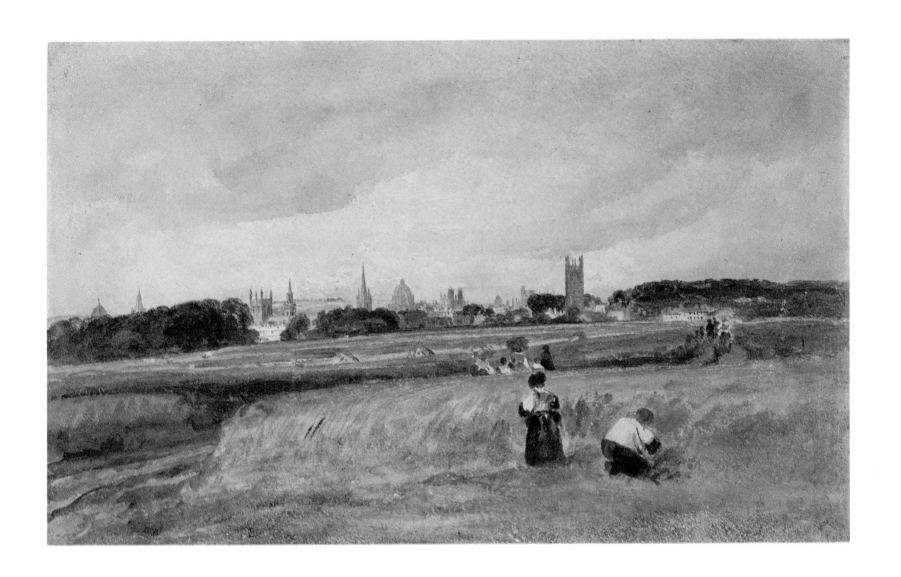

INDEX